Changing Habits

Changing Habits

Women's Religious Orders in Canada

ELIZABETH M. SMYTH, EDITOR

NOVALIS

© 2007 Novalis, Saint Paul University, Ottawa, Canada

Cover images: Jupiter Images (front cover) and Cleo (back cover)
Layout: Christiane Lemire and Dominique Pelland

Business Offices:
Novalis Publishing Inc.
10 Lower Spadina Avenue, Suite 400
Toronto, Ontario, Canada
M5V 2Z2

Novalis Publishing Inc.
4475 Frontenac Street
Montréal, Québec, Canada
H2H 2S2

Phone: 1-800-387-7164
Fax: 1-800-204-4140
E-mail: books@novalis.ca
www.novalis.ca

Library and Archives Canada Cataloguing in Publication

Changing habits : women's religious orders in Canada / Elizabeth M. Smyth, editor.

Includes bibliographical references and index.

ISBN 978-2-89507-903-3

1. Monasticism and religious orders for women–Canada–History.
2. Monastic and religious life of women–Canada–History.
I. Smyth, Elizabeth M. (Elizabeth Marian)

BX4200.C44 2007 255'.900971 C2007-905067-0

Printed in Canada.

We acknowledge the financial support of the Government of Canada through the Book Publishing Industry Development Program (BPIDP) for our publishing activities.

5 4 3 2 1 12 11 10 09 08

Contents

Changing Habits: Introducing the Collection of Essays /
Elizabeth M. Smyth.. 7

1. The Contribution of Convent Schools to the Development
of the French Language in Late Nineteenth-Century
New Brunswick / Sheila Andrew.. 21

2. Charity in the East: Sectarianism, Ethnicity and Gender
in Saint John, New Brunswick, Schools /
Elizabeth W. McGahan.. 38

3. An Educational Odyssey: The Sisters of Charity of Halifax /
Mary Olga McKenna, SC ... 69

4. Entering the Convent as Coming of Age in the 1930s /
Heidi MacDonald ... 86

5. Blasphemes of Modernity: Scandals of the Nineteenth-Century
Quebec Convent / Rebecca Sullivan...................................... 103

6. Sites of Prayer and Pilgrimage Within a Convent:
The Architectural Manifestations of a Religious Vocation /
Tania Martin... 129

7. "The harvest that lies before us": Quebec Women Religious
Building Health Care in the U.S. Pacific Northwest,
1858–1900 / Sioban Nelson.. 151

8. The Educational Work of the Loretto Sisters in Ontario,
1847–1983 / Christine Lei... 172

9. Writing a Congregational History: The Insider Problematic /
Veronica O'Reilly, CSJ .. 191

10. Teaching Sisters, Leading Schools: Two 20th-Century
Canadian Women Religious in Educational Leadership /
Elizabeth M. Smyth.. 209

11. The Process of Transformation: Women Religious and the
 Study of Theology, 1955–1980 / *Ellen Leonard, CSJ* 230

12. The Process of Renewal of the Missionary Oblate Sisters,
 1963–1989 / *Rosa Bruno-Jofré* ... 247

13. Gender and Mission: The Sisters of Saint Ann in British
 Columbia / *Jacqueline Gresko* ... 274

Contributors ... 297

Index ... 299

Introduction

Changing Habits:
Introducing the Collection of Essays

Elizabeth M. Smyth

On July 4, 1639, the first women religious arrived in New France. Two women named Marie led two small groups of teachers and nurses. Marie Guyart, known as Mother Marie de l'Incarnation, led the Ursulines (the Order of St. Ursula), a religious congregation dedicated to teaching. Marie Guernet, known as Mother Marie de Saint-Ignace, led the Augustine Hospitalières de la Miséricorde de Jésus of Dieppe, an order of nurses. From this handful of women, the numbers of congregations and of women drawn to them grew exponentially over the next three centuries. At their zenith in 1965, there were 183 congregations with 65,254 members in Canada (or 6.9 per cent of the female population), as listed in *The Census of Religious Sisters of Canada*.[1] Some of these women played significant roles in the development of Canada's education, social service and health care systems. Among their number were female firsts – the first teachers, nurses, school principals, superintendents of schools, university presidents and chief executive officers of hospitals – as well as significant writers on the subjects of history, spiritual direction and social policy, and creators of key works of material culture.

While Canadian francophone scholars have actively investigated the history of women religious, anglophone scholars have only begun to do so.[2] This collection of essays is a sampling of current research on historical and contemporary Roman Catholic women religious in Canada.

Women religious is the term scholars currently use to describe vowed women in the Christian tradition who live as nuns and sisters. Canon law, the body of jurisprudence governing ecclesiastical matters, defines nuns and sisters as representing two paths in religious life. Nuns are women who have taken solemn vows and who lead lives of prayer and contemplation in cloistered settings, while sisters have taken simple vows and lead lives of prayer in active apostolates. For many sisters, this means working in fields as diverse as education, social service and health care, and in ecclesiastical endeavours such as parish missions and retreats. Nuns have the longer history of the two groups within the Christian tradition, with the role of a sister emerging as an option in more recent times, generally the last 300 years. Most of today's women religious are sisters. Thus, while the words *nuns* and *sisters* are often used synonymously, even among women religious, *women religious* is the more inclusive term and is used throughout this volume to describe vowed women.[3]

Women religious lead lives with multiple identities, rooted in their response to a call from God to join a religious congregation. To the secular observer, one congregation may seem identical to the next; however, each is unique, operating according to a set of goals and a vision, called a charism. The interplay between the individual member and the community is essential, since each individual embodies the charism of the community. A woman enters a congregation as a postulant, generally for three to six months, during which time she lives within, yet apart from, the community. If she is deemed acceptable by the community leadership, and if she chooses to continue, she is received into the congregation as a novice and begins the multi-year journey of prayer, studies and work to become a vowed religious. She generally takes vows of poverty, chastity and obedience. In some communities, she also takes a fourth vow related to the type of work in which she will be engaged, such as a vow of teaching.

In the years following the Second Vatican Council (1962–1965), both the meaning of the vows and the features of religious life changed radically. The most external signs of this were that many moved away from large convent buildings to live in smaller houses or community groups, with varying degrees of connection to their congregations, and many women religious no longer wore the habit. These changes were so significant because each of these outward dimensions of religious life reflects the founding purposes of congregations: opportunities for women to live and to work together in mutual spiritual support and, in the visible witness of the habit, to address unmet societal and religious needs.

Congregations of women religious possess rich historical sources that document the contribution of their members to Canadian society and form an important part of the country's historical record. Bound by canon law to maintain "properly equipped and carefully arranged archives,"[4] women religious have amassed over the centuries a variety of written and print records, as well as objects of material culture, that yield insight not only into the world of the religious but also the larger society of which they are a part. Among these records are annals that detail "any remarkable or edifying occurrence,"[5] necrologies – post-mortem commentaries on the life of the religious that were used to build community history and to instruct novices – community-generated histories and biographies of key figures. Convent buildings and other structures that housed congregational enterprises are themselves sources from which to learn about the communities, the women religious and their traditions. While some sources have found their way into public, ecclesiastical and other private archives, the vast majority reside with the congregations themselves.

Access and attitudes are two of the major challenges scholars seeking to research the history of women religious encounter. Historically, some congregations have spurned public recognition, serving silently and with humility. As one congregation taught its novices,

> Desire neither praise nor reward for your good works in this life …
> On the contrary behave in such a manner that your good actions
> are hidden in time and known to God alone, to appear only in
> eternity and even never to appear, if God so wills.[6]

This mindset exists to the present day in some congregations, such that they deny the requests of scholars to consult archives and other congregational records. As well, the legacy of the residential schools has caused some congregations to close their archives. For scholars to do significant work, they must have access to congregational archives. As John Moir, a leading scholar of Canadian church history, explained:

> Without historical records there will be no historical research …
> The churches [and communities] fear that the researcher may be
> unsympathetic to their particular positions (and in a minority of
> cases they are probably right) but in fact they are doing no more
> than denying their own creatureliness. Mistakes will be made by
> historians, but the road to truth is surely paved with mistakes
> and with their rectifications.[7]

A second challenge that scholars of women religious face is related to the views of academic colleagues. Some scholars have dismissed the study of women religious, viewing them as supporting the patriarchal Roman Catholic Church, since they are separate from and unequal to vowed men. As well, many histories, even of the Roman Catholic Church itself, only minimally acknowledge or, more frequently, ignore the contribution of women religious.[8]

Yet in spite of these challenges, the national and international scholarly literature on women religious has been growing, especially over the past decade. Commissioned histories of communities such as the Sisters of Charity of Halifax and the Sisters of St. Martha of Antigonish, commissioned biographies of founders such as Catherine Donnelly, of the Sisters of Service, and doctoral dissertations have contributed to this growing body of literature. Studies on women religious in other countries – as dual professionals, as writers of history and as fonts of oral history – have emphasized the significance of women religious as leaders in education and the academy as well as, more broadly, the professions.[9] Carol Coburn and Stephanie Burley have written on the rise of literature on women religious in the United States and Australia.[10] In Britain and Continental Europe, the literature has likewise expanded.[11] In an era when their numbers are declining and their enterprises are increasingly being staffed by lay men and women, scholarly interest in women religious is on the rise.

About this collection

The contributors to this collection of essays, both Canadian and international scholars, are historians, sociologists, theologians, architectural historians and material culturalists who examine historical sources on women religious with diverse methodologies. Although all the essays are written in English, the authors used sources written in English, French and Latin. Each essay is set against two broad canvases: current scholarship in the authors' field of study and a series of overarching themes related to gender and ethnicity that link the entire collection.

The essays reflect the diverse origins of Canadian congregations of women religious. Some, such as the Irish Institute of the Blessed Virgin Mary, more commonly known as the Loretto Sisters (Toronto, 1847, from Rathfarnham, Ireland), Sisters of St. Joseph (Toronto, 1851, from St. Louis and Lyons, France) and the Ursulines of the Chatham Union (Chatham,

Ontario, 1860, from Le Fouet, France) were founded in Canada with European roots. Others, such as the Sisters of Charity of Halifax (Halifax, 1849) were founded directly from the United States, in this case the Sisters of Charity of New York. Still others are indigenous Canadian foundations, a collaboration among laywomen, priests and bishops to meet local needs: the Sisters of Charity of the General Hospital of Montreal, more commonly known as the Grey Nuns (Montreal, 1737), the Sisters of Providence (Montreal, 1844), the Sisters of Charity of the Immaculate Conception (Saint John, 1854), the Sisters of Providence of Saint Vincent de Paul of Kingston (Kingston, 1861), the Missionary Oblate Sisters of the Sacred Heart and Mary Immaculate (St. Boniface, 1904) and the Sisters of St. Ann (Vaudreuil, 1850).

As the authors in this collection document, founding a congregation was challenging and fraught with conflict that centred on gender, class and ethnicity, sometimes exacerbated by personality. Some of these congregations had clearly defined missions and never deviated from their roots. The Loretto Sisters were an order of teachers and, except for their initial and brief foray into nursing the victims of the Toronto typhus epidemic in 1847 (which claimed the life of, among others, their summoning bishop, Michael Power), never broadened their activities. Others, such as the Religious Hospitallers of St. Joseph, while primarily a nursing order, did open schools in response to local needs.

The authors' personal and professional histories intersect in a number of ways. While all authors possess doctoral degrees, some combine other professional training as architects, journalists, nurses, teachers and theologians with their academic credentials. Three of the authors are vowed women and active members of their religious congregations. Yet not all contributors are members of the faith traditions about which they write. Some have been allowed considerable access to the archives of the congregations about whom they write. Many authors situate themselves within their essays and use their presence to bridge historical and contemporary issues.

The essays explore the enterprises of women religious in the Maritimes, Quebec, Ontario, and the American and Canadian West. The subjects about whom Elizabeth McGahan, Sheila Andrew, Mary Olga McKenna and Heidi MacDonald write live primarily in New Brunswick and Nova Scotia. Rebecca Sullivan draws upon Quebec sources, more particularly those in Montreal, as a focus of her essay. Tania Martin and Sioban Nelson's studies of Quebec women religious draw on evidence from their enterprises

across the continent. Christine Lei, Ellen Leonard, Veronica O'Reilly and Elizabeth Smyth situate their essays in Ontario, yet their subjects work not only across the country but also around the world. Rosa Bruno-Jofré and Jacqueline Gresko locate their studies in the Canadian West. Most essays create links between their subjects and other national and international associations, enterprises and trends.

Methodologically, the authors employ a variety of techniques. While most primarily use document analysis, some use tools of text and artifact analysis, drawn from the domain of material culture. Others, including MacDonald and Bruno-Jofré, use techniques of oral history to explore the impact of changing times upon congregational development and governance. Still others use frameworks drawn from other disciplines, including nursing science, architectural science and theology, in which to cast their arguments. Lei, Sullivan and Martin ground their essays in an analysis of the physical aspects of convents. Using photographs, drawings, and the gardens and the buildings themselves, Martin persuasively argues for the use of multiple sources to gain insights into the lives of congregations of women religious and the roles they play in the urbanization, industrialization and colonization of North America. Lei analyzes convent artifacts to learn how they communicated cultural and religious values. Sullivan examines what the convents and their residents represent to the outside world. O'Reilly draws on archival sources, internal manuscripts, and oral sources and traditions to explore how congregations construct their history, analyzing how memory is constructed and how the past is reinterpreted in light of changing times. Andrew, Gresko, Lei, MacDonald, McGahan, McKenna and Smyth mine congregational and public archives to construct finely grained portraits of the work of the individuals and congregations they study. Nelson brings elements of nursing science to her analysis of historical sources. Leonard brings her experience as a feminist theologian to her exploration of women religious.

Some of the essays explore contemporary issues facing communities of women religious. They highlight the challenges that congregations face due to declining numbers and the implications for how women religious live out their charisms through the type and extent of the services they offer. Other essays elaborate on tensions resulting from the professional demands Church and state impose on women religious, including the interaction between their religious communities and the broader religious and secular communities of which they are part. In many of the essays, the

authors explore the extent to which gender, race, class and ethnicity have influenced and still shape the course of a congregation's development.

Several of the essays focus on education as a prime enterprise of women religious. In her essay, "An Educational Odyssey: The Sisters of Charity of Halifax," Mary Olga McKenna reflects on the historical experience and the contemporary challenges facing her own congregation. McKenna argues that, in spite of declining numbers, the spirit of the congregation's founder, Elizabeth Seton, continues to grow into new and diverse areas. MacDonald's essay, "Entering the Convent as Coming of Age in the 1930s," explores the impact of the Depression on this same congregation, identifying how the educational experience of the novices shaped their professional and vocational outlooks. The essays of Sheila Andrew, Christine Lei, Elizabeth Smyth and Elizabeth McGahan examine the complex worlds of religious congregations in state and parish schools. Andrew's essay, "The Contribution of Convent Schools to the Development of the French Language in Late Nineteenth-Century New Brunswick," argues that a number of religious congregations, including the Congregation de Notre Dame, the Religious Hospitallers of St. Joseph and the Sisters of Charity of the Immaculate Conception, played a purposeful and active role in promoting and maintaining Acadian culture. Through her analysis of cross-congregational records, Andrew demonstrates how these three religious congregations supported the French language through their work in education and cultural activities, using the example of the entertainments to promote Acadian culture that the sisters created and their female pupils staged. Lei's essay is a case study of a teaching order whose members taught in both the publicly funded Roman Catholic schools and in their own independent schools. While Lei finds that the order did adapt their curriculum in some regards to meet changing societal needs, she concludes that the order's conservatism and its diminishing members led to its withdrawal from elementary and secondary education. Smyth's two subjects, both general superiors of their orders, present contrasting images of leadership. Mother Genevieve Williams, an Ursuline, lived at a time when leadership structures were beginning to be formalized. Mother Mary Lenore Carter, a Sister of Providence of St. Vincent de Paul, was a member of a powerful family, who, with her siblings, was a leader not only in the world of religion but in secular organizations as well. Mother Carter's life and career raise important questions about the intersection of family connections, class and power. McGahan uses the constructs of gender, sectarianism and ethnicity to probe the teaching history of the

Sisters of Charity of the Immaculate Conception in publicly funded schools in Saint John. She traces the process (and the personalities) that guided the Sisters of Charity's unique experience in that city, negotiating a path among competing secular and ecclesiastical interests.

Sioban Nelson draws upon her larger body of research on the history of nursing to argue that the members of the Sisters of Providence who journeyed to the west were intrepid and entrepreneurial frontier women who challenged the status quo within their secular and religious communities.

In an essay that invites its reader to view the current status of religious life as one that is evolving, theologian Ellen Leonard, a member of the Sisters of St. Joseph, explores the role of women religious in the transformation of theological education. Acting as both participant and observer and drawing data from oral history, Leonard argues that, as students and teachers of theology, women religious have been challenged to change. She concludes that this change is ongoing and that a new form of religious life is emerging.

Two essays analyze the writing of congregational history from the perspectives of the insider and the outsider. Veronica O'Reilly, a member of the Sisters of St. Joseph of Peterborough, tackles the complexities she encountered in writing her congregation's history in her essay, "Writing a Congregational History: The Insider Problematic." She traces her personal experience both within her congregational and biological families, highlighting the tensions that exist between the official and the unofficial record. She reflects on the extent to which, as an historian, she finds herself in both a privileged and a challenged position. Rosa Bruno-Jofré is a laywoman and outsider to the Missionary Oblate Sisters of the Sacred Heart and Mary Immaculate in St. Boniface. She draws upon her research for her compelling congregational history, *Missionary Oblate Sisters: Vision and Mission*, to study leadership in turbulent times. Her essay, "The Process of Renewal of the Missionary Oblate Sisters, 1963–1989," explores the internal processes and complexities involved in post–Vatican II congregational renewal. Using three recent general superiors as the focus, she presents the difficult and painful experience of arriving at a reformulated congregational vision in the wake of the Second Vatican Council. Juxtaposed, these two essays raise provocative questions about the nature of congregational histories.

In her essay, "Gender and Mission: The Sisters of Saint Ann in British Columbia," Jacqueline Gresko uses a model drawn from the sociology of

religion to analyze the interplay between the Sisters of St. Ann and the Missionary Oblates of Mary Immaculate, an order of male religious with whom the sisters worked in Canadian residential schools. Gresko argues that the women did not entirely integrate their separate culture into the male system. Gresko's essay leaves many questions for future generations of historians to explore, as the analysis of the legacy of the residential school experience continues. Gresko suggests that the perspective of the women religious who administered and taught at those schools will be a necessary component of that analysis.

Two essays in the collection represent the work of two young scholars who are exploring Quebec-based congregations and convent life from the perspectives of communication theory and architectural history. Architectural historian Tania Martin explores how scholars can gain critical insights into the lives of women religious from their purpose-built convents. Martin analyzes more than 250 convents, hospitals, hospices, schools, orphanages and other Catholic institutional buildings across North America administered primarily by the Sisters of Charity of the General Hospital of Montreal (the Grey Nuns) and the Sisters of Providence, and supplements her discussion with examples of buildings used by the Augustines of the Hôtel-Dieu of Quebec, the Ursulines of Quebec, and the Sisters of Charity of Quebec. Martin explores how women religious created spaces in these buildings that embodied their religious aspirations, cultural values and institutional priorities. She argues that these built environments not only made a lasting impression on the physical landscape but also on people's collective imagination. Communications scholar Rebecca Sullivan analyzes the representation of women religious in the mass media, in both historical and contemporary settings, to explore the convent as a vehicle for social communication that challenged power relations and values held by the society outside of its walls. Focusing on the sensational stories of the runaway nun (typically, a Montreal woman) featured in the nineteenth-century penny press, Sullivan examines what these stories tell us about the power of the convent – in actual and imaginative terms. Together, the essays of Sullivan and Martin reveal how scholars in other fields add new dimensions to the historical and contemporary study of women religious and raise questions concerning what the public face of the congregations, as observed by contemporary society, says about women religious and society at large.

Further research

This collection of essays represents some of the diverse contemporary scholarship on Canadian Roman Catholic women religious currently being written in English. The richness and breadth of this body of literature is clearly apparent in the references contained in the endnotes of each essay. Many congregations are commissioning histories that are furthering the presence of women religious on library shelves. The proceedings and journals of scholarly organizations such as the Canadian Historical Association, the Canadian Society for the History of Medicine, the Canadian History of Education Association and the Canadian Catholic Historical Association attest to the number of scholars currently working in the field of women religious, as does the significant presence of scholars of Canadian women religious at such international meetings as the triennial History of Women Religious Conference, the Berkshire Conference on Women's History and the Women's History Conference of the International Federation of Historians. There is much work yet to be done, especially methodological and historiographical studies that will bridge the linguistic gap still segregating much of Canadian history.

Studies that explore the more problematic issues associated with the history of women religious are needed. As authors in this collection suggest, issues such as the gender, power and race dynamics in residential schools must be explored. The clash between conservative patriarchy and feminism that continues to be played out within both ecclesiastical and secular settings must be analyzed. The roots of the decline of congregations of women religious need to be studied, mindful of the fact that the institutional phase of religious life, when large numbers of women resided in convents, is in itself an anomaly.[12] Methodologies and models drawn from a number of disciplines may offer effective strategies to delve into these sensitive areas.[13]

Comparative studies need to be undertaken among vowed women in various faith traditions. There are Buddhist nuns as well as congregations of Anglican women religious who have operated similar enterprises to those administered by their Roman Catholic counterparts. Such studies may include the communities of the Sisterhood of St. John the Divine, Sisters of St. Margaret and Sisters of the Church. As well, international comparative studies are needed, particularly of the various international congregations, such as the Religious of the Sacred Heart and the Dominicans, and the Sisters of Mercy and the Presentation Sisters, whose

transatlantic interactions between Newfoundland and Ireland need much more analysis. The international enterprises of Canadian women religious, most notably their work in the Far East that began in the 1930s, and the Central and South American missions that arose in the aftermath of Vatican II, also need to be studied. As well, the interaction between and among the congregations of Roman Catholic women religious and their secular sisters of all faith traditions needs much more analysis. While scholars such as Jeanne Beck have documented the key formative interplay between the Catholic Women's League and the Sisters of Service, additional work is needed.[14] Issues in heritage management must be explored in order to prevent the built heritage of women religious from being lost.

While there is much exciting and important work on Canadian women religious being generated by scholars in English and French, much more effort is needed to integrate them more effectively into the larger field of Canadian history. In the introductory essay to the 2003 volume of *Histoire sociale/Social History*, which focused on the intersection of religious and social history, Nancy Christie and Michael Gauvreau argue for "the ongoing function of religious institutions as an apparatus of social regulation and the concomitant search for cultural authority (and political power) by which both groups and individuals sought to articulate a particular vision of social order." The authors include within the volume an essay by Lucia Feretti and Chantal Bourassa that analyzes the Dominican Sisters of Trois-Rivières as an example of the "social consequences of the need for [the Catholic Church] to compete in a climate of religious pluralism … by creating charitable and educational institutions managed directly by Catholic clergy." While the authors and editors are to be commended for this fine scholarly volume that methodologically and historiographically challenges the many false dichotomies currently apparent in the study of Canadian social and religious history, it also highlights the gaps that still exist. For, with the exception of the work of Marta Danylewycz, neither the editors of the volume nor the authors of the essays refer to any of the current scholarship on Canadian women religious being published in English.[15]

The current generation of scholars of women religious has the chance to capitalize on exciting scholarship that is occurring in this segment of the larger field of history in both a national and international context. In addition, these scholars have a rare opportunity to study the lives and enterprises of their subjects at a critical juncture in their history. As the essays in this collection demonstrate, this is a time of continuity and change

in the lives of women religious. Women religious are at the end of one phase of their history and the beginning of another. They have left behind their large institutions but have retained their mission of operating both on the margins and in the centre of secular and religious societies. The work of the scholars represented in this collection documents and analyzes the changes that women religious have been able to effect and the continuity they have been able to maintain through the transformation not only of their own institutions and enterprises, but also of contemporary society itself.

Endnotes

1 M. Lessard and P. Montminy, *The Census of Religious Sisters of Canada* (Ottawa: Canadian Religious Conference, 1966).

2 For a more detailed analysis see M. Danylewycz, "Changing Relationships: Nuns and Feminists in Montréal, 1890–1925," *Histoire sociale/Social History* 14 (28) (1981): 413–34; M. Danylewycz, *Taking the Veil: An Alternative to Marriage, Motherhood, and Spinsterhood in Quebec, 1840–1920* (Toronto: McClelland and Stewart, 1987); M. Dumont, "Les garderies au 19e siècle: les salles d'asile des Sœurs Grises de Montréal" in *Maîtresses de maison, maîtresses d'école: Femmes, famille et education dans l'histoire du Québec*, dir. N. Fahmy-Eid et M. Dumont (Montréal: Boréal, 1983), 261–8; N. Laurin, D. Juteau et L. Duchesne, *A la recherche d'un monde oublié. Les communautés religieuses de femmes au Québec de 1900 à 1970* (Montréal: Les Éditions du Jour, 1991); C. Langlois, *Le Catholicisme au feminine, Les congregations francaise a superior generale au XIX siecle* (Paris: Le Cerf, 1984); M. Dumont, *Les religieuses, sont-elles feministes?* (Montréal: Bellarmin, 1995); D. Juteau et N. Laurin, *Un metier et une vocation: le travail des religieuses au Quebec 1901–1971* (Montréal: Presses de l'Université de Montréal, 1997); E.M. Smyth, "Writing the History of Women Religious in Canada (1996–2001)," *International Journal of Canadian Studies* 23 (Spring, 2001): 205–11; E.M. Smyth, "Preserving Habits: Memory Within Communities of English Canadian Women Religious" in *A Century Stronger – Women's History in Canada 1900–2000*, eds. S. Cook, L. McLean and K. O'Rourke (Kingston and Montreal: McGill-Queen's Press, 2000), 22–26; E.M. Smyth, "'Writing Teaches Us Our Mysteries': Women Religious Recording and Writing History," in *Creating Historical Memory: English Canadian Women and the Work of History*, eds. A. Prentice and B. Boutilier (Vancouver: University of British Columbia Press, 1997), 101–128; E.M. Smyth, "Professionalization Among the Professed" in *Challenging Professions: Historical and Contemporary Perspectives on Women's Professional Work*, eds. E.M. Smyth, A. Prentice, S. Acker and P. Bourne, (Toronto: University of Toronto Press, 1999), 234–54.

3 See R. Sullivan's essay in this collection that further nuances this debate.

4 J. Creusen, *Religious Men and Women in the Code*, 5th English Edition (Milwaukee: Bruce, 1951), 286.

5 Before the 1917 Code of Canon Law, the requirements were somewhat more flexible than they became subsequently. Canon 282 of the 1917 Code required bishops to ensure that "two copies of documents" related to diocesan enterprises and residing "confraternities" be made and that "one copy shall be kept in the respective archives and the other in the episcopal archives." [S. Woywood, *A Practical Commentary on the Code of Canon Law*, 2 vol. (New York: J.F. Wagner, 1926), I: 138.] Canon 88 requires Pontifical Institutes to generate quinquennial reports and submit them to Rome. Among the questions which institutes are required to answer is "Are the Archives of the Institute and of the individual houses properly equipped and carefully arranged?" (Creusen, *Religious Men and Women in the Code, 286*).

6 J.P. Medaille (1657), *Maxims of the Little Institute* (Erie: translated and published by the Federation of the Sisters of St Joseph USA, 1975).

7 J.S. Moir, "Coming of Age, but Slowly: Aspects of Canadian religious historiography since Confederation," *CCHA Study Sessions*, 50, 1983, 97.

8 See, for example, diocesan histories such as K. Foyster, *Anniversary Reflections 1856–1981: A History of the Hamilton Diocese* (Hamilton: Griffin, 1981).

9 E.M. Smyth, "Writing the History of Women Religious in Canada (1996–2001)," *International Journal of Canadian Studies* 23 Spring: 205–11. See congregational histories such as G. Anthony, *A Vision of Service: Celebrating the Sisters of Charity* (Kansas City: Sheed and Ward, 1997); G. Anthony, *Rebel, Reformer, Religious Extraordinaire: The Life of Sister Irene Farmer SC* (Calgary: University of Calgary Press, 1997); J.M. Beck, *To Do and To Endure: The Life of Catherine Donnelly, Sister of Service* (Hamilton: Dundurn Press, 1997); J. Cameron, *'And Martha Served': History of the Sisters of St Martha, Antigonish* (Halifax: Nimbus, 2000); T.C. Corcoran, *Mount Saint Vincent University: A Vision Unfolding 1873–1988* (Lanham: University of America Press, 1999); and work on women religious in a wider social context such as H. MacDonald, *The Sisters of St. Martha and Prince Edward Island social institutions, 1916–1982,* (Ph.D. diss., University of New Brunswick, 2000); M.O. McKenna, *CHARITY ALIVE: Sisters of Charity of Saint Vincent de Paul, Halifax 1950–1980* (Lanham: University of America Press, 1998); J.K. Gresko, *Gender and Mission: The Founding Generations of the Sisters of Saint Ann and the Oblates of Mary Immaculate in British Columbia 1858–1914* (Ph.D. diss., University of British Columbia, 1999); C. Lei, *Academic Excellence, Devotion to the Church and the Virtues of Womanhood: Loretto, 1865–1970* (Ph.D. diss.,University of Toronto, 2003); M.J. Losier, *Amanda Viger: Spiritual Healer to New Brunswick's Leprosy Victims 1845–1906* (Halifax: Nimbus, 1999); D. Rink, *Spirited Women: A History of Catholic Sisters in British Columbia* (Vancouver: Harbour Publishing/ Sisters' Association Archdiocese of Vancouver, 2000); E.M. Smyth and L. Wicks,

Wisdom Raises Her Voice (Toronto: Transcontinental/ Sisters of St Joseph, 2001); R. Sullivan, *Revolution in the Convent: Women Religious and American Popular Culture, 1950–1971,* (Ph.D. diss., McGill University, 1999); T. Martin, *Housing the Grey Nuns: Power, Religion, and Women in fin-de-siècle Montréal* (MA thesis, Montreal: McGill University, 1995); T. Martin, *The Architecture of Charity: Power, Gender, and Religion in North America, 1840–1960* (Ph.D. diss., University of California, Berkeley, 2002).

10 See C.K. Coburn, "An Overview of the Historiography of Women Religious: A Twenty-Five-Year Retrospective," *US Catholic Historian* 22 (1): 1–26. S. Burley, "Historiography of Women Religious in Australia," paper presented before the Triennial Conference on Women Religious, Acheson: June 27–30, 2004.

11 See S.A. Curtis, *Educating the Faithful: Religion Schooling and Society in Nineteenth Century France* (DeKalb: Northern Illinois UP, 2000); N. Davis, *Women on the Margins: Three Seventeenth Century Lives* (Cambridge: Harvard University Press, 1995); J.K. McNamara , *Sisters in Arms: Catholic Nuns Through Two Millennia* (Cambridge: Harvard University Press, 1996); E. Rapley, *The Devotees: The Women and Church in Seventeenth-Century France* (Montreal and Kingston: McGill-Queen's Press, 1992); E. Rapley, *A Social History of the Cloister: Daily Life in the Teaching Monasteries of the Old Regime* (Montreal and Kingston: McGill-Queen's Press, 2001).

12 See the work of J. McNamara, *Sisters in Arms,* and P. Wittberg, *The Rise and Fall of Catholic Religious Orders: A Social Movement Perspective* (Albany: SUNY Press, 1994) for further discussion of this concept.

13 The work of Australian historians C. Trimingham Jack, *Growing Good Catholic Girls: Education and Convent Life in Australia* (Melbourne: University of Melbourne Press, 2003) and T.A. O'Donoghue, *Keeping the Faith: The Process of Education in Catholic School in Australia* (New York: Peter Lang, 2001) are of particular use. Both use post structuralist theory to examine the complex issues of culture and gendered identity. In *The Rise and Fall of Catholic Religious Order,* American sociologist P. Wittberg uses organizational theory to explore the life-cycle of religious communities. Two Master of Arts theses that use both sociological and anthropological theory are V. Taylor-Hood, *Religious Life in French Newfoundland to 1714* (St. John's: Memorial University of Newfoundland M.A. thesis, 2000), and R. Whitaker, *Staying Faithful: Challenges to Newfoundland Convents* (Toronto: York University M.A. thesis, 1993).

14 See J. Beck, *To Do and To Endure: The Life of Catherine Donnelly, Sister of Service.*

15 N. Christie and M. Gauvreau, "Modalities of Social Authority: Suggesting an Intersection for Religion and Social History," *Historie Sociale/ Social History* 36 (1) (2003): 2; L. Feretti and C. Bourassa, "L'éclosion de la vocation religieuse chez les souers dominicanes aux Trois Rivières: pour un complément aux perspective de l'historigraphie récente," *Historie Sociale / Social History* 36(1) (2003): 225–53.

The Contribution of Convent Schools to the Development of the French Language in Late Nineteenth-Century New Brunswick

Sheila Andrew

In late nineteenth-century New Brunswick, the survival of French as the language of a vibrant culture was threatened. Government policies, urbanization, and geographic and social mobility all encouraged the use of English. A male Acadian elite worked to keep French alive through education, newspapers and colonization schemes to counteract urbanization, but there was some criticism of convent schools for promoting English at the expense of French.[1] For example, former schools inspector Valentin Landry criticized the Memramcook, Chatham, Bathurst and St-Louis convents for using too much English, even during the 1870s and 1880s. He claimed the Irish church hierarchy had allowed Acadians to build convents, then staffed them with anglophones to assimilate the Acadians. While the religious certainly had problems meeting the needs of anglophone and francophone students, this essay shows through analysis of public school records and convent archives that the women religious teachers made a significant contribution not only to bilingualism but also to the development of French as a language of work, social life and culture.

Challenges to Catholic and French education

While the New Brunswick government's education policies were not openly hostile to the French language, they clearly gave priority to the anglophone majority and little consideration to developing francophone education. Before 1871, the schools Acadians attended could receive government grants, the language of education was the choice of the school trustees, and the parish priest was often a major supporter, promoter and participant in school activities. The male French classical college, St-Joseph, run by the Pères de Ste-Croix, received government grants and so did the small residential and day school of the Sisters of Charity of the Immaculate Conception in St-Basile. The *New Brunswick Schools Act* of 1871 removed funds from any school teaching the doctrines of a particular church. Since Acadians were, almost without exception, Roman Catholic, they saw this measure as a threat to their language as well as their religion. The subsequent refusal by Catholics to pay rates to secular schools in Catholic parishes and the death of two men in the riots in Caraquet associated with this led to a compromise in 1875 that restated an earlier agreement allowing the use of religious symbols, including letting teachers wear habits or soutanes. It also allowed Catholic children to be grouped together in the same school, restated the practice of allowing school boards to lease premises from churches, and allowed specific church doctrines to be taught outside school hours.[2] The only mention of the French language in the Act was that Board of Education approval of textbooks was required and that French elementary texts were still being considered.[3] However, the government did not make providing French textbooks a priority, and by 1888 there were still only four bilingual texts and four French texts approved for use in public schools.[4] Teacher training in French was also given low priority. The overwhelmingly anglophone authorities in the Provincial Board of Education responded as if they hoped French education would be only a temporary gateway to higher education in English. A French department was established at the provincial normal school, but it only prepared students for the lowest class of teaching licence; they were expected to shift to the English-language course for the higher levels.

Urbanization and the increased geographic and social mobility of Acadians also threatened the French language. Railways made access to towns easier, and greater opportunities for education allowed some Acadians to enter politics and the professions. This educated elite was

forced to use English frequently and a few of its members married anglophone women who could fit into their new social and economic circles. Non-elite Acadians often went to find work in predominantly anglophone towns in the Maritimes or New England, where they also had to learn and use English. As a result, not all Acadians supported French education, since English seemed to be the language of upward mobility. In public schools, offering courses in French was optional throughout the late nineteenth century, and teachers were in part responding to the desires of parents and school boards when they offered them or instead concentrated on English. Fee-paying boarding schools run by male and female religious faced the same challenge as public schools. Collège St-Joseph, for example, was bilingual, and the Abbé Biron, who taught at the rival college in St-Louis, which opened in 1874, criticized his counterparts at St-Joseph for paying far too much attention to English.[5]

Support for the French language was made more difficult because of differences of opinion about language within the Catholic Church. Poorer Irish and Acadians were moving to the towns, and many priests thought urbanization brought secularization. Some priests thought the answer, for the Acadians at least, was to protect French as one of the links with Catholic Quebec and a proud Catholic past. Others were not convinced that maintaining French was the best use of limited church resources. This division reflected the larger dispute on the issue of language within the North American church, with German and Polish parishes in the United States, for example, struggling to maintain services in their own languages.[6]

The religious orders suffered the same tensions. As with the Quebec women religious studied by Micheline Dumont and Nadia Fahmy-Eid, New Brunswick women religious wanted to improve the economic and social position of Catholic women, and many religious of Quebec, Irish and Acadian origins also wanted to preserve and develop the French language;[7] however, they had limited numbers and resources and a wide territory to cover. The women religious took on a bigger task than their male counterparts, who concentrated on higher education in central locations served by the railway, and tried to provide elementary and advanced education to as many New Brunswick women as possible. They took on the additional problem of educating girls to rise in the very complex world of Victorian polite society.

Developing female religious institutional frameworks for French education

To reach as many pupils as possible, the women religious established convents and schools to provide French education in all the counties where there were large concentrations of Acadians. Fees for day school students were kept to a minimum and boarding facilities were provided for more intensive instruction and religious life. Even before the *Schools Act* became law, the Sisters of Charity of the Immaculate Conception, an anglophone order that had come from the Sisters of Charity in New York to meet the desperate needs of Irish Catholics in Saint John, had already answered Abbé Hugh McGuirk's plea for someone to educate the girls in St-Basile. This was a predominantly francophone area at the northern end of the province, close to the Quebec border. In a petition to New Brunswick's Legislative Assembly, McGuirk and some of the parents made it clear that they saw English-language instruction as the way to improve the education of young women in the area.[8] However, the Sisters of Charity recognized the need for French instruction as well and, by 1871, an Acadian, Sister Marie-Regina, was sent to offer an elementary class in French.[9] In response to the removal of government funding from religious education in the 1871 *Schools Act*, the Sisters of Charity of the Immaculate Conception established residential and day schools at Memramcook in central Westmorland County (1873), Bouctouche in southern Kent County (1880) and, by 1888, in Shediac on the southwest coast of Westmorland County. All of these provided education in French and English. The francophone Hospitalières of St-Joseph from Montréal also responded to the need for French education. This was remarkable, since the Hospitalières was a nursing order already dealing with smallpox, leprosy, tuberculosis and the other diseases of poverty. In 1873, the order opened a day school that provided elementary French education in Tracadie, in southern Gloucester County, and replaced the Sisters of Charity at the school in St-Basile. The Congrégation de Notre-Dame, with a mother house in Montréal, also responded. The Congrégation was primarily francophone, but had established a policy of bilingual education where needed long before it established its first New Brunswick convent schools in 1874.[10] It established fee-paying schools in Caraquet, on the north coast of Gloucester County, and in St-Louis in northern Kent County. This congregation was also trying to staff schools in central Canada, New England, and the Canadian and American wests. Convent records show

there was a demand for these services. By 1874, the Congrégation de Notre-Dame day schools had 20 pupils in St-Louis and 24 in Caraquet, and in 1886 it opened another day school in Bathurst Town with 77 students. By 1888, the congregation had 90 day pupils in Bathurst and by 1889 had 85 pupils in Caraquet and 73 in St-Louis.[11] The Bathurst day school accepted boys as well as girls. Boarding facilities were quickly set up to provide a more intensive educational environment and to fund the day schools.[12] Account books that list the boarders at the schools of the Congrégation de Notre-Dame and the Sisters of Charity show at least 959 Acadian pupils between 1871 and 1900.[13] The Congrégation de Notre-Dame only provided boarding school education for young women but by 1886 the Sisters of Charity in Bouctouche were also providing boarding facilities and education for a few young boys.[14]

Maintaining French classes: policies and practical problems

Providing education in French was a response to local needs and was made possible by available teachers among the Sisters of Charity and the Hospitalières and because of a conscious policy on the part of the Congrégation de Notre-Dame. The Sisters of Charity had already shown it was sensitive to the need for French education in St-Basile and was reported to have refused Bishop James Rogers of Chatham's request to open a school in Bathurst in the 1870s because there were no sisters able to teach in French.[15] Those sisters who were able to teach in French were moved to areas where French instruction was needed.[16] Advertisements show that the sisters from the Memramcook convent also aimed to provide education in both languages and that Bouctouche school had elementary classes in French and English from at least 1877 to 1895.[17] The Hospitalières were also responding to local needs. Much of the enthusiasm for the move into teaching was generated by Quebec-born Sister Amanda Viger, who does not appear to have met opposition from the mother house.[18] The Congrégation de Notre-Dame's teaching policies and curriculum were coordinated out of the mother house in Montreal and policy was to provide education in the maternal language while encouraging at least conversational skills in the second language.[19] Compared with the assimilationist approach of official provincial government policies, this bilingual policy was seen as positive by the local francophone newspaper, *Moniteur Acadien*.[20] Even in Newcastle, where the population was predominantly anglophone, the Congrégation was welcomed to educate the Irish and the Acadians, with religious able to

work in English and French.[21] The sisters' St-Louis convent was praised in the same paper for teaching half in French and half in English, producing excellence in both languages.[22] However, this policy of bilingualism had drawbacks, since Acadian members of the Congrégation were also sent to teach English outside the Acadian region.[23]

Acadian vocations and the provision of teachers

Acadian women were welcomed as religious by the Sisters of Charity, the Hospitalières and the Congrégation de Notre-Dame. The Hospitalières appears to have attracted the most Acadians, since at least 53 women entered the order between 1860 and 1894.[24] Thirteen of them had teaching licences at the Class III level and experience in the public school system; seven of these had attended the provincial normal school, raising their qualification above the local Class III.[25] The Sisters of Charity recruited at least 31 Acadians between 1874 and 1894. These included two former teachers with Class I licences, one at the Class II level and two at the Class III level. Four of them had previous experience in the public school system.[26] No religious normal school was established in New Brunswick, but the Sisters of Charity trained their pupils to a level at which the superior could approve them to teach with a Class III licence. The Congrégation accepted at least ten Acadian recruits over the same period. Four of them were former teachers, including one with a Class I licence and three with a Class II. While the numbers were limited and two of the Acadians were sent elsewhere to teach English, the Congrégation de Notre-Dame seems to have been more successful than the Sisters of Charity in maintaining a francophone atmosphere. When Elisabeth Bourgeois decided to move from the Sisters of Charity of the Immaculate Conception to the Congrégation, the opportunity to promote French influenced her decision, according to historian Alexandre Savoie.[27] Some of the Congrégation's Acadian religious were sent to the mother house in Montreal for further education.

Although it stretched the limited resources of the women religious, the compromise of 1875 allowed them to bring French to more students and apply for government subsidies. The religious teachers were paid, under their lay names, which likely brought welcome relief from at least some of the convents' financial problems. Members of the Sisters of Charity in Bouctouche began teaching in the public school system in 1880. Members of the Hospitalières in Tracadie did similarly in 1881, and Sister Mary Trudel of the St-Basile convent was invited to teach in the public school

system in 1884. Members of the Sisters of Charity in Moncton were teaching at St-Bernard's Catholic public school by 1892.[28] These public schools were funded from the rates, without additional fees from parents, and boys were admitted to these classes as well as girls. This allowed the religious to serve poorer families and preserve and promote the use of French among a wider section of the population. The sisters continued to encounter problems with limited texts available in French and very high class sizes in some instances, but the records of New Brunswick public school classes, which are available from 1877, show that women religious and convent-educated women continued to make a valuable contribution to the preservation of French and comprised a significant number of those teaching in French.[29]

Table 1: Public school teachers reporting classes given in French in five sample years, 1877–1898, listed according to their first language as indicated by francophone or anglophone surnames

Year	English men	English women not known to be convent students**	English women convent students or sisters	Acadian men	Acadian women not known to be convent students**	Acadian women convent students or sisters
1877	5	0	0	28	10	14
1882	10	1	0	11	2	17
1887	6	0	2	1	14	12
1892	1	3	6	9*	6	17
1898	8	5	8	19	15	18

Source: Teacher and Trustee School Returns. R.S. 657, *PANB*

* Felix Michaud, one of the men teaching in French, was a former boarder and pupil at Bouctouche convent school.

** The list of convent school pupils is far from complete, especially of those who went to day schools. Those going to normal school after 1877 can be clearly identified, since records name the candidate's previous school and last teacher, but there may be several teachers with local teaching licences who were former day girls.[30]

By 1882, public school returns reported whether the teacher gave classes in French above Grade VI. These figures make the problems of French education and the importance of the convent contribution to the survival of French in public education even clearer. The figures can only be used to suggest a general trend, since some teachers did not specify the number of pupils or the grades they taught, giving instead the vague answer, French I–VIII, but it seems likely that those with significant numbers in the higher grades were the ones who set down grades and student numbers. Some returns listed the names of pupils taking the courses. These suggest that where religious or former convent pupils were not involved, upper-level French was predominantly an academic subject for anglophone males attending the grammar and high schools.[31] While this indicates a positive attitude to French among some educated anglophones, it did not necessarily serve the needs of francophones in the public school system or a vibrant Acadian francophone culture.

Table 2: Number of public school pupils in French classes above Grade VI in the counties of Acadian concentration: Gloucester, Madawaska, Kent and Westmorland, divided according to known convent membership or education of the teacher

Year	Gloucester Other	Gloucester Conv.	Madawaska Other	Madawaska Conv.	Kent Other	Kent Conv.	Westmorland Other	Westmorland Conv.
1882	175	110	31	67	96	29	241	123
1887	138	15	1	0	67	29	30	31
1892	182	15	106	63	190	181	92	110
1898	13	0	22	32	96	46	134	536

Source: Teacher and Trustee Returns, R.S. 657, *PANB*

These statistics present some interesting anomalies and deserve detailed analysis of economic trends and individual influence leading women to become religious, but this is beyond the scope of this paper. In general, they show that the sisters and their pupils made a useful contribution to the preservation of upper-level French education in all areas, but their greatest impact was in the prosperous, more urban parts of the province. The most extreme example of the convent contribution

is in Westmorland County, where sisters in Moncton and former pupils from Memramcook and other convent schools taught 80 per cent of the French classes beyond Grade VI in 1898. The sisters in Bouctouche taught nearly half of the upper-lever French classes in Kent County in 1892. These figures suggest that far from only serving the original language needs of poor rural people destined to move into the anglophone world, the convents were meeting a demand for higher level French in the more urban and prosperous areas of Westmorland County.

Facing new challenges

As well as showing the achievements of the religious teachers, Table 2 also illustrates the problems limiting what the convents could contribute to public school education in French. Even when education was rate-funded, poorer Acadians could not easily spare their children for education beyond the elementary level. This was particularly true in the fishing communities of Gloucester County. The dramatic decline in 1898 in the number of pupils in that county coincides with economic problems, always endemic in that area but particularly evident at the end of the nineteenth century.[32] Madawaska County also suffered from problems in the lumber industry and many people sought work or education in the United States.[33] The marked dip in the 1887 statistics for Westmorland County coincides with economic problems in the area.[34]

Another challenge was that resources in the convents were being seriously stretched. Religious who were well qualified to teach upper level courses, such as Sister Marie-Hélène (Marguerite Michaud) and Sister Marie-Julienne (Mary-Marguerite Maillet) of the Sisters of Charity, entered the order with Class I teaching licences from the normal school. However, they were sometimes faced with elementary classes of more than 50 students of mixed abilities. Sister Marie-Julienne regularly taught more than 100 students. In 1898, her class included 118 students, both girls and boys, ranging in age from 6 to 18 years.[35] In some years, these sisters reported that they were teaching in French; in other years, there was no mention of language. When the Congrégation de Notre Dame closed its schools in Bathurst, the Sisters of Charity of the Immaculate Conception did not feel able to take over and so the Sisters of Charity from the Halifax mother house did, in 1891.[36] While these sisters were open to the idea of teaching French and accepting Acadian recruits, their school returns show very few students learning French.[37] In 1887, the

Sisters of Charity of the Immaculate Conception from Saint John agreed to take over the French department of the Shediac grammar school. As with the French department at the Normal School, the intention was that the sisters would only teach elementary subjects in French, but thanks to some dynamic teachers, such as Elizabeth Doiron, who was not a sister but convent-educated, they had sometimes gone beyond this to offer courses at higher levels. As with some of the teachers in the public school French department before them, the Sisters of Charity seems sometimes to have been overwhelmed and unable to offer a full French program.[38] The sisters did not report any teaching in French at all in 1889 or 1891 and had three students learning French at levels spread between grades I and VIII in 1899. There were similar problems in Bathurst, where the Sisters of Charity of Halifax only reported twelve students learning Grades I to VIII French in 1898. The Moncton Catholic school of St. Bernard's also reported teaching French intermittently.

There were other problems with rising qualifications that made it harder for women religious and convent pupils to offer higher level classes. By January 1888, even renewing a local Class III licence theoretically required attending normal school.[39] Obtaining a Superior School licence required higher qualifications through the Normal School English program.[40] Apart from the seven former teachers with Class I or II licences, all teaching sisters in the public school system were technically qualified to Class III, although their abilities may have been far above this. There was limited incentive for their pupils to seek higher education in French, since nothing in the government regulations required the teaching of French at any level and there was no extra pay associated with bilingualism or the ability to teach French at lower levels. Local school boards made their own decisions on language and advertised accordingly. At the upper levels, French was just one of many options.

Hostility to sisters in the public school system was also growing, forcing the closing of the Hospitalières' school in Tracadie in 1885.[41] In Bathurst, the Congrégation de Notre-Dame, with 180 pupils in its two schools, had been unable to raise enough money in 1890 to keep running without public funding. When the Sisters of Charity of Halifax came to take over the publicly funded schools, they were faced with Protestant protests and demonstrations.[42]

Continuing achievements

These problems make the survival of French as the language of a vibrant culture in New Brunswick all the more remarkable. The convent fee-paying schools were vital to this, even though they were subject to some of the same pressures as the public schools. The male classical colleges of St-Joseph throughout the period, and of St-Louis until 1882, made great contributions, and individual teachers, such as Jerome Boudreau of Petit Rocher, inspired many future teachers. However, as more careers opened to male college graduates, the proportion and number of females among francophone teachers rose significantly and the convents' contribution became even more important.[43] The curricula of the various boarding schools all included French as a requirement for civilized young women, although there were some limits to the subjects offered. The Congrégation de Notre-Dame established its curriculum, which promoted French at all levels, centrally through a council to consider curriculum, known as the "Conseil au sujet du corps d'études" and a "Mâitresse genérale" to supervise this from the mother house in Montreal. The Congrégation had the advantage of access to French texts in all subjects, as recommended by the curriculum council. The religious at St-Louis acknowledged the ideal of training students to be bilingual, and the convent still claimed to base its curriculum on the French course used in Quebec as late as 1931.[44] Although the Congrégation appears to have attracted only a limited number of Acadian recruits, the francophone presence was very strong because of the sisters from Quebec.

The Sisters of Charity made a strong contribution to French education, but only because they responded to the local pressure. In Bouctouche, they kept French and English on an equal footing at least until 1887.[45] In Memramcook, where early advertisements for the school in the newspapers had promised equality, the 1887 prize list shows the sisters taught first- and second-level classes in French for first-language students and a separate French class for anglophones. These classes included studies on language, history and domestic economy; however, specialized subjects beyond this level, even bookkeeping, which was also part of the Congrégation's curriculum, were offered only in English.[46] Even while he was criticizing St-Louis and Memramcook convent schools for using too much English, former schools inspector Valentin Landry reported that the sisters were responding to pressures from parents and the local lay elite, who wanted them to teach in French. The board of trustees appointed

to run Bouctouche convent's public school in 1910 insisted on retaining French sisters and French courses, and parental pressure on the sisters in Shediac in the same year forced the sisters to continue to teach the catechism in French.[47] The eventual separation of the French-speaking sisters from the main congreation of the Sisters of Charity in the 1920s shows the strength of French within the order as well as the pressures that were threatening the survival of the language.

The survival of the language involved more than formal classes. The sisters in all the convents included powerful francophone role models, and the Acadians who joined them included well-educated and able women capable of instilling pride in the French language and heritage.[48] At least sixteen of the Acadian Hospitalières of St-Joseph, seven of the Acadian Sisters of Charity of the Immaculate Conception and six of the Acadians in the Congrégation de Notre-Dame came from families that could be defined as elite by economic status, education or political activity. They do not seem to have faced any barriers keeping them from leadership roles within their religious communities, since at least three Acadians became superiors in the Hospitalières and two became head nurses. Six Acadians became superiors in the Sisters of Charity of the Immaculate Conception and though none reached that level in the Congrégation de Notre-Dame, their biographies suggest they were respected members of their communities. Some of their pupils clearly thought the convent atmosphere accepted Acadians, since at least 28 of the Acadians taking vows between 1870 and 1899 were former convent pupils.

The French language was part of the convent school culture. In the 1870s, entertainments provided for parents and visitors had often included a disproportionate number of English-language parlour ballads, but by the 1880s francophone content was increasing and French recitations and songs made up at least half of the program. Plays such as "Geneviève, Fondateur de Paris" provided French role models, and music from French composers seems to have been increasingly favoured in music lessons, since convent-trained church organists played everything from French masses to French marches.

Convent social events also provided a focus for former pupils who were successful role models working in French. Elizabeth Doiron returned to Memramcook convent to present the medal she had donated for excellence in mathematics. Obelline Poirier, a former pupil at the Miscouche, P.E.I., convent, who became probably the most successful Acadian businesswoman in New Brunswick at the time, and was certainly

among the most elegant in Shediac society, came to prize-givings at the Shediac convent. Wives of the developing Acadian elite also attended, demonstrating their economic success and social standing.

Outside the convent, Marie Belliveau, wife of the French department director, Alphée Belliveau, and another former convent pupil, was an important part of the morale-building process that led normal school students in the French department to see themselves as representatives of French language, culture and heritage rather than neophytes begging for a place at the anglophone table. By 1889, the *Moniteur* was pushing the department as worthy of admiration from "a people who, under great difficulties, wish to conserve their maternal language."[49] Marie Belliveau deserves a large part of the credit for this, since she worked with the growing French community in Fredericton's Catholic Church and made her home a hospitable place for politicians, civil servants and students to get together, speak French, sing French songs, act French skits and make French speeches.[50] Before her marriage, she is credited with having sewn the first Acadian flag.

These examples only show part of the story. Another part is convent school pupils teaching future teachers to teach in French. Even at this early period, Adelina Arseneau, a former Bouctouche convent pupil, had taught eight of the recruits to the normal school who went on to teach French, and her former student Catherine Arseneau was already providing more. New convent schools were opened and new orders moved in. Isabelle McKee-Allain has shown the powerful contribution the convent classical colleges made to the later development of Acadian community identity.[51] Aldea Landry, deputy premier of New Brunswick in the McKenna government, pays moving tribute to the contribution made by the sisters in Shippagan to her own development.[52] The Université de Moncton was eager to take over this convent school in the great secularization of the 1960s. The convents, therefore, made a valuable contribution to keeping French alive in the public school system, to encouraging the study of French beyond elementary school and to promoting the use of French as a language of work, social life and culture for all New Brunswickers.

Endnotes

1 *Moniteur Acadien* 3, 6 and 10 août, 1886 contains criticism from a former convent student and response from readers. Landry's comments were published as "L'énseignement dans nos couvents," *Revue franco-américaine*, vol. VII, 2, (1 Jan. 1911): 120–133. Page 9 of handwritten copy, Centre d'études acadiennes (hereafter *CEA*) 7.2.10, Moncton, NB. N. Boucher, "Un example du nationalisme de l'Église en Acadie: les 'French Sisters' chez les Sœurs de Charité de Saint Jean, 1914–22," *SCHEC Études d'histoire religieuses,* vol. 60 (1994): 25–34.

2 K. MacNaughton, *The Development of the Theory and Practice of Education in New Brunswick, 1784–1900: A Study in Historical Background*, University of New Brunswick Historical Studies #1 (Fredericton: UNB Press, 1947), 209 and 220.

3 A.-J. Savoie, *Un Siècle de Revendications Scolaire au Nouveau-Brunswick, 1871–1971* (Edmundston: Savoie, 1978), vol. 1, 57.

4 Ibid., 112.

5 Biron to Edmé Rameau de St-Père, 9 August 1875, cited in C.-A. Doucet, *Une étoile s'est levée en Acadie* (Charlesbourg: Renouveau, 1973), 90.

6 M. Spigelmann, "Race et religion: le race acadien et le hiérarchie catholique irlandaise de Nouveau-Brunswick," *Revue de l'histoire de l'Amérique-francaise*, 29, 1 (1975), 69–85.

7 M. Dumont and N. Fahmy-Eid, *Les couventines, L'éducation des filles au Québec dans les congrégations religieuses enseignantes, 1840–1960* (Montréal: Boréal, 1986); M. Dumont, *Les religieuses, sont-elles féministes?* (Saint Laurent, QC: Bellarmin, 1995). Dumont's focus was the Congrégation de Notre Dame and the Sœurs de la Misericorde.

8 Records of the Executive Council of New Brunswick, R.G.2. "Madawaska Academy" Petition 146, McGuirk to the Executive Council, 12 Jan. 1860. However McGuirk explained that he did not consider the signature of a large number of parishioners was necessary.

9 R.G. Census, St-Basile and A. Lagacé, *How Grand Falls Grew* (Saint John, NB: Lagacé, 1945), 49.

10 "The English Language in the Congrégation de Notre Dame of Montréal from the Seventeenth Century," Sr. St-Brendan, 28, Archives du Congrégation de Notre Dame, (hereafter *ACND*) Montréal, no date of publication details, notes the sisters' pride in introducing English to their Montreal curriculum in 1823 and to schools outside Montreal in 1842.

11 "Liste des élèves, Bathurst-ville 1886-1890" *ACND*, Montréal, 301-100-3; "Histoire abregée du Couvent St-Louis" *ACND*, 311.560.2; "Histoire du Congrégation de Notre Dame, 1855-1900" Tome II , 1889, Montréal; T. Lambert

CND, Sœur Marie-St-Médiatrice, *Histoire de la Congrégation de Notre-Dame de Montréal* (Montréal: Maison Mère de la Congrégation de Notre-Dame, 1969).

12 See S. Andrew, "Selling Education: The Problems of Convent Schools in Acadian New Brunswick, 1858-1886," *Study Sessions/Sessions d'Études Canadian Catholic Historical Association,* 62 (1996): 15–32.

13 Caraquet, "Livre de Comptes" and "Pensionnaires 1874–1905" *ACND,* 302-050-19 Bathurst "Comptes des Pensionnaires 1874–1890" 301-100-7 *ACND,* Bouctouche "List of Boarders 1880–1900" Archives des Sœurs de Notre Dame du Sacré Coeur (hereafter *ASNDSC*), Moncton, St-Louis "Elèves des Premières Heures" in *Un siècle au service de l'Education à St-Louis de Kent 1874–1974, Les Sœurs de la Congrégation de Notre Dame, ACND,* 311-560-7, supplemented by prize lists in *Moniteur Acadien;* Memramcook, Account Book 1873–1900, *ASNDSC.*

14 "Élèves du Couvent de Bouctouche, N.-B.1880–1951," *ASNDSC,* M2-211-2. The first boy was Félix Michaud, the orphaned nephew of the parish priest, and seven boys with anglophone names were listed later. Michaud was there for two years and some of the anglophone boys were there for longer periods. Many, but not all, of the boys appear to have had sisters among the female pupils.

15 "À la suite de Marguerite Bourgeoys jusqu'en Acadie," E. Godin CND, *Héritage,* 32, (mars 1999).

16 The sisters should not be held responsible for the views of the parish priest, Fr. Hugh Mcguirk, whose petition to the Executive Council asking for a school said that "It is essential for the French to learn English if they are to make any further progress." Records of the Executive Council, RG2, Public Archives of New Brunswick (hereafter *PANB*), Petition 146, 12/1/1860. The course was advertised in *The Morning Freeman,* 11 July 1863, cited in R.G. Census, et al., 49.

17 For advertisement, see for example *Moniteur,* 1 Jan. 1880. Bouctouche sisters and their tasks are listed in "Sœurs du Notre-Dame-du Sacré-Coeur, Bouctouche," *ASNDSC,* Moncton.

18 Sr. Corinne LaPlante, "Sœur Amanda Viger: la fille d'un patriote de 1837, véritable fondatrice de l'Hôtel Dieu de Tracadie," *Revue d'Histoire de la Société Historique Nicolas-Denys,* XII, 1 (jan-mai 1984) and M.J. Losier, *Amanda Viger, Spiritual Healer to New Brunswick's Leprosy Victims* (Halifax: Nimbus, 1999).

19 "Décision du Conseil au sujet du Cours d'études," juillet 1882, *ACND,* Montréal, 660-310 stated it was not advantageous to introduce a second language beyond the conversational level until a student could read in the language of origin.

20 *Moniteur,* 5/8/1870

21 Ibid.

22 *Moniteur,* 11/7/1878.

23 See S. Andrew, "Gender and Nationalism: Acadians, Québécois and Irish in Nineteenth-Century New Brunswick Colleges and Convent Schools, 1854–1888" *CCHA Historical Studies*, 68 (2002) esp. 17. For examples see the necrology of Emélie Babineau, "Annales" 49ᵉ année, oct. 1943, no. 12: Marguerite Babineau, Ibid. 64ᵉ année, juin 1958. *ACND*, Montréal.

24 Sources for the number of recruits for the Sisters of Charity, the Hospitalières and the Congrégation de Notre-Dame include biographies at the mother houses in Moncton, Tracadie and Montreal, newspaper reports, family and parish histories, and histories of the convents. As the convent files on the religious are under the name in religion, there is still a great deal of work to do before the figures can be considered inclusive.

25 Names of teachers are found in the pay records of the *Journal of the House of Assembly* (Fredericton: Queen's Printer).

26 Savoie, p. 135.

27 A.-J. Savoie, *Un Siècle de Revendications Scolaire au Nouveau-Brunswick, 1871–1971* (Edmundston: Savoie, 1978), vol. 1, 136.

28 Teacher and Trustee Returns, RS 657, *PANB*. The invitation to Sr. Trudel is noted in Sr. Georgette Desjardins, "Le role des Religieuses Hospitalières de St-Joseph dans l'education au Madawaska depuis 1873" *SCHEC sessions d'études,* 48 (1981): 62.

29 Teacher and Trustee Returns, RS 657, *PANB*. Convent records as listed in note 9 and Miscouche, "Pensionnaires et Externes, 1873–1883" *ACND*, 312-450.38; "Liste des élèves Bathurstville 1886–1890" *ACND*, 301-100-3.

30 "Official Register" Records of the New Brunswick Normal School, RSS 117, 1, A 7-15 and "General Record" 2, Books B and C. *PANB*.

31 See for example Dorchester Grammar School 1885, 22 students taking French at levels VII and VIII, no Acadian names; Moncton Central High School, 1886, 25 taking French at level VIII, two Acadian names.

32 D. Robichaud, *Le Grand Chippagan: Histoire de Shippagan* (Montréal: Robichaud, 1977), 174–179.

33 T. Albert, *Histoire du Madawaska* (Lasalle, QC: Hurtubise, 1982, orig. 1920), 561–2 and ch. XI also show some powerful potential anglicising agents on prosperous francophones seeking education in the area with the foundation in nearby Maine of a Normal School, 1886, a classical college in 1887, and convents of orders not working in New Brunswick in 1891, 1897 and 1898.

34 D. Hickey, "Introduction," *Moncton 1871–1929 Changements socio-économiiques dans une ville ferroviare* (Moncton: Editions d'Acadie, 1990), 8.

35 Teacher and Trustee Returns, RS 657, *PANB*. This regular over-loading was confirmed by Mère Rosalie, NDSC, "Histoire du Couvent de Notre Dame du Sacré-Cœur," *ASNDSC*, Moncton.

36 R.Wilbur, *The Rise of French New Brunswick* (Halifax: Formac, 1989), 82.

37 Sr. Maura, *The Sisters of Charity of Halifax* (Toronto: Ryerson Press, 1956). This book does not give a detailed list of entrants, but only one Acadian, Sr. Mary Alphonsus Doucet, is mentioned up to 1900. See 119.

38 For criticism of earlier teachers, see *Moniteur*, 2/5/1878.

39 *Moniteur*, 17/1/ 88.

40 MacNaughton, *Development of Theory and Practice*, for licensing, 169 and 175. For Superior Schools, 142.

41 Sr. Corinne Laplante, "Sœur Amanda Viger, la fille d'une patriote de 1837, veritable fondatrice de l'Hôtel-Dieu de Tracadie" *Revue de la Société Historique Nicolas Denys*, vol. XII, no. 1, (jan-mai 1984), 20, says the sisters blamed it on "the artifices of Free Masons in the parish."

42 Wilbur, ch. 8.

43 For the slow progress, see S. Andrew, "Mother's helper? Factors affecting the feminisation of teaching in New Brunswick Acadian public schools 1861–1881," in *L'Acadie au féminin. Un regard multidisciplinaire sur les Acadiennes*, ed. M. Basque and I. McKee-Allain (Moncton: Centre d'Études Acadiennes, 2000).

44 "Histoire Abrégée du Couvent St-Louis, 1874–1931," typescript, 311.560-2 *ACND*, dated 12 juin 1931, no name.

45 *Moniteur,* 12/8/87.

46 *Moniteur,* 24/6/87.

47 Landry.

48 For nationalism, see S. Andrew, "Nationalism in nineteenth-century Acadian Convents and Classical Colleges," *CCHA Historical Studies*, 68 (Spring 2002): 7–23.

49 *Moniteur*, 20/1/89.

50 See for example *Moniteur,* 7/6/87.

51 I. McKee-Allain, *Rapports ethniques et rapports de sexes en Acadie: les communautés religieuses de femmes et leurs collèges classiques* (Université de Montréal: Ph.D. thesis, 1995).

52 Talk at St. Thomas University for History 3903, "Acadians in the Maritimes," Fredericton, Nov. 1995.

2

Charity in the East: Sectarianism, Ethnicity and Gender in Saint John, New Brunswick, Schools

Elizabeth W. McGahan

And forty little faces,
Childish, eager, sincere
Looked up at their teacher, so trusting
They awoke in my heart a fear.

For I stand as a mirror before them
Wherein childish ideals are portrayed.
O child! I bow in humble supplication
To God, who gives this charge of love to me.

"Teaching" – *Sister M. Brendan, Saint John, c. 1936*[1]

A t the close of each school year, the Sisters of Charity of the Immaculate Conception would organize an exhibition highlighting their students' accomplishments.[2] In July 1871, as the event, held at St. Patrick's School on the western side of the harbour, was concluding, Father Edward J. Dunphy addressed the mainly, but not exclusively, Irish

crowd: "… the attendance of Protestant children at the [Catholic] schools is large … and although the education is religious … their convictions [are] never assailed … Were it not that the teachers wear the garb of the Sisters of Charity, they might almost forget the school is Catholic."[3] While many would have been able to embrace the sentiments in Sister Brendan's poem, it is unlikely that any of them could "forget the school is Catholic," despite the admiration between Dunphy and members of the Protestant community.[4] Nonetheless, the occasion and ambience of Father Dunphy's reflection capture the sectarianism, ethnicity and gender issues surrounding the teaching mandate of the Sisters of Charity in the schools of Saint John.

Sectarianism, in its principal forms of conflict and harmony, coloured all facets of life in Saint John throughout the nineteenth century and much of the 20th.[5] The Sisters of Charity first encountered this phenomenon in the mid-1850s, when they responded to the sectarian-based challenges of instructing predominantly Irish-Catholic children within a state-supported denominational system. More than 20 years later, in 1877, they began to deal permanently with the consequences of sectarianism when they started functioning as teachers within the larger Protestant-dominated public school system.

This essay examines sectarianism as experienced by the diocese of Saint John and the Sisters of Charity of the Immaculate Conception. The essay explores the negotiation of sectarianism by a diocesan congregation of women religious that taught within and were regulated by the secular public school board. The essay also considers gender relations as expressed through the staffing of Catholic schools and student body organization.

Sectarianism and the Irish in Saint John

Saint John was overwhelmingly Protestant in the late 1700s.[6] By the mid-nineteenth century, massive immigration from Ireland resulted in almost half the households in the city being headed by Irish.[7] As well, each of Saint John's "peninsulas," including Father Dunphy's Carleton area, had by that time a Roman Catholic church in those neighbourhoods where the Irish had largely self-segregated.[8]

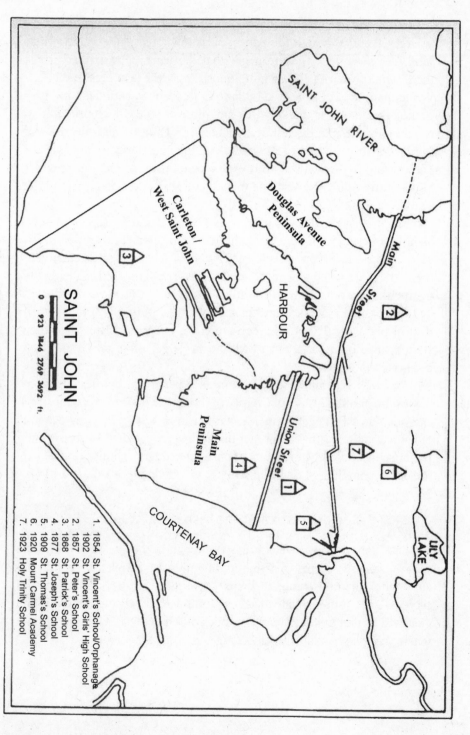

Sisters Of Charity, Saint John School Foundations

SAINT JOHN

0 923 1846 2769 3692 ft.

SAINT JOHN RIVER

Douglas Avenue Peninsula

Carleton / West Saint John

HARBOUR

Main Street

Main Peninsula

Union Street

COURTENAY BAY

LILY LAKE

1. 1854 St. Vincent's School/Orphanage
2. 1902 St. Vincent's Girls High School
3. 1857 St. Peter's School
4. 1868 St. Patrick's School
5. 1877 St. Joseph's School
6. 1909 St. Thomas's School
7. 1920 Mount Carmel Academy
 1923 Holy Trinity School

For the famine Irish, hobbling from disease-ridden vessels in the mid- to late 1840s into the stratified colonial society of Saint John, the familiar but sparse religious institutional presence would have helped to minimize their sense of cultural isolation.[9] At mid-century, the Catholic community contained a modest share of relatively successful Irish businessmen catering to their fellow Catholics, and had a tri-weekly community newspaper providing commentary on politics, religion and education, *The Morning Freeman*.[10] But it was the famine Irish-Catholics, the bulk of the most recent arrivals, who worked at menial tasks, that provided the prism through which most of the more successful Protestant community viewed Irish-Catholics.[11]

Although those who lived in Father Dunphy's congregation resided in the "... prettiest and most cheerful ..."[12] section of the city, most of the Irish found shelter in the overcrowded and marginally habitable waterfront areas of Kings [sic] Ward and Prince Ward on the eastern side of the harbour.[13]

This was the Irish-Catholic world of Saint John that welcomed its new bishop, an Irishman, Thomas Louis Connolly, in 1852. Recognizing the plight of his flock, Connolly set about providing a means by which the Irish could preserve their faith and advance themselves. Familiar with Ireland, in communication with his fellow bishops there and in North America, and in correspondence with "... the premier witness to a distinctively American Catholicism," Father Isaac Hecker, Connolly began to envision an organized system of Roman Catholic education suitable for the country he and thousands of his fellow countrymen had adopted.[14] Regardless of the few rudimentary Catholic schools that did exist in the city, Connolly correctly feared that they were inadequate to handle the increased demand accruing from the recent famine arrivals and incapable of forging the kind of Catholic identity that would safeguard the faith in the larger and more influential Protestant society.[15]

Within a few years, Connolly met this challenge by establishing a congregation of women religious, the Sisters of Charity, to socialize Ireland's unwanted, primarily through Catholic education. Viewing their students as "charge[s] of love," the congregation expressed and implemented its teaching mandate in religious terms.[16] These women, drawn initially from the ranks of the pre-famine Irish, as well as the recently arrived, began teaching in a multilayered social context of ethnicity and gender as well as religious affiliation and its corollary, sectarianism.[17]

Sectarianism and education

By 1850, the state partially supported most schools in New Brunswick.[18] This system of funding denominational schools was in place when Connolly arrived, although a number of Protestants in the provincial legislature challenged its legitimacy, arguing for tax-supported, non-sectarian schools.[19]

When Connolly arrived in Saint John, the legislature had recently passed a parish school act in 1852, the first legislative attempt to put in place a formula for organizing, supporting and managing the schools in the province.[20] Two years later, in 1854, the same year in which the Sisters of Charity were founded in Saint John, the province established a commission to review the function of the provincial university.[21] In the course of their report, the commissioners concluded that all the educational institutions of the province should be linked in one comprehensive system and that "every child had the right to such an education as would fit him for Christian citizenship."[22] But the immediacy of the famine onslaught added a new urgency to the education question.[23] And so there continued within the provincial legislature a Protestant opposition that resented the rapid increase of the Roman Catholic population and the development of a fledgling school system, utilizing members of religious teaching orders for its staff and focusing on religious training as a core of its instructional program.[24] Undoubtedly, also, the newly founded Sisters of Charity, whose schools were partially funded by the government, had drawn the attention of that segment of the community hostile to Catholics.

Despite this evidence of negative sectarianism, the encouraging spirit of the commissioners' report became a part of the subsequent act regarding parish schools that was passed in 1858. Acknowledging that the denominational question in education had become something of a Protestant-Catholic issue, the commissioners concluded that "... the Bible, when read in Parish Schools by Roman Catholic children shall ... be the Douay version, without note or comment."[25]

Under the liberality of this act, denominational schools, including those operated by the diocese of Saint John and staffed by the Sisters of Charity, flourished in the 1860s, because all schools received aid from the province.[26] Most importantly, the provision that Catholic children be allowed to read from the Douay version of the Bible later became the basis for the Roman Catholic claims that separate schools could exist under provincial laws.[27]

The entire system, which had emerged from the Act of 1858, changed with the passage of *The Common Schools Act of 1871*, as it was commonly known.[28] The new Act made two fundamental alterations to the management of provincial schools: they were to be completely tax-supported and to be non-sectarian. The Act challenged the Saint John city officials to make provisions for the administration of education within the municipality. The school board trustees immediately began making arrangements with various groups, denominational and non-denominational, to rent buildings for the purpose of instruction. The board reported in 1874 that it rented its buildings from the Baptists, the Anglicans and the Presbyterians, in addition to the Roman Catholics.[29] All of these buildings and numerous others came under the administration of the school board and were subject to the board's regulations. The board viewed the necessity of renting buildings from various groups and individuals as a temporary measure, as its chairman Charles A. Everett lamented, "Our school buildings are scattered all over the city ... The disadvantages of such a state of affairs are fully realized by this Board"[30] *The Common Schools Act of 1871* also prohibited the teaching staff from wearing religious garb in the classroom.[31] There were to be no crucifixes or religious pictures (except as examples of art work) and no statues of saints.[32] Essentially, the interior and exterior of all school buildings could not contain ornamentation of any kind that would suggest a particular religious orientation.

There are many complex reasons for this overturning of the denominational system, two of which merit mention: ultramontanism and the devotional revolution.[33] The former maxim promoted the authority of the pope. The latter, associated in the minds of some Protestants with ultramontanism, comprised the material and cultural panoply of "... the rosary ... novenas, devotion ... to the Immaculate Conception ... shrines, processions and retreats."[34] Women religious attired in a habit, such as the members of the Sisters of Charity, would have been a highly visible symbol of Roman Catholicism within the public school system.[35]

Catholics in Saint John (and elsewhere) responded vigorously to this assault on their schools and religious traditions.[36] Many refused to pay their taxes. In essence, the Catholic community objected to double taxation – that is, being taxed for a public non-sectarian school system and then having to support a separate Catholic school system. The Catholics of New Brunswick wanted what the Catholics of Quebec and Ontario had, separate school systems partially funded by tax support.[37] In 1874, the

provincial election settled the separate schools issue: those candidates who favoured supporting denominational schools were soundly defeated.[38]

Bishop John Sweeny, Connolly's successor, suspected that the Catholics could not win.[39] Even before the election, he had appealed to the provincial government to remove what many Catholics considered the odious regulation prohibiting the wearing of religious habits.[40] The government acquiesced, possibly having sensed that this was an unnecessary impediment to place on the Sisters of Charity.[41]

Following the election, Sweeny realized that the province would not amend The Common Schools Act of 1871 beyond rescinding the ban on religious garb. More importantly, the bishop knew that he could not afford to operate his schools, which were staffed by the Christian Brothers and the Sisters of Charity, without financial assistance.[42] He approached the government with some compromise suggestions on how the Catholics could continue to function under the legislation of 1871. He suggested that he might be able to help the school board in Saint John by renting his school buildings to the public school system for a modest sum in exchange for some modifications to the Act[43] (similar arrangements had worked elsewhere in the Maritimes).[44] In fact, across the harbour in the Carleton section of Saint John, Father Dunphy had entered an arrangement with the school trustees by which he would select and approve the Catholic teachers to be hired. Also, he would have some authority to approve what books would be used, and religious instruction would be held at a fixed time each day.[45] After 1872, however, Dunphy was employing members of the Catholic laity as his teachers and thus was not dealing with or apparently challenging the prohibition of religious garb.[46] Staffing his school with laity may have been the compromise necessary to gain the accommodations he did from the school board. Sisters had been on the staff of the Catholic school in Carleton in the 1860s and continued to be, at least until 1871.[47]

The government and the bishop reached a consensus on the schools question in August 1875. Known as the "Gentlemen's Agreement," it was to govern the position of the Catholic schools for 90 years within the Saint John public school system.[48] The agreement allowed the continued segregation of children according to religion within any school district, where the trustees felt the need to co-operate with the Church. It permitted members of religious communities to be licensed without normal school training. Of course, they still had to write the licensing examination. Textbooks could be edited to remove objectionable material, and religious

instruction could be given after hours. Lastly, the agreement authorized public school trustees to rent the bishop's school buildings.[49] In the opinion of one student of New Brunswick education, "… these concessions … legalized within the non-sectarian system of the province schools of [sic] a sectarian bias …"[50] In short, this agreement enabled Roman Catholic schools to exist within the public school system *de facto* but not *de jure*.[51] Upon acquiring the administrative rights to the Catholic schools, the school board was required to pay the salaries of all teaching personnel in the bishop's schools, including the Sisters of Charity.[52]

The new system started operating on April 4, 1877. The school board trustees appeared to be as anxious as the bishop, and possibly, the Sisters of Charity, to make do with a system that in the best of all worlds no one had really wanted.[53] How did it work? What accommodations did the Sisters of Charity have to make? In large measure, the arrangement worked because of the professional respect that appears to have emerged on the part of the secular teachers who worked with the sisters and, no doubt, on the part of the sisters who interacted with these professionals.

Whatever the difficulties during that first year, the trustees reported in 1877 that "the industry both of the teachers and pupils" was evident and boded well for the new system. The Sisters of Charity, who were responsible primarily for the education of girls and initially for younger boys, staffed St. Vincent's and St. Malachy's. The Temperance Hall site was staffed by laymen and laywomen, probably hired hastily to replace the Christian Brothers, who withdrew from Saint John rather than have their school placed under the administration of a secular school board.[54] All teachers, including the sisters, were listed in the school board report by their secular names.[55] At St. Patrick's School across the harbour, where Father Dunphy had allowed his school to come under the administration of the board in 1872, the Sisters of Charity resumed their duties, which had been halted when *The Common Schools Act of 1871* had taken effect.[56]

In contrast to all the strife that had preceded the new arrangement, the cordial atmosphere of the first few weeks was encouraging.

The Sisters of Charity: religion and gender in a public school system

On June 20, 1877, before the students and teaching sisters in the Catholic schools had barely begun to adjust to the new administration,

Saint John suffered one of the worst fires of the nineteenth century in North America.[57] Two thirds of the main peninsula burned to the ground, rendering thousands homeless, jobless and generally traumatized. The fire leveled virtually all the city's prominent public buildings, disrupting all facets of urban life. Destroyed as well were a number of school buildings and with them the beginnings of the new school administration. The bishop lost two of his buildings: St. Malachy's Hall and the Temperance Hall. By the fall of 1877, temporary accommodations for students had been made throughout the city.[58] Perhaps the need for a collective response to a universal calamity tempered the harsher edges of sectarianism. Immediately after the Great Fire, as the conflagration became known, Protestants and Catholics cooperated as they struggled to rebuild their lives.[59]

The bishop moved quickly to have the girls from St. Malachy's Hall schooled in temporary rooms at St. Vincent's Convent. Catholic boys who had been instructed in the Temperance Hall were removed to temporary school rooms at the Academy Building at the rear of the Cathedral.[60] Fortunately, a number of the bishop's principal properties, which were located at the northerly tip of the main peninsula, had escaped the flames, including the Cathedral and St. Vincent's Convent and School, the primary foundation site of the Sisters of Charity. These and temporary accommodations at two other sites were utilized until St. Malachy's was rebuilt in 1878 to house boys and, temporarily, girls. The following year, St. Joseph's School was constructed and opened exclusively for girls on the site of the former Temperance Hall.[61]

Between 1877 and 1884, Saint John was largely rebuilt, and the administration of the city's schools reflected the changes in the wider society as well as, perhaps, some mellowing of the sectarian divide within the education system. For the board's report of 1884, each principal submitted an assessment of the activities in his or her school during the year just completed. At St. Joseph's, the principal confirmed that "the teachers have faithfully attended to their duties," signing her name as "Margaret Nealis (Sister M. Liguori), Principal."[62] For the first time, the school report included a sister's name in religion. This is remarkable, since the trustees had undoubtedly reviewed the report before it was printed. Significantly, opportunities for principalships were available to women religious teaching in the Catholic schools. That same year, the principal at St. Patrick's, Thomas O'Rielly, noted, "The ability to govern, as well as teach, is a quality possessed by the Sisters – and they also possess

another qualification, the highest conscientious devotion to duty."[63] While O'Rielly's observation may appear to be the partisan viewpoint of a lay Catholic, John Bennet, the superintendent of schools, had expressed the general perception regarding devotion to duty on the part of all teachers in an earlier school board report, writing, "... a conscientious devotion to duty ... makes amends for lack of many other talents"[64] Clearly, in the midst of an era marked by sectarian sensitivity, there was on the part of some, and perhaps most, in the educational fraternity agreement about the essence of what was required in a desirable school teacher. Equally important, the "conscientious devotion to duty" associated with the teaching Sisters of Charity may be viewed as a testament not merely to the limited career opportunities open to Catholic women at that time but also to the individual and communal commitment of women religious to the vowed apostolic life. Their mission in the classroom appeared to have been bolstered by an internalized fidelity to the preservation of faith as each in her turn welcomed, in Sister Brendan's words, "... forty little faces, childish, eager, sincere"[65]

Although the Sisters of Charity occupied the role of front-line workers in Saint John's Catholic schools in the nineteenth and much of the 20th centuries, the bishop of Saint John acted as the conduit between the congregation and the school board – a salient reminder of the gender relationships between male clergy and female religious within Catholicism.[66] Nevertheless, although the bishop presented the names of the sisters who were to teach in the Catholic schools, teaching assignments were made in consultation with the mother general of the order. At the end of the selection process, the school board made the formal offer of appointment.[67]

After the bishop's schools came under the governance of the school board in 1877, the local school inspector held the examination for the sisters and granted licences valid until the following April. The government expected that the sisters would then write the licence examination with the other candidates in September 1878. However, the sisters refused to write with the other candidates, claiming through the bishop that they had been granted permission to write at a separate examination site.[68] Their reasons are unclear. Even though on one level they were very much a part of the feminization of the teaching profession well underway since mid-century, perhaps they wished to preserve an element of social distance between both their secular and Protestant colleagues.[69] Whatever the sisters' reservations may have been, the government eventually acceded

to their request and, in 1884, the provincial department of education officially declared that members of religious orders holding certificates of professional qualification might write a separate examination each June in Saint John, at the same time as the other provincial examinations were being conducted.[70] All candidates, of course, wrote the same examination. In their affirmative response to the Sisters of Charity's request, it seems as though by the mid-1880s the secular and almost exclusively Protestant authorities in the provincial department of education were attempting to preserve the harmony that resulted from the "Gentlemen's Agreement" of 1875.[71]

Although teachers' institutes had existed in New Brunswick at the provincial and county level since the 1860s, the Sisters of Charity chose not to attend these meetings.[72] Their absence was noted at different times in the school board reports. Various trustees wondered about the wisdom of keeping the sisters' schools open when all the other schools were closed to enable their teachers to attend the institutes.[73] No explanation for the sisters' decision not to take part in the wider secular teaching fraternity exists. Perhaps the congregation chose to maintain a certain degree of separation from their secular colleagues, and only after they were able to develop a sense of balance between that "necessary withdrawal from the world" and functioning as teaching professionals at every level within the public school system did they feel both comfortable and confident being present at such public gatherings.[74] Attendance at the institutes by the Sisters of Charity cannot be documented before 1940.[75] Possibly, the sisters may have believed that by living in community and interacting in the formal sessions conducted by senior sisters at St. Vincent's Convent they were engaging in their own professional development.

Under *The Common Schools Act of 1871*, provision was made for the eventual establishment of one high school in Saint John. By the end of 1895, the two so-called Protestant high schools had amalgamated into the new Saint John High School.[76] However, the Sisters of Charity at St. Vincent's School, under Sister Bernard's (Mary Shortland) direction, resisted all efforts to have their students go to the coeducational central high school. As a result, Catholic high school girls continued for the most part to be educated at St. Vincent's. Sister Bernard's commitment to the education of women may be gauged by the title of the book awarded to the student with the highest marks in 1883: *What Girls Can Do*.[77] Since teaching the senior grades at St. Vincent's was considered a private effort on the part of the sisters, the school board did not rent rooms for the

upper levels from the bishop and, therefore, did not pay the salaries of the sisters who taught these grades. Eventually, this situation would change through the sisters' quiet persistence.

In the early 1890s, Sister Francesca (Mary McDonald) assumed the principalship of St. Vincent's School.[78] Eighteen years had passed since the Catholic schools had come under the school board's purview. During that time, the co-operative sectarianism that had developed was fostered by the lengthy tenure of Bishop Sweeny, who served the diocese from 1860 to 1901, and of Mother Augustine (Mary O'Toole), mother general of the Sisters of Charity for much of the late nineteenth century.[79] Under their direction, and with Sister Francesca's judicious supervision, St. Vincent's achieved permanent status as a high school, which gave considerable profile to the city's Catholics within the Saint John public school system. In 1892, the diocese built an extension onto the Sisters of Charity complex, which eventually became the first St. Vincent's High School.[80] In the school board records, this new extension was noted simply as "new building," and the school board, in keeping with the terms of the "Gentlemen's Agreement" of 1875, supplied new blackboards, tables and chairs for it, because grades seven and eight were also taught there.[81] Besides, although there was no publicity about it, the board's salary records indicate that Sister Francesca was paid from 1893 until 1919 and, thus, it seems that the board informally acknowledged the status of St. Vincent's High School prior to granting it formally.[82]

What were the circumstances that encouraged this development? Perhaps it was the fluidity of teaching assignments from year to year in response to student enrolments that resulted in Sister Francesca teaching an elementary grade and high school grade one year, two upper level elementary grades in another and two high school grades in yet another. It is quite possible, too, that the school board did not rigidly enforce the regulation about only supporting grades one through eight. All of this would underscore the generally harmonious sectarianism that tended to characterize how the school board administered its schools.

Not to be underestimated was Sister Francesca herself. Described as a woman of "unusual foresight and exceptional intellectual ability,"[83] she had been a teacher in Kent County prior to entering the Sisters of Charity.[84] No doubt her pre-convent teaching experience afforded her some knowledge of the politics of the education system in New Brunswick. She is credited by her congregation with having ensured St. Vincent's position within the public school system by cultivating a friendly relationship with the

local superintendent of schools, Dr. Henry S. Bridges, who reportedly encouraged her efforts.[85] Oral tradition recorded within the congregation in the 1940s notes that when Dr. Bridges conducted his routine inspections of St. Vincent's, Sister Francesca often invited him to read Virgil or Cicero with the girls in her class. After a few years of this, Bridges reportedly acknowledged that the girls at St. Vincent's had assimilated their high school subjects thoroughly. He decided that since they had done the required work, they should receive the official diploma recognized by the school board.[86] Apparently Bridges was impressed with Sister Francesca's talents. In 1899, he invited her and Sister Alphonsus (Joanna Carney) to join the small group of secular teachers in the public school system who served as readers for the high school entrance examinations.[87] A few years later, in 1902, the girls of St. Vincent's received their diplomas from the Saint John school board and, thus, St. Vincent's became a recognized high school within the public school system.[88]

Paralleling her efforts to attain a distinct Catholic and girls' high school within the public school system, Sister Francesca advocated ardently for advanced education for all teachers.[89] Within the mother house, she was the supervisor of young sister-teachers in their teacher training classes. The classes, conducted at "The Study" in St. Vincent's Convent by senior sister-teachers, were essentially an extension of the provincial normal school's program and covered the basics for those Sisters of Charity who had entered the congregation lacking teacher training.[90] Additionally, in the 1920s, at a time when normal school certificates were generally considered adequate preparation for public school teachers, Sister Francesca petitioned the president and senate of the University of New Brunswick to establish a summer school to enable teachers to attend university classes during the summer months.[91] A summer program was instituted in 1928.[92]

Throughout the 1920s, the *de facto* sectarian system that existed within the Saint John public school system continued to operate smoothly. In keeping with the orientation of the always Protestant-controlled school board, all teachers were recorded in the official *Register of Teachers* by their secular names, and so Sister Francesca appears officially as Mary McDonald. However, each Sister of Charity's name in religion was recorded in parentheses. The register was a confidential record book; it is most likely, then, that the sisters were unaware that the board even acknowledged their distinctiveness as women religious.[93] This, it would appear, also

reflected the quiet respect the school board accorded to the sisters who served within the school system.

The strictures enumerated in *The Common Schools Act of 1871* that prohibited displays of the material culture of Roman Catholicism were lifted slightly at the turn of the 20th century. Crucifixes could now be displayed in the classrooms.[94] One sister recalled that when she was at St. Vincent's School in the pre–World War I years, her teacher, Sister Paul (Helena Kirk), would reward achievement by handing out a prize, such as a rosary, a holy card or a medal.[95] The sisters considered these forms of material culture to be within the boundaries of the law. Another sister, Sister Constance (Veronica McKenna), stretched the law by erecting a small shrine to the Blessed Virgin in the corner of her classroom. According to Sister Carmela Nugent's recollections of her own school days at St. Vincent's School, the "… shrine was covered with a curtain during school hours [as] school regulations said 'no religious emblems' but after school hours, when formal religious instruction could commence, then Our Lady came out."[96] This, too, was the reality of accommodation within the public school system of Saint John. Because St. Vincent's and the other Catholic schools operated within the public system, the children did.not wear uniforms, although it appears from some photographs that the girls were encouraged to dress to a certain standard of uniformity for class graduation pictures or special functions.[97]

Beyond the material cultural elements, the impact of the sisters on the folkloric dimension of elementary school education persisted through St. Patrick's Day celebrations, and schoolgirl songs about legendary teachers such as Sister Alphonsus. One sister recalled students singing "O the days of Sister Alphonsus" to the melody of an Irish air, "O the days of the Kerry dances."[98] More than 60 years after the famine migration, and despite the constraints of functioning within a public school system, a measure of Irish cultural and Catholic religious identity was conserved and passed on for several generations through the efforts of the Sisters of Charity, whose members had initially been drawn from the Irish immigrant community and then, by the turn of the 20th century, came from the Irish-Canadian community.[99] However, the Irish overtones of the community, particularly in Saint John, may have inadvertently fostered a sense of cultural isolation for the Acadian sisters. In 1924, when the French-speaking sisters left the congregation, some Acadians, including Sister Regina (Frances Bourgeois), who had worked much of her life in Saint John and taught for a time at St. Joseph's School with Sister Alphonsus, decided to join the new French-

speaking Moncton-based congregation.[100] A half-century of religious life, much of it spent in Saint John, had not muted Sister Regina's Acadian ethnic identity, which speaks to the underlying ethnic and linguistic tensions that existed within the community from its founding in 1854 to the separation of the French-speaking sisters in 1924.[101]

Where and when it was economically possible, the sisters appeared to have chosen to operate in a single gender system.[102] At St. Vincent's Girls' High School, the staff was female and mostly Sisters of Charity.[103] In elementary schools staffed by the sisters, and when enrolment levels permitted, either the classes were gender segregated or the entire school was single gender, female.[104] Within the Saint John public school system, the Catholic schools tended to retain the single gender system longer than did the non-sectarian schools.[105] These girls' schools not only provided opportunities for the education of young Catholic women but they also became the proving ground for members of the Sisters of Charity who would later serve in the position of mother general, such as Mother Thomas (Teresa O'Brien) and Mother Alphonsus Carney, who first encountered administrative responsibilities as principals of the Catholic schools in Saint John.[106] Virtually all the sisters who served as mother general emerged from the congregation's teaching stream.

Operating schools largely attended by girls, the sisters served as role models for those aspiring to become women religious. Even in the initially small high school classes "… there would be each year one or two vocations to the religious life."[107] A thread of inter-generational migration may be documented from St. Vincent's Girls' High School into the congregation from the late nineteenth century to the mid-20th century. An 1887 secular publication listed prize winners from the local schools, including among them a student from St. Vincent's who had won an honour certificate for her Grade 9 examination. The teacher, a Sister of Charity, is identified by her secular name, Mary Shortland, and the student as Agnes Quirk, who would later be known as Mother Loretto Quirk.[108] Seventy years later, a congregational vocational brochure graphically portrayed the life journey of one young woman from being the captain of the 1958 St. Vincent's High School basketball team to becoming a member of the Sisters of Charity.[109] As well as educating the city's Catholics, the sisters' schools helped supply the human resources needs of the congregation.

The generally harmonious relationship between the Catholic schools and the school board ruptured briefly during the 1930s. The board constructed a new building for Saint John High School. Claiming that the

Depression strained its financial resources, it wanted the boys from St. Vincent's Boys' High School, who were taught largely by Roman Catholic laymen, to attend the new school. St. Vincent's Boys' School had been established after World War I and the high school grades had been added in the mid-1920s. The diocese claimed that some Catholic boys might cease attending high school if they could not attend a Catholic school.[110] The board did not attempt to pressure girls from St. Vincent's to attend the new school, because the Sisters of Charity had made it known that they would never teach at Saint John High School. Furthermore, by the mid-1930s St. Vincent's Girls' High School was well established. Annoyed by the diocesan position, the school board ceased renting the high school classrooms at the boys' school from 1932 to 1936. Rental was resumed when it became clear that the new Saint John High School building would not be able to accommodate the additional boys from the Catholic high school.[111]

This was the most rancorous period between the Catholics and Protestants since the difficult days of the 1870s, when the Catholics had first secured a place within the public school system. The issue did not directly affect the operations of St. Vincent's Girls' High School, but it underscored the tenuous environment within which the Catholic institutions functioned. If the school board wished to do so, it could exercise ultimate financial control and refuse to pay the salaries of the teachers in the Catholic schools.

Again, at the end of World War II, when the school board began to plan for the eventual return of servicemen and the anticipated strain that new and growing families would place on the public school system, some members began to question whether or not the city could afford to support a system that recognized separate schools. In the fifteen years between 1950 and 1965, several events occurred that were to alter the continued application of the "Gentlemen's Agreement." In 1950, Bishop Patrick A. Bray proposed that the diocese construct a new Catholic high school for boys, replacing St. Vincent's Boys' High School. The local Protestant Ministerial Association strongly objected to continuing to have separate schools in the public system. Although the school board accepted the newly named St. Malachy's Memorial Boys' High School as part of the public school system in 1954, this outburst of negative sectarianism may have rekindled tensions in Protestant-Catholic school relations.[112]

During the 1950s and 1960s, a system of dual school facilities was initiated in Saint John, whereby schools contained both a non-sectarian

section, which was viewed as essentially the Protestant section, and a Catholic section.[113] The two school buildings (a non-sectarian or Protestant building and a Catholic building) were joined together in the centre by a shared gymnasium or auditorium that each group used at different times. Sisters of Charity taught classes in the Catholic section. The dual system continued until 1965, when the school board stopped hiring one Roman Catholic and one Protestant principal for these schools and had one principal to oversee both teaching staffs.[114]

By the late 1960s, it was apparent that the "Gentlemen's Agreement," which had informally guided the close monitoring of Catholic-Protestant relationships within the Saint John public school system, was an anachronism. The new *Schools Act* passed in 1966 declared definitively that only non-sectarian schools could receive provincial aid.[115] Gradually students and Catholic lay teachers began to work in both the Catholic and Protestant schools.[116] The Sisters of Charity continued to be assigned to what were increasingly becoming, in the years just after the Second Vatican Council, Catholic schools in name only. In the mid-1960s, all that truly remained of the sectarian-based Saint John public school system were the historical identifications of its schools as being either Protestant or Catholic – an administrative remnant of a once thoroughly sectarian system.

Conclusion

The story of the Sisters of Charity of the Immaculate Conception in Saint John documents one congregation's teaching apostolate within a secular public school system. Although provincial authorities set the curriculum, a faith-based discourse undoubtedly imbued its delivery in the sisters' schools. The poignant dedication in *Stray Bits of Verse* – "… to our Saint Vincent's Girls, those whom we have had in years past, those who are with us today, and those who shall in future come to us …"[117] – underscores the commitment of the sisters to the education of young women in their high school, and speaks to a personalized vision of the teacher-pupil relationship, which appears to have characterized their schools. Teaching was an extension of the sisters' religious vocation, and their activities within the classroom were reinforced by vows and sustained within the congregation by a sense of shared mission.

An absence of large-scale immigration into Saint John after the famine deluge helped to solidify Irish control of the Roman Catholic community and the Sisters of Charity. Essentially, the principal groups who had worked out the "Gentlemen's Agreement" in the 1870s – the Protestants and the Catholics – continued to negotiate with each other for the next 90 years. This situation, in turn, nurtured a generally co-operative sectarianism until the forces of post–World War II secularism and post–Vatican II ecumenism further softened the boundaries between Protestant and Catholic schools.

Unimagined consequences of post–Vatican II changes in apostolic congregations, greater secularization in the broader society, and increased opportunities for women contributed to diminished vocations and an out-migration of members from the Sisters of Charity, thus sharply reducing the sisters' presence in the public school system.[118] The end of the era of the teaching sister garbed in a religious habit – an embodiment of the unspoken curriculum – removed one of the most visible symbols of Catholicism from the Saint John public school system. The gradual retreat by the sisters was met by a corresponding increase in the number of lay teachers.

Changes in provincial legislation resulted in teachers being assigned to schools regardless of their religious affiliation, making *Protestant* and *Catholic* even less significant designations within the public schools than they had already become. Support for single-gender education eroded, enrolments declined, the congregation was unable to provide sisters to staff the high school, and St. Vincent's graduated its last class in 2002, 100 years after the school board had officially recognized its diploma. That year, too, witnessed the retirement of the last sister teaching in an elementary school. Religious education, traditionally given at the end of the day for children in the Catholic schools, became less frequent and eventually reverted to church-based religious instruction, similar to the system adopted by the Protestants generations earlier.

More than a century after Father Dunphy's remarks on that July afternoon in 1871, many in 21st-century Saint John could easily "... forget the school is Catholic."

Endnotes

1 This essay is part of a larger study funded by the Social Sciences and Humanities Research Council of Canada. The University of New Brunswick, Saint John campus also provided generous support. Selected aspects were presented at the following conferences: Women's History: Irish/Canadian Connections, Halifax, NS, 2002; Famine 150 Conference, Saint John, NB, June 1997; and the History of Women Religious Conference, Milwaukee, Wisconsin, June 1995. Sr. Marion Murray, scic, located a number of documents at the Archives of the Sisters of Charity of the Immaculate Conception. Loretta MacKinnon and the late Sisters Rita Keenan, scic, and Jean Burns, scic, shared their recollections about teaching in the Catholic schools of the Saint John public school system. Peter D. Murphy researched the Teachers' School Returns. Mary McDevitt and Marie Corkery of the Saint John Diocesan Archives retrieved a number of important documents, and Evelyn Costello of the Saint John Regional Library offered valuable assistance. Sr. Monica Plante, scic, and Sr. Margaret MacLean, scic, helped identify individuals in the photographs. The photographic reproduction was prepared by Rob Roy Reproductions, Saint John, NB. Mary Astorino of UNB–Saint John's Department of Information Services and Systems prepared the map of Saint John. Research files of the late Peter McGahan, UNB–Saint John, were consulted on several issues.

Sr. M. Brendan, scic, Archives of the Diocese of Saint John [hereafter *ADSJ*], "Teaching," in *Stray Bits of Verse*, ed. Sr. M. Bernard, scic, and Sr. M. Brendan, scic (Saint John, NB: privately printed, c. 1938), 21–22. Sr.Bernard [Mona McGrath] and Sr. Brendan [Elizabeth Leger] probably collaborated while they were teaching together at St. Vincent's Girls' High School during the 1930s. See Saint John Regional Library, Special Collections Room. Province of New Brunswick, Department of Education, Trustee Returns, Teachers Reports, 1877–1939. [Teachers' School Returns] for Mona McGrath and Elizabeth Leger, St. Vincent's Girls' High School.

2 From 1854 until 1914 the congregation was known as the Sisters of Charity of Saint John. In 1914 upon receiving its Decree of Praise the name of the congregation was changed to the Sisters of Charity of the Immaculate Conception. As of that date, too, the congregation ceased to be a diocesan congregation. Today sisters sign their names, adding the congregational initials "scic," a relatively recent development beginning in the late 1970s.

3 M.A. Nannary, *Memoirs of the Life of the Rev. E. [Edward] J. [John] Dunphy* (Saint John, NB: Printed at the *Weekly Herald* Job Roome [sic], 1877) 47–48. Mary Agnes Nannary, a Catholic laywoman, was employed as a teacher at St. Patrick's School in Carleton. She would have been recommended to the school board by Fr. Dunphy, the parish priest based in Carleton. See *Report of the Board of School Trustees of Saint John, 1874; 1875; 1876; 1877; 1878* (Saint John: N.B.: 1875, 1876, 1877, 1878, 1879).

4　Nannary, 25.

5　Sectarianism concerns more than conflict, although the conflict dimension generally receives greater attention. There is also the other side to sectarianism: harmonious or cooperative sectarianism. This phenomenon has been described as "ordered segmentation," a process whereby antagonistic groups in an urban area develop formal characteristics (or structures) for peaceably accommodating their differences to insure the preservation of the larger social unit. See G.D. Suttles, *The Social Order of the Slum, Ethnicity and Territory in the Inner City* (Chicago: The University of Chicago Press, 1968), 10–11, 31–35.

6　T.W. Acheson, *Saint John: The Making of a Colonial Urban Community* (Toronto: University of Toronto Press, 1985), 252, Table 1, and P.D. Murphy, *Poor Ignorant Children: Irish Famine Orphans in Saint John, New Brunswick* (Halifax: The D'Arcy McGee Chair of Irish Studies, Saint Mary's University, 1999), 9.

7　Acheson, 231. See also J. Jennings, *Tending the Flock: Bishop Joseph-Octave Plessis and Roman Catholics in Early 19th Century New Brunswick* (Saint John, NB: Diocese of Saint John, 1998), 145–147. Bishop Plessis made two major observations about the Catholic community in 1815: some had lapsed and joined Protestant congregations; others demonstrated a strong "commitment to their faith."

8　St. Malachy's Chapel on the main peninsula was completed in 1820; Assumption Church on the West Side (known as Carleton for much of the 19th century) was founded in 1849. See *Official Historical Booklet Diocese of Saint John* (Saint John, NB: Diocese of Saint John, 1948). St. Peter's Church in the North End dated from 1840 (old St. Peter's constructed in 1840 and the present day church constructed in 1884). See *ADSJ*, Parishes and Missions. St. Peter's Church (Portland): 1840–1855 Mission of St. Malachy; 1855–1884 Mission of Cathedral, 2. See Map of Saint John on page 40.

9　See Acheson, 92–114; Murphy, 1–26.

10　W.M. Baker, *Timothy Warren Anglin, 1822–96, Irish Catholic Canadian* (Toronto: University of Toronto Press, 1977), Chapter 3.

11　Ibid., 21–22 and Acheson, 247. See also S.W. See, *Riots in New Brunswick: Orange Nativisim and Social Violence in the 1840s* (Toronto: University of Toronto Press, 1993), 30–32.

12　Archives Church of the Assumption, Saint John West. Peter D. Murphy, Extracts compiled from *The Morning Freeman, 1851–1884. The Morning Freeman*, 4 January 1859. "Notes of a visit from the New York Tablet to St. John, N.B. [sic]."

13　E.W. McGahan, "Fire Effects," *The New Brunswick Reader*, June 14, 1997, 13. Fr. Dunphy came to the parish of the Assumption in 1855, serving until 1862 when he was transferred to Milltown, NB. He returned again to the parish in 1867. See *Official Historical Booklet Diocese of Saint John*, 77.

14 D. O'Brien, "Isaac Thomas Hecker," in *The Harper Collins Encyclopedia of Catholicism* (New York: HarperCollins, 1995), 606. See also K.F. Trombley, scic, *Thomas Louis Connolly (1815–1876): The Man and His Place in Secular and Ecclesiastical History* (Louvain: Katholieke Universiteit Leuven, published dissertation, 1983), 164–172. Hecker was a convert to Catholicism. He was deeply influenced by Orestes A. Brownson, "one of the most influential Catholic laymen of the nineteenth century ..." Trombley, 164. Hecker had been dismissed by his Redemptorist superior who disagreed with his goal to convert Protestants as well as preserve the faith of Catholic immigrants. Connolly lobbied Pius IX to allow Hecker to form his own missionary society, the Paulists. He sympathized with Hecker's missionary goal. While in Rome during 1857–1858 Connolly asked Hecker if he would preach a mission in Saint John. In 1859 two of Hecker's fellow Paulists, Fathers Augustine Hewit and Francis Baker, also converts, preached in the Cathedral to a crowd of 1,500. See L.J. Hynes, *The Catholic Irish in New Brunswick 1783–1900* (Fredericton, NB: Cummings Typeset and Service Bureau, 1992), 101–102. The Sisters of Charity Archives holds a copy of Isaac Hecker's best known work, *Questions of the Soul*, containing Mother Vincent's name and probably a gift from Bishop Connolly. The circulation of Hecker's works and the mission of the Paulists suggest the level of Catholic intellectual and evangelical activity within the diocese during the 1850s. For a discussion of the religious and intellectual climate in the United States as it relates to Hecker's Paulists, Orestes A. Brownson and the Transcendentalists, see P. Allitt, *Catholic Converts: British and American Intellectuals Turn to Rome* (Ithaca: Cornell University Press, 1997), 67–73.

15 Trombley, 111–116. See also D.B. Flemming, "Thomas Louis Connolly," in *Dictionary of Canadian Biography, vol. x* (Toronto: University of Toronto Press, 1972), 191–193.

16 See Sr. M. Brendan, "Teaching" and T. Fahey, "Nuns in the Catholic Church in Ireland in the Nineteenth Century," in M. Cullen, ed., *Girls Don't Do Honours: Irish Women in Education in the 19th and 20th Centuries* (Dublin: Women's Education Bureau, 1987), 20. See also R. Bechtle, s.c. and J. Metz, s.c., eds., *Elizabeth Bayley Seton Collected Writings, Volume II,* (New York, 2002), 189. Mother Elizabeth A. Seton to Antonio Filicchi June 24, 1811, remarking on "... parents who have committed the whole charge of their children to us ..." and its implications for educating the whole person.

17 For discussion on the founding of the Sisters of Charity of the Immaculate Conception see G. Hennessy, scic, *Honoria Conway: Woman of Promise, Foundress of the Sisters of Charity of the Immaculate Conception, Saint John, N.B.* (Saint John, NB: privately printed, 1985); E.W. McGahan, "The Sisters of Charity of the Immaculate Conception: A Canadian Case Study,"*CCHA, Historical Studies* 61 (1995): 99–133; K. Trombley, scic; E.W. McGahan, "Honoria Conway," in *Dictionary of Canadian Biography, vol. xii* (Toronto: University of Toronto Press, 1990), 208–210.

18 K. MacNaughton, *The Development of the Theory and Practice of Education in New Brunswick, 1784–1900* (Fredericton: UNB, 1947), 41.

19 Ibid., 155. See also P.M. Toner, "The New Brunswick Separate Schools Issue, 1864–1876" (University of New Brunswick: unpublished M.A. thesis, 1967), 31–32.

20 MacNaughton, 149. See "An Act for the better establishment and maintenance of the Parish Schools," *Acts of the General Assembly of Her Majesty's Province of New Brunswick, 1852* (Fredericton, NB: 1852), 84–92.

21 Thomas Louis Connolly is considered the co-founder of the community with Mother Vincent Conway (Honoria Conway).

22 MacNaughton, 152.

23 Murphy, 13–17.

24 Toner, 125. See also *The Morning Freeman*, 15 July 1871 for the remarks of Fr. E.J. Dunphy on the value of "schools in which the education is religious" and comments of J.V. Ellis of the *Globe* [Saint John] who, as a resident of the Carleton section of Saint John, said: "Whatever may be the opinions respecting denominational schools all the people of Carleton admired this institution for the great benefits it had conferred on the whole community."

25 MacNaughton, 169. See "An Act relating to Parish Schools," *Acts of the General Assembly of Her Majesty's Province of New Brunswick, 1854–1860* (Fredericton, 1860), 39. The Douay version of the Bible (also referred to as the Douay-Rheims version) was read by Catholics whereas the King James version was read by Protestants. Catholics objected to having the King James version read to their children. See M.A. Noll, *A History of Christianity in the United States and Canada* (Grand Rapids, MI: Eerdmans, 1992), 405.

26 Toner, 30.

27 MacNaughton, 169.

28 "An Act relating to Common Schools," *Acts of the Assembly of Her Majesty's Province of New Brunswick*, 1871 (Fredericton, 1871) 136. The opening preliminary to the act notes: "This Act may for all purposes be cited as 'The Common Schools Act of 1871.'"

29 *Report of the Board of School Trustees of Saint John for the Year 1874* (Saint John: Printed by Barnes and Company, Prince William Street, 1875), 14–16. The Roman Catholic school was St. Patrick's in Carleton.

30 Ibid., 6.

31 MacNaughton, 197 and 201.

32 Archives of the Sisters of Charity of the Immaculate Conception [hereafter *ASCIC*]. Sr. Marion Murray, scic, Handwritten Notes, May, 1995.

33 Toner, 33–34.

34 E. Larkin, "The devotional revolution in Ireland, 1850–75," *American Historical Review* 77 (June 1972): 645. See also A. Taves, *The Household of Faith: Roman Catholic Devotions in Mid-Nineteenth Century America* (Indiana: University of Notre Dame Press, 1986), 71–88, for discussion of the impact of St. Alphonsus Liguori's writings on devotional literature. Liguori's religious congregation, the Redemptorists, was invited into the diocese by Bishop Sweeny in the 1880s. Their impact on the devotional life of the diocesan community resonated for decades especially through the preaching missions conducted by the order. See *The New Mission Book of the Congregation of the Most Holy Redeemer, a manual of prayers and instructions drawn chiefly from the works of St. Alphonsus Maria de Liguori and adapted to preserve the fruits of the Mission* by Very Rev. F. Girardey, C.Ss.R. 25th ed. rev. (St. Louis, MO: B. Herder, Bookseller and Publisher, 1911). The Sisters of Charity taught in the schools established in Saint John's Redemptorist parish: St. Peter's Boys' School and St. Peter's Girls' School.

35 See page 3 of the photo section. *ASCIC, Generously daring, a challenge to sacrifice* (Saint John, NB: privately printed, c. 1963). An illustration from a vocation brochure produced by the Sisters of Charity of the Immaculate Conception.

36 G. Stanley, "The Caraquet Riots of 1875," *Acadiensis* II, 1(Autumn 1972): 21–38. "Caraquet Riots, 1875," Provincial Archives of New Brunswick, P146/57. Photograph taken in 1927 more than fifty years after the riots shows group of men who participated in the riots. Reprinted in *The New Brunswick Reader*, January 25, 2003, 5.

37 Toner, 97. See also M.R. Lupul, "Educational Crisis in the New Dominion to 1917," in *Canadian Education: A History*, eds. J.D. Wilson, R.M. Stamp and L.-P. Audet (Scarborough, ON: Prentice-Hall, 1970), 271–273. For a comment on the issue of separate schools, see R.J. Carney, "Going to School in Upper Canada," in E.B. Titley, ed., *Canadian Education: Historical Themes and Contemporary Issues* (Calgary: Detselig Enterprises, 1990), 9–43; H. Adams, *The Education of Canadians, 1800–1867: The Roots of Separatism* (Montreal: Harvest House, 1968), chapter vii.

38 Baker, 176.

39 Ibid., 175.

40 MacNaughton, 209.

41 Perhaps the opinion espoused by John Bennet, Superintendent of Schools, may have been more widespread than scholars have realized. In 1869 Bennet advocated general instruction for girls, believing that uninstructed mothers raised uninstructed children. The Sisters of Charity were committed to female education. See MacNaughton, 184 for discussion on universal female education. John Bennet was appointed Chief Superintendent of Education in the 1860s and held that post until 1872 when Theodore Rand of Nova Scotia was hired at the inauguration of

the free school system. See also MacNaughton, 173. Bennet then moved to Saint John where he assumed the position of Superintendent of the Saint John public school system. See The Saint John High School Alumnae (compilers), *A History of the Saint John Grammar School 1805–1914*, with an introduction by H.S. Bridges, Superintendent of City Schools (Saint John, NB: The Saint John Globe Publishing Company Limited, 1914), 39. Bennet was on good terms with Roman Catholic clergy; see Toner, 30. Bennet's position on the necessity for instructing girls was championed in Newfoundland by Bishop Michael Anthony Fleming. See P. McCann, "Class, Gender and Religion in Newfoundland Education, 1836–1901," *Historical Studies in Education/Revue d'Histoire de l'Éducation* 1, 2 (Fall/automne): 187–188.

42 Toner, 40.

43 M.A. MacMillan, *The 'Gentlemen's Agreement': Towards a Viable Educational System, Saint John, 1871–1971* (University of New Brunswick: unpublished M.A. thesis, 1989), 22–24.

44 See Archdiocese of Halifax, *A Study of the School System of the City of Halifax* (Halifax, 1968). This synopsis is based on Sr. Francis Xavier Walsh, S.C.H., "The Evolution of the Catholic Public Schools in Nova Scotia" (Boston College: unpublished M.A. Thesis, 1958) and L.G. Power, *Halifax Public Schools Attended by Catholic Children* (Halifax: privately printed, 1937, originally printed in 1899).

45 Baker, 175.

46 *Report of the Board of School Trustees for the year 1874, … for the year 1875 ,… for the year 1876* (Saint John, NB: Printed by Barnes and Company, Prince William Street, 1875, 1876, 1877 [respectively]).

47 Nannary, 47–48. Fr. Dunphy's actions would have been approved by Bishop Sweeny. Sweeny and Dunphy had known each other since their student days together at St. Andrew's College in PEI. (Nannary, 18). See also T. Murphy, "John Sweeny," in *Dictionary of Canadian Biography, vol. xiii* (Toronto: University of Toronto Press, 1994), 1004–1007.

48 MacMillan, 1–10.

49 MacNaughton, 220.

50 Ibid., 221.

51 W.W.B. Martin and A.J. Macdonell, *Canadian Education: A Sociological Analysis* (Scarborough, ON: Prentice-Hall, 1978), 157–158. See also *ASCIC*, Sr. Magdalena Sullivan Notes, c. 1941. "Reception Card given to His Lordship The Right Rev. T. Casey on his return from Rome by the pupils of The Sisters' Schools Tuesday morning, April Twenty-fifth, 1903."

52 Archives New Brunswick Museum [hereafter *ANBM*]. Saint John Board of School Trustees, Record, Appointment of Teachers, City of Saint John, 1872–1927.

53 *Report of the Board of School Trustees of Saint John, 1877* (Saint John, NB: Printed by Barnes and Company, Prince William Street, 1877), 63. [Note: This report contains the chairman's report dated December 31, 1877. Yearly reports usually appeared in the following year, thus the date of publication may have been incorrectly printed.]

54 Bishop Sweeny wished to retain the services of the Christian Brothers in his diocese for the education of boys. Their decision to leave Saint John must have upset him, but he had no control over them as they, unlike the Sisters of Charity, were not a diocesan-based congregation. See also *Archives des Frères des Écoles chrétiennes du Canada francophone.* Établissement St. Jean (Nouveau Brunswick), 1866–1877. The Christian Brothers had come to Saint John in 1866 and established two schools and an academy. The academy apparently developed a fine reputation. As part of the agreement with the brothers the Bishop promised to construct a house for their use. By 1874 the house still had not been constructed but, of course, the school crisis was underway and the Bishop probably was focused on that matter. In any event, the brothers left in 1877 as they would not submit to the requirements of *The Common Schools Act of 1871* and, therefore, would not be salaried by the school board. The Bishop was unable to pay their salaries, and perhaps as well, the brothers were unhappy that the original understanding with the Bishop, the construction of a brothers' house, had not been fulfilled. The archival record includes a moving statement from Brother Tobias on the departure: "Before leaving the Brothers sold their furniture ... they received benediction from the Bishop ... the Brothers were accompanied by a crowd until they arrived at the train station. Their goodbyes were touching and tearful." In the short term, the departure of the Christian Brothers created a staffing crisis for the Bishop who now had to recruit the services of qualified Catholic lay teachers to teach boys and supplement the lay faculty in the boys' lower grades with Sisters of Charity. See also *Archives De La Salle Provincialate* [Toronto], "Biographical sketch of Brother Tobias." Perhaps the education of young boys would have benefited from the Christian Brothers had they remained. Brother Tobias went on to Toronto where he was appointed supervisor of the separate schools by the school board. In the long term the departure of the Christian Brothers left the field of male education open largely to the Catholic laity.

55 *Report of the Board of School Trustees of Saint John, 1877* (Saint John, 1878), 14–18; 45–46.

56 Although the Assumption Church and its school, St. Patrick's, were under the Bishop's control it is quite possible that he had permitted Fr. Dunphy to hire Catholic lay teachers and to allow St. Patrick's to be administered by the public school board rather than remove a Catholic presence from the western side of the harbour. If St. Patrick's had not continued to operate it would have been almost impossible for most Catholic parents to undertake the difficult task of ferrying their children across the harbour to attend the Catholic schools on the main peninsula. Because of the regulation prohibiting the wearing of religious garb in

public schools, the Sisters of Charity had to be removed from St. Patrick's once the school came under the administration of the school board.

57 C.A. Hale, *The Rebuilding of Saint John, 1877–1881* (Fredericton, NB: National Historic Parks and Sites, Directorate, 1990).

58 *Report of the Board of School Trustees of Saint John*, 1877, 27.

59 G. Stewart, Jr., *The Story of the Great Fire in St. John, N.B. June 20th, 1877* (Toronto: Belford Brothers, 1877).

60 *Report of the Board of School Trustees of Saint John, 1877*, 24.

61 *Report of the Board of School Trustees of Saint John, 1879* (Saint John, NB: Printed by Barnes & Company, Prince William Street, 1880), 16–17.

62 *Report of the Board of School Trustees of Saint John, 1884* (Saint John, NB: Printed by Geo. W. Day, Prince William Street, 1885), 31–32. Sr. Liguori (Margaret Nealis) was the sister-in-law of Jean E.U. Nealis, and the aunt of Mother Margaret Mary Nealis, the famous painter of religious subjects.

63 Ibid., 35. Thomas O'Rielly's surname appears as "O'Rielly" rather than the more common spelling of "O'Reilly."

64 *Report of the Board of School Trustees of Saint John, 1876* (Saint John, NB: Printed by Barnes and Company, Prince William Street, 1877), 51.

65 Sr. M. Brendan, scic, "Teaching." See page 4 of the photo section. *ASCIC*, Photograph of elementary classroom, Holy Trinity School, c. 1955, Sr. M. Norberta (Margaret McFadden) with her class of "forty little faces."

66 For example, see Provincial Archives of New Brunswick [PANB]. The Board of School Trustees of Saint John, Minute Book A, July 1871–December 1881, November 12, 1878 . Letter received from Rt. Rev. J. Sweeny, RC Bishop of Saint John asking the Board for the retirement of a sister and the substitution for her of another sister, Sr. Regina.

67 Saint John Regional Library, Special Collections Room. *Reports of the Board of School Trustees of Saint John, 1872–1939* inclusive. See also PANB, The Board of School Trustees of Saint John, Minute Book A, July 1871–December 1881, November 12, 1878. Bishop Sweeny's request that Sr. Regina be appointed was referred to the Board's committee on teachers and salaries. Sr. Regina appears as a teacher in 1879 at St. Vincent's School under her secular name, Frances Bourgeois. See *Report of the Board of School Trustees of Saint John, 1879* (Saint John, 1880).

68 MacNaughton, 221.

69 J.E. Picot, *A Brief History of Teacher Training in New Brunswick, 1848–1973* (Fredericton, NB: Department of Education, Province of New Brunswick, 1974), 13–14.

70 *ADSJ*, *Sweeny Papers*, William Crockett, Chief Superintendent, Education Office, Province of New Brunswick to John Sweeny, Bishop of the Diocese of Saint John, NB, May 3, 1884. See also MacNaughton, 221.

71 Sectarian conflict in the broader society took a negative tone in the 1880s over the highly publicized religious controversy between Catholics and Anglicans regarding the Roman Catholic dogma of the Immaculate Conception. See E.W. McGahan, "William Munson Jarvis," in *Dictionary of Canadian Biography*, vol. xv (Toronto: University of Toronto Press, 2005), 514.

72 MacNaughton, 181.

73 *Report of the Board of School Trustees of Saint John 1888* (Saint John, NB: Printed by Geo. W. Day, Cor. Prince Wm. and Princess Sts., 1889), 42 and *Report of the Board of School Trustees of Saint John, 1893* (Saint John, NB: Daily Telegraph Book and Job Press, 1894), 13.

74 Apostolic Exhortation of His Holiness Pope Paul VI, *On the renewal of the religious life according to the teaching of the Second Vatican Council*, June 29, 1971 (Boston, MA: Daughters of St. Paul, 1971), 25.

75 This situation may have been different for women religious teaching in those provinces with separate school systems. Attending teaching institutes with religious from other communities would not have involved breaching either the secular or sectarian divide. The teachers' institutes in New Brunswick appear to have been organized initially by the Provincial Superintendent of Education, Henry Fisher. The institutes were an attempt by the government to have teachers offer suggestions for the improvement of education. See MacNaughton, *Theory and Practice*, 181. For reference to Fisher see W.S. MacNutt, *New Brunswick, A History* (Toronto: MacMillan, 1963), 385.

76 Outside of Saint John, in the suburb of Rothesay, the Netherwood School for girls was established in 1894 by Mary Gregory. It provided a boarding school from the early grades through high school, eventually graduating its first high school class in 1903 under the administration of Ms. Ganong.

77 The book was awarded to Mary Hayes. See *Report of the Board of School Trustees of Saint John 1883* (Saint John, NB: Geo. W. Day, Prince William Street, 1884), 146. See also *The Daily Record* [Saint John], 26 November 1896. Noting the attitudes in the city regarding the gendering of education: "The Roman Catholics do not believe in co-education and their feelings on the matter will be recognized. The Protestants must have it whether they want it or not ..."

78 *Report of the Board of School Trustees of Saint John, 1893*, 5. Sr. Francesca identified by her secular name, Mary McDonald, was transferred from St. Peter's Girls, Grade VII to St. Vincent's, Grades X, and IX.

79 [Sr. M. Brendan], *Laus Deo! 1854–1954 Centenary of the Sisters of Charity of the Immaculate Conception, Saint John, New Brunswick, Canada* (Saint John, NB: Sisters of the Immaculate Conception, c. 1954), 29.

80 L. MacKinnon, "St. Vincent's High School, a history of adaptation," (University of New Brunswick: unpublished M.A. Thesis, 1985), 118.

81 *Report of the Board of School Trustees of Saint John, 1893*, 58.

82 ANBM, Saint John Board of School Trustees, *Record, Appointment of Teachers*, City of Saint John, 1872–1927.

83 MacKinnon, "St. Vincent's High School," 55, 60–61. Interview with Ms. Genevieve Dever, 13 June 1984, Saint John. Ms. Dever graduated from St. Vincent's High School in the class of 1904.

84 *ASCIC*, "St. Vincent's High School," Sr. Magdalena Sullivan Notes, c. 1941.

85 The Saint John High School Alumnae (compilers), 42. Bridges became Superintendent of Schools in 1896. Previously he had been principal of the Saint John Grammar School and had held a Professorship at the University of New Brunswick.

86 *ASCIC*, "St. Vincent's High School," Sr. Magdalena Sullivan Notes, c. 1941.

87 *Report of the Board of School Trustees of Saint John 1899* (Saint John, NB: [no printer indicated, 1899), 40.

88 *ASCIC*, "St. Vincent's High School," Sr. Magdalena Sullivan Notes, c. 1941.

89 *ASCIC*, "St. Vincent's High School," Sr. Magdalena Sullivan Notes, c. 1941.

90 There is little written information regarding "The Study" at the Archives of the Sisters of Charity of the Immaculate Conception [*ASCIC*]. Information about this period in the teacher formation process is based on conversations with sisters who remember the program at St. Vincent's. "The Study" continued to operate from the late 1930s until 1967, largely under the direction of Sr. M. DePazzi (Mary McElwaine) who was the last 'dean' at "The Study." Undoubtedly, some form of recognized professional development had been underway from the community's beginnings as certificates presented by the community were acceptable to the government and enabled a Sister to write the licensing exam. As "The Study" was drawing to a close, Sr. M. de Pazzi became a member of the first faculty assembled to staff the Saint John campus of the University of New Brunswick in 1964, serving for a few years as a part-time lecturer in Latin. Sister's name on the first faculty listing in 1964 is recorded as Sr. de Pazzi. In 1967, the year that "The Study" ceased operation, Sister's name appeared as Sr. McElwaine. See P. McGahan, *The 'Quiet Campus': A History of the University of New Brunswick in Saint John, 1959–1969* (Saint John, NB: University of New Brunswick in Saint John, 1998), 143, 149, 195, 275. A letter of gratitude recognizing Sr. McElwaine's "… shepherding of 'young Latinists' …" through the university was signed by the entire department of Classics in April, 1966. See McGahan, 256. Ironically, Sr. M. de Pazzi/Mary McElwaine was engaged by the university when its President was Colin Bridges Mackay, grandson of Dr. Henry S. Bridges who had first invited Sr. Francesca to join the high school entrance examination board of the Saint John Public School System.

91 *ASCIC*, "Sister Francesca," Sr. Magdalena Sullivan Notes, c. 1941. When Sr. Francesca retired from St. Vincent's High School in 1919 she spearheaded the founding of the community's private academy, Mount Carmel Academy, a boarding and day school staffed by the sisters. The academy was a testament to the intellectual vitality and personal dynamism of Sr. Francesca. Sisters who taught at the academy were not salaried by the school board. The academy was supported by tuitions, and no doubt, some measure of work overloads on the part of the sisters who served on its teaching staff. It attracted young women from throughout the province, including Protestants. Interview, Elizabeth W. McGahan with Sr. Anne McLaughlin (1909–2003), Saint John, NB, June 20, 2003.

92 S. Montague, *A Pictorial History of the University of New Brunswick* (Fredericton, NB: UNB, 1992), 62.

93 *ANBM*, Saint John Board of School Trustees, Record, Appointment of Teachers, City of Saint John, 1872–1927.

94 MacMillan, 23.

95 *ASCIC*, [Sr. Carmela Nugent], "Reminiscences of By-gone days, typescript," 1. In 1877 Sr. Paul, then a laywoman named Helena Kirk, was hired as one of two teachers to staff the Academy School opened by the Bishop to accommodate some of the students burned out of their schools following the Great Fire. The Academy School was the site of the Christian Brothers Academy which ceased operations when they left in the Spring of 1877. The school board trustees report described her as "… exceedingly industrious and successful in her work." See *Report of the Board of School Trustees of Saint John 1877*, 64. In 1880 when the Academy School closed following the post-fire rebuilding of St. Malachy's and the opening of St. Joseph's School, Helena Kirk entered the Sisters of Charity and continued to serve in the Catholic Schools of the Saint John public school system for many years. See *ASCIC*, Novitiate Register; *ANBM*, Saint John and Saint John Board of School Trustees, Record, Appointment of Teachers, City of Saint John, 1872–1927.

96 *ASCIC*, [Sr. Carmela Nugent], "Reminiscences," 2. See also *ASCIC*, Novitiate Register.

97 See *Evening Times-Globe* [Saint John], May 4, 1966. A photograph of the grade six choir at St. Joseph's School indicates that children are not dressed in uniforms, however, their teacher, Sr. David (Doreen McGuire), is dressed in complete habit. For an illustration of the habit in use until 1967, see page 3 of the photo section.

98 *ASCIC*, [Sr. Carmela Nugent], "Reminiscences …," 4. Kerry is a county in southwestern Ireland.

99 McGahan, "The Sisters of Charity," 111–123; 133. See also Sr. M. Brendan, scic, "My Mother's 75th Birthday," in *Stray Bits of Verse*, 35–36 for Sr. M. Brendan's poetic reflections on the birth date of her late mother: "Could you be in a better place your birthday, my own old Mother Machree!"

100 *Report of the Board of School Trustees of Saint John, 1897* (Saint John, NB: Geo. A. Knodell, Printer, Church Street, 1898), 63.

101 *ASCIC*, Novitiate Register. See McGahan, "The Sisters of Charity" for further discussion. *Laus Deo* written in 1954 to celebrate the congregation's 100th anniversary reveals little of the tensions preceding the separation. A gathering in Saint John in March, 2004 between the Sisters of Charity of the Immaculate Conception and les Religieuses de Notre-Dame du Sacré-Coeur (ndsc) marked the first such reunion since the separation. The Sisters of Charity celebrated their 150th anniversary, and the Moncton community celebrated its 80th anniversary. See Sr. Roma De Robertis, scic, *The New Freeman*, 23 April 2004.

102 *Reports of the Board of School Trustees of Saint John 1877–1939* (Saint John, NB: [various printers], 1878–1940). See also MacKinnon, "St. Vincent's High School," Chapters 3 and 5.

103 For an example of Catholic education for girls in Ontario, see E. Smyth, "'A Noble Proof of Excellence': The Culture and Curriculum of a Nineteenth-Century Ontario Convent," in R. Heap and A. Prentice, eds., *Gender and Education in Ontario* (Toronto: Canadian Scholars' Press, 1991), 269–290.

104 *Report of the Board of School Trustees of Saint John, 1877*; *Report of the Board of School Trustees of Saint John, 1878* (Saint John, NB: Printed at the Christian Visitor Office, 1879); *Report of the Board of School Trustees of Saint John, 1879*.

105 When Saint John High School was established in the mid-1890s, its student body was comprised of the boys from the Saint John Grammar School and the girls from the Girls' High School. See Saint John High School Alumnae, *A History of the Saint John Grammar School,* 36–37.

106 *Report of the Board of School Trustees of Saint John, 1898,* 56, 57. Joanna Carney (Sr. M. Alphonsus) is principal of St. Peter's Girls' School and Teresa O'Brien (Sr. M. Thomas) principal of St. Joseph's School.

107 *ASCIC*, Sr. Carmela Nugent, scic, "Reminiscences," c. 1975, typescript, 9.

108 *Loyalists' Centennial Souvenir* (Saint John, NB: J & A. McMillan, 1887), 11. See also *ASCIC*, Novitiate Register, Mary Shortland entered the community in 1855 and died in 1915. Sometimes referred to as "old Sr. Bernard" so as not to confuse her with Mona McGrath who entered in 1922 and received the name, Sr. Bernard.

109 See vocation brochure on page 3 of the photo section. *ASCIC, Generously daring, a challenge to sacrifice.*

110 MacMillan, 74.

111 Ibid., 79–93. For four years between 1932 and 1936 the school board withdrew its recognition of St. Vincent's Boys' High and did not pay the teachers' salaries or include the four years towards the teachers' seniority. Some of the teachers at St. Vincent's Boys' High who were teaching in the lower grades took

a leave of absence from those grades to teach in the high school grades, a move of great personal sacrifice and probably indicative of the Catholic commitment to retain a gender segregated Catholic High School system within the public school system. See *Report of the Board of School Trustees of Saint John 1933–1934* (Saint John, NB: J. & A. McMillan, 1936), 6. Fred J. Morris and William J. Shea each requested a leave of absence to "teach in St. Vincent's Boys' High."

112 *The New Freeman*, 4 September 1954 and 27 November 1954.

113 MacMillan, Appendix II, Map of elementary schools showing Hazen White/ St. Francis, and Crescent Valley/St. Pius X.

114 MacMillan, 115–130. At Hazen White/St. Francis the first principal to head the joint school was a Protestant in the late 1960s. In the early 1980s, Sr. Mary Ann Maxwell, scic, became principal of Crescent Valley/St. Pius.

115 "Schools Act," Acts of the Legislature of the Province of New Brunswick, 1966 (Fredericton, NB: 1966), 193.

116 Province of New Brunswick, Department of Education, *Education: Two Centuries of Progress, 1784–1984* (Fredericton, NB: Province of New Brunswick, 1984), 20.

117 Sr. M. Bernard and Sr. M. Brendan, eds., "*Stray Bits of Verse*."

118 [Sr. Carmela Nugent], "*Reminiscences*." Commenting on the trials of Mother Loretto Quirk's term of office (served during the 1930s), Sr. Nugent notes: "… in many ways times were easier then. No great crosses. Postulants were coming. No one was leaving."

3

An Educational Odyssey: The Sisters of Charity of Halifax

Mary Olga McKenna, SC

Spirit and mission of the Sisters of Charity of Halifax

The Sisters of Charity of Saint Vincent de Paul of Halifax is one of the major educational congregations of women religious in Canada. Established in Halifax in the mid-nineteenth century, the congregation quickly expanded to the rural areas of Nova Scotia, other provinces in Canada, the United States, Bermuda and, later, Peru and the Dominican Republic. The members have devoted their lives to teaching and learning at all levels of the education system – from pre-school through university – for more than 150 years.

The Halifax congregation is an offshoot of the congregation founded in 1809 by St. Elizabeth Ann Seton in Emmitsburg, Maryland. The spirit and mission of the Halifax congregation reflect the rules and constitutions of Mother Seton's congregation. These documents, in turn, were based on the original *Règles des Filles de la Charité* that Saint Vincent de Paul drew up for the Daughters of Charity in France.[1] Before Mother Seton adopted them for the sisters in Emmitsburg and Archbishop John Carroll of Baltimore approved them in 1812, the archbishop placed added emphasis on education to serve the needs of nineteenth-century America, saying, "They must consider the business of education as a laborious, charitable, and permanent aspect of their religious duty."[2] The *Constitution* for the

Halifax branch was similarly adapted when Pope Pius IX formally approved the fledgling community in 1856 as an independent congregation called the Sisters of Charity of Saint Vincent de Paul, Halifax.[3] Article One reads as follows:

> The Sisters of Charity in the Archdiocese of Halifax ... are the Daughters of St. Vincent de Paul. Their institute is similar to that of the Sisters of Charity in France, with this difference: 1st. That the education which the Sisters of Charity were there bound to give only to poor children will be extended here to all female children in whatever stations of life they may be, for which the Sisters will receive a sufficient compensation, and out of which they will endeavor to save as much as they can to educate gratuitously poor Orphan Children. 2nd. That there will also be adopted such modifications of the Rules as the difference of habits, customs and manners of the country may require.

Also incorporated into the Halifax document was a key statement of purpose, inspired by St. Vincent de Paul and adopted by Mother Seton in 1812:

> The principal reason for which God called and assembled the Sisters of Charity is to honor Jesus Christ our Lord as the source and model of all charity, by rendering Him every temporal and spiritual service in their power, in the persons of the poor, whether sick, invalid, children, prisoners, even the insane or others who through shame would conceal their necessities.[4]

Imbued with this spirit and mission, the Sisters of Charity of Halifax were empowered to provide more than one-and-a-half centuries of educational service to persons from all spheres of life throughout various parts of Canada, the United States, Bermuda, the Dominican Republic and Peru.

Beginnings in education: 1849–1899

At the request of Bishop William Walsh of Halifax, four members of the Sisters of Charity of New York came north in May 1849 to serve as teachers in the cathedral parish.[5] Their ministry began on May 24, just thirteen days after their arrival in Halifax. Classes for girls were held in Saint Mary Convent on Barrington Street, where conditions were far from

ideal. Just seven months later, on December 28, the bishop and priests conducted a public examination in reading, writing, grammar, arithmetic, geography and other subjects. A local newspaper noted the results. They "proved, if proof were needed, that one of the greatest blessings which the people of Halifax had ever received was the establishment of the Convent of the Sisters of Charity."[6]

Care for orphans was part of the sisters' educational enterprise from the beginning. The first day the school opened they accepted a few orphans; by the end of the year 1849, they had 20 homeless children in their care.[7] It soon became evident that the convent revenue was insufficient to maintain both the sisters and orphans. The yearly school fee had been fixed at three shillings ninepence, or two shillings sixpence, depending on whether the pupil learned to write on paper or on a slate.[8] The children of the poor were not charged, but the government paid 25 pounds a year for their tuition.[9] Even with generous donations from personal friends of the sisters, the funding was inadequate. To supplement their income, the sisters planned a huge bazaar to be held in the summer of 1850. The 4000 pounds realized from this event was invested and the interest put at the sisters' disposal to be used primarily for the orphans.[10]

As the sisters' sphere of activity expanded, they received requests for their services from the newly formed parish of Saint Patrick on Brunswick Street. The New York community was not able to provide sisters for a new mission, so the bishop, now archbishop, decided to create an independent mother house in Halifax. To secure the necessary revenue for such a project, the diocese gave more space to the sisters at Saint Mary's to open "a select school" for girls whose parents could afford to pay a substantial tuition fee.[11] These children had their own teachers, their own classrooms and their own entrance when the school opened in 1855.

The parent foundation in New York subsequently approved the plans for the new mother house and Saint Mary Convent became the official mother house of the Halifax community on December 8, 1855. Two months later, on February 17, 1856, Pope Pius IX approved the diocesan community as an independent institution. During the first eighteen months of its existence, six promising recruits from the local area joined the congregation. By May 1857, the congregation could send three sisters to conduct classes in the basement of nearby Saint Patrick's Church. Before long these sisters, too, opened a "select school," this time for 40 paying pupils. In September 1858, Saint Patrick's Convent was formally established as the first mission of the pioneer institute, offering evening

classes for adults in the convent. In 1859, the sisters accepted a teaching assignment in Saint Peter's parish, Dartmouth. It was here that the first music teacher was assigned to supplement the revenue from the school and the designated government grant.

Archbishop Walsh died in 1858 and was replaced the following year by another great friend of education, Bishop Thomas Louis Connolly of Saint John, New Brunswick. He urged the sisters to make their schools rank among the best and suggested that they engage instructors to prepare the teachers for the more advanced educational work for which they would soon be responsible.

In 1864, the sisters undoubtedly stretched their resources to the limit when they responded to requests from Sister Martina Rogers' brother – the Most Reverend James Rogers, Bishop of Chatham, New Brunswick – to provide six sisters to teach in his diocese – three in Bathurst and three in Newcastle. This was to be the congregation's first venture outside of Nova Scotia.[12]

Meanwhile, *An Act for the Better Encouragement of Education* became law in Nova Scotia on April 18, 1865. This legislation allowed the board of school commissioners to arrange that existing schools be considered public schools, with the understanding that no public money would be granted to any but free schools. Another provision of the law was that the board would approve the teachers for the public schools and that the teachers would be subject to all tests and requirements set down in the provincial law relating to public schools. The sisters had no problem dealing with the teacher education component of the Act. Since 1856, they had run a normal school in connection with their mother house to train sisters destined for the teaching profession. When public schools were introduced in 1865, the sisters adapted the normal school curriculum to meet the requirements for obtaining teachers' licences in Nova Scotia.[13] The sisters teaching in the public schools were not exempt from the examinations set by the Council of Public Instruction – a multi-denominational group of state inspectors – at the end of the school year. All passed successfully!

Archbishop Connolly had been concerned about the education of Catholic boys in the archdiocese, so he engaged the De la Salle Brothers to accomplish the task. To this end, he built a new Saint Mary's School to serve the needs of both boys and girls. When the new school opened on September 1, 1865, the sisters had 300 girls on the register. The archbishop was delighted when, at the end of its first year as a public school, Saint Mary's led the city in organization, teaching and equipment. Public

schools were introduced in 1865. The School Commissioners made their first Report to the School Board in 1866. According to that report:

> The School Commissioners can point with entire approval to only one of the buildings placed at their disposal, namely the new Saint Mary's School …This is in all respects a model.[14]

An unexpected initiation into health care came the same year, when the sisters responded to the plight of some 1,300 immigrants and others who contracted Asiatic cholera on board the passenger boat *England* before it arrived in Halifax. When the ordeal was over two weeks later, the sisters were commended by the city council for their heroism in tending the victims and especially for their care of the children orphaned by the tragedy.[15]

In 1867, the archbishop built a school in Saint Joseph's parish, which he leased to the school commissioners. The building accommodated 200 children and relieved the overcrowding at Saint Patrick's School. A roomy addition was made that year to Saint Patrick's Convent to house orphan boys, yet the sisters were adamant that the orphans should have a building of their own. Thus, on March 18, 1868, they purchased property adjacent to Saint Joseph's Church and opened Saint Joseph's Orphanage and Convent in June.

That same year, the sisters expanded their services to serve the Acadian French population in western Nova Scotia when the pastor of Saint Mary's parish, Church Point, invited them to take over the public school there. In response to a more general demand for education in that area, the sisters opened Saint Mary Academy and soon had as many pupils as they could accommodate. Two years later, the Academy was amalgamated with the new Sacred Heart private boarding school, which the sisters had opened in nearby Meteghan. Another school opened in Saint Anne's parish, Eel Brook, later Sainte Anne du Ruisseau, in 1872.

Overcrowding at Saint Mary Convent in Halifax, occasioned by the number of new entrants to the community, signalled the need for a new mother house. The sisters decided on a site in Rockingham, a suburb of Halifax overlooking the Bedford Basin, and named it Mount Saint Vincent. The sisters opened an academy there in 1873 and it flourished until 1972. They revised the academic curriculum after 1895 to make it possible for lay students to qualify for teachers' licences, all the while continuing normal school classes to train those sisters who were destined for the teaching profession.

During the last quarter of the nineteenth century, the sisters opened thirteen new educational institutions to expand their ministry in Halifax and reached out to rural areas of Nova Scotia and industrial towns on Cape Breton Island. Here, they served a large population of miners from Europe. From Nova Scotia, the sisters spread north to New Brunswick and south to the land of their origin and to Bermuda.[16]

The sisters opened a fourth public school in Saint John's Convent on Dutch Village Road, Halifax, in 1875; Saint Patrick's became Central High School for girls in 1884; the Halifax Infirmary began in 1886 as a home for elderly ladies; St. Teresa's Retreat for working girls and immigrants opened in 1887; and the Home of the Guardian Angel for unmarried mothers and their babies was established in 1888. The sisters opened the first primary and grammar school in the U.S.A., in Saint Patrick's parish, Roxbury, in the diocese of Boston in 1887, and it is still serving the children of that area today. In 1889, a high school was added. In 1893, the sisters started a private academy dedicated to teaching and scholarship for girls in Wellesley Hills, Massachusetts, which served its clientele until 1973.

The sisters initiated another educational enterprise in 1894 when they established a second community within the Sisters of Charity to provide domestic services to educational and other institutions. The members of this auxiliary community, called the Sisters of Saint Martha, received their initial religious training and instruction in household management and domestic service at Mount Saint Vincent. This group of women religious served Saint Francis Xavier College in Antigonish and other institutions throughout the congregation until 1920, when it became an independent religious congregation with its own mother house in Antigonish.[17]

A major achievement for the congregation was the recognition in 1895 that the training given at Mount Saint Vincent Normal School was the equivalent of the training given at the provincial normal school in Truro for the purpose of receiving a public school teacher's licence for Nova Scotia. This recognition came in the report of a committee appointed by the provincial secretary:

Having considered the course of instruction pursued, the qualifications of the teachers in charge, the provisions provided for practice teaching under competent oversight, and taking into due account the generally and justly recognized efficiency of the teachers already trained at this school, we have no hesitation

in recommending to the Council [of Public Instruction] the acceptance of its certificates.[18]

When, in 1899, Saint Mary's, the pioneer house of the congregation, celebrated its golden jubilee, the number of sisters had grown from the original four to 185, and the congregation's status as a leader in education was solid. Due to good management, the Sisters of Charity were free of debt and in a position to extend its educational ministry of teaching and learning into the 20th century.

A period of educational expansion: 1899–1949

Early in the 20th century, the sisters realized that college degrees would soon be required for licences to teach senior grades and beyond in Nova Scotia. Higher education, then, seemed to be the logical next step for the sisters' apostolate of education. However, the legislative council of Nova Scotia turned down the sisters' request for a college charter in 1907 (although it had passed the assembly), because the congregation had insisted on a tax-exempt clause. Undaunted, the sisters turned to Dalhousie University, which agreed to an affiliation in 1913 whereby teachers at Mount Saint Vincent College Normal School taught the courses for the first two years of collegiate study and Dalhousie professors taught the upper-level courses at "the Mount." Successful students received their degrees from Dalhousie University.

In the meantime, many of the sisters themselves had begun studying for higher degrees. By 1917, three sisters had completed their required term of residency and had received doctoral degrees from the Catholic University of America; others pursued higher degrees through summer schools and correspondence courses in various universities in Canada, the United States and England. In 1925, Mount Saint Vincent was granted a college charter, making it the only degree-granting college for women in Canada.[19]

During the 25 years from 1924 to 1949, the congregation's membership more than doubled – from 678 to 1,437. Hundreds of young Canadian and American women from various ethnic backgrounds, but predominantly Irish, came to the Mount Saint Vincent mother house in Halifax for two-and-a-half years of initial preparation for religious life and a ministry in education. After taking their vows, they were sent to various educational institutions in Canada and the U.S. on the basis of

their academic and personal qualifications. Many American sisters found themselves working in schools and hospitals in Canada, while many Canadians were sent to missions in the United States. This policy of international assignments and the surge in vocations at this time enabled the congregation to establish 40 new educational institutions in the United States, the Canadian West and Nova Scotia.

On the occasion of the congregation's centennial, Sister Maura Power, SC, in her work *The Sisters of Charity, Halifax*, chronicled the congregation's 100 years of apostolic service.[20] Her record of the congregation's achievements was a triumphal account that depicted the Sisters of Charity as a highly visible group, eminently respected, successful and sought after in their various works of the apostolate in five Canadian provinces, four American states and Bermuda. Teaching was pre-eminent. Sister Maura enumerated the involvement of the sisters in 86 elementary schools, 43 of which were public, 39 parochial and four private; and 22 high schools, eight of which were public, seven parochial and seven private. The sisters ran an independent, accredited college for women and a normal school for members of the congregation. In the health care professions, the sisters founded six hospitals and ran two nursing schools in Nova Scotia. In the area of social services, their endeavours included founding homes for the aged and orphans; homes for unwed mothers and their infants; residences for students, immigrants and working girls; and the staffing of residential and day schools for Aboriginal children. As the need arose, the sisters also led study clubs, choirs, youth organizations, night classes and literacy programs, volunteered their time to work in summer schools and vacation camps, and held innumerable Sunday school and religion classes.

Commitment to higher education for women: 1949–1999

In 1949, the sisters turned the sod for a new college building as part of the centennial celebrations. This marked a significant stage in the Sisters of Charity's commitment to higher education. On June 13 of that year, Mount Saint Vincent was admitted to the National Council of Colleges and Universities in Canada.

In the post-war world of the 1950s, education at all levels was undergoing a dramatic change, with the growth in population and the increased demand for higher education. The Sisters of Charity kept abreast of all these changes. In 1955, Sister Francis d'Assisi McCarthy, SC, president of Mount Saint Vincent College, attended the conference of the National

Council of Colleges and Universities as the only woman president. Here, the prime minister addressed the crisis in education, its impact on higher education and the government's plans to assist universities. The Mount was determined to take advantage of the government's largesse and made long-range plans.

During the same period, the increase in vocations to the religious life enabled the congregation to expand its educational ministry across Canada and in the eastern United States.[21] The sisters enlarged academy, high school and hospital facilities throughout the far-flung congregation. The Pottier Commission in Nova Scotia (1956) made possible tremendous expansion of school buildings to meet the needs of the post-war baby boom and provided modern elementary and secondary facilities for Nova Scotia's rural schools. The congregation opened new high schools in Vancouver, Bermuda, Boston and New York. In addition, it opened five new elementary schools in Quebec to serve the English-speaking population and provided staff for three new high schools in the province: St. Patrick's in Arvida, and John F. Kennedy and Pope John XXIII in Montreal. The congregation opened three additional elementary schools in Boston and one in New Hampshire. In 1961, the Halifax Infirmary became a teaching hospital for Dalhousie University's medical school.

In her work *Sisters for the 21st Century*, Sister Bertrande Meyers, DC, noted that "… the decade 1950–1960 was to mark the greatest changes in the active Orders of women during their more than three centuries of existence."[22] She was referring to the "Sister Formation Movement," a movement designed to prepare young women religious of the 1950s for the technological age by promoting their spiritual, intellectual, social and professional development through a program of systematic advanced education. During those years, the Sisters of Charity of Halifax, to its undying credit, gave the highest priority to the total Christian development of its members through education. This educational investment prepared a new generation of teachers to accept the challenge to shape the congregation's commitment to education for the remainder of the century.

Due to the new demands for services of the Sisters of Charity of Halifax in the 1960s and the commitment of the young religious to full-time study, the congregation found it necessary in 1962 to place a moratorium on the opening of new foundations that had not been negotiated prior to that time. Furthermore, the congregation adopted a policy whereby the number of sisters available to teach in parochial schools was limited, first in Boston and gradually in other areas. By the end of the decade, a

number of parochial schools in Nova Scotia were absorbed into the public school system; others were phased out and the sisters transferred their services to the public system. The residential schools in Shubenacadie, Nova Scotia, and Cranbrook, British Columbia were closed in 1969 and 1971, respectively.

In Quebec, the 1965 report of the Parent Commission replaced the classical colleges with the CEGEP program, a two-year course encompassing grades 12 and 13. Graduates of the program were eligible for direct entry to Laval and other French-speaking universities in Quebec. This sounded the death knell for English-language education at the college level and threatened its demise at the high school level. The Sisters of Charity of Halifax had become identified with apostolic work for English-speaking Catholics in Quebec. Dr. Larkin Kerwin of Laval University described the congregation as "the only unifying force in education for English-speaking Catholic metropolitan Quebec."[23] The sisters had opened their first Catholic school for girls in Quebec in 1935 and it is still operating.

Times were changing, indeed, and the sisters responded by creating services to meet identified needs. In 1964, Sr. Mary James Kelly, SC, opened the Elizabeth Seton Psycho-Educational Center at Mount Saint Vincent, Wellesley Hills, Massachusetts, to provide special services required by schools in the surrounding area. The sisters also began working at an inner-city parish school in Brooklyn, New York, to serve the Puerto Rican, Spanish and black communities. Fifteen additional sisters from New York volunteered to become involved in the Brownsville Community Council Project by providing remedial reading and arts and crafts instruction to black and Puerto Rican children. On the initiative of Sister Dennis Marie Kane, SC, Operation Continuous, based in Saint Patrick's parish, Roxbury, helped the Spanish, Portuguese, Haitian and black communities of Boston's inner city. In Halifax, Sister Mary Fabian Matthews, SC, with the support of the Halifax school board began an upgrading program for deprived and underprivileged adults and their children in the area of Saint Patrick's School, and many of the adults received the General Education Diploma.

By 1965, enrolment at Mount Saint Vincent College in Halifax had reached almost 600 students, and the following year the college was conferred university status through a new charter.[24] The Sisters of Charity retained all powers but they could and did delegate many of these to a board of governors. This was an important step, and indirectly prepared the university to move into subsequent phases of its development.

Continuing education had always been part of the life of the Sisters of Charity and of the college, but now, in the changing world of the 1960s, the sisters established a continuing education department as a way to open the doors of higher learning to a broader range of students. This program also alerted the university to the differing needs of women in higher education. Programs and extension courses brought the benefits of higher education to businesses and into rural areas. In the 1970s, universities came under increasing pressure and competition for students. While Mount Saint Vincent University had admitted and encouraged male students since the 1960s, it did not waver from its focus as a woman's university. During these critical years, the Mount introduced professional courses, such as those in child development, public relations, hospitality and tourism, gerontology, co-operative education and distance education, all of which were designed to prepare female students to enter the new professions. These same professional courses attracted more men to the university.[25]

In 1972–1973, Sister Catherine Wallace, SC, President of Mount Saint Vincent University, was elected to the Association of Universities and Colleges of Canada, first as vice-president and the following year as president. In such critical times, this was no token election, but she was conscious of her unique role as the first woman president of that organization. While never losing sight of the broader university concerns, she remained a consistent advocate for women at all levels.[26]

In the late 1960s, the sisters extended their ministry to Latin American countries: to Chiclayo, Peru, in 1968, where they were involved in lay leadership programs for adults; and to Bani in the Dominican Republic, where they opened a dispensary and taught women to prepare, use and dispense medicines. They also started a pre-school for children, in connection with which they taught practical courses in nutrition and parenting skills.[27]

The scientific and technological advances of the 1960s, paralleled by political, economic, religious, social and intellectual ferment in the Church and in society, effected a cultural revolution that had an impact on every level of North American society. Rising costs for higher education and other services in the 1970s and increasing government financial assistance for education, health and welfare, forced the sisters to re-assess their involvement in these ministries. These were the "signs of the times" and called for the congregation to evaluate its original mission. Accordingly, it assessed its resources and commitments in light of local, national

and international trends in order to determine how to respond effectively to current and future needs. This in-depth study, which provided a new focus on the congregation's charism – its spirit and mission – in the 1970s, prepared the way for a congregational commitment to provide service wherever there were unmet needs. This decision, accompanied by the harsh reality of a diminishing number of sisters and an older median age, necessitated the sisters' gradual withdrawal from traditional ministries. This, in turn, led to the congregation negotiating the sale or transfer of ownership of some of its most cherished educational institutions. Among the prestigious academies and high schools closed in the 1970s were Seton Academy, Vancouver; Mount Saint Agnes, Bermuda; Mount Saint Vincent Academy, Halifax; the Academy of the Assumption, Wellesley Hills, Massachusetts; and Seton Hall High School, Patchogue, New York. These educational institutions, built by arduous labour to carry out the charism of founder St. Elizabeth Ann Seton, had been the corporate expression of the congregation's dedication to teaching and scholarship for more than a century.

Meanwhile, Mount Saint Vincent University continued to achieve remarkable growth and visibility in the next two decades. In 1988, the Sisters of Charity applied for a new charter to place ownership of the university in the hands of the board of governors. By this time, the Mount was at its peak, with an enrolment of more than 4,000 students. It had also broadened and solidified its position in Canada as a university whose primary concern was the education of women.[28]

Many of the sisters continued to be involved in formal education but their number had decreased by 50 per cent by the end of the 1970s. Despite the decrease, sisters were still serving at the elementary and secondary levels of parochial and public schools and at college and university levels as teachers, administrators and staff members. Some served in special programs for the handicapped and mentally challenged in the parochial and public sectors. The congregation also maintained a corporate interest in the apostolate of education by establishing and financing the Elizabeth Seton Lecture Series at Mount Saint Vincent University.

Responding to societal and congregational trends, the sisters' focus on education changed gradually in the 1970s from formal education to education in the broadest sense. Sisters dedicated their time and talents to a variety of apostolic projects: teaching refugees and immigrants needing help to adjust to a new country and a new language; directing programs in adult spirituality and personality development, and leadership programs in

effective communication; experimenting with catechetical programs; starting education and advocacy programs for the poor, particularly women; providing adult, liturgical and religious education; opening centres for troubled youth; participating in chaplaincies in hospitals, prisons and nursing homes; and supporting refuges for women in crisis and homeless men. Some sisters worked in youth centres and drug clinics; others worked as social workers, nurses, technicians, aides and clerical workers.

The call for solidarity with the economically poor, reflecting the sisters' Vincentian heritage, became a major focus in the 1980s under the leadership of Sister Paule Cantin, SC.[29] Before leaving office in 1980, her predecessor, Sister Katherine O'Toole, SC, asked: "Can we use all the resources we have, for as long as we have them, in whatever circumstances, with whatever risks, to continue to live the mission of the Sisters of Charity and show forth the love of God by serving those in need?" She challenged the sisters to raise the downtrodden, the poor, the uneducated and the cast-offs of society; to lift up the difficult, the discouraged, the anxious and troubled whether in the local community, the school, the campus, the hospital, the civic neighbourhood, wherever the religious vocation finds scope for service.[30] It was Sister Katherine's contention that the sisters' apostolate as religious is ultimately wherever their shadows fall, within working hours and outside of them, whether in a school or a soup kitchen.[31] To this end, the congregation approved a three-year plan to promote the development of ministries through the establishment of a foundation in each sector of the congregation. The amount of $50,000 was made available to be used either for the establishment of a trust fund or as a direct grant for the development of ministries.[32]

Into the 21st century

Sister Katherine stated that the congregation's dedication to the education of women should be even more pronounced with the approach of the new millennium. In an address to the Canadian Religious Conference entitled "My Dream of Religious Life in the Year 2000," she underscored her genuine concern for the plight of women. "Concern," she said, "will focus on facilitating equality of women in all aspects of life; involvement with single and married women, widows, victims of abuse, female alcoholics, and addicts"[33] When the sisters (now numbering almost 800) celebrated their sesquicentennial year in 1999, her prediction had been realized in the various sectors of the congregation, but not without

angst.[34] Some felt the congregation was abandoning formal education for social services; others expressed concern that it was forsaking its corporate apostolate for individual ministries. Among the new ministries were a single-parent centre in Halifax, which offered courses in pre-natal and post-natal care and parenting; Adsum House, a shelter with services for homeless women; an intergenerational literacy program for disadvantaged families in Dartmouth; Rosie's Place in Boston, an emergency shelter for women; the WAITT House (We're All In This Together) neighbourhood centre in Roxbury, Massachusetts, which focuses on education and advocacy for women in the inner city; the Elizabeth Seton Centre for Asians in Lawrence, Massachusetts, serving the new immigrants of the Merrimack Valley; and, in Queens, New York, a shelter for battered women and their children, known as the Women Helping Women program. The sisters also served in the Maura Clarke–Ita Ford Center in Brooklyn, which provided educational opportunities for poor women, and in Amethyst House, the only halfway house for alcoholic women in New York City. As the new millennium approached, feminine consciousness and vision were at an all-time high and the sisters launched programs to help rehabilitate women prisoners in Nova Scotia, Ontario, Alberta and Washington, D.C.

Thus, as the congregation moves into the third millennium, education in its manifold forms remains an important apostolate of the Sisters of Charity of Halifax. With the establishment of the Elizabeth Seton Academy in Dorchester, Massachusetts, in 2003, the congregation has shown that the educational odyssey on which it embarked more than 150 years ago is not over. Despite dwindling numbers, an aging membership, decline in recruitment of new members and loss of traditional educational institutions, the sisters, inspired by the spirit and mission of their founder, St. Elizabeth Ann Seton, are determined, in her words, to "hazard yet forward," and continue their educational ministry into the 21st century.[35]

Endnotes

1 Archives of the Sisters of Charity, Halifax Congregational Archives (hereafter *SCHCA*). St. Vincent's *Règles des Filles de la Charité* Approved by John Francis Gondi. Archbishop of Paris, 1646. Revised Rules signed and sealed by Fr. Rene Almeras in Leonard-Coste. (Handwritten copy from the Generalate, Rue de Bac, Paris.)

2 SCHCA, *A Memoir of Mother Elizabeth Seton, Foundress of the Sisters of Charity in America*, with some of her spiritual maxims and a brief account of the establishment of her daughters in Halifax, Mount Saint Vincent, Halifax, Nova Scotia, 1924, 29. The quotation, dated September 11, 1811, is taken from *The John Carroll Papers*, Thomas O'Brien Hanley, ed., 3 vols. (Notre Dame, 1976), 3:157.

3 SCHCA, *Constitution of the Sisters of Charity in·the Archdiocese of Halifax* (mimeographed). See also, J. Dirvin, *Mrs. Seton: Foundress of the American Sisters of Charity* (New York: Farrar, Straus and Giroux, 1962), 303–306.

4 SCHCA, *Regulations for the Society of the Sisters of Charity in the United States of America, 1812*, Chapter 1, Article 1 (mimeographed copy of Saint Vincent's Rules adopted and adapted for the community at Emmitsburg).

5 Brian Harrington, *Every Popish Person: The Story of Roman Catholicism in Nova Scotia and the Church in Halifax*, 1604–1984 (Toronto: Scanner Art and Service, Inc, 1984), 72, 102; see also Sr. Mary Olga McKenna, SC , *Charity Alive: Sisters of Charity of Saint Vincent de Paul, Halifax*, 1950–1980 (Lanham, MD: University Press of America, 1998).

6 Sr. Maura [Power], SC, *The Sisters of Charity, Halifax* (Toronto: Ryerson Press, 1956), 4. I am indebted to Sr. Maura for most of the information relating to the first one hundred years of education.

7 Sister Marie de Lourdes Walsh, *The Sisters of Charity of New York, 1809–1959*, Vol. 1 (New York: Fordham University Press, 1960), c. 8, p. 159.

8 In 1849 the approximate value would have been $9.62 and $8.00 respectively; in 2005, the value would have been circa $27.48 and $18.32. See "Current Values of Old Money," www.ea.ac.uk; also, "Economic History of Services," eh.net/hmit.

9 Ibid. In 1849, the government would have paid circa $120.25 a year tuition for poor children; the value today would be circa $3,664.00.

10 Ibid. The 4000 pounds was roughly equivalent to $19, 240; in today's money, that would be about $586,000! .

11 Sr. Maura, ibid., 7.

12 Ibid., 14, 151–152.

13 SCHCA, *Mount Saint Vincent Normal School*, Brochure and Supplement, 6 pp.

14 Sr. Maura, 16.

15 Ibid., 17–21.

16 Ibid., 163–200.

17 SCHCA, "Sisters of St. Martha Share Discovery: Letters Reveal History of Our Marthas," *Chapter News*, August 1980, A.

18 *SCHCA*, "Mount Saint Vincent Normal School," 3.

19 *The Statutes of Nova Scotia, Chapter 180, Acts of 1925.* An Act to Amend Chapter 161, Acts of 1907, entitled "An Act to Amend and Consolidate the Acts Respecting the Sisters of Charity." See also Sr. Theresa Corcoran, SC, *Mount Saint Vincent University: A Vision Unfolding, 1873–1988* (Lanham, MD: University Press of America, 1999), 55–65.

20 Sr. Maura, 257.

21 Sr. Mary Olga McKenna, 119–143.

22 Sr. Bertrand Meyers, DC, *Sisters for the 21^st Century* (New York: Sheed and Ward, 1965), 59. For an account of the Sister Formation Movement, see 104–124. See also T. Schier and C. Russett, eds., *Catholic Women's Colleges in America* (Baltimore: Johns Hopkins University Press, 2002); and K.M. Kennelly, CSJ, "Women Religious, the Intellectual Life and Anti-Intellectualism: History and Present Situation," in B. Puzon, ed., *Women Religious and the Intellectual Life: The North American Achievement* (San Francisco: International Scholars Press, 1996).

23 Sr. Lawrence Mary Egan, SC, "The Apostolate of Teaching," in *Report for the First Provincial Chapter,* Central Province, 1968, 2; see also Sr. Mary Olga McKenna, 132–133.

24 *The Statutes of Nova Scotia*, 15 Elizabeth II, Chapter 124, "Mount Saint Vincent University Act, April 6, 1966"; see also, Sr. Theresa Corcoran, 97, 124–127, 181–182.

25 Sr. Theresa Corcoran, 125–127.

26 Ibid., 184–187, 221–228.

27 Sr. Mary Olga McKenna, 179–189.

28 Sr. Theresa Corcoran, 197, 232–234.

29 Sr. Mary Olga McKenna, 355. The Vincentian spiritual heritage is best summarized in a line from the musical version of *Les Misérables:* "To love another person is to see the face of God." For Vincent, to serve one's neighbour is to serve God. Throughout his lifetime (1581–1660) he served God in the *anawim*, the poor, sick, abandoned outcasts of society. As spiritual Father of the Daughters/ Sisters of Charity worldwide he designated in three words the virtues on which their spirituality must be built: humility, simplicity and charity.

30 *SCHCA*, Sr. Katherine O'Toole, SC, "*Report to the Fourteenth General Chapter, 1976–1980.*" Part II, A, p. 120.

31 *SCHCA*, Sr. Katherine O'Toole, SC, "*Ministries, Present and Future,*" Address to the Sisters of Charity, Greensburg, PA, September 24, 1978.

32 *SCHCA*, Sr. Katherine O'Toole, SC, "My Dream for the Year 2000." Paper presented to the Canadian Religious Conference, 1980; see also, Sr. Maureen Regan, SC, *A Biography of Sister Katherine O'Toole* (Halifax, NS: Sisters of Charity of Saint Vincent de Paul, 1996), 56.

33 *SCHCA*, Communications Office, Sisters of Charity. "150 Years of Service: Sisters of Charity, Halifax 1849–1999," Brochure.

34 Sisters of Charity, Halifax, "Charity Alive," in *Newsletter* (May/June, 1998), 7.

35 Foundress Elizabeth Ann Seton was canonized in Rome on Sunday, September 14, 1975 by Pope Paul VI.

4

Entering the Convent as Coming of Age in the 1930s

Heidi MacDonald

The Canadian economy was more vulnerable to the Depression than that of most nations because of its heavy dependence on a few exports to two countries; exports to the United States dropped by half and exports to Britain decreased by two thirds between 1929 and 1932.[1] The unemployment rate in the population of 10 million reached 27 per cent in 1933. While deprivation was widespread, youths were considered more vulnerable than any other group. According to social workers, medical professionals and educators, the "normal" transition to adulthood depended on achieving specific goals within a certain time frame, most notably employment, marriage, setting up a household and starting a family.[2] Failure to meet these goals could result in youths losing their ambition, never contributing to society and becoming a lost generation. Yet meeting these targets became increasing unrealistic in the 1930s, which was reflected in falling marriage and birth rates. Given that approximately 90 per cent of Canadians married at least once in their lifetimes in the early 20th century, it is natural that historians use marriage and birth rates as indicators for how youths' entrance into adulthood was delayed in the 1930s. However, this methodology misses an important group: those young adults who entered religious life in the 1930s. For the approximately 45 per cent of the population who were Catholic, religious life was an option for achieving adulthood. As Marta Danylewycz has said, entering a convent was an alternative for women to marriage, motherhood

or spinsterhood.[3] One might expect the appeal of the convent to grow during the Depression, perhaps in inverse proportion to the falling marriage rate. In fact, 1930s entrance rates were very comparable to rates in the 1920s.[4] Nevertheless, this essay considers entering a convent, whether permanently or temporarily, as a step in the coming of age process during a particularly difficult decade for North American youths, the Great Depression. In addition to a broad Canadian analysis, a case study of a particular congregation, the Sisters of Charity of Halifax, is presented.[5]

Coming of age is a complex process, made that much more so in an economic crisis. There was no single experience of Depression era youth and no single moment or age when childhood was completed and the entry into adulthood began. Rather, there were as many experiences as there were youths, and their coming into adulthood comprised many individual but cumulative events. The six events most associated with becoming an adult in the 1930s were leaving home and arranging new accommodations; obtaining education and/or training; seeking and finding employment; participating in the youth political movement particular to the time; engaging in peer relationships (including friendships and courtship); and marrying, setting up house and having children. While it is often assumed these events normally occurred in a particular sequence, according to historian of childhood Harvey Graff, "Normative theories' notions of a relatively linear progression from total dependency to full autonomy seldom approximate the actual paths taken by persons growing up ... No less consequential are the interactions of dependency with the main influence of growing up: age, class, sex, race, ethnicity, location, and time."[6] The remainder of this essay considers entering the convent not so much as a single alternative path to marriage but as a varied experience itself, dependent on a variety of steps and affected by Graff's "interactions of dependency."

In the population of approximately two million adult Catholic women in Canada in 1931, almost 31,000 were vowed women religious. During the 1930s, an additional 10,000 women made a permanent commitment to religious life, increasing the total number to 40,607 in 1941.[7] A few thousand women also tried religious life, entering a convent for a short period and then leaving, either of their own volition or as required by the congregations they had entered weeks or perhaps months earlier. These entrants, whether they stayed or not, were on particular pathways toward adulthood in much the same way their secular sisters were. Whereas their secular counterparts may have anticipated engagement, marriage, children

or a paid occupation, prospective postulants negotiated an equally complex and socially constructed path to fulfilling or testing their vocations.

In North America from the mid-19th to mid-20th centuries, the decision to pursue a religious vocation was often fostered by informal influences, such as an aunt, sibling, cousin or friend already in religious life. Marta Danylewycz notes that 13 per cent of entrants to the Congregation of Notre Dame and 21 per cent of entrants to the Sisters of Miséricorde between 1840 and 1920 already had a sister in the congregation, and many more had siblings or other relatives in other congregations.[8] Women religious could purposefully seek out and encourage young women to consider religious life through more formal avenues such as spiritual retreats or sodalities.[9] Using the image of a pathway, one might say that many who entered religious life were lead to the path by someone who was already a member of a religious congregation. Thus, individual women often cite powerful childhood memories of women religious as major influences in their decisions to enter religious life, at least in retrospect.

Anecdotal evidence suggests a large proportion of women religious in Canada attended schools run by sisters. The sister-teachers at these schools were in a unique position to approach the young women whom they thought would make good women religious. Sister Mary Albertus Hagerty (b. 1913) attended the high school in Wellesley, Massachusetts, run by the Halifax Sisters of Charity. In her final year of high school a teacher whom she really admired asked her whether she would consider becoming a Sister of Charity. Sister Albertus explained, "There wasn't any fuss about it. Once I said yes they just went ahead and prepared me for it."[10] Once Sister Albertus became a teacher herself, her superior suggested she encourage a particular pupil to consider religious life. Sister Albertus broached the subject with the girl, and, "She was a lot like me; it only took 10 minutes to sell it to her (laughs)!"[11]

Some girls and young women, while students at Catholic schools, were moved to consider joining the convent during school-sponsored retreats. Sister Irene Farmer and her classmates attended a weekend retreat at an Edmonton convent when they were in Grade 6. Sister Irene's biographer explained,

> The retreat master ... [told] the retreatants ... they should draw
> two columns on paper, writing in one their reasons for not wanting
> to enter religious life, and in the other their reasons for choosing

religious life … . Of her religious vocation, Irene said years later: "I think I knew it quite clearly when I was in grade eight …"[12]

Such retreats were meant to give women the opportunity to consider seriously religious life. Sister Francis Xavier Walsh (b. 1914) was also prodded to consider religious life during a retreat, although the approach was less explicit. Along with a few other high school girls, Sister Francis Xavier was asked to help at her teacher's congregation's annual retreat in early September 1930, when she was in Grade 11 at St. Patrick's School in Halifax. While the high school girls were meant to be serving the older sisters, they were also on retreat, and Sister Francis Xavier was very moved by the experience. Remembering it, she explained, "Oh I just thought it was wonderful to go to the old mother house on retreat. The high school sisters look after that retreat. So, I entered in Grade 11 … I was going on 17."[13] In her mind, the retreat and the decision to enter were synonymous. She entered the Sisters of Charity a few months later and soon became a teacher herself.

For women religious who came of age in the 1930s, entering a convent was a major step on the path to adulthood. Entering a convent not only corresponded with one of the six major events associated with coming of age – leaving home and arranging new accommodations – but it also signified a more serious commitment. While entrants did not take vows of poverty, chastity and obedience for another two or three years, and then only for twelve months, entering a convent had a real gravity for these women. By entering a convent, a woman declared that God was calling her to a particular life and that she was prepared to accept, or at least try to accept, whatever challenges and obligations that life entailed. In fact, entering a convent *did not* necessarily mean becoming a sister forever, as many women who entered religious congregations did not stay permanently.[14] Secular society might associate the act of entering a convent with marital engagement: chances were the relationship would continue, but if it did not work out a young woman could likely return to her previous life. She would inevitably return a different person, significantly affected by her experience, but many doors would likely remain open to her, and the rest of her path to adulthood might still be quite smooth. Marta Danylewycz makes this point even more sharply, writing that "… novitiates were way stations through which young women passed in search of a life's vocation."[15]

Sister Katherine Horgan, an only child whose mother died in the Spanish Influenza epidemic, entered the Sisters of Charity at age 17 and *did* stay permanently, much to her father's surprise. Her path to final profession did not seem linear, mostly because her father kept appearing at the mother house to make sure that his precious daughter was happy. Sister Katherine explained:

> I entered on Thursday, and the next Thursday I'm called to parlour. I went down and there was the Mother General, the Mistress of Postulants, my cousin, and my dad. He had come [on the train from Dorchester, Massachusetts] to take me home. He wasn't nasty about it; he just wanted to see if I was ok …. He said he would be back, … and [over the next four years] he'd been down eighteen times. Everybody knew him.[16]

For a woman who did leave the convent during the initial phase of religious life, one of her many options was to join another of the hundreds of North American women's congregations, particularly if she thought the problem was one of "fit." Catholic women in the 1930s had more than 100 congregations from which to choose if they decided to test their vocation by entering a convent. Most women chose according to a variety of criteria, including the main work or mission of the congregation; for example, those who thought they would enjoy teaching would be attracted to congregations with an educational mission. A significant proportion of women religious joined congregations to which relatives or friends already belonged.[17] The variety of congregations precludes generalizations about who entered religious life in the 1930s. Instead, the remainder of this essay focuses on one congregation, the Sisters of Charity of Halifax and answers the following question: Who, exactly, entered the Sisters of Charity in the 1930s and how did they experience coming of age?

A total of 485 women entered the Sisters of Charity of Halifax between 1930 and 1940 and stayed a minimum of six months.[18] They entered at a relatively steady rate, which suggests that the convent did not become more appealing in difficult economic times, a haven for families who could not support teenaged children or for older women who had failed to marry. The percentage difference in the number of entrants over the decade between the year with the highest number (1931) and the lowest (1938) is less than twelve per cent, which signals an evenness rather than spikes in entrance that might correspond with economic crisis. Moreover, the year in which the most women entered, 1931, seems too early in the

decade to warrant a connection to the Depression, because it preceded the worst years of the economic crisis, 1932 and 1933. This contributes to my argument that entering religious life was not widely used as a way to avoid the difficulty of coming of age in secular society in the 1930s.

Table 1: Entrants to the Novitiate of the Sisters of Charity, Halifax, 1930–1939, Age at Entrance, and Proportion who Stayed at least Seven Years

Year Entered	Number	Proportion of Entrants for 1930s in per cent	Median Age (Sample size in parentheses)	Proportion who Stayed 7 + years (in per cent)
1930	65	13.4	18.4 (49)	92.3
1931	84	17.3	19.7(83)	95.2
1932	66	13.6	19.1(35)	92.4
1933	43	8.9	21.0(29)	95.3
1934	53	10.9	21.2 (19)	86.7
1935	41	8.5	20.7 (22)	90.2
1936	45	9.3	21.4 (26)	88.9
1937	25	5.2	21.5 (14)	96
1938	24	4.9	22.3 (8)	87.5
1939	39	8	20.5 (15)	82.1
Total	485	100	20.6*	90.6*

Source: Compiled by author from Novitiate Reception Binders and Sisters' Personal Cards, Archives, Sisters of Charity, Halifax. Partly because of a fire in 1949, some personal information is unavailable for some members, including the age at entrance.

*These are averages for the decade.

With regard to the idea that the convent was a refuge for women who failed in their intention to marry, age at entrance suggests that this is not so. Although complete data are available for only 62 per cent of all entrants, among that number the median age per year ranged from a low of 18.4 (1930) to a high of 22.3 (1938) over the decade. These

average ages are markedly below the average age at first marriage, which was 25.1 in 1931 in Canada, and increased over the decade but dropped again at the beginning of the Second World War.[19] The relatively young age of those entering convents suggest that the decision to do so was not usually made after women had failed to complete their path to marriage but rather that the majority of women who entered the convent were in fact on a different path to adulthood.

The average age does not account for the range of age among entrants to the Sisters of Charity in the 1930s, which was between 16 and 38. Sixteen was the minimum age at which entrants could be accepted, based on the canon law requirement that religious could not take vows before age 18 and that entrants would not be asked to take permanent vows until at least two years after entrance; between 1930 and 1939, approximately fourteen per cent of entrants to this congregation were 16.[20] The eldest entrant in the 1930s was 38, but she was a rarity; less than four per cent of all entrants were older than 30.

One can discern a relatively steady rise in the age at entrance during the 1930s that might be compared to the increasing age of marriage in the same decade. Entrants may have held off entering for some of the same reasons men and women delayed marriage, which, according to Paul Axelrod and John Modell, included longer schooling, primarily linked to many middle class and lower middle class youths' determination to find well-paid employment.[21] The rate of marriage dropped by one quarter in the first three years of the Depression, largely because of the difficulty accumulating the goods necessary for setting up a household.[22] Although many congregations similarly requested cash dowries, they waived them if a family could not afford the suggested amount. National figures are unavailable for the increase in the age at marriage that is connected to the drop in the marriage rate, but given that women's average age at first marriage was 25 in 1931 and is known to have increased during the decade, it is certain that the average age of entrants to the Sisters of Charity, Halifax, was always well below the average rate of marriage. In other words, the age of entrance to the Sisters of Charity increased during the 1930s but only at a rate that paralleled the increasing age of marriage rather than surpassing it.

Those women who stayed in the convent for the whole term of the postulancy, usually six months to a year, and who wished to continue in religious life, and had earned the approval of the congregation, were that much farther along the path to a particular kind of adulthood. The

next step was the novitiate, the entrance to which was formally marked in several rituals. Most notable was a ceremony not unlike a wedding ceremony. In many congregations, the postulants began the ceremony in wedding dresses, and ended the ceremony in the habit, thereby marking their new status as novices.[23] They also received their new name in religion. For the Sisters of Charity of Halifax, novices were asked to submit three possible names they would like to receive, and the congregation's leaders chose from among them. Women religious are often described as brides of Christ, and probably never is the comparison with marriage so literal as during the novitiate ceremony.

The progression to adulthood would accelerate in the novitiate, which usually lasted two years and was associated with a woman's formation in religious life through apprenticeship and education.[24] The novitiate included many of the same steps associated with the transition from youth to adulthood in secular society: education, employment and deepening peer relationships. A woman's experience in the novitiate partly depended on her age, level of education and employment experience when she entered the novitiate; the farther she already was on the path to adulthood when she entered, the less would likely be required of her before she was assigned to one of the congregation's missions.

Novices lived together in a separate area of the mother house and were the responsibility of the mistress of novices. Many sisters describe the novitiate as an intense and regimented but very rewarding part of their lives. In Carol Coburn and Martha Smith's words,

> [E]nclosed in a self-contained, highly structured environment, they bonded with each other, absorbing community ideals as they worked toward professing vows. The powerful combination of religious ritual, structure, dress, and direct spiritual education molded, shaped, and focussed their efforts to fit in and become part of the larger professed community. This shared experience built an esprit de corps among the novices, though youthful idealism and frivolity could not always be tempered.[25]

Because so many sisters entered their congregations within a few years of high school, they often remember the novitiate as a time of becoming an adult. A Sister of St. Joseph of Toronto explained that in the novitiate, "quite a few of us were young, just out of high school. Maybe that is also what made it more traumatic in the sense that entering that young, right from home, you were not really grown up yet. So everything that

happened, all the rules and regulations that were in existence, you took very, very seriously. I did anyway."[26] The song of the group of Halifax Sisters of Charity who entered the novitiate on St.Patrick's Day 1932 also acknowledged the expectation for growing up in the novitiate:

> St. Paul himself could claim us,
> As we grew in age and grace –
> And no more "as children" acted,
> While we strove to win the race –
> Trying to attain adulthood,
> As all childish ways were dropped,
> And onto this very moment,
> Our strivings ne're have stopped.[27]

Canon law stipulated several requirements for congregations training their novices, and thus the first year of the novitiate is sometimes referred to as the *canonical year*.[28] Classes in such subjects as languages, catechism and theology, as well as spiritual exercises and prayer several times daily, prepared women for life as a religious. Sister Teresa Sullivan, who entered the Sisters of Charity of Halifax in 1931 at the age of 18, remembered her time in the novitiate as

> [B]eautiful years, a very knowing time where we learned a lot about prayer and appreciated the silence and the depth of what our life was going to be in the future. We came from young, youthful activities into the silence [of religious life.] I really appreciated learning about prayer and the quietness and peace of prayer and the presence of God more than anything.[29]

The course of the second year of the novitiate depended on an entrant's age and level of skill. For those who entered young, usually right out of high school – and these formed the majority in the early 1930s – the second year focused on training in either normal school or nursing school or for another health profession, or studying for a bachelor's degree. For the few who entered with a particular qualification, work could begin in that profession in one of the congregation's missions. Others who were seen not to have an aptitude for a profession would do full-time, unskilled work in the congregation, usually in domestic service, beginning in the second year of the novitiate. Whether novices continued their education or worked in one of the congregations' missions, they took several additional steps on the path to adulthood during the second year of the novitiate.

Many novices in the Sisters of Charity in the 1930s spent this training in one of the congregation's primary mission fields, education or health care. In order to continue to staff the dozens of schools the congregation operated in Nova Scotia, New Brunswick, Alberta, British Columbia, Quebec, Massachusetts, New York and New Jersey, many novices were assigned to take teacher training at Mount Saint Vincent College, which the Sisters of Charity ran. The college began granting degrees in 1925, so sisters were able to obtain a bachelor's degree within their own organization. Wary of charges of inbreeding, however, the congregation also sent novices to Dalhousie University to complete their degrees. In 1933, for example, 12 of the 84 second-year novices went to Dalhousie.[30] After a few years of teaching, a significant portion of sisters were sent to earn master's degrees, library science degrees or even PhDs, which was quite rare for women in the 1930s. In fact, fewer than 8,000 women attended university at the undergraduate or graduate level in 1935 in all of Canada.[31]

The Sisters of Charity ran hospitals in many of the same provinces and states in which they taught, and some novices were trained in health care professions, especially nursing and pharmacy, and as x-ray and lab technicians. The Halifax Infirmary, run by the Sisters of Charity since 1886, had its own school of nursing, which was where many novices became registered nurses.

Since novices lived separately from the rest of the congregation and their formation required scheduled group prayer, study and recreation, they spent a tremendous amount of time in each other's company. Novices in the Sisters of Charity of Halifax even slept in dormitory-style rooms. Thus, many opportunities existed for the novices to develop peer relationships, which is considered an integral step toward adulthood. Yet in the convent, friendships between sisters were governed by rules and were regularly interrupted by changes of assignment. Particular or exclusive friendships were not only considered potentially divisive and damaging to the spirit and mission of the group but also to an individual sister's ability to maintain her vows. After the Second World War, the focus of this concern shifted toward sexuality, but in the 1930s it was on the need to sacrifice one's self to the group by avoiding special friendships.[32] An alert mistress of novices would monitor developing one-on-one friendships and separate women whom she considered at risk.

Friendships in the novitiate were complex; when senior women religious talk about their friends in the novitiate they are quite likely talking about the shared experience in the novitiate that led to a deepening of the

relationship in later years. In the novitiate, more bonds probably developed than relationships. Those bonds were very strong, however, and were reinforced over a lifetime. The celebration of the anniversary of a woman religious's profession was a very special occasion, especially in five-year increments, as is the popular practice with wedding anniversaries. Because women religious shared their profession date with the members of their novitiate class, these celebrations provided them with the opportunity to reconnect at regular intervals over their lives.

Just as the larger congregation had a particular culture, a distinct culture developed within the novitiate as a given cohort or band progressed through it over two years.[33] One particular group, which entered the Sisters of Charity, Halifax, in September 1931 and February 1932, is legendary. According to Sister Francis Xavier, the congregation, whose membership numbered slightly more than 1,000 in 1930, had prayed for 100 new sisters because so many bishops were asking for teachers "for all over the place."[34] These prayers were answered: 101 women entered as postulants and 84 of them made their profession two-and-a-half years later, on April 1, 1934. Early in their novitiate, this cohort was given a name, as was the custom: while the story varies in some details, it is told that a visiting bishop said to the mistress of novices that the large group of novices, who were wearing their white veils and deeply genuflecting, reminded him of a field of lilies.[35] The term stuck and became part of the culture of that band of novices. Among the Lilies, many memories concern problems associated with having so many new entrants. According to one, "We were so many that the Mistress of Novices would send some to bed early because we were so noisy. The Cape Breton sisters were all in one dorm, and they would [take their turn] and go early some nights … . There were so many of us, we just followed the rules. There were so many."[36] The unruliness of many of the novices was noted in one of the verses of the Lilies' song:

> But then, to the Novitiate,
> Went we all on St. Pat's Feast!
> Irish hearts (or not) felt happy
> From the Greatest to the Least!
> Until our Mistress' welcome
> Cooled the ardor of our fire –
> While for ten or twenty minutes
> Each felt burned, "as on a pyre"![37]

Biographical data are available on most of the 84 Lilies who made their profession in 1934, and may be used to show some of the characteristics of the women who joined the Sisters of Charity during the Depression, particularly regarding age, geographic origin, ethnicity, level of education and family of origin.

The majority of the Lilies entered before they were age 20; the average age was 19.3. The vast majority had completed high school but only a couple listed any employment experience. Of the 54 Lilies whose parents' date of death was recorded, ten did not have both parents living when they entered; in nine cases, the father had died and in one case both parents had died fourteen years earlier. This seems like a high proportion of entrants from families who had lost their primary breadwinner, and may be relevant to the Great Depression era.[38] A majority of entrants were of Irish origin, with Scottish ethnicity a distant second; only one Lily appears to have been of Acadian descent. Approximately 20 of the 84 Lilies who stayed in the congregation were the first-generation of their families to be born in the United States, their parents having been born in Ireland.

The most striking characteristic of the Lilies is geographic origin. Residence at the time of entrance is available for 64 of the Lilies, and shows a very strong tendency for entrants to be either from Massachusetts (34 entrants or 53.1 per cent) and Nova Scotia (25 or 39.0 per cent). When the rest of Atlantic Canadian entrants are added to the Nova Scotia group, the data divide even more evenly into two groups (Massachusetts: 53 per cent; Atlantic Canada: 47 per cent). This reflects the congregation's tradition of service in both the United States and Canada. In fact, the homes of the entrants correspond closely with the communities in which the sisters taught, most notably in Nova Scotia (North Sydney, Reserve Mines, Glace Bay, New Waterford and Halifax) and in Massachusetts (Roxbury, Wellesley, Dorchester and Lowell). Sister Katherine Horgan explained that she was taught by the Sisters of Charity at St. Peter's School in Dorchester. Out of the eighteen girls who took the classical stream of studies in her high school year, nine of them entered the Sisters of Charity in September 1931 and eight of them completed the novitiate and took their vows.[39]

Strong ties have always existed between the Maritimes and New England. By the 1880s there was regular steamship service from Boston to the Maritimes five days a week, as well as regular rail service.[40] The labour force was quite fluid between New England and the Maritimes, and New England was the preferred destination for the approximately half a million Maritimers who emigrated between 1871 and 1931.[41] More than 20,000 women from the Maritimes were living in Boston in 1915.[42] In addition

to this connection, the Sisters of Charity of Halifax also had a strong link with New York and were in fact descended from the New York Sisters of Charity, whom Bishop William Walsh had invited to Halifax in 1849 to start a community to educate Catholic children there.[43] It was natural, then, that women in New England considering a religious vocation would look to Nova Scotia. Once the Sisters of Charity set up houses and missions in Massachusetts, women from Nova Scotia often moved south to begin their religious life.

Youth were identified as the cohort that would be most threatened in the long term by the economic crisis. They were perceived to be at risk of becoming permanently stuck in the youth phase of the life course – teetering on the cusp of adulthood – because the economic crisis interrupted the trajectory to the next stage, early adulthood. Many historians make reference to the falling marriage and birth rates in the 1930s to indicate the extent of the economic crisis. This excludes the considerable number of women who entered religious life in the 1930s, the majority of whom never intended to marry. Between 1921 and 1931, the number of women religious in Canada increased by almost 10,000, from 21,352 to 30,968, an increase of 31 per cent. In the decade of the 1930s, another 10,000 women joined religious congregations, an increase of 24 per cent from the previous decade, which brought the total to 40,607 in 1941. Membership did not increase so significantly in the following decade; only 4,378 women joined religious congregations in that decade, perhaps because of the federal government's appeal to young women to take up volunteer or paid war work.

The fact that membership in women's religious congregations did not increase at a higher rate in the 1930s compared to the 1920s, and that membership in the Sisters of Charity of Halifax did not spike at any point during the decade, strongly suggests that the convent did not become a refuge for a significant number of young women during the economic and social crisis of the Great Depression. Not only did the rate of entrance remain relatively constant, entrants themselves do not associate their joining with the Depression. Of the five women I interviewed who entered the Sisters of Charity in 1931, each one insisted that the difficult economic times had nothing to do with their decision to enter. Moreover, four of the five said that the novitiate kept them isolated from any knowledge of the Depression. This is a very small sample but, when combined with the data on entrance rates and low average age of entrants, it suggests

the Depression was not a significant factor in young women's decision to enter the convent.

Coming of age was an acknowledged part of the convent experience, especially in the postulancy and novitiate. Of the six most common events associated with the cumulative experience of becoming an adult in the early 20th century in Canada, all but political protest and marrying and having children were cultivated by novices in the crucial stage of their formation. And, as for marrying and having children, one might say that women religious made equally significant commitments and contributions in their vows and in their work in education, health care, social work and domestic service. There is no reason to consider their paths to adulthood as any less of "a conflict-defined, conflict-ridden and conflict-bound historical process" than coming of age was for young lay adults in the 1930s.[44]

Endnotes

1 K. Norrie and D. Owram, *A History of the Canadian Economy*, 2nd ed. (Toronto: Harcourt Brace, 1996), 354–55.

2 J. Modell, *Into One's Own: From Youth to Adulthood in the United States, 1920–1975* (Berkeley: University of California Press, 1989), 14–15.

3 M. Danylewycz, *Taking the Veil: An Alternative to Marriage, Motherhood, and Spinsterhood in Quebec, 1840–1920* (Toronto: McClelland and Stewart, 1987).

4 Between 1921 and 1931, the number of women religious in Canada increased by almost 10,000, from 21,352 to 30,968, an increase of 31 per cent. In the decade of the 1930s, another 10,000 women joined religious congregations, an increase of 24 per cent from the previous decade, which brought the total to 40,607 in 1941. Data compiled by author from *Le Canada Ecclésiastique* (Montreal, 1921, 1931, 1941). Comparable statistics on membership in men's congregations are not available, but the *Census of Canada* lists the number of religious brothers as 876 in 1921; 1133 in 1931; and 1432 in 1941, which is an increase of 13 per cent between both 1921 and 1931, and 1931 and 1941. *Census of Canada, 1921, 1931,* and *1941*.

5 I would like to thank the Sisters of Charity, Halifax for providing me with access to their novitiate records and putting me in contact with five entrants from 1931 whom I interviewed in June 2006. These five sisters were representative

of the congregation's variety of entrants regarding place of birth, age at entrance, ethnicity and level of education at entrance.

6 H. Graff, *Conflicting Paths: Growing Up in America* (Cambridge and London: Harvard University Press, 1995), 7.

7 *Le Canada Ecclésiastique*, 1921, 1931, 1941.

8 Danylewycz, 112–13.

9 Danylewycz, 44.

10 Interview, Sr. Mary Albertus Hagerty, 12 December 2004, Wellesley, MA. Archives of the Sisters of Charity, Halifax [*ASCH*].

11 Sr. Mary Albertus Hagerty, interview.

12 G. Anthony, SCH, *Rebel, Reformer, Religious Extraordinaire: The Life of Sister Irene Farmer* (Calgary: University of Calgary Press, 1997), 15.

13 Interview, Sr. Francis Xavier Walsh, 19 June 2006, Halifax, NS. *ASCH*.

14 There is a wide variety in attrition rates among different congregations, and no median has ever been compiled. The highest published rate of attrition I have ever seen is from Danylewycz's study in which in the decade 1911 to 1920, only 24.5 per cent of entrants to the Sisters of Misericorde remained in the congregation more than two years. See Danylewycz, "'In Their Own Right': Convents, An Organized Expression of Women's Aspirations," V. Strong-Boag and A. Clair Fellman, eds., *Rethinking Canada: The Promise of Women's History*, 3rd ed. (Toronto: Oxford, 1991), 185.

15 Danylewycz, 106.

16 Interview, Sr. Katherine Horgan, 18 June 2006, Halifax. *ASCH*.

17 Danylewycz, 112–113.

18 The figures exclude those who entered and left during the postulancy.

19 E. Gee, "Fertility and Marriage Patterns in Canada, 1851–1971," (PhD, University of British Columbia, 1976) table 36, cited in V. Strong-Boag, *The New Day Recalled: The Lives of Girls and Women in English Canada, 1919–1939* (Markham, ON: Penguin, 1988), 83.

20 This is based on their year of birth being subtracted from their year of entrance, so it is likely that some of these entrants were actually 17. Because most entered in September, though, the majority would be 16.

21 Modell, 122 and P. Axelrod, *Making a Middle Class: Student Life in English Canada during the Thirties* (Montreal and Kingston: McGill-Queen's, 1990), 21. In fact, full-time university enrolment increased 10 per cent in Canada in the 1930s (Axelrod, 21).

22 The marriage rate decreased from 7.7 per thousand population in 1929 to 5.9 per thousand in 1932, and the birth rate decreased from 23.5 per thousand

in 1929 to 20.6 in 1939. J. Herd Thompson with A. Seager, *Canada 1922–1939: Decades of Discord* (Toronto: McClelland and Stewart, 1985), 153.

23 E. Smyth, "Professionalism Among the Professed: The Case of Roman Catholic Women Religious," in E. Smyth et al., eds., *Challenging Professions: Historical and Contemporary Perspectives on Women's Professional Work* (Toronto: University of Toronto Press, 1999), 238.

24 Smyth, "Professionalism," 239.

25 C. Coburn and M. Smith, *Spirited Lives: How Nuns Shaped Catholic Culture and American Life, 1836–1920* (Chapel Hill and London: The University of North Carolina Press, 1999), 74.

26 "Sister Stephanie Sinkewicz" in E. Smyth and L. Wicks, eds., *Wisdom Raises Her Voice: The Sisters of St Joseph of Toronto Celebrate 150 Years, An Oral History* (Toronto: Sisters of St Joseph, 2001), 47.

27 "The Lily Song," *ASCH*.

28 Smyth, "Professionalism," 239.

29 Sr. Teresa Ann Sullivan, interview, 20 June 2006, Halifax, *ASCH*.

30 Sr. Francis Xavier Walsh, interview.

31 F.H. Leacy, ed., *Historical Statistics of Canada*, 2nd ed. (Ottawa: Statistics Canada, 1983), table W340–438.

32 Coburn and Smith, 78–79.

33 "Band" or "class" are common terms used to describe a group of women who entered the congregation at the same time.

34 Sr. Francis Xavier, interview.

35 Sr. Teresa Ann Sullivan, interview.

36 Sr. Francis Xavier, interview.

37 "The Lily Song," *ASCH*.

38 Incomplete data prevents me from making any conclusion on this, yet it seems significant that of the 54 entrants for whom parents' date of death is available, nine were fatherless at the time of entrance. Assuming the father was the main family breadwinner, the death of the father would have put the family in particularly intense economic stress during the Depression, some of which might have been relieved by having a teenaged daughters enter a convent rather than be an economic burden on the family. On the other hand, a teenaged daughter could be an important source of income that would be lost if she entered the convent. Further study on the families of origin of convent entrants is needed.

39 Sr. Katherine Horgan, interview.

40 B. Beattie, *Obligation and Opportunity: Single Maritime Women in Boston, 1870–1930* (Montreal and Kingston: McGill-Queen's University Press, 2000), 45.

41 P. Thornton, "The Problem of Out-Migration from Atlantic Canada, 1871–1921: A New Look," *Acadiensis* 15:1 (Autumn 1985), 3.

42 Beattie, 68.

43 Sr. Maura, *The Sisters of Charity, Halifax* (Toronto: Ryerson, 1956) 2 .

44 Graff, 11.

5

Blasphemes of Modernity: Scandals of the Nineteenth-Century Quebec Convent

Rebecca Sullivan

The convent and its inhabitants have a certain hold on the cultural imagination. Their secretive, other-worldly nature stands at odds with traditional conventions of feminine piety, rooted in the family and domestic duty. Most research on Catholic women religious seeks to debunk myths about their way of life and open the convent up to analysis rather than rank speculation. While this is important work, crucial to developing more responsive and reflective theories of religious life, it does not engage directly with the meanings and values invested in the convent outside the religious milieu. Communications studies is well placed to interconnect the historical, social and cultural to reveal those practices of meaning-making and strategies of representation that so often stymie efforts to improve the image of women religious. Thus, for this essay, I have set out to examine Canadian women religious from two rather neglected vantage points. In the first instance, my concern is not with the truth or reality of religious life but with its representations in the mass media. Truth is usually contingent on its context, so when the frequent lament of misrepresentation comes up, my response is to question the values being represented in the images of women religious rather than the subject alone. This means exploring what Lynn Spigel calls the "discursive rules" surrounding feminine religious culture in general and the convent

in particular.[1] These are the strategies and conventions prevalent in the media and other popular texts that set the parameters for representation. Second, and related, I am interested in the imaginary potential of the convent rather than its actual contributions to society. In other words, I see the convent as an institution of social communication: a site of meaning production, value exchange and power relations. What sorts of epistemic and discursive properties emanate in the space between the convent as a physical site and its presence in culture through its interactions with other institutions of social communication such as the mass media?

To begin exploring this question, I decided to look back to the nineteenth century, a time when Catholic sisters were at the centre of nation building and urban development. Not coincidentally for my purposes, this era is also marked by the rise of the mass media and massive technological revolutions in communications. In this period of the penny press and chapbooks, stories of convent life, particularly that of convents in Montreal, circulated widely. However, these were not faithful accounts of industrious and devout women in community. Rather, they were lascivious narratives of torture, rape, abductions and massive conspiratorial networks. At the centre was one lonely soul, usually from a Protestant background, who had been tricked into entering the convent. This holy innocent had managed to escape to the United States, land of Protestant freedom. She then sought the new channels of mass media to tell her tale and warn others of the nefarious plots in French Canada to destroy the lives of young women and eventually overthrow civic society. These tales received support from nativist sympathizers, who believed that American democracy was the social manifestation of Protestant faith.[2] Adherents to this cause ran printing presses and published prototype tabloid newspapers to warn citizens of the religious threat from the north. Their argument was not with British-dominated Upper Canada but with that strange throwback to antiquated European culture, Lower Canada or Quebec. Thus, a triadic relationship of gender, religion and nation convened in the pages of early mass media, establishing long-standing anxiety and distrust toward Catholic women religious, particularly those from Montreal, a city that was constantly in a state of flux between the heritage of its French founders and the influence of its British conquerors.

While the essays in this collection evidence current scholarship on the lives, experiences and accomplishments of Canadian women religious mostly from an historical or theological perspective, the subject has been all but ignored by communications scholars. When such analyses do

appear, they tend to focus on some of the bleaker moments in the history of women religious and their representation in the media. It is this lurking distrust, mixed with intrigue and residual awe, that make nuns deeply ambivalent figures in our cultural representations. It is something that many scholars feel a need to address before delving into any other analysis that seeks to reveal "real" sisters and their "real" lives. For example, Marta Danylewycz' seminal book on the Quebec sisterhood in the nineteenth and early 20th centuries begins by responding to these stereotypes as false and pernicious:

> Film and fiction produced powerful and frequently negative images of nuns. They sometimes emerged as tight-lipped and tight-laced troubled souls, haunted by memories of unrequited love; at other times they appeared as cruel disciplinarians or as the unquestioning and obedient servants of bishops and priests. In the light of such powerful images, it was all the more unfortunate that historians failed to address the reality of nuns' individual and collective experience.[3]

In the years since that book was published, historians and other social scientists have taken great steps to correct these absences and to write about women religious using the lexicon of both religion and feminism. However, as a communications scholar, I am not as convinced that the only option available is to disown or discredit the stereotypes and misconceptions Danylewycz describes.[4] Surely, as forms of discourse that have been widely circulated through both information and entertainment media, these representations of women religious are worth exploring in their own right. The key here is not to ask about their truth-value or their reflection of reality. The media does more than merely mirror reality, if it even does that to begin with. What insight can be gained here comes from analyzing the underlying fears, anxieties, confusions and contradictions that made nuns such unsympathetic characters. In other words, the issue is not how accurately the media represents nuns and their experiences but about what other sorts of experiences are mediated by representations of nuns.

While there are many common stereotypes of nuns in the media – the ruler-wielding nun, the sexy nun, the singing nun – the images tend to be scattered, with no coherent or recognizable origin. There was, however, a particular moment in the nineteenth century that produced a unique genre. With its heyday in the 1830s to 1850s, the runaway nun story electrified

audiences and occasionally engendered mass moral panics and even the odd riot. The story's success was due to a curious confluence of anxieties over urbanization, the role of women in society and the rapid acceleration of the mass media. As such, it offers an original and challenging perspective from which to analyze the discursive power of the convent and its long-standing hold on our imagination. It is important to note that while the central character was always an escaped nun, the main antagonist was not necessarily a sadistic priest or mother superior. It was the institution itself that oppressed freedom of religion and the rights of the individual, two cornerstones in the liberal Protestant dream for building a perfect society in the new world. The convent, therefore, becomes key to the cultural imaginings of the religious life. Embedded in the convent's architecture and organization were a host of conflicting and ambivalent attitudes toward the meaning, value and power of the religious life that found their most graphic expression in the runaway nun story.

The runaway nun in cultural context

Many tales circulated during the nineteenth century that suggested nefarious activities behind the cloister walls. I am focusing on two runaway nun narratives in particular, both set in Montreal in the middle years of the nineteenth century. *The Awful Disclosures of Maria Monk* is perhaps the best known of the genre and considered a classic text of the nativist movement.[3] The scandal first broke in 1835 and continued unabated for at least two years. Eventually, like all scandals, it withered away, although it would occasionally crop up during periods of nativist uprising and still has a few believers today. *Life in the Grey Nunnery at Montréal*, by Sarah J. Richardson, does not have the same notoriety. This is likely because it was published in 1858, almost 25 years after *The Awful Disclosures*, when the runaway nun story was already a bit overdone. Still, the subtitle, *An Authentic Narrative of the Horrors, Mysteries and Cruelties of Convent Life*, would have been enough to grab some attention. There are many more of these books and still more reports in nativist publications.[5] Booksellers saw the advantage of marketing such tales to a new generation of urban commuters. The books were cheaply packaged in convenient pocket size and sold especially to young men looking for something gripping to read on the new public transit systems in the fast-paced cities of New York and in New England.[6] As historians of the nativist era concur, the runaway nun genre was crucial to the anti-Catholicism cause, replacing the tedium

of political debates and sermons with emotionally driven sensationalism and throat-catching propaganda.[7]

The runaway nun stories were a key element of a populist, scandal-driven media. Carol Bernstein argues that scandals are a natural by-product of urbanization, deriving from the convergence of multi-faceted networks of mass communication, bureaucratic capitalism and the ideological construction of a private sphere where secrets could germinate.[8] In North America, cities were mushrooming at an alarming rate, and state authorities relied on religious groups to help tend to the teeming masses. At the same time, there was great distrust between Protestants and Catholics over the salvific culture of the new world. As Jenny Franchot discusses, the belief of American Protestants that they were building "Nature's Nation" was compromised by the encroachment of French-Catholic culture, with its emphasis on ritual and ornamentation.[9] Thus, even while the Protestants looked to Catholic congregations to assist in social welfare, they were concerned not to let them become too powerful in case they attempted to take over and lead America into a religion of corruption and decay, such as had happened in Europe, at least in their opinion. Dependency on sisters went hand in hand with suspicion and resentment, further fuelled by their cloistered way of life hidden behind the imposing gates of the convent, which was viewed as a perversion of a newfound sense of privacy and anonymity and was, therefore, a prime target for media speculation. The convent was a sublime structure, displacing notions of privacy, femininity and institutionalism, and bringing the fabulous artifice of Catholic Europe into the pristine landscape of the new world.[10] As such, the media could not wait to pry open those gates and give their readers a forbidden glimpse inside.

In examining these two runaway nun stories, I became less interested in the characters of the nuns than in the heavily detailed description of everyday life within the convent. It became evident that the convent buildings themselves, significant and highly visible landmarks across urban Montreal, were enough to sow seeds of doubt. What could possibly be going on behind those high walls? In the absence of any real knowledge, elaborate tales of labyrinthine tunnels, secret dungeons or torture rooms, and forgotten women buried alive in underground crypts filled the void. Thus, while my analysis relies on texts and examines them in their historical context, it is ultimately about the cultural meaning of the convent as a spatial configuration both real and imaginative. There is no question that these tales were untrue and genuinely damaging to the sisters of both

the Hôtel Dieu Congregation and the Sisters of Charity of the General Hospital of Montreal, known as the Grey Nuns. However, as mass-media scandals, they point towards a long-standing cultural fascination with the convent and what it represented in terms of discourses on gender, religion and nationhood, all of which were hotly contested at this time.

The convent, long since relegated by scholars to the status of a total institution, is something quite different altogether when considered as imagined space portrayed in the mass media. As Erving Goffman defines it, a total institution is one that places physical and social barriers on its inhabitants from outside influences and controls them through strategies of self-curtailment.[11] That is certainly true of congregations in nineteenth-century Montreal whose ritualistic techniques of self-effacement were anathema to contemporary values of liberty and individualism. Thus, as he argues, congregations profaned liberal society and required some kind of justification for their existence based on the security and well-being of that society. Prisons or army barracks could be accepted as necessary total institutions, since they helped maintain and protect social order. However, convents did not fit this model as easily, since, unlike prisons, they were voluntary, and, unlike the army, they did not directly contribute to the maintenance of the dominant social structure. If anything, by disrupting conventions of domesticity, they undermined it. Furthermore, by fulfilling duties that the state either could not or would not attend to, the women that lived in the convents straddled the divisions between public and private, and secular and sacred, that characterized modern life in the nineteenth century. The convent was a problematic space in the urban landscape because it did not fit neatly into models of domestic Protestant culture. It brought to the surface latent fears of captivity and control in the overcrowded, chaotic labyrinth of the city.[12] There, in its midst, was a massive, impenetrable fortress that hid potential mothers away forever. Even worse, the women religious volunteered to enter and have the door shut behind them forever. To the nativist mind, this was unthinkable and demanded explanation if not outright action against it. Thus, unlike a total institution predicated on conformity and rationalization taken to extremes, the nineteenth-century Montreal convent offered an alternative social ordering for the city, invented largely by outsiders who could not make sense of the convent's existence. As a site of perpetual contradiction within the urban environment, its identity was not total at all but problematically partial and fragmented, and therefore scandalous. In this sense, then, the convent acted more like a heterotopia, a boundary space

of the imagination.[13] It is this cultural aspect of the convent that interests me more than its historical, architectural or religious value, although all are interconnected.

Cultural studies of the convent

In an era of civic religion, nativism, domestic ideology and Marian devotion, developing a unique vision for statehood in the new world was inextricably linked to the role of women and institutionalized religion. Such a statement flies in the face of conventional understandings of modernity, such as there being a division between public and private spheres, the supremacy of rationalism and secular humanism, the ideology of the common man and civic liberty, and the rise of functionalist theories to explain social life. If all this were the uncontested state of nineteenth-century society, then why did convents matter so much to the public imagination? The runaway nuns of Montreal tell a story that suggests that modernity, in the guise of industrialization, urbanization and liberal individualism, was not proceeding apace in North America without great anxiety and confusion. According to nativist sympathizers, institutions such as convents were supposed to have been left behind in decrepit, corrupt Europe.[14] They were not touchstones of progress and enlightenment, but bastions of social control over the individual; therefore, something was terribly wrong. The runaway nun scandals inverted the hierarchies of modernity, revealing an underbelly that gave lie to triumphant histories of unrelenting progress, technological advancement and the domination of the human spirit over all. At first glance, convents seem to be sacred spaces, consecrated by the Catholic Church as havens for prayer and good works. As these scandals show, however, they proved such an affront to powerful ideologies of liberal society that they themselves became a kind of moral pollution – blasphemes of modernity and all it promised. I am interested here in moving beyond conventional critiques of the convent as a total institution to understand the discursive flows and juxtapositions inherent in its spatial configurations, both real and imagined.

Clearly, then, a communicational analysis of the convent conjures up significantly different questions having to do with media, culture and representations than those another type of analysis would raise. Yet, the interdisciplinary field of religious communications studies is still quite small and tends to focus on specific areas and contemporary issues such as televangelism. What Stewart Hoover and Lynn Schofield Clark term

"cultural media studies" of religion has gained significantly less attention.[15] Influenced by the work of scholars such as Raymond Williams and Stuart Hall, cultural studies of religion were all but defined out as mere residual traces of worn-out cultures.[16] Based on Marxist theories of culture, ideology and hegemony, cultural studies struggled to come up with something beyond a theory of religion as opiate, a source of false consciousness. Due to their overwhelming emphasis on new or emergent cultures, most cultural studies of religion have been interested in subcultures and ritual. Yet as Robert White argues, religious studies and cultural media studies have much to offer each other when their theoretical and historiographical connection to concerns over the definition of the public sphere and publicly mediated textual discourse are taken into account.[17] Thus, a communicational analysis can investigate religion neither resorting to claims of eternal or universal values nor seeking a definitive moral rationale to justify its interpretation. Understanding religion as both social structure and social discourse opens it up to more satisfying theoretical frameworks. Through communications it is possible to analyze, assess and critique the inter-relationships of religious cultures as well as the texts and images that mediate their meaning and value. Cultural media studies examine religious attitudes and practices as contingent and reflexive, part of an ongoing process of meaning-making and signifying the sacred.[18] Such a configuration would only be possible in the modern world of mass-media, in which clerical authority and sacralized power may not have been completely discarded (as some would like to argue) but rather were forged through constant negotiation, adaptation and competition. It is not a coincidence that whole new paradigms of religion and culture emerged in the social sciences during the nineteenth century, with specific interests in social institutions, power relationships and new media technologies. As Graham Murdock has suggested, the "sacred canopy" of medieval Catholicism was in tatters by then but no one institution could replace it. Thus, a new kind of resolutely modern religious sensibility was forged through a variety of ideologies competing over the communicative value of religion and the constitution of sacred beliefs in a secular society.[19]

Mass media technologies, hailed by Jurgen Habermas as a crucial factor in the constitution of the public sphere and communicative reason, were easily adapted to serve the needs of this new, fractured religiosity.[20] Steam-powered presses replaced old, hand-cranked presses, driving down the price of starting an independent newspaper or book publishing company. The number of publications skyrocketed as costs plummeted.

In New York, a centre for nativist sentiment, the first penny paper – so called for its price – was launched in 1834, one year before the Maria Monk scandal broke. Thirty-five more papers were started by 1840, many of which were backed by religious groups bent on stopping the spread of Catholicism. With names such as *The Protestant Vindicator*, their editorial policy was abundantly clear: their target was not merely Catholicism but its institutional foothold in North America. As one paper proclaimed, it would be "a faithful exposé of the moral and religious conditions of Lower Canada, as debased by the prevalence of Roman supremacy."[21] Not to be outdone, the ultramontanist elites in Quebec countered with pro-Vatican and pro-French publications. At least six Catholic newspapers were founded in the mid-period of the nineteenth century, alongside more mainstream fare such as *Ami du Peuple* and *The Montreal Courier*. Situating themselves as stalwarts of the faith, these publications decried the unchecked spread of liberalism and modernism that was destroying the authority of the one true Church.[22]

At stake in these early tabloid wars was nothing less than the salvation of the new world. However, it is clear that what counted as sacred and as profane radically diverged, depending on whose version of Christianity the paper espoused. Gunter Barth claims that the rise of nineteenth-century urbanity was the foundation of this shift in media discourse away from reasoned debate to populist outcry.[23] In this suddenly intensely competitive milieu, sensationalism took root in the mass media. It was not only an attempt to attract audiences but was also a cultural response to feelings of isolation and alienation in the city. The endless diversity and mystery of the city, its dark secrets and dangerous maze of streets containing different and competing cultures, were made real through lurid tales about otherwise anonymous individuals. A scandal is ultimately about taking hidden, private concerns and exposing them in the most public manner.[24] Their two-pronged function for audiences as both a cause for moral disapprobation and an outlet for lustful titillation made the convent an ideal subject for this new form of media narrative. An enclosed, medieval-like structure filled with young virginal women must contain some secrets. Revealing them would unravel the mysterious hold of Catholicism on its capital city in the new world and set to rights not only the true course of womanhood but also of piety and nationhood according to the principles of liberalism and Protestantism.

The gender of the occupants of the convent goes a long way to explaining why it became the lightening rod for the media, as opposed

to the churches or the seminaries. Widening gender divisions in society helped contribute to a specifically bourgeois domestic ideology that demanded women take on sacred roles in society as wives and mothers. These relationships signify another, sublimated trajectory in the history of modernity. Established in secure domestic enclaves, the bourgeois woman could be the mainstay of traditional values and pious sentiments that seemed displaced but not completely destroyed by industrialization, urbanization and technology. In other words, she was hailed as the keeper of the flame of religious fortitude. Thus, invested in this new cultural figure were all the unfulfilled promises of a civil religion based on Protestant ideals of liberty, individualism and progress. The fact that such an ideology required that women adopt a passive, nurturing guile only served to reinforce this contradictory role of religion to provide the moral foundations for a secularized but still staunchly Christian society. The double bind of gender and religion assigned women the role of inspirational forces, not of active agents of society in their own right. Within this convoluted cultural logic, it is not difficult to see why a convent teeming with hundreds of women who had spurned their civic duty to maintain the home and produce a new generation of children unblemished by European culture was taken as a moral affront to all that made the new world sacred. In a counter-narrative of modernity that claimed the perfection of American society was the result of Protestant ethics, it was the pious young mother who stood out as the iconic citizen, not the independent working man. Nuns, therefore, undermined this perfect society and threatened its very soul by snatching away and hiding from view its heart, women. While every major city had its religious congregations running schools, hospitals and orphanages, one city in particular seemed to have far more convents than could be decently tolerated. Montreal, already a lightning rod for nationalist tensions due to its status as bilingual and bireligious, was a breeding ground for new religious foundations and especially attracted women to their midst. It therefore became a prime target for nativist accusations of impropriety if not outright impiety.

Montreal: The contradictory city

Montreal belied the pervasiveness of the twin ideologies of femininity and piety and the true course of society according to Protestant values of bourgeois domesticity. Its bifurcated status as both an English and French city made it the crux of the struggle between Protestant and Catholic

leaders bent on fashioning a new and perfect society according to their distinct religious impulses. The anxiety over Montreal was exacerbated by its political and economic clout within British North America that extended as far back as the American Revolution. In order to limit republican sentiment within the resentful French colony, the British government introduced the *Quebec Act* in 1774 to assure some measure of freedom of religion and the right of Catholics to serve in the courts. This Act, coupled with negotiations to cede land stretching as far as the Ohio River to the Jesuits, dismayed American colonists who already had many reasons to distrust the British. Not surprisingly, they rebelled soon after.[25] Following the revolution, Montreal became the largest city in British-controlled territory and, with its strategic location on the St. Lawrence River, a centre for trade in goods but also the first stop in North America for thousands of immigrants and labourers. More than 50,000 immigrants poured into Quebec every year during the 1830s and 1840s, although many of them just as quickly departed for New England or New York.[26] By 1850, the population of Montreal had swelled to nearly 50,000 – a 400 per cent growth since the turn the century.[27] With the opening of a new channel in the St. Lawrence in the 1830s, it was clear that Montreal would thrive as an economic powerhouse in North America, vying directly with the great Protestant cities to the south.

And then there were the nuns. It is not that they were absent from the United States. The history of American sisters during this period has been well documented and their efforts to build schools, hospitals and other welfare institutions have not gone unnoticed.[28] However, in Montreal, both the state and a very powerful clergy actively supported the sisters. In addition, they received considerable public admiration in the press; so much so that Kathleen Jenkins argues that, in the earliest decades, nuns were hailed as the exception to Romanist treachery, only interested in devotion and good works and not to be blamed for the evilness of their male counterparts.[29] Of course, it helped that there were strict controls on the number of congregations and their inhabitants until the 1830s. By then, certain that Quebec was a sacred oasis in the midst of a profanely liberal Protestant society, church leaders convinced the government to cede control of education to them and, in turn, passed the responsibility onto the sisters.[30] From 1837 to 1859, eleven communities were founded in Quebec and five more were imported from France, and the limits on numbers were lifted altogether.[31] The number of sisters in Quebec skyrocketed from slightly more than 200 in the 1830s to more

than 2,000 by the 1870s. At mid-century, one in every 300 women older than 20 was vowed to a religious community.[32]

The convents were second only to the churches in terms of architectural and social importance. Not only among the sturdiest buildings in Montreal, the convents were also examples of elegance in an otherwise cramped and squalid city. Their sheer size overwhelmed whole city blocks, and they became cornerstones for urban planning and development.[33] Few could praise Montreal as a beautiful city back then. It was still trying to shed its history as a garrison town and take its place as a major mercantile centre. The linguistic and cultural differences led to a proliferation of architectural styles, as did the frequent fires that wiped out whole neighbourhoods.[34] In the harsh climate, urban spread was not as expansive as in other cities across the border, nor was there much emphasis on green space until quite late in the century. In many ways, convents took the place of parks, opening up the streetscapes with their expansive architectural glory. They were landmarks signifying Montreal's unique Catholic vision of urbanity and attracting the attention of newcomers. Visitors would approach them as tourist destinations, desiring to catch a glimpse of this secret world and often purchasing a crocheted doily or other such handiwork from the convent gift shop.[35] Of course, they could not receive a full tour, since only the front rooms were open to the public. This combination of grandeur, secrecy, curiosity and uniqueness fuelled deeper interest in the convent and helped spur the imaginations of nativists, who viewed Montreal as a missionary colony waiting to be saved.

It is within this deeply ambivalent urban culture that the convent reached into the spatial and social imaginations of nativists. Since the days leading up to the American Revolution, republicans viewed Canada as a dangerous and untrustworthy place. Alexander Hamilton, a key figure in the American Revolution and noted politician in its first government, raised the spectre of a Canadian-run Inquisition against Protestant colonials in 1775, fanning the flames of rebellion.[36] In the 1830s, notable public figures such as Samuel Morse and Lyman Beecher revived such fears with their damning tracts foretelling a Catholic conspiracy to overtake America.[37] Not to be outdone, a nativist preacher named W. K. Hoyt established the Canadian Benevolent Association in New York to send members to Montreal in the hopes of preserving Protestantism against the growing tide of ultramontanist Catholicism, with its alluring, quixotic devotionalism. As a response to the rationalism and functionalism of urban development elsewhere, Montreal religious and civic leaders dedicated

their city to the Holy Mother, Mary. Religious practices in her honour that emphasized obedience and humility became commonplace by the middle of the century. These were a specifically Catholic response to Protestant domestic ideology, also praising women's unique abilities to sublimate their identities in the service of higher powers. In return, the city revelled in the splendour and spectacle of rituals, rites and elaborate ornamentation.[38] Those closest in likeness and demeanour to Mary – the women religious – were the most blessed inhabitants of the city, whose vows were supposed to ensure their compliance with an autocratic, controlling regime. Thus, by the 1830s, nuns had ceased to be iconic figures of feminine piety at its most benign, the way Jenkins describes them.[39] As the sensationalist stories about them suggest, they were viewed as the ultimate threat to new world prosperity and moral superiority, especially by hard-core nativists. The formal debating style of Morse and Beecher was too tame to enflame the religious passions of Americans.[40] Hoyt felt that they must be more aggressive in this battle and attack Catholicism at its most vulnerable and unique point, its nuns. To the nativists, the convent was more like a religious garrison in this new holy war than a sanctuary of devotion and piety. It was therefore imperative that the secrets of these institutions be revealed so that truth would inevitably triumph and Romanism would be completely stamped out in North America. With this noble cause in mind during one of his trips to the blighted city, the Reverend Hoyt met a young and not particularly innocent woman named Maria Monk.

The awful disclosures of Maria Monk

The saga of Maria Monk and her exploitation by Hoyt and others is well documented, a subject of intrigue for scholars and history buffs alike.[41] Arriving in New York after Maria became pregnant, the couple joined forces with George Bourne, the publisher of the penny paper *The Protestant* and the author of his own runaway tale, *Lorette: Story of a Quebec Nun*. After breaking the story of Maria Monk in his newspaper, he then published a full-length account with Howe & Bates, a dummy press set up by two employees of Harper Collins who were sympathetic to the project but unable to link the name of a reputable publisher to it. The book transformed Monk from the daughter of a low-ranking British garrison soldier, who spent much of her adolescence in a Catholic asylum for wayward girls, to the virtuous child of an officer who entered into the convent of her own free will after being seduced by the outward appearance

of serenity and holiness of the Black Nuns at the Hotel Dieu. On her first night after taking the veil, she was led into a secret room where the local priests gang-raped her until dawn. After that, she was subject to all kinds of degradations, including maintaining the lime pit where murdered illegitimate babies were tossed. Sometimes, she and other young nuns would be shuttled across town in underground passages to service the priests in the seminary. Along the way, there were many detours to hidden dungeons and torture chambers, where women who refused to have their virtue compromised were locked away, starved and beaten. Without the support of family, Monk was prepared to accept her fate until she herself became pregnant by one of the priests. Unable to bear the thought of her own child suffering as she had seen hundreds of others suffer, she fled to New York, where she was discovered on the street by Hoyt and members of his ministry. Despite fears for her own safety and that of her newborn daughter, Monk claimed that she revealed her story in order to save other daughters of good Protestant families, whose parents unsuspectingly sent them to convents for their education.

From the time that the first report was published on October 14, 1835, the scandal remained on the front pages of the nativist press for nearly two years, due mostly to the conspirators' ability to add new information in subsequent editions of the book, publish new horror stories under different titles altogether or simply increase sales through sensationalist exposés in the nativist newspapers. Their credibility ultimately hinged on Monk's impeccably detailed knowledge of the interior of the Hotel Dieu. Few could refute her claims, for the sole reason that no one else really knew what the convent looked like, except for its inhabitants, who refused to be dragged into the scandal. Emboldened by this knowledge, it was a hollow challenge for Monk to insist on being allowed into the convent to prove her claims. As she concluded her epic tale of degradation and terror:

> Permit me to go through the Hotel Dieu Nunnery, at Montreal, with some impartial ladies and gentlemen, that they may compare my account with the interior parts of that building, into which no persons but the Roman Bishop and the priests,* are ever admitted; and if they do not find my description true, then discard me as an imposter.

> *I should have added, and such persons as they introduce.[42]

Needless to say, Monk and Hoyt knew that this would never happen, although the sisters of Hotel Dieu eventually relented in 1836 and allowed an inspection from a more respectable newspaperman, Col. William Stone of the *Commercial Advertiser*. Since Stone published the largest paper in New York and was a hard-line Protestant, his opinion would be treated seriously by all doubters. In his widely publicized report, he not only referred to Monk as "an incorrigible blockhead" but also stated categorically that "I was utterly unable, throughout, to discern any mark, or sign, or trace of resemblance to anything she has laid down or described, other than the external localities, which nobody could well mistake."[43] But this was not the end of the Maria Monk scandal. Her supporters insisted that she was recounting from memory and therefore was bound to make a few mistakes and that the sisters had renovated the space after her departure to maintain their subterfuge. Still, Stone's report did go some lengths to dispelling the power of the *Awful Disclosures* over a gullible public. Although Monk tried to capitalize on her infamy by publishing the *Further Disclosures* in 1837, this time detailing the summer retreat on Nun's Island, she soon fell out of favour with the public and died in obscurity in 1849.

What made Monk's story so real and vivid, and what ultimately became her undoing, was the precise manner in which she described the interior of the Hotel Dieu. In court affidavits, she gave painstaking details of various secret rooms, trap doors and hidden staircases, where otherwise virtuous women were held against their will. Armed with these affidavits, her supporters would occasionally make the trip to Montreal and demand that the cloister gates be opened so the convent could be inspected. Until such time, it was her word against the priests, and who in their right mind would trust a Romanist before an innocent, victimized young mother? While Monk soon began to show her true colours in public, switching allegiances from Hoyt to her new lover, the Reverend Slocum of Philadelphia, audiences may have begun to doubt her virtue but were still not willing to completely discredit her story of the Hotel Dieu convent. Simply put, any convent was already a focal point for Protestant suspicion. *Awful Disclosures* had graphically publicized unholy terrors within the convent that went beyond the imagination, but they did not materialize out of thin air. Rather, they stemmed directly from the lurking ambivalence and confusion about the place of the convent in the city. Thus, the book established a key element in the genre, the exacting detail of the convent as a site of dread and loathing mixed with unholy

thoughts of rogue desire and seduction. What Franchot has called the "exoticized threat of confinement" became exemplified in the runaway nun stories, which emphasized an image of Catholic architecture comprising vast labyrinths that ensnared the most innocent feminine souls.[44]

Sarah J. Richardson's contribution to the runaway nun genre, *Life in the Grey Nunnery*, took its cue from this intricate layering of description and imbued her own outrageous claims with an equally strong sense of veracity. It became the source of proof that could never be proven and a public exposure of a space that would never be made public.

Sarah J. Richardson's house of horrors

Richardson's story did not receive nearly as much attention as Monk's, despite ratcheting up the violence and hysteria considerably higher. Monk had tended to dwell on her repeated sexual assaults and her pregnancy by Father Phelan. Richardson did not bother to track down the names of priests or sisters in the Grey Nun convent, but was more intent on exposing the inner sanctums of the cloister as sites of the utmost horror. Her story is a long and detailed account of various dungeons, cellars, pits and passages filled with a wide array of torture instruments. Offered to the convent while still a child by her drunken and ne'er-do-well Catholic father after her saintly Protestant mother had died, Richardson was indoctrinated into a kind of carnival of lost souls. Rooms with trick doors and screens set the stage for elaborate spectacles of demons coming to prey on tender girls who did not submit to priestly authority. Richardson's prison extended beyond the four walls of the convent, as detailed in her two failed escape attempts, during which clergy spies tracked her across the countryside. In both cases, she was eventually waylaid by the priests in their specially designed nun paddy wagon, with agents grabbing her off the side of the road and locking her into a trunk made expressly for transporting runaways back to their convents. Eventually, she made it to New England and took refuge in a Protestant home, but it was not until she married that the priests reluctantly gave up their pursuit and she was free to declare her faith and tell the tale of her sufferings.

Sexual perversion is downplayed in this story in favour of pure, unbridled sadism against any nun over the smallest offence. After spilling a drop of water on the floor outside a priest's room (in these accounts, the priests frequently moved into the convent so they could be attended to

by nun slaves), Richardson was sent down into an underground prison
that surpassed in horror any medieval nightmare.

> He immediately led me out of his room, it being on the second
> floor, and down into the back yard. Here, in the centre of the
> gravel walk, was a grate where they put down coal. This grate he
> raised and bade me go down. I obeyed, and descending a few steps
> found myself in a coal cellar, the floor being covered with it for
> some feet in depth. On this we walked some two rods, perhaps,
> when the priest stopped, and with a shovel that stood near cleared
> away the coal and lifted a trap door. Through this we descended
> four or five steps, and proceeded along a dark, narrow passage,
> so low we could not stand erect, and the atmosphere so cold and
> damp it produced the most uncomfortable sensations. By the
> light of a small lantern which the priest carried in his hand, I was
> enabled to observe on each side of the passage small doors, a few
> feet apart, as far as I could see. Some of them were open, others
> shut, and the key upon the outside. In each of these doors there
> was a small opening, with iron bars across it, though which the
> prisoner received food, if allowed to have any. One of these doors
> I was directed to enter, which I did with some difficulty, the place
> being so low, and I was trembling with cold and fear. The priest
> crawled in after me and tied me to the back part of the cell, leaving
> me there in midnight darkness, and locking the door after him. I
> could hear on all sides, as it seemed to me, the sobs, groans, and
> shrieks of other prisoners, some of whom prayed earnestly for
> death to release them from their sufferings.[45]

The painstaking attention to detail, even mentioning distance,
height and architectural flourishes, overlaid Richardson's account with a
veneer of accuracy and therefore truthfulness. The banal location of this
underground prison, in the back of the coal room, made such a site all
the more plausible. The average visitor may have noticed that grate along
the walk; indeed, such things were commonplace. Even if Richardson had
never seen the backyard of the convent (which is most likely), it is not a
far step to assume that a coal grate would be there somewhere. Integrating
these imaginary spaces with real and mundane things, such as gravel paths
and storage rooms, speaks to the extent to which the very space of the
convent in the city was central to these tales of suspicion.

Before the worst of her degradations began, Richardson laid out in an explanatory chapter the overall look and layout of the Grey Nunnery. She described the tin roof, the imposing front entrance and the high fence that surrounded the building, all visible to the public from the street. While acknowledging its beauty somewhat begrudgingly, she also took pains to point out its impenetrableness and foreboding silence. While the building was ostensibly an orphanage, Richardson claimed that only a small part of the house was set aside for such pious activities, while the rest was nothing less than a prison.[46] Of the publicly accessible exteriors and interiors, her description was faultless. However, of her claims for the secret tortures behind these facades, no one could say for sure without exploring the confines themselves. Thus, like Monk, she established unassailable proof, not because it was true but because it could not easily be proven to be false without forcing entry into the convent against the wishes of the Grey Nuns. While mother superiors and priests could be tracked down and questioned by authorities, usually to the discredit of their accusers, the convent could not speak for itself, per se. It was therefore the perfect villain in these bizarre tales of treachery and licentiousness. Its contradictory presence in the city was enough to breed suspicion, distrust and contempt, even as urban dwellers looked to the women inside to provide sustenance and solace.

There are many explicit descriptions of hidden spaces in Richardson's narrative, as there are in Monk's. In that sense, the two stories share a number of literary devices, in keeping with this genre of early media scandal. Both the heroines were young daughters of staunchly bourgeois Protestant pedigree who were lured into the convent. They forged alliances with other tortured nuns to try to help each other survive. They made futile escape attempts, were chased after by priests and then returned to the convent. Interestingly, their failed escapes were detailed fully while their successful break to freedom lacked such clarity. They were also both present when a young and beautiful nun was murdered for embracing Protestantism. Yet the most important shared element is a hyperactive, excessively detailed account of a vast, labyrinthine network hidden behind the public doors of the convent. Richardson even went so far as to claim that a grid of tunnels and underground passages extended five miles in every direction from the convent.[47] Monk described an underground prison, not too far from the trap door used by the priests to enter the convent undetected, where young women who had refused the veil were held until their spirits were completely broken along with their bodies.[48]

Through such devices, the convent itself took centre stage, since it was the most tangible and concrete element in the stories. It was also the greatest physical threat to the dream of a purely Protestant society, since its imposing presence served as a constant reminder that Catholicism was strong and growing in the new world. In that sense, by ruminating on both the visible and invisible, the runaway nun stories tapped into the inherent contradictions of the convent and gave the institution a life and personality of its own.

The character of the convent

Ultimately, the elaborate architectural descriptions were key to the gloss of veracity in the runaway nun stories because they tapped into a pre-existing ambivalence about the convent's place in the new social order. As a highly visible marker of an invisible world, the convent created contradiction and confusion about what counted as urbanity in modern society. In other words, the space between the convent and secular, progressive society could not be bridged and was therefore scandalous. Carol Bernstein argues that scandal is intricately linked to the sublime, since both occur in the space between opposing forces of the rational and the sensorial.[49] The feminized, devotional piety exemplified by Montreal's convents, juxtaposed against a city that was split between Catholics and Protestants and growing exponentially as a major trade centre, undermined the dominant narrative of progress through rationalism, functionalism and technology. Thus, while on some levels the convent was a widely admired site of distinctly feminine piety, it was also a seductive site of apparently taboo values. It was, as a result, a constant threat, ready to erupt into scandal over its challenge to urban order and constraint.[50]

The convent, therefore, became its own distinct character in these tales of fallen women and shattered piety. It was not merely a total institution but, more crucially, a discursive configuration with both a physical and psychical presence that can best be characterized as ambivalent. The generally accepted sociological approach to the convent, as exemplified by Goffman, simply does not go far enough in explaining the convent's discursive potential beyond its physical or even social presence. How did he derive such an argument and based on what evidence? For the most part, Goffman's research is not based on ethnographic observation of clearly identified convents but rather on other narratives. In addition to using religious rule books, he also relies heavily on a quasi-fictional

novel, *The Nun's Story*, which had its own scandalous reception in the media.[51] Thus, he depends upon fictional accounts shored up by official regulations without exploring how closely they are followed in practice. I am not completely dismissing Goffman's analysis, since it has been invaluable in sparking critical research about the convent, but do think it curious that even while he uses discursive and textual evidence exclusively, he fails to address how convents express themselves as part of larger communicational networks. In the case of the nineteenth-century representations in runaway nun tales, the convent stood at the crossroads of urbanity, modernity and new formulations of the sacred-profane divide that made it both and neither. It was certainly not total but was discursively incomplete, unresolved and incompatible with its wider environment.

This problem of desanctifying space so that its meaning is no longer total or eternal but forged in relation to its location vis-à-vis other sites has been approached by Michel Foucault, who conceived on the concept of heterotopia. As with the nineteenth-century convent in Montreal, a heterotopia is a real site that undermines or inverts relations of power as represented by the other real sites that exist in proximity to it.[52] In other words, a heterotopia destabilizes the boundaries of the imagination for what is possible in society. Since space is meant to contain culture, heterotopic spaces disrupt that logic and challenge dominant cultural authorities. As Bernstein suggests, certain spaces enact the sublime and therefore the scandalous by confusing the distinctions between sacred and profane, and nature and culture.[53] Foucault takes this idea one step further by redefining the categories of the spatial imagination to make room for these heterogeneous sites and understand their meaning according to their own counter-logic.

While Foucault first conceived of this concept of heterotopia when coming to grips with what he termed the desanctification of space in postmodernity, by historically situating it, he limited its theoretical potential to a specific point in time.[54] As Keith Hetherington argues, heterotopias are not only possible in earlier epochs, such as the nineteenth century, but are also crucial to understanding the ambivalences of any age.[55] To be sure, Foucault acknowledges the existence of heterotopia in all successive cultures, counter-sites that simultaneously represent, contest and invert the dominant logics of space, form and social control.[56] The potential of this concept to unravel the meaning and value of the convent is that it takes a very real site that has physical, historical and social aspects and re-orders it as imagination. That is not to say that the convent is an

imaginary space but it is instead a space of the imagination, a locus for seduction, horror and intrigue.[57] In that, the fascination with the convent in the nineteenth century, especially the mysteries of its architecture, begins to make a certain amount of sense. It explains why the nuns themselves are such shadowy figures in these narratives, which feature little in the way of character development. The only supporting character of any depth in either tale is Monk's friend Mad Jane Ray, who conspires to trick the nuns and priests and rescue Monk from punishment many times. However, when it comes to villainy, the real culprit is the convent, with its hidden secrets safely buried in its impregnable design.

What was supposed to be a holy space of devotion and industry turned out to be designed for acts of the utmost degradation, according to the runaway nun stories. Richardson even hinted that the Grey Nun asylum was akin to a brothel:

> Here let me remark, that since I left nunnery, I have heard of another class of people who find it convenient to have a slide in their door; and if I am not very much mistaken, the character of the two houses, or rather the people who live in them, are very much alike, whether they are nunneries of private families, Catholics or Protestants. Honest people have no need of a slide in the door, and where there is so much precaution, may we not suppose that something behind the curtain imperatively calls for it? It is an old adage, but true notwithstanding, that 'where there is concealment, there must be something wrong.'[58]

Brothels and convents take shape along the same continuum, perpetuating this sense of the convent as a heterotopia of illusion, a site that compromised the assuredness of everyday life by exposing the dominant social order as illusory.[59] The convent threatened the promise of a new Eden. Its existence was a constant reminder that the project of modernity was forever on the precipice and could topple over at any moment under the weight of its own contradictions. The lack of cohesion between the convent and the dominant social ordering of space disrupted the flow of discourse not only from one building to the next along the streetscape but also in the natural progression toward a perfect society built on rational principles. The convent disrupted the order of modernity as surely as it did the architectural coherence of the city as a secular paradise with its religiosity dutifully sublimated. It therefore took very little for even the most rational individual to accept the fabulous tales of Monk, Richardson

and the many others as at least plausible. The scandalous nature of the convent was not merely the result of mass media strategies to garner new and rapt audiences. The media tapped into a disturbing cultural dissonance based on competing ideologies of gender and religion in the construction of a new, thoroughly modern vision of civic society. This ambivalence has become part of the bedrock of media portrayals of nuns even as the convents empty and their edifices crumble. Communications studies looks at the convent and its meaning-making capacity as an institution of social communication operating within networks of knowledge and power. Lurking deep within contemporary media narratives of convent scandals, therefore, is the residue of these earlier, fabricated tales that tried to create a sense of space based on the anxieties of a deeply ambivalent and conflicted social imagination.

Conclusion

I recall when I first began researching this topic a few years ago talking with another scholar in the Rare Book Room at the Toronto Reference Library and suddenly finding myself in an argument over the possible truth behind Maria Monk's story. In his eyes, even if much of her story was fabricated, the underlying sinisterness of the convent was not. It was not the last time I faced this rather frustrating argument, as the convent's detractors pointed to contemporary scandals in the media to justify their position. And as I would walk the streets of Montreal, friends would point out the strangeness of the high walls and menacing architecture of the Grey Nuns' convent, which is right in the heart of downtown. What they would often fail to notice were the open doors and windows, and the play sets on the lawn for the children under their care. Thus, even today, the convent in the city breeds confusion and sometimes derision among residents as a misplaced space. In this way, past and present are locked in a deeply complicated discourse that hails the convent as a site of perpetual suspicion and contradiction across time as much as space. To that conundrum I offer this suggestion, which will likely satisfy neither detractors nor supporters. The convent is indeed sinister but not because of anything it has done or created that can be analyzed sociologically or historically. As a heterotopia, the convent disassembles the dominant set of relations imposed on our desacralized time and space and renders them suspect.[60] Its discursive power resides in that disassemblage and can only be countered by having its own internal order exposed as the

sublimated other of modernity. It makes a certain kind of sense, then, that the convent became a target for mass media scandal from the moment the two institutions converged onto the cultural landscape, and has remained there since.

Endnotes

1 L. Spigel, "The Domestic Economy of Television Viewing in Postwar America," *Critical Studies in Mass Communication* 6, no. 4 (1989): 340.

2 I. Leonard and R. Parmet, *American Nativism 1830–1860* (New York: Van Nostrand Reinhold Company, 1971), 4.

3 M. Danylewycz, *Taking the Veil: An Alternative to Marriage, Motherhood and Spinsterhood in Quebec, 1840–1920* (Toronto: McClelland and Stewart, 1987), 16.

4 A rather obvious example here is the insistence by scholars to use the formal "women religious" instead of the more colloquial term, "nun." Canonical regulations notwithstanding, it is worthwhile to acknowledge the particular meaning of the word nun in popular culture, perhaps even to recognize it as another legitimate category that reflects common reactions and responses to the religious life. It is for that reason that I use the term here whenever referring to the imagined or mass-mediated figure while relying on either women religious or sister for actual individuals engaged in social practices.

5 For more examples of runaway nun literature see R. Sullivan, "A Wayward from the Wilderness: Maria Monk's Awful Disclosures and the Feminization of Lower Canada in the Nineteenth Century," *Essays in Canadian Writing* 67, Fall (1997): 201–23; and N. Lusignan Schultz, *Fire & Roses: The Burning of the Charlestown Convent, 1834* (New York: Free Press, 2000).

6 Leonard and Parmet, 57.

7 J. D. Hart, *The Popular Book: A History of American Literary Taste* (Berkeley: University of California Press, 1963), 99.

8 C. Bernstein, *The Celebration of Scandal: Toward the Sublime in Victorian Urban Fiction* (University Park, PA: The Pennsylvania State University Press, 1991), 3.

9 J. Franchot, *Roads to Rome: The Antebellum Encounter with Catholicism* (Berkeley: University of California Press, 1994), 11.

10 Franchot, 14.

11 E. Goffman, *Asylums: Essays on the Social Situation of Mental Patients and Other Inmates* (Garden City: Anchor Books, 1961).

12 Franchot, 112.

13 K. Hetherington, *The Badlands of Modernity: Heterotopia and Social Ordering* (New York: Routledge, 1997), 49.

14 Franchot, 155.

15 S. M. Hoover and L. Schofield Clark, "At the Intersection of Media, Culture and Religion" in *Rethinking Media, Religion and Culture*, ed. S. M. Hoover and K. Lundby (London: Sage Publications, 1997), 17.

16 R. Williams, *Marxism and Literature* (Oxford: Oxford University Press, 1977), 122.

17 R. White, "Religion and Media in the Construction of Cultures" in *Rethinking Media, Religion and Culture*, ed. S. Hoover and K. Lundby (London: Sage Publications, 1997), 40.

18 Ibid., 47.

19 G. Murdock, "The Re-enchantment of the World: Religion and the Transformation of Modernity" in *Rethinking Media, Religion and Culture*, ed. S. Hoover and K. Lundby (London: Sage Publications, 1997), 88.

20 J. Habermas, *The Structural Transformation of the Public Sphere: An Inquiry into a Category of Bourgeois Society* (Cambridge, MA: MIT Press, 1994).

21 Billington, *The Protestant Crusade, 1800–1860* (Chicago: Quadrangle Books, 1964), 54.

22 Danylwycz, 29.

23 G. Barth, *City People: The Rise of Modern City Culture in Nineteenth Century America* (Oxford: Oxford University Press, 1980), 65.

24 J. Lull and S. Hinerman, *Media Scandals* (New York: Columbia University Press, 1997), 3.

25 H. Neatby, *The Quebec Act: Protest and Policy* (Scarborough, ON: Prentice-Hall of Canada, Ltd., 1972), 1.

26 K. Jenkins, *Montreal: Island City of the St. Lawrence* (Garden City: Doubleday and Company, Inc., 1966), 262.

27 A. Sutcliffe, "Montreal Metropolis" in *Montreal Metropolis 1880–1930*, ed. I. Gournay and F. Vanlaethen (Montreal: Canadian Centre for Architecture and Stoddart Publishing, 1998), 20.

28 M. Ewens, *The Role of the Nun in Nineteenth Century America* (New York: Arno Press, 1978). C. Coburn and M. Smith, *Spirited Lives: How Nuns Shaped Catholic Culture and American Life* (Durham: University of North Carolina Press, 2002).

29 Jenkins, 276.

30 Danylwycz, 22.

31 Danylwycz, 46.

32 Danylwycz, 7.

33 L. D'Iberville-Moreau, *Lost Montreal* (Toronto: Oxford University Press, 1975), 118.

34 I. Gournay and F. Vanlaethen, *Montreal Metropolis 1880–1930* (Montreal: Canadian Centre for Architecture and Stoddart Publishing, 1998), 12.

35 Jenkins, 276.

36 Leonard and Parmet, 17.

37 Leonard and Parmet, 54–57.

38 Danylwycz, 38.

39 Jenkins, 276.

40 While his published essays may have been less sensationalist than *Awful Disclosures*, the powerful oratory of Beecher turned out to be enough to incite a mob to burn down the Ursuline convent in Boston, following a particularly rousing speech he gave in 1834. See N. L. Schultz, *Fire and Roses: The Burning of the Charlestown Convent, 1834* (Boston: Northeastern University Press, 2002).

41 See Billington; N. L. Schultz, *Veil of Fear: Nineteenth Century Convent Tales* (Ashland, OH: Purdue University Press, 1999); R. Sullivan, "A Wayward in the Wilderness: Maria Monk's Awful Disclosures and the Feminization of Lower Canada in the Nineteenth Century" in *Essays in Canadian Writing* 62, Fall (1997).

42 M. Monk, *The Awful Disclosures of the Hotel Dieu Nunnery of Montreal* (New York: De Witt and Davenport, Publishers, 1835), 191.

43 W. Stone, *Maria Monk's Show-Up!! Or the "Awful Disclosures," a Humbug* (New York: Go Ahead Press, 1836), 18.

44 Franchot, 87.

45 S. J. Richardson, *Life in the Grey Nunnery at Montreal: An Authentic Narrative of the Horrors, Mysteries and Cruelties of Convent Life* (Boston: Damrell and Moore, Printers, 1858), 61.

46 Ibid., 64.

47 Ibid., 185.

48 Monk, 134.

49 Bernstein, 5.

50 Bernstein, 171.

51 K. Hulme, *The Nun's Story* (Boston: Little, Brown and Company, 1956). The book was loosely based on the real-life experiences of a former sister from Belgium but the author freely admitted to using artistic licence in recounting the story, touching off a series of heated arguments between women religious, the author and her supporters which were played out mostly in the Catholic press.

52 M. Foucault, "Of Other Spaces," *Diacritics* 16, no. 1 (1986): 24.

53 Bernstein, 10.

54 Foucault, 23.
55 Hetherington, 42.
56 Foucault, 24.
57 Hetherington, 40.
58 Richardson, 44.
59 Foucault, 27.
60 Foucault, 24.

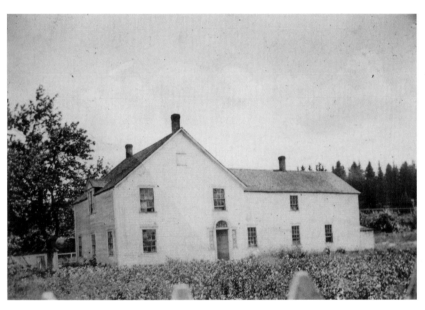

The first home of the Religieuses Hospitalières in Tracadie.
Photograph taken in 1887.

Archives of the Religieuses Hospitalières St-Joseph
from Public Archives of New Brunswick, P24 #1.

Mademoiselle Obéline Poirier, former pupil of the Congrégation de
Notre Dame at its school in Miscouche, PEI. As Madame Gallant,
she became the most successful business woman of her time
and regularly visited prize-givings at Shediac, New Brunswick, Convent.

Archives of the Societé Historique Nicolas Denys
from Public Archives of New Brunswick, P20 #23.

Yesterday . . .

as captain

leading the team

to victory

⟶

Today . . .

as Sister

going forth to

conquer

for Christ

⟶

Teamwork: on the court … and on the missions

Vocation brochure, *Generously daring, a challenge to sacrifice,*
Sisters of Charity of the Immaculate Conception.
Cited in footnotes #35, 97 and 109 of Chapter 2.

Left: Sister in habit: Sister M. Ian (Margaret MacLean), c. 1963.

Upper right: St. Vincent's High School basketball team, 1958. First row
(centre): Margaret MacLean, team captain (holding basketball); second row
(far right): Shirley Britt Dysart, teacher and team coach, graduate of
St. Vincent's, class of 1945, and later elected Liberal member of the
New Brunswick legislature; top row (second from left): Mary Ann Maxwell.

Lower right: Recently professed sisters going on mission assignments, c. 1963.
Top: Sister M. Ellen Maurice (Mary Ann Maxwell); middle: unidentified;
bottom: Sister M. Ian (Margaret MacLean).

Source: Archives of the Sisters of Charity of the
Immaculate Conception (*ASCIC*),
Saint John, c. 1963, 37-38.

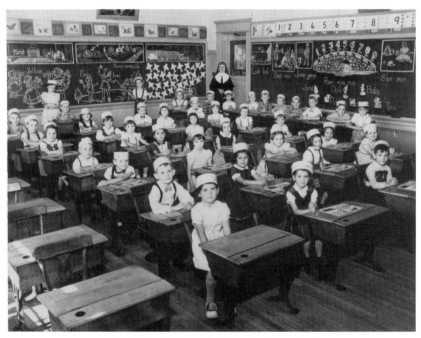

Holy Trinity School, Grade 1, Saint John, c. 1955. "Forty Little Faces"
with their teacher, Sister M. Norberta (Margaret McFadden).
Cited in footnote #65 of Chapter 2.

Source: *ASCIC*, Saint John.

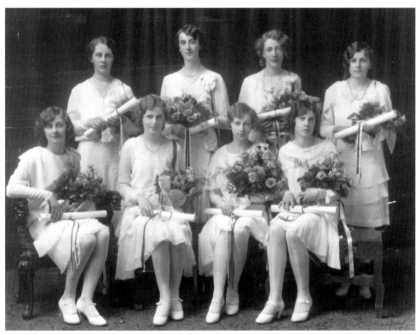

Graduating class of 1929, Mount Carmel Academy, Saint John.
Seated (left to right): M. Commins (Bath, N.B.), M. Macdonald (Fairville, N.B.), D. Harper (Saint John), A. McLaughlin (South Branch, Rexton). Standing (left to right): M. McInerney (Saint John), K. Nickerson (Moncton), M. Friel (Moncton), W. Mooney (Wirral, N.B.).

Courtesy: The late Sister Anne McLaughlin, scic.

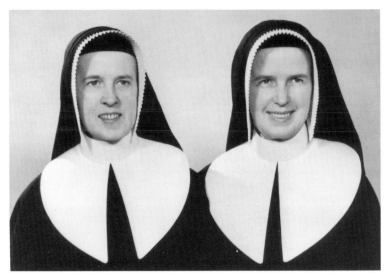

The McLaughlin twins from South Branch, Rexton, in Edmonton in the mid-1950s, when Sister Anne McLaughlin was teaching in Edmonton and Sister Agnes visited her from Vancouver, where she was stationed at St. Vincent's Hospital in the medical records department.
Left: Sister Anne McLaughlin (Sister M. Agnes Veronica, 1909–2003).
Right: Sister Agnes McLaughlin (Sister M. Eugenie, 1909–1974).

Courtesy: The late Sister Anne McLaughlin, scic.

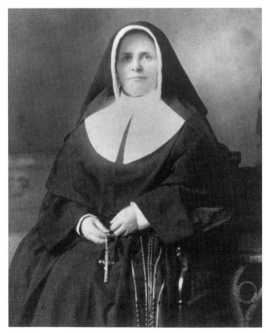

Sister M. Francesca (Mary McDonald), Saint John, c. 1920.

Courtesy: *ASCIC*, Saint John.

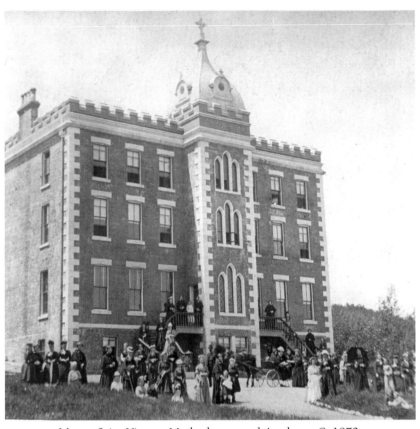

Mount Saint Vincent Motherhouse and Academy, C. 1873.

SC Halifax Archives #521.

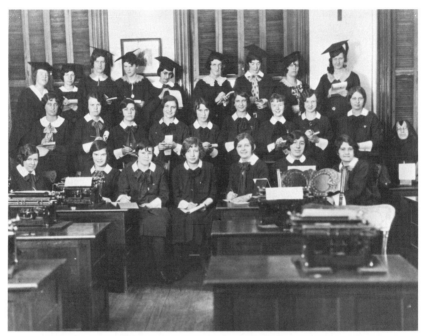

Commercial Class, Mount Saint Vincent College girls back row,
Mount Saint Vincent Academy girls first two rows, Spring, 1930.

SC Halifax Archives #6046.

Language Class, Elizabeth Seton Hight School, Wellesley Hills, MA.

SC Halifax Archives Uncatalogued Image 1.

Sister Catherine McGowen, Bani, Dominican Republic,
in Nutrition Centre, c. 1981.

SC Halifax Archives #2257.

Teacher assisting a student at Elizabeth Seton Academy,
Dorchester, MA c. 2004.

Sisters of Charity, Halifax, Communications Dept.

Lilies (Sisters of Charity, Halifax) 35-year Reunion, 1969.

Sisters of Charity, Halifax,
Congregational Archives.

Lilies (Sisters of Charity, Halifax) Diamond Jubilee, 1994.

Sisters of Charity, Halifax,
Congregational Archives.

The Grey Nun Mother House, Rue St. Pierre, Montréal.
This was the sisters' main dwelling until 1870.

Reprinted with permission from the Grey Nuns
Archives-Grey Nuns Regional
Centre in Edmonton (courtesy of
Sister Marie Rose Hurtubise, archivist).

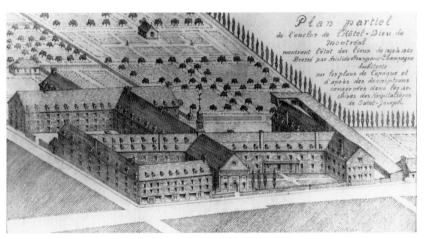

L'Hôtel-Dieu de Montréal, circa 1828–1860.

Reprinted with permission courtesy
of les Religieuses Hospitalières de Saint-Joseph
(courtesy of Sœur Nicole Bussières, archivist).

Fig. 1

Photograph circa 1925 of the Sainte-Croix corridor decorated in Thanksgiving, Mother House of the Grey Nuns, Montreal. Colourful ribbons hang from the gasoliers; flags, flowers and greenery line the hallway. Above the doors leading into the chapel hangs a painting of the Sacred Heart.

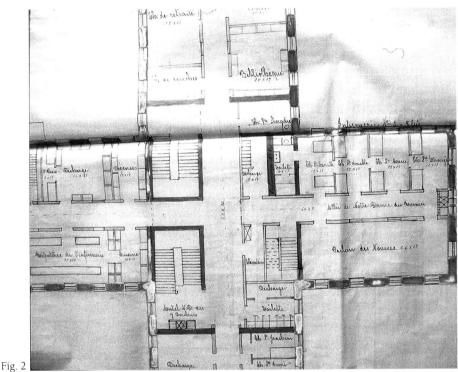

Fig. 2

Plan of the second-storey parlour wing in the mother house of the Grey Nuns.
Note the altars in the stair landing to Our Lady of Sorrows (bottom left)
and at the end of the corridor to Our Lady of the Holy Rosary (middle right),
each represented by double Xs inside of a rectangle.

Source: Archives des Sœurs de la Charité de
Montréal, "Sœurs Grises" (*ASGM*), MM 1190 rue
Guy Plans, 1900 Doc. 76C. Drawings produced
by Sister Saint-John-of-the-Cross.

Fig. 3

Photograph of the altar to Our Lady of Sorrows that was outfitted in the stair landing depicted in the previous illustration Notice the religious mottoes hanging on either side of the retable. The area in front of the altar, delimited by a railing and decorated with potted plants and vases of cut flowers, recalls contemporary chapel sanctuary decor.

Source: *ASGM, Album souvenir:*
Hôpital Général des Sœurs de la Charité
(Sœurs Grises), Montréal, 1930
(Montréal: Imprimerie de la Maison Mère,
1930), 37.

Fig. 4

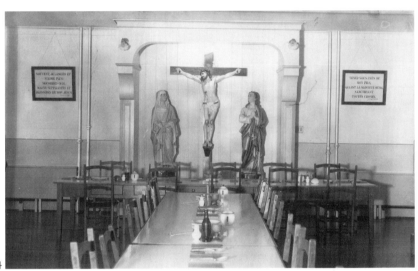

Photograph of the refectory of the religious community, Mother House
of the Grey Nuns, ca. 1920. Two religious mottoes hanging in their frames
and the statues of Mary and Saint-John the apostle bracket the crucified
Christ set within an architectural niche.

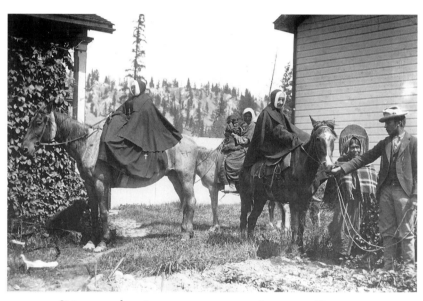

Sisters on a begging tour at a construction camp, Kootenay, British Columbia, 1896. The sisters were begging to raise funds for Mission St. Eugene.

Courtesy of Providence Archives, Seattle.

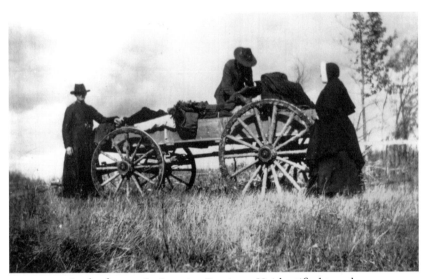

In the former St. Ignatius Province. Unidentified travel.

Courtesy of Providence Archives, Seattle.

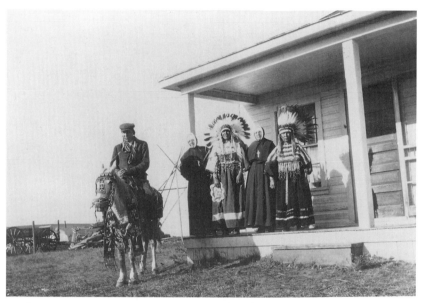

Sisters visiting St. Ignatius Mission on the Flathead Reservation (Jacko),
Montana, 1910s [?]. Standing L-R: Sr. John of God; Chief Charlot
(also spelled Chorlo or Charlo); Sr. Jane de Chantal, [?].
Rider unidentified.

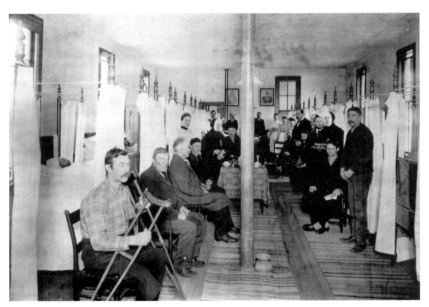

Men's ward, Providence St. Vincent Medical Center, Portland, 1890s.
Note what appears to be a spittoon on the floor.

Courtesy of Providence Archives, Seattle.

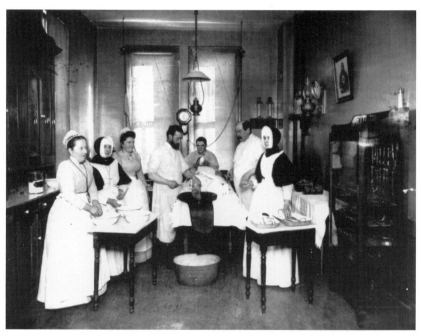

Anesthetizing the patient prior to an amputation,
Providence St. Vincent Medical Centre, Portland, c. 1892. L-R:
Rosa Philpott; [?]; [?]; Dr. Andrew C. Smith; Dr. John Kane (intern);
Dr. William Boyd; Sr. Andrew.

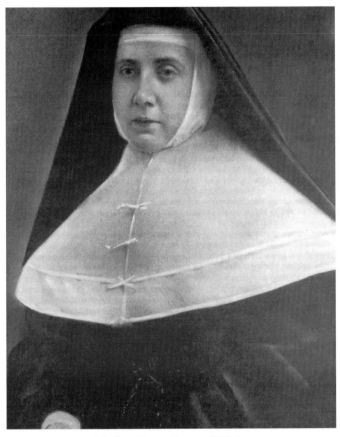

Mother Teresa Dease, IBVM.
Loretto Hamilton Academy Centennial Yearbook, 1965.

Reprinted with permission from Loretto Abbey
Archives, Toronto.

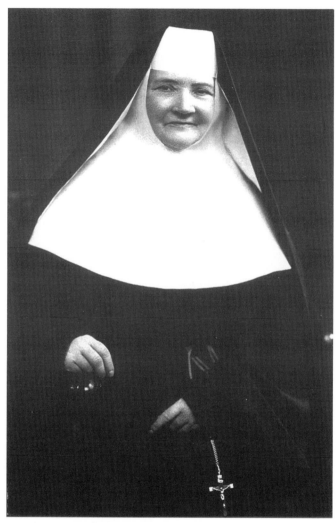

Mother Genevieve Williams, OSU

Courtesy Archives of the Ursulines, "The Pines."

Mother Mary Lenore Carter, SP

Reprinted with permission of the Sisters
of Providence of St. Vincent de Paul.

Sister Ellen Leonard, CSJ, in class, 1958.

Courtesy of the Archives of the
Sisters of St. Joseph.

Archbishop of St. Boniface, Adélard L. P. Langevin, OMI,
founder of the Missionary Oblate Sisters of the Sacred Heart
and Mary Immaculate.

Archives of the Missionary Oblate Sisters,
St. Boniface, Manitoba.

Mère Marie-Saint-Viateur

née Ida Lafricain,
de Montréal, P.Q.,
première supérieure générale,

Mère Marie-Joseph-du-Sacré-Cœur

née Alma Laurendeau,
de Saint-Boniface, Man.,
deuxième supérieure générale,

pieusement endormies dans le Seigneur

le 8 février 1957
dans la 87e année de son âge
et la 53e de sa vie religieuse

le 25 février 1958
dans la 79e année de son âge
et la 54e de sa vie religieuse

Mother Marie-Saint-Viateur (Ida Lafricain), first superior general
of the Missionary Oblate Sisters in St. Boniface, and Mother Marie-Joseph
du Sacré Cœur (Alma Laurendeau), second superior general
of the Missionary Oblate Sisters in St. Boniface.

Archives of the Missionary Oblate Sisters,
St. Boniface, Manitoba.

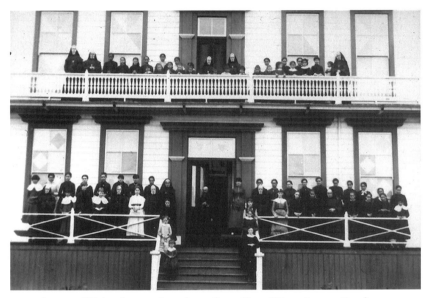

Sisters of Saint Ann and students from New Westminster, Kamloops
and Mission schools with Bishop Paul Durieu at St. Mary's Mission 1887.
This image comes from a lantern slide used by Sister Mary Theodore ssa
in her talks on pioneer Sisters.

Archives of the Sisters of Saint Ann, Victoria, B.C.

Program cover from
celebration of the
"Golden Jubilee 1858 – 1908
St. Ann's Academy, Victoria, B.C."

Archives of the Sisters of Saint Ann, Victoria, B.C.

6

Sites of Prayer and Pilgrimage Within a Convent: The Architectural Manifestations of a Religious Vocation

Tania Martin

After having gathered in the first-storey main stair hall one June morning in 1878, all 435 inhabitants of the mother house of the Sisters of Charity of the General Hospital of Montreal, commonly known as the Grey Nuns, in Montreal, and some invited guests began to climb the stairs.[1] The orphan girls, the Enfants de Marie devotional group, the postulants, novices, professed sisters (in ascending order from youngest to oldest in religion), the choir and the clergy, followed by the orphan boys, elderly residents and a number of lay people, processed to the entrance of the cloister. They saluted the statue of the "glorious Saint Ann" as they crossed the stair landing and, once upstairs, the statue of the Blessed Virgin Mary keeping guard outside of the professed sisters' dormitory, before entering the second-storey passageway. The pilgrims then inched along the novitiates' corridor, passing under "four elegant arches" whose printed words composed "a rich pious maxim." The corridor led the celebrants to the end of the novitiate where they stopped to contemplate a "magnificent altar." An array of burning candles, a "throne of fire," illuminated a "beautiful, large picture of the Immaculate Conception."

Having paused, the procession next marched through the sewing room, whose white draperies, suspended in each of the windows especially for this occasion, "offered a new spectacle of profound piety." Down "the stairs of the ironing and candle-making room" descended the congregation, to enter a passage of greenery. Fir branches had been hung from the ceiling to form a vault over the processional route and aromatic wreaths scented the air wafting through the open doors and casements of the workshops. Those in the orderly file admired "not only the exquisite tidiness of the workrooms, but even more the artists' ardent decorations," as "daylight penetrated through the pink and green tissue paper [they had] applied over the windows." More arches carried words of veneration and "roses, lilies, hyacinth, and other flowers of diverse colours." New wreaths, "large handsome fir trees," and "magnificent flags with their Hosanna continued the finery right to the entrance of Sainte Croix corridor" whose gasoliers were entwined with ivy. It was the last devotional stop the assemblage would make before entering the chapel. Although it was the terminus of the 1878 Corpus Christi procession, and as elaborately decorated as all of the makeshift shrines along the way, the chapel constituted but one of many sites of prayer and pilgrimage in the mother house.

What do we know about the other sites of religious devotion, the oratories, sculptural niches, crypts, grottoes and gardens located throughout the convent interiors and exteriors of French-Canadian religious communities in the years before the Second Vatican Council? Architectural guidebooks on religious heritage focus exclusively on the chapel, with little consideration of the larger building complex of which it was a part.[2] This implicitly sends the erroneous message that religious life was centred uniquely on the chapel. I draw upon my research on the architecture of Roman Catholic convents and religious-run institutions to argue that through careful interpretation of the content, placement and use of statuary, paintings (both fine art and amateur), interior finishes and furnishings, and other religious artifacts, such as mottoes and outdoor shrines, historians can more richly appreciate the multitudinous ways women religious manipulated their physical settings in ways that supported their vocation. My examples come primarily from buildings of the Grey Nuns located in Canada and the United States. In this essay, I analyze architectural plans, historic photographs, religious community annals, constitutions and customaries (a book of ways and customs containing the rules governing daily life within the convent developed through experience

and tradition), building inventories, the results of site visits and memoirs to explore those other, less obvious spots of worship.[3]

Processions

Processions took place within many institutions, including mother houses, schools, hospices and orphanages. The path of the procession, the spaces requisitioned for the celebration, and their ornamentation were altered from year to year, depending on the season and the weather. The month of May brought a procession in honour of Mary outdoors, through the convent gardens to adore the various statues of the Virgin (of the Miraculous Medal, for example) stationed there, before coming back indoors through the postulants' hall to worship Our Lady of Grace and finally ending in the chapel to venerate Our Lady of the Great Power, recalled Gabrielle L. K. Verge, a student-boarder at the Ursuline monastery in Quebec City.[4]

Those in charge of feast-day preparations took great care to plan visual and sensory variation. Each time the procession crossed a threshold – between the pure all-white upstairs workroom and the colourfully lush downstairs corridor of the mother house of the Grey Nuns, for instance – the level of lighting, and the amount, type and colour of decoration changed. With bunting and branches, magnificent altars and triumphal arches, flowers and lights, sisters temporarily converted stair landings, hallways, assembly rooms, workshops, exterior balconies and garden corners, the ordinary living and work spaces of the convent, into places of contemplation and thanksgiving (see Fig. 1, page 16 of the photo section). On these occasions, the whole building became a processional site.

Standard mid- and late nineteenth-century forms of piety, processions (religious parades) and pilgrimages (journeys to shrines) were occasions when sisters could introduce orphans and pupils to the rudiments of church teachings and involve the infirm and elderly in religious observances. "It was touching to see the elderly indigent men clasping their rosary, wiping away a tear or joining their voice to the choir singing Ave, Ave Maria ..." recorded an annalist of the Grey Nuns. "There, groups of children transformed into little angels ... graciously lined up along the route ... everywhere statues decorated and illuminated, which we joyously saluted ... do they not seem to reply to our piety?"[5]

Laity often viewed devotions to the Blessed Virgin Mary, Saint Joseph and Saint Ann made manifest through processions and pilgrimages of assembled religious and their wards (patients, pensioners and pupils), especially when they took place outdoors. In August 1886, the public "pressed themselves against the gate to see the procession" and thus benefited from the presence of the Eucharist as it travelled through the gardens and alongside the walls of the mother house of the Grey Nuns.[6] The involvement of outsiders, even as onlookers, in the religious community's "private" procession turned a religious act into a public, social event. Some years, procession organizers invited religious communities to erect an altar and host pilgrims during a parish- or diocese-wide observance of a holy day; thus, sisters actively participated in the activities of the wider Catholic community.[7]

Doing, singing, seeing and touching were fundamental to the practice of Catholicism. Hence, when Sister Saint-Jean-de-la-Croix affixed strips of paper on which litanies to Mary had been printed to the walls of the mother house of the Grey Nuns for an October 1904 indoor pilgrimage, they were not only for decoration but also in order to facilitate participation. The pious retinue would have read such invocations as "Hail Mary, lily dazzling white" as they proceeded along the Holy Cross and Saint Joseph corridors.[8] Participating in religious festivities made prayer fun and catechism easy.

Sites of prayer within religious institutions

The several shrines strategically placed along the path of a procession that took place in the Ursuline monastery in Quebec City – such as the one to Saint Joseph of the Harvest located on a stair landing, Saint Joseph of the Good Death located outside of the nuns' infirmary, Saint Joseph of the Money located outside the treasurer's office, or Saint Joseph Carrying the Infant Jesus (the Ursulines' patron) located above the chapel's main altar[9] – were not always specially erected for a feast day. Rather, the oratory in a stair landing, the sculptural niche inset into the wall or the statue standing on a pedestal in the middle of a hallway often comprised an intrinsic part of the interior ornamentation and spatial organization of the convent. For example, one of the stair landings in the mother house of the Grey Nuns housed an altar to Our Lady of Sorrows and the end of a second-storey parlour wing harboured an altar to Our Lady of the Holy Rosary (see Figs. 2 and 3, pages 17 and 18 in the photo section). It was at altars similar to these that processions stopped for devotion and prayer.

More architecturally distinctive and permanent looking in appearance than makeshift altars, which were made up of decorated statuary and paintings and therefore easily erected and dismantled, they nonetheless shared the religious vocabulary of these and chapel altars. In the monastery of Augustines of the Hôtel-Dieu in Quebec City, the oratories of Saint Ann, Saint Joseph and Saint Michael were built into passageway walls.[10]

Sites of prayer, then, were as essential to daily life in the convent as they were on procession days. Religious decorations and furniture that created devotional spaces out of hallways or corners worked simultaneously on several levels: as didactic teachings, inspirational decor, mnemonic devices, expressive tools and facilitators of religious practice. Being surrounded by such objects as the plaques representing each of the stations on the way of the cross, which had been installed in the common rooms of elderly women and men, the sisters' infirmary, and the infirmary chapel at the mother house of the Grey Nuns, affirmed the faith of women religious, adult patients and boarders.[11] Nineteenth- and 20th-century Catholics developed a rich material culture through which to pass on ritual behaviour, the tenets of the faith and the habits of religious community. When teaching the catechism or initiating children in the proper forms of devotion, for instance, a saintly statue or religious painting helped centre attention on the lesson.

Women religious designed and decorated gardens, grottoes and corridors in keeping with contemporary Catholic practices. By constructing a grotto to Our Lady of Lourdres in the yard of Saint Paul's Hospital in Saskatoon, the Grey Nuns participated in the popular, church-wide devotion to Mary.[12] What the nuns were doing in their convents was not dissimilar to what Catholic parishioners were doing at home and at church.[13] Just as a family might place a statue of the Blessed Virgin Mary, often in an upright bathtub, on its front lawn, or parishioners one of the Sacred Heart in front of their church, the Grey Nuns erected statues of Saint Joseph and Mary on either side of the entry porch of Saint Joseph's hospice in Saint Benoit, Quebec, one of their several missions having the same name.[14] Formal landscaping lent solemnity to the statues of Saint Joseph and Mary standing in the centre of short evergreen shrubs encircled by a pathway bordered with white rocks and ringed with rosebushes and tall spruce topiary in the gardens of Holy Ghost Hospital in Cambridge, Massachusetts.[15]

Involving objects of religious iconography in practices made those practices memorable. The faithful associated Christian lessons and stories

with the physical artifacts that depicted the story's essential elements, symbols or characters, especially when these associations were repeated consistently. Statues and images harkened back to historic and mythic pasts. The way of the cross, standard furniture for a chapel, infirmary or novices' quarters, not only portrayed the last days of Jesus' life but also invited a mental re-enactment of his final moments, a revisiting of the very roots of Christianity. The statues of Saint Joseph or Our Lady of Sorrows that were decorated with flowers and boughs and that were made into objects of special attention to which particular hymns would be chanted and prayers recited on special occasions more than simply "watched" the goings on in the convent on ordinary days. These saints acted as God's eyes in the Catholic imagination, the protectors of the religious community. Performing a ritual or decorating a room, therefore, was very much a concrete world-making activity that not only structured the temporal, material dimensions of the environment of the women religious but that also bridged the natural and supernatural worlds.[16]

Using statues and religious paintings, the sisters anthropomorphized the saints, imaginatively turning them into real people with whom they might broker a contract. The Grey Nuns, for instance, promised Saint Joseph to "feed three families in his honour as well as give food to any poor person who knocked on their door on the condition that this great saint furnished the religious community with the funds required to build the chapel."[17] The "Acte," signed the first Wednesday of February 1873 and solemnly placed at the feet of Saint Joseph,[18] exemplifies Joseph P. Chinnici's notion of an "economy of salvation," in which Catholics "set up a series of required obligations between those on earth and those in heaven."[19] Religious communities tried as much as possible to inaugurate new missions on the feast day of the saint to whom the work or building was entrusted in order to guarantee its success. When the Grey Nuns officially opened a new domestic science school, which they dedicated to Saint Joseph, they held the inauguration on a Wednesday in March, the month in the Catholic calendar reserved for this venerable saint.[20]

Building names and room designations as prayer

The names that sisters gave to their sites, buildings, and building wings, hallways and rooms did more than assert Catholic identity or place a task or locaton under the protection of a spiritual benefactor. The name "Our Lady of Liesse Orphanage," for example, refers to the area in which

the orphanage was situated, Côte de Liesse, and followed the popular late nineteenth-century practice of naming churches, schools and seminaries with Mary's various titles.[21] "Sainte Croix Corridor," the administration wing of the mother house of the Grey Nuns, recalled the name of the site, Mont Sainte Croix, which itself commemorated a historic event – a hanging that had taken place on the corner of Guy and Dorchester streets before the Grey Nuns had acquired the property and that was memorialized by the red cross erected there.[22]

Rather than label a room alphanumerically, women religious called a male employee's room Saint George, a professed nuns' dormitory Saint Ann, or a little girls' apartment Sainte Martine, which necessarily invoked the names of the saints in conversation.[23] So while the designation of a room performed the job of orienting a person to the right locale, vocalizing sacred words amounted to subtle devotion. Parts of speech referred to specific places; referent (name of room) and milieu (the room itself) together constructed a Catholic world view and its corresponding built environment. Because they contained multiple referents, such appellations linked the spiritual, historical and material domains.

Naming places, as with the display of religious statuary and pious paintings, was an important part of creating a religious environment. A given name affected the way sisters perceived and regarded a place. It identified a room, building or site, calling attention to that space, expressing a connection between that space, the religious community, the wider public and even the supernatural world, and making obvious the associations between the name of a room and the work performed therein. Religious communities gave to places names that supported their avocations, which was not unlike individuals choosing names of favourite saints as their religious names; this forced the religious to recall the virtues of their saint or saints and to aspire to them each time they were addressed.

Religious artifacts as prayerful instruction

Women religious further animated or enlivened the walls and corridors of the convent by hanging religious images in various apartments, by displaying statuary in a vestibule, by painting pious sentences over an entrance and by placing holy water fonts outside of offices (see Figs. 3 and 4, pages 18 and 19 in the photo section).[24] Crucifixes were present in every room, and stoups at every door.[25] Each of these objects held

explicit religious associations; their influence could be felt. The stoup that contained holy water, for instance, extended to the passerby an invitation to make the sign of the cross. In so doing, a sister performed a form of prayer and purification when crossing the threshold from one space into another.

In many ways, religious statuary and pious pictures functioned as mnemonic devices, helping a sister remember her catechism. An image and the symbolism it contained could evoke a passage of scripture that dispensed a lesson worthy of contemplation or a story to mull over. An artifact could also help the sisters recall more mundane events, such as the day a benefactor offered the community the painting or statue in question, and by extension keep him or her in their prayers. A painting dating from the foundress's tenure and saved from a fire carried its own history – of the heroics of its preservation, of the hardships endured by the community's foremothers – that perhaps enabled a sister to put her current experiences into perspective.

Similarly, pious images functioned as props that supported a particular frame of mind, a condition of the heart. By displaying objects that depicted love and compassion, for example, sisters cultivated these emotional states in and for themselves. The feelings such depictions generated could lead sisters to insights about the nature of God and about the spirit in which they were expected to carry out their work among the poor.[26] In this manner, pious images reflected goodness and helped the sisters' personal and collective journeys of striving towards perfection, in addition to being objects that elicited adoration of the person represented therein.

Painting pious maxims on convent walls and displaying religious images was not dissimilar to the practices of laypeople who hung religious mottoes and pictures in their homes.[27] Both practices accomplished the same goals. As devotional devices that conveyed a religious message and as decoration appropriate to the function of the space, religious iconography provided a source of comfort, emphasized the overt reading of the space as Christian and, depending on the context, reminded a woman of her religious or maternal vocation. Whether lay parishioners learned to decorate their walls with religious words and images from their days at convent school or in a Catholic hospital, outfitting a home or institutional building in this manner provided a scaffold on which men and women built pietistic practices.

Sisters chose images appropriate to their vocation and in keeping with the decorative strictures of convents in order to beautify their spaces.

Although the palette was limited, religious decor allowed the religious community to pretty up a room or corridor without breaking the rules. In creating beautiful objects and admiring the beauty around them, sisters found another way to worship God.

By developing patterns of use or habitual associations with the artifacts with which they surrounded themselves, women religious gave meaning to their environment. A sister going about the temporal business of administration, house cleaning or tending to the infirm could look up from her work to gaze at a statue of Mary benevolently looking down on her and feel comforted, reassured. A sister could spontaneously address a small prayer to a picture of a saint in the course of doing some activity or, when in distress, make a humble petition for much needed aid. Clergymen liked to remind members of religious communities of the dangers of losing themselves in their work in ways detrimental to religious life. "Ever present is the danger that daily tasks would slowly gnaw away into religious obligations, causing one to forget to carry them out," admonished two Fathers of the Holy Spirit in their treatise on poverty.[28] Visual reminders of one's religious vocation diminished that danger by encouraging sisters to wed service and spiritual devotion into a single act.

It was not for nothing that the name "d'Youville" was stencilled in an arc above a painting of the founding mother of the Grey Nuns hanging overhead a window at the end of the workshop corridor. Her name and person represented a model existence. She was someone to whom the women toiling there could aspire and emulate.[29] Implied was the exhortation to her disciples that the products of their labour would be given to a greater good. In similar fashion, the pious sentence, "Possessing all the goods in the world cannot approach the joy of living together united,"[30] which was painted on the entrance walls at the opposite end of the workshop corridor, gently chastened a sister against wanting things (such a desire would go against her vow of poverty), while simultaneously acknowledging the difficulties of communal living. The reminder about the benefits of community life must have helped those experiencing a moment of discouragement and who, in despair, might have wished for a more comfortable, domestic middle-class existence. The motto served to recall why the struggle to live collectively as women religious was indeed worth the sacrifices.

Built environments as prayerful environments

The built environment of the convent acted as a constant support to living a life of poverty, as set out in one of three vows women religious took. Theologians encouraged the cultivation of poverty as a fundamental virtue of community life. A sister was to derive a sense of fulfillment from spiritual pursuits rather than the acquisition of material goods.[31] By providing spaces conducive to pious practices, religious superiors helped sisters develop a rich interior life. It mattered little whether these spaces were formally designed (e.g. chapels) or whether they were simply leftover spaces that had been transformed, sometimes only temporarily. Both accomplished the same goals. A kneeler strategically positioned under a statue of the Virgin Mary at the end of a hallway turned that otherwise ordinary space into an oratory. When not the focus of a feast day celebration, such hallway oratories and garden grottoes potentially offered secluded areas for prayer, recollection and meditation. When walking by this kind of space, a sister might have been tempted to steal a moment of personal reflection. Who could refuse the smile of the "stone virgin" of Our Lady of Lourdes standing on her pedestal in the grotto a few feet away from Saint Joseph Hospice in Beauharnois, Quebec? Undoubtedly a sister or patient could lose herself "in this seductive place," where the "regular splashing" of "a water fall in the nearby Saint Louis river" would have blocked out extraneous noise from such a "pious and agreeable scenery."[32] Alternatively, if feeling discontented with a particular saint, a sister might avert her eyes when passing a depiction of that saint. (She could hardly turn the statue or the picture to face the wall.) Although a sister might not regularly visit a sculptural niche at the end of a corridor or a grotto tucked into a garden corner, knowing it was there would have held out the promise of psychological escape, enabling her to visualize an individual moment of respite, time away from the collectivity. These quiet spots were spaces apart, in contrast to the chapel, which gathered the whole congregation together.

Even if a sister did not stop to kneel or sit, the visual reminder that such a possibility existed might have incited momentary contemplation of her relationship with God, with various members of her order, or with her patients or pupils, just as a painting of the Sacred Heart hanging in the hallway or a maxim stencilled on the wall would have reminded her of her vocation. The authors of a treatise on poverty insisted that "the Rule assists a religious by frequently offering her occasions for meditation on

the life of poor Jesus, in Bethlehem, in Nazareth, on the Cross, the life of the Blessed Virgin Mary, and the examples of the saints who cultivated a preference for poverty."[33] The spatial environment of the convent, its various rooms, yards and gardens, was designed to reinforce the Christian attitude a sister carried with her, making each space within it a site of prayer. Not only did religious iconography and maxims evoke pious emotions in the beholder but they also helped sisters maintain and create relationships with Christ and the saints, with the outside world through their prayers, service and charitable activities, and with each other.[34]

Images as reflections of religious sensibilities and group identities

The choice women religious made of religious image or pious sentence was one way they expressed their religious sensibilities. Religious communities, not surprisingly, adopted and upheld the dominant views of the Roman Church through their display and use of Catholic material culture. Since the last quarter of the nineteenth century, representations of the Sacred Heart of Jesus and the Blessed Virgin Mary were readily found on practically all of the side altars of chapels regardless of which religious community an institution belonged or in which parish it was situated.[35] These representations were part of a universal register of meaning shared by the whole Church, irrespective of local particularity, so widely popularized were the devotions. Recourse to ecclesiastical authority and institutionalized traditions legitimated the practices and architecture of the nuns. Yet, they had enough latitude to make choices that fit the charism of the order, the ethnicity of the neighbourhood and historical circumstances.

Religious communities selected patron saints and religious motifs from the panoply of Catholic iconography to reflect national, parish, ethnic, group and personal preferences. In their houses, the Sisters of Providence were likely to have statues of Saint Vincent de Paul, author of the Vincentian rule they followed, whereas the Grey Nuns were likely to have paintings of the Eternal Father, because their founder, Mother d'Youville, had cultivated a particular devotion to Him.[36] Every institution would have displayed at least one image or statue of its patron saint, as at Saint Ann's orphanage in Worcester, Massachusetts. Moreover, the name of an institution typically borrowed the name of the parish in which it

was located.[37] Saint Patrick and Portuguese-born Saint Anthony of Padua usually denoted Irish- and Italian-Canadian institutions, respectively. Seeing the statue of Saint Joseph holding the child Jesus in the lobby of a social service department of an orphanage cum adoption bureau additionally alerted the visitor to the kind of work being done by the nuns there; in this case it was primarily with children.[38] The choice of pictorial references differentiated one religious community from another. Just as the colour of the robe, the shape of the headdress and the cut of the sleeve distinguished a Sister of the Holy Names from a Sister of Saint Ann, so too did the choice of saints and images give particularity to a convent.

Expressions of poverty in the built environment

If "the Church sees religious life as exemplary, the model that all its other children should strive to follow," as two clerics maintained in their treatise on how to live a life of poverty,[39] then women religious and their confessors and religious advisors necessarily had to be preoccupied down to the last detail with the management of the impressions that their buildings projected to others. The rules that governed the furnishing and decor of the convent very much controlled what Erving Goffman called "the presentation of the self in everyday life."[40] The architecture of the convent, then, might be thought of as a stage set whereupon the nuns enacted the roles they had voluntarily assumed. To please the archbishop, the Grey Nuns affixed the temperance cross "in all of the principle places of the house: community, infirmary, corridors Sainte Croix, Saint Joseph, among others." The cross was supposed to remind the sisters of their "narrow obligation as religious especially to hasten the success of crusade undertaken for the reform of society and of the salvation of souls by our prayers and our sacrifices."[41] The setting, therefore, was a crucial means by which a religious community modelled virtue.

Despite the "scripts" handed down to them by the Church, such as the wish of the archbishop to hang temperance crosses throughout Catholic institutions, sisters manipulated their environment to their advantage. Sisters used material culture to express themselves by displaying objects that represented or projected internal states of being. They engineered their environments in such a way that their world talked back to them in a language that they could understand and that told them things that were important to them.

Religious communities communicated their spiritual intentions, their vow of poverty, not only through the pictures and statues they chose to display and the small areas they set aside for private prayer but also through the lack of ornamentation. Austerity suffused the material environment of the convent, especially in the cloister, the space of the convent restricted to members of the religious community. The fact that an Ursuline mother superior had little else in her cell but a narrow bed, a kneeler, a chest of drawers-cum-desk impressed the student-boarders at a Quebec monastery. They fully appreciated the lone crucifix that adorned the whitewashed walls as a representation of the Ursulines' asceticism.[42]

Attention to detail was incredibly important for the construction and maintenance of internalized role preferences, or habitus, so much so that the comportment of the members of a religious community and the disposition and furnishing of spaces were precisely prescribed.[43] Both the Grey Nuns' customaries (traditions, constitutions and rules) and a mid 20th–century essay on the theory and practice of poverty in religious communities recommended that they tolerate no luxurious, precious or superfluous objects that engage the pleasures of the eye in the cloister.[44] Here, the walls were devoid of mouldings, gilded frames and any other superfluous ornamentation, and the style of the furniture reflected the spirit of poverty: it was simple, utilitarian and convenient, as stipulated in the customaries, canon law and the 1599 decree of Clement VIII.[45]

The community room in the Grey Nuns' Bethléem convent in Montreal was a good example of this simplicity. Typical of a 1940s Catholic institution, a simple chair rail divided the upper and lower portions of a room's plaster walls. The dado, the lower part, was painted a darker colour than the upper. Except for the baseboard, no other mouldings or panelling lent visual relief to the hard, flat surfaces. Linoleum tile covered the floor. A solid wood table stood in the centre of the room; straight-back chairs lined the walls. Sparsely ornamented, the only decorations in the room were a framed religious motto, a large crucifix, a painting of Mother d'Youville and a photograph of the local superior.[46] The relative absence of visual stimuli outwardly expressed the vow of poverty. Ornamentation was minimal when contrasted with that in a middle-class or bourgeois home. Any boredom or monotony the decor engendered was to be accepted as a tenet of religious poverty.[47]

Although the authors of the customaries and those of the treatise on poverty dictated austerity for the cells, offices and workspaces, they made some exceptions for areas where the public could freely enter. In

the patients' rooms of a Catholic hospital or the classrooms of a convent school, embellishments were permissible and even desirable.[48] Indeed, the Grey Nuns' customaries advocated hanging a modest number of religious images, stencilling pious maxims on the walls and placing a few statues in common rooms, parlours, infirmaries, refectories and corridors. In comparison with the cloister, the bishop's quarters, the chaplain's apartments and the paying pensioners' rooms were luxuriously furnished. Upholstered chairs, stately chests of drawers with mirrors, writing tables and carpets accompanied the standard accoutrements: cast iron bed, sink, upright chair and pictures with religious motifs.[49] Areas reserved for the poor, however, more closely resembled those of the sisters. For instance, a dark dado contrasted with the light-coloured upper wall and ceiling of the men's common room at Saint Bridget's Refuge in Montreal. Blinds regulated the amount of light coming in through the tall window. The men sat in their upright and rocking chairs in groups or around a table in the centre of the room. A hefty cabinet provided space to store books and other acceptable forms of entertainment, while a crucifix, pictures with religious motifs and a statue standing on a bracket mounted high against the wall adorned the space.[50] Religious figurines and crucifixes, and pious images and sentences embellished the individual apartments. The degree of finery in the furnishings, reflected the differing class, economic and social status of the various groups living in Catholic institutions.[51]

Both the customaries and the treatise on poverty stipulated that the decoration and furnishing of a convent should respect the norms of a working-class home. Similar statues and images repeatedly show up in the photographs of chapels and other rooms at various missions of the Grey Nuns, which suggests that many of the prints and statues that decorated the convent were mass-produced and commercially bought. The inexpensive price of an *Ecce Homo* print (Christ wearing the crown of thorns) would have corresponded with what the average working-class family, who could barely make ends meet, could afford. The picture, because cheap and religious in content, was in keeping with "the quality of life we find in our modern congregations" and would have met the theologians' approval.[52] Purveyors of *art Saint Sulpice,* otherwise known as catalogue art, targetted a much broader market than parish chruches by advertising all manner of objects of religious devotion in the *Canada Ecclésiastique,* (a directory of religious communities), religious periodicals and newspapers. Yet, this standard Catholic iconography – the artwork that had become a fixture in the chapels and corridors of any convent – was as likely to be copied

from French standards as imported from France.[53] The painting of the
Holy Family over the main altar at Saint Joseph hospice in Saint Benoit,
Quebec, for example, was a copy of a Raphael.[54]

As with smaller congregations that could ill afford imported art and
statuary, ornate altars, fine wooden pews and good organs – the types
of furnishings recommended by American Catholic architect Edward
Joseph Weber, a self-proclaimed expert on Catholic ecclesiology[55] –
some communities of women religious bought or were given commonly
available prints and inexpensive plaster replicas of religious art.[56] They
also fabricated objects for themselves. After all, the workshops and artist
studios of religious communities supplied many a Quebec parish church
with *art Saint Sulpice*.[57] Historian Colleen McDannell, unlike Weber, who
derided this wildly popular art form in his 1930s treatise on Catholic
ecclesiology, assures us that nineteenth-century Catholics "saw it as
modern and technologically sophisticated."[58] For religious communities,
this debate was theoretically of little importance, since "poverty [was] the
… freely accepted mediocre level of material culture."[59]

Not surprisingly, sisters made the things they had last as long as they
could through regular maintenance and recycling. The mother superior of
the Grey Nuns had two statues of Mary taken down from the attic of their
mother house on Guy Street in Montreal to be repaired in preparation for a
procession to Mary. The statues had been rescued from the former mother
house, the cradle of their community now called Maison Mère d'Youville.[60]
Several years later, the Grey Nuns similarly reused a sculptural niche, a
remnant that had been saved from the partial demolition of the Maison
Mère d'Youville, to build a grotto in the yard of the Saint Mathieu wing
of the mother house. Sister Saint-Jean-de-la-Croix repaired and repainted
a statue of the Blessed Virgin Mary found in the garret to place into the
newly assembled grotto.[61]

The chapel: the jewel of Catholic institutions and convents

The austerity and mediocrity of the workaday areas of convents and
Catholic institutions contrasted starkly with the spectacular ornamentation
of the chapels. The most decorated space in the convent, the chapel often
featured vaulted or coffered ceilings (in the sanctuary at least), chandeliers
hanging from plaster rosettes, coloured or stained glass in the windows,
carved solid wooden pews, stations of the cross and lamps in the nave.
Imitation woodwork and faked marbling gave dadoes, mouldings and

columns the appearance of expensive finishes. Otherwise, ceilings and the upper and lower parts of the walls were simply painted contrasting colours to imitate wainscotting and panelling.[62] The customaries' interdiction against gilded picture frames did not apply to the chapel and sacristy. Although a few specially commissioned or imported works were displayed elsewhere, most original art pieces, such as the matching gold oval frames surrounding the *Ecce Homo* and an image of Saint Joseph that Father Villeneuve, a private benefactor, had sent to the Grey Nuns, were exhibited in the chapel.[63] Framed cheap prints and painted plaster statues, however, also embellished the chapel.

The chapel altar, which was situated behind a balustrade in the chancel and was raised three steps from the floor of the nave, commanded the attention of the all congregants. The altar was generally elaborately carved and made of fine materials, or assembled to look as if it were. Equally ornate retables or reredos, ornamental wood screens or partition walls above and behind an altar, embellished the sanctuary, as did the various statues that surrounded it. These were placed on pedestals, supported on wall brackets and set into sculptural niches flanking the chancel. The altar, covered with embroidered linens and lace, was also laden with candles and brass work, ferns, potted plants and vases of cut flowers. Required liturgical elements, including the censer, tabernacle, crucifix and chalice, completed the sanctuary furnishings.[64] Although much more modestly decorated, oratories outfitted on stair landings, such as the one in the mother house of the Grey Nuns with its communion rail and retable (Fig. 3 – see page 18 of the photo section), or against the wall in assembly rooms such as the refectory (Fig. 4 – see page 19 of the photo section), not surprisingly recalled the decor of typical pre–Vatican II chapel sanctuaries and altars.

Religious communities lavished significant financial, material and human resources on planning and decorating their chapels. The importance of these spaces was often expressed on the exterior by their fenestration, their larger and taller volume and their central location within the building. By placing the chapel in the middle of two wings of their larger convents or institutional buildings, the sisters ensured that patients in second-storey infirmaries and sick rooms could look down into the nave and hear the mass. Architects such as Alphonse Piché devoted much energy to designing chapels, drawing full size details for pilasters, beams and consoles.[65]

Judging by the number of photographs, architect plans and written descriptions that exist, the chapel was the most documented space within the convent. It also figured foremost in the women's imagination. Mentions of the benediction of mission chapels recur in the annals. Local superiors vaunted the simplicity of a chapel's decor or, when built in a more fortunate parish, its tasteful ornamentation.[66] When walking her readers through a new building or addition, such as the renovated Lajemmerais Hospice, Varennes, Quebec, the annalist most often described the chapel first.[67]

Conclusion

The chapel was evidently a place of congregation within the convent. It was where the religious community and other inhabitants of the building came together to celebrate Mass as the body of Christ. Yet, although they were required to daily assist in certain religious offices, apostolate sisters spent the majority of their time outside of the chapel. It was through acts of service that the women religious gained their heaven. Perhaps this is why they felt inclined to animate other areas of the convent so that these spaces could also bridge the temporal and the supernatural worlds and respond to their spiritual needs. The sisters transformed work and living spaces into sites of prayer and pilgrimage.

Through the design and manipulation of their built environment, religious communities of women constructed the physical and imaginary spaces that embodied their religious aspirations, cultural appurtenances and institutional priorities, as this analysis of the architectural and spatial dimensions of Roman Catholic convents and charitable institutions has shown. Buildings, gardens and a room's appointments were all important scaffolds upon which religious life was built. Without an appreciation of these vocational supports, the history of women religious would be impoverished, indeed. Apprehension of the convent's multi-faceted material culture allows us to discover the potential richness of a life vowed to poverty.

Despite the centrality of the chapel physically and figuratively in religious life, a multitude of spaces facilitated the expression of faith and religious practice. Whereas the celebration of Mass was restricted to a particular setting, other devotional practices were not so place-bound. The decor of Catholic institutions proved a powerful pedagogical tool in the training and catechism of novices, orphans and students. The stark walls of the convent manifested the poverty of the community. Sisters sacralized

ordinary spaces, such as hallways and workrooms, by giving them holy names and by repeatedly appropriating them through ritual activities such as Corpus Christi processions. Pilgrimages involved the whole community and taught celebrants how to interact with the supernatural community of saints. By generating and codifying an iconography of religious expression, the women designed an environment that celebrated their national identities, paid homage to the founders of their community and affirmed their Christian beliefs. Rather than being concentrated in a single spot, all spaces of the convent were suffused with religious meaning and were potentially sites of prayer.

Endnotes

1 The author thanks Rebecca Ginsburg, who attentively read and critiqued a draft of this essay, and Sœurs Gaëtanne Chevrier and Julienne Massé, s.g.m, whose assistance in the Archives des Sœurs de la Charité de Montréal, "Sœurs Grises" (hereafter *ASGM*) proved invaluable.

The number of participants given here is approximate. Included in the tally are professed sisters, novices, and postulants; elderly men and women; orphans of both sexes; and employees. I excluded abandoned infants. The statistics for 1878 (published in the annals January 1879) combined the resident populations of the Mother House of the Grey Nuns and Saint Joseph Hospice, Montreal as the same superior administered both houses. *ASGM, Circulaire Mensuelle 1877–1880,* 277, 170–173. For other descriptions of Corpus Christi observances see *ASGM, Circulaire Bimestrielle,* 1904–1906, 508, 859–61; 1906–1908, 633; 1909–1911, 175. Translations of quoted or paraphrased material from the French are my own. The names of the Grey Nuns' missions and other names (spaces, statues, etc.) have been anglicized.

2 See *Circuit du Patrimoine Religieux de Charlevoix Religious Heritage Trail,* a pamphlet published by the Charlevoix Association Touristique Régionale, 2003.

3 I undertook a good part of this research as part of my doctoral project, which was partially funded by the Social Sciences and Humanities Research Council. T. Martin, "The Architecture of Charity: Power, Gender, and Religion in North America, 1840–1960," (University of California, Berkeley: Ph.D. diss., 2002), examined some 250 convent and Catholic institutional buildings administered by two religious communities – the Sœurs de la Charité de l'Hôpital Général de Montréal, commonly known as the Sœurs Grises, or in English, the Grey Nuns of

Montreal, and the Communauté des Filles de la Charité, Servantes des Pauvres, dites Sœurs de la Providence, or known in English as the Sisters of Providence of Montreal – in North America. For this essay, I supplemented the examples taken primarily from the Grey Nuns' buildings located in Canada and the United States with discussions of buildings from the Augustines of the Hôtel-Dieu of Quebec, the Ursulines, Quebec, and the Sisters of Charity of Quebec.

4 G.K.-L. Verge, *Pensionnaire chez les Ursulines dans les anneés 1920–1930: Reminiscences d'un passage heureux* (Sillery: Septentrion, 1998), 122–123. For a description of a procession to Mary that used the whole building as a pilgrimage site see *ASGM, Circulaire Bimestrielle* 1906–1908, 509.

5 *ASGM, Circulaire Bimestrielle* 1906–1908, 509.

6 *ASGM, Circulaire Mensuelle* 1884–1887, 421–422.

7 *ASGM*, Sainte Cunégonde Doc. L44/Y1, B; *Ancien Journal* vol. 1 1688–1857, 121.

8 *ASGM, Circulaire Bimestrielle* 1904–1906, 279–81, 287–90, 294–95.

9 Verge, 75–76.

10 Guided visit of the Augustines' Monastery of the Hôtel-Dieu de Québec, 2002; P. Trépannier, *Le patrimoine des Augustines du monastère de l'Hôtel-Dieu de Québec: Étude de l'architecture* (Ville de Québec, Division design et patrimoine, Centre de développement économique et urbain, 2001), 40–41, 48.

11 *ASGM, Ancien Journal*, vol. 3, 1867–1877, 219, 286; *Circulaire Mensuelle* 1892–1895, 184.

12 *ASGM* Saskatoon L70/1Y5, H.

13 In chapter 2 of her book, C. McDannell, *Material Christianity: Religion and Popular Culture in America* (Berkeley: University of California, 1998) discusses how Catholics practiced their faith at home.

14 *ASGM* Saint-Benoit L11/Y1.1, B; L11/Y1, A. To distinguish a mission having the same name as another I have included the place name just as the nuns did in their records. Thus, Saint Joseph hospice, Saint Benoit, Quebec should not be confused with Saint Joseph hospice, Beauharnois, Quebec discussed later in this essay.

15 *ASGM* Cambridge L50/1Y3, F; L50/1Y4, A.

16 In addition to McDannell, D. Morgan, *Visual Piety: A History and Theory of Popular Religious Images* (Berkeley: University of California, 1998) and C. Bell, *Ritual Theory, Ritual Practice* (New York: Oxford University Press, 1992) provided useful discussions of ritual, religious practices, and material culture.

17 *ASGM, Circulaire Mensuelle* 1877–1880, 247.

18 *ASGM, Ancien Journal*, vol. 3, 1867–1877, 347.

19 McDannell, 140.

20 *ASGM, Circulaire Bimestrielle* 1904–1906, 450–51.

21 This was a phenomenon observed by McDannell, 137, among others.

22 *ASGM, Ancien Journal*, vol. 3, 1867–1877, 213.

23 *ASGM, Ancien Journal*, vol. 1, 1688–1857, 117; *Circulaire Mensuelle* 1877–1880, 353, 441.

24 McDannell, 18, considers how people enliven objects, how religious objects achieve an "affecting presence" or come to possess power or energy.

25 ASGM Doc. G5/9C8, *Coutumier-Directoire des Sœurs de la Charité de l'Hôpital Général de Montréal (Sœurs Grises)* (Montréal: Infirmerie de l'Hôpital Général, 1931), 55, article 266. Elizabeth W. McGahan, "Inside the Hallowed Walls: Convent Life Through Material History," *Material History Bulletin* Spring (1987), 5 observes a similar adornment of rooms.

26 C. Campbell, *The Romantic Ethic and the Spirit of Modern Consumerism* (Oxford: Blackwell: 1994), 148–154 discusses the relationship between a work of art, people's emotional reaction to it and its ability to register ethical sensibilities.

27 McDannell, 48.

28 J. Peghaire and A. Poisson, *Être pauvre pourquoi et comment: Essai théorique et pratique sur la pauvreté des Congrégations* (Montréal: Fides, 1960), 11.

29 Sœurs de la Charité de Québec, *Centenaire du couvent Notre-Dame de Grâce, 1858–1958* (Lévis, 1958), 10, offers the example of a Sister gaining inspiration from a portrait of Mother d'Youville.

30 "Tout les biens du monde n'approchent pas du bonheur de vivres bien unies," *ASGM, Circulaire Bimestrielle* 1904–1906, 204–206.

31 Peghaire and Poisson, 174, discuss poverty as a virtue to be practiced.

32 *ASGM* Beauharnois Fin. Doc. 68-A, "Foyer Saint-Joseph de Beauharnois, Historique".

33 Peghaire and Poisson, 190.

34 McDannell, 25, discusses ways that the Church encouraged their members to cultivate relationships with Christ and the saints.

35 E.J. Weber, *Catholic Ecclesiology* (Pittsburgh: E.J. Weber, 1927), 57; P. Sylvain and N. Voisine, *Histoire du catholicisme Québécois volume 2 Les XVIII et XIX siècles: Réveil et consolidation 1840–1898* Tome 2, ed. N. Voisine (Montréal: Boréal Express, 1991), 358–359; ASGM, Nashua L62/Y1, Chapel 1909; Saskatoon L70/1Y5, D, Chapel of the first hospital.

36 C. Drouin, *L'Hôpital général des Sœurs de la Charité "Sœurs Grises"*, Tome 3 *1853–1877* (Montréal: Maison-Mère, 1943), 22; *L'Hôpital général des Sœurs de*

la Charité "Sœurs Grises", Tome 2 1821–1853 (Montréal: Maison-Mère, 1933), 461–463.

37 ASGM, *Circulaire Bimestrielle* 1911–1912, 108.

38 *ASGM* Bethléem L26/Y2, D, c. 1943. The works of a religious community evolved over time. The Bethléem Asylum referred to here was variously an orphanage, children's asylum, day care centre, among other social missions.

39 Peghaire and Poisson, 20.

40 E. Goffman, *The Presentation of Self in Everyday Life* (Garden City, NY: Doubleday, 1959).

41 ASGM, *Circulaire Bimestrielle* 1904–1906, 303.

42 Verge, 76–77.

43 In his introduction, Morgan, 1–11, provides a good road map to the social construction of reality through material culture.

44 ASGM Doc. G5/9C7, *Coutumier ou recueil des coutumes et usages des Sœurs de la Charité de l'Hôpital Général de Montréal: Première partie, coutumes et usages généraux* (Montréal: Infirmerie de l'Hôpital Général, 1907), Chapter 20 "On Furniture" 146–154; Peghaire and Poisson, 49.

45 ASGM Doc. G5/9C6, *Coutumier ou recueil des coutumes et usages des Sœurs de la Charité de l'Hôpital Général de Montréal* (Montréal: Infirmerie de l'Hôpital Général, 1875), Chapter 17, "Furniture" 100–108; Peghaire and Poisson, 160, 170, 174.

46 *ASGM* Bethléem L26/Y2, A, Community room c. 1943.

47 This is a notion propounded in Peghaire and Poisson, 194.

48 Ibid., 175.

49 *ASGM* Sainte-Brigitte L8/Y2, A Men's private room; Sainte-Brigitte L8/Y2, B Lady's private room; *Album souvenir: Hôpital Général des Sœurs de la Charité (Sœurs Grises), Montréal, 1930* (Montréal: Imprimerie de la Maison Mère, 1930), 27–37, 41.

50 *ASGM* Sainte-Brigitte L8/Y2, D Men's common room.

51 T. Martin, "Housing the Grey Nuns: Power, Women, and Religion in fin-de-siècle Montréal," in *Perspectives in Vernacular Architecture, VII*, eds. A. Adams and S. McMurry (Knoxville: University of Tennessee Press, 1997): 212–229, analyzes how the organization of spaces in the Mother House of the Grey Nuns also reflected differences between groups of inhabitants.

52 Peghaire and Poisson, 50, 161.

53 McDannell, 168–170, relates that since the mid-nineteenth century, liturgical and sacred arts firms in the Saint Sulpice quarter of Paris marketed and distributed mass produced plaster statues, stained glass windows, holy water fonts, medals,

crucifixes, rosaries, holy cards and much else that came to be called *art Saint Sulpice* and discusses the production of these artefacts.

54 *ASGM* Historique Couvent d'Youville, Saint-Benoît, L11.

55 Weber, 21–36.

56 The same pictures and statues showed up over and over again in my survey of historic photographs of the interiors of Catholic institutions.

57 L. Noppen and L. Morrisset, *Art et architecture des églises à Québec* (Québec: Publications du Québec, 1996), 36. Sister Saint Joseph of the Sacred Heart, s.p., sculpted statuary. The Ursulines, whose work was featured in an exposition "Les Broderies des Ursulines de Québec" at the Musée du Québec 6 June–November 17, 2002, were renowned for their elegant embroidered altar linens. The museum of the Sœurs du Bon Pasteur, Quebec City, displays some of the artwork produced by members of that community.

58 McDannell, 169.

59 Peghaire and Poisson, 52.

60 *ASGM, Circulaire Bimestrielle* 1904–1906, 279–81, 287–90, 294–95.

61 *ASGM, Annales* 1919–1920, 614.

62 For sample descriptions of chapels see: *ASGM, Circulaire Bimestrielle* 1909–1911, 153–54; *Circulaire Mensuelle* 1881–1883, 552–553; *Annales* 1915–1916, 400–401. Typical interior chapel photographs include, *ASGM* Bethléem L26/Y5, A, Chapel in 1943; Cambridge L50/1Y8, A, Chapel.

63 *ASGM, Ancien Journal*, vol. 3, 1867–1877, 248.

64 This generalization is made from the analysis of such photographs as: *ASGM* Lawrence L27/Y6, Chapel, 1902; New Brunswick L72/Y2, E, Chapel of Divine Providence; *ASGM* Saint-Henri L19/Y1, E, Altar at old Saint-Henri; Sainte-Cunégonde Doc. L44/Y1, G-H; Toledo L13/1Y3, C, among others. McDannell, 170–71, made similar observations in her analysis of parish churches.

65 *ASGM* Saint-Jean Plans Doc. L28/Z1, 9, 6.

66 For examples of these see: *ASGM Circulaire Bimestrielle* 1911–1912, 305; 1904–1906, 633; *Circulaire Mensuelle* 1895–1898, 32–35; 1898–1901, 655 among others.

67 *ASGM, Circulaire Mensuelle*, 1881–1883, 32–35.

7

"The harvest that lies before us": Quebec Women Religious Building Health Care in the U.S. Pacific Northwest, 1858–1900[1]

Sioban Nelson

In the second half of the nineteenth century, Catholic hospitals, owned and administered by communities of women religious, played a major role in the hospital foundation movement in the United States. The Protestant pride and rampant anti-Catholicism of the period could lead one to assume that the United States was the country least likely to support the work of Catholic women through taxes levied on the hard-working Protestant majority. One would be wrong. In fact, unlike Britain, whose Protestant dominance was never breached by a Catholic hospital system, or Australia, where the large Catholic community produced a network of fine public hospitals owned and run by communities of women religious with virtually no government aid in the nineteenth century, the spirit of free enterprise in the United States paradoxically functioned to support the sisters' efforts.

Throughout the country, the sisters were able to provide care of the indigent sick for the lowest cost; compete for public tenders to secure these monies; and gain contracts with insurers, the marines, the army, railroad companies, mining companies and so on. The sisters attracted the best doctors, collaborated with medical schools and ran teaching facilities.

Importantly, in return for their private patients, they opened up hospital practice to private practitioners excluded by the self-seeking medical boards of competing hospitals. They were therefore an important element in establishing private hospital care not as the province of the poor, nor even only of the rich, but of the modest. By the end of the century, patient fees were what supported Catholic hospitals, thereby creating something of a prototype for the modern 20th-century hospital and helping lay the foundation for the dominance of private institutional and medical care in the United States health care system.

The success of the sisters' nursing work, far more so than their work in schools and orphanages, is the story of the sisters coming to understand the particularities of the American political and economic climate in order to run the best businesses in the market. America respected that.

However, there is no reading of nursing history or hospital foundation work (outside of the "insider" Catholic histories)[2] that would give anyone even the vaguest idea that this was the case. My work addresses a conceptual blind spot in relation to the history of women religious. The course of research in which I am engaged, and that I launched in my book *Say Little, Do Much: Nursing, Nuns and Hospitals in the Nineteenth Century*, examines the story of how the achievements of French, Irish, German and French-Canadian women became overwritten by Florence Nightingale and the nurses who followed her ideas, and how the story of modern nursing and hospital reform became an English one.

The story of Florence Nightingale and the women she trained is a familiar one. These new "English nurses," as they were commonly called, took the world by storm and established trained nursing as the province of respectable and educated women. The history of nursing is intimately bound up with this story, and in the British and North American coalition of new nurses that was to exert such an extraordinary force in late nineteenth- and early 20th-century nursing. But this essay tells another story, one with which few are familiar. It is the story of European women and their influence on nursing in the new world. These Irish, French, German and Scandinavian women have long been invisible in the glare of the Nightingale nursing story. Yet they too played a major role in the emergence of nursing, both in its reformulation as a respectable practice by good women and in its evolution into an effective health care profession. Moreover, a great many of these European women were religious women: Catholic nuns (Irish, French and German), Anglican nuns, and deaconesses (German and Scandinavian).[3]

One of the common errors in contemporary thinking is that we look back on the nineteenth-century religious nurses as simply part of the long history of nursing by religious women; yet this is misleading. Of course, religious women had engaged in nursing and hospital work for centuries; however, these nineteenth-century communities of women were different. They were new, outward-looking and not confined to the convent or cloister. In the nineteenth century, huge numbers of women flocked to religious communities dedicated to nursing the sick. In fact, according to Gibson, there were 135,000 women religious, seven per thousand women in France alone in 1878.[4] This was a new phenomenon. The impact of this movement among women was phenomenal: it created the possibility for female professions and, especially in the new world, created an enormous number of the institutions we now take for granted – hospitals, schools, orphanages and asylums – in every major town and city in the United States, Canada and Australia.

This essay focuses on the remarkable phenomenon of foreign women who worked as nurses in the United Stares – building hospitals, health services and nursing schools and who were at the forefront of the professionalization of nursing – through the story of a community of women from Quebec and traces that community's impact on the northwestern states of the U.S.

Sisters of Providence

"We had to struggle against fanatical Protestantism here; against unbelief, atheism, impiety and, unhappily, not a single notable Catholic here to encourage works of charity."

Mother Joseph, Sisters of Providence,
Washington Territory, 1878.[5]

Although a separate foundation from the Daughters of Charity, the Sisters of Providence of Montreal was part of the larger Vincentian family. The founder of the Montreal congregation, Saint Émilie Gamelin, was a Quebec widow who died of cholera while nursing the afflicted during the 1851 cholera epidemic.[6] From the beginning, then, the Sisters of Providence perfectly embody the tradition of religious vocation that inspired women to enter nursing and hospital work in the name of God. However, this community is atypical of nursing congregations in the U.S. in that

the Sisters of Providence attracted few Irish women (or the daughters of Irish immigrants) for their American mission in the nineteenth century. It was not simply a case of language (as with German congregations), for Irish women comprised a large part of many French orders; it was the fact that the Sisters of Providence in the U.S. Northwest were a missionary branch of a Quebec congregation. Nurtured by their mother house in Montreal, and sustained by plentiful vocations of Quebec women, the Sisters of Providence was able to maintain its French-Canadian identity until well into the 20th century. That said, a rich mix of women did become Sisters of Providence. The register shows Irish, English, American and German women, and even an Australian one, trained in Montreal. Nonetheless, Montreal women predominate, even in the 1900s. In fact, it is not until the 1930s that there are more American than Quebec women on the register.[7]

Missionary nurses

Following gold strikes in the American Pacific Northwest, expansion of European settlement occurred rapidly. Aboriginal communities had densely populated this part of the United States, and French Jesuit missionaries had long been involved with this fur-trading society. The Sisters of Providence shared the Jesuits' francophile mission and moved west ostensibly to work among and bring into the Church the Aboriginal people of the Northwest. In 1856, Mother Joseph Pariseau led five women from Montreal to Fort Vancouver in Washington Territory. These women were pioneers and missionaries. They became the first white women to cross the Bitterroot Mountains of Montana, which they did in response to repeated pleas by Chief Seltice of the Coeur d'Alenes people for "women blackrobes" to come to care for and teach their orphan girls. The first of five letters in 1870 from Chief Seltice to Sister Catherine Eunic read in part:

> Rev Sister, Since the time you passed by this place, all my people have been greatly wishing to have amongst us some of your Sisters for the education of our girls. The fathers (Jesuits) here are doing their best to teach our boys, and we are glad of it, but our girls are orphans, and if you or some other sisters do not come, they will always be so, because nobody will take care of them.[8]

These French-Canadian women embraced the challenges of frontier life under the leadership of Mother Joseph to build a remarkable network

of charitable institutions (including eleven hospitals, two orphanages and seven academies, and five Indian schools) between 1856 and 1902.[9] For this group of women, the term *build* had literal meaning. Mother Joseph was a carpenter, builder and architect, and is today honoured by the American Institute of Architects as the first architect in the Northwest, and by the West Coast Lumbermen's Association as the first artist to work in wood. In 1980, Mother Joseph's role as a pioneer leader was recognized with a statue in the National Statuary Hall in Washington DC.[10] When she first entered the mother house in Montreal, her father told the founder, Mother Gamelin,

> I bring you my daughter Esther ... She has had what education her mother and I could give her at home and at school. She can read and write and figure accurately. She can cook and sew and spin and do all manner of housework as well. She has learned carpentry from me and can handle tools as well as I can.
>
> Moreover she can plan and supervise the work of others, and I assure you Madam, she will someday make a very good superior.[11]

On arrival in Fort Vancouver, Mother Joseph knocked together the altar for the sisters' cabin and built an extension for a laundry and a bakery. With a few adjustments, she opened this building as St. Joseph's Hospital, Fort Vancouver, on June 7, 1858.[12] Throughout her life, she worked as both spiritual leader and property manager for the Sisters of Providence. Her correspondence appears to deal with spiritual concerns and renovations in equal measure. It is peppered with quotes from builders, compliments on an altar she built and requests for her opinion on building repairs or elevator design.[13] The sisters' first foundation was in Fort Vancouver but, according to the Chronicles (the mandated journal of the community activities), they were desperate for an opening that would allow them to extend their operations through the Territory. They had to wait from 1856 until 1877 for this opportunity. As is so often the case with women religious, and in keeping with common nineteenth-century devotional practices, the sisters attributed a reversal of their circumstances to the intercession of a saint. In this case, a special devotion to St. Joseph produced an invitation to tender for the care of county or indigent patients in Seattle.[14]

The evangelical nature of the sisters' work was something they were fervent and open about. The deathbed conversions, in particular, were said to "excite our ardour."[15] In fact, the object of a good death for all led them to consider only those who died without grace as failures – "lost" – and it was those failures that caused them to reproach themselves. They took to heart St. Vincent de Paul's admonition to the original Daughters of Charity to be responsible for souls who died without God's grace.[16] Barbra Wall argues that, for the sisters, closeness to death accounted for much of nursing's importance. It was an evangelical opportunity that belonged to them alone. As such, the sisters were able to participate in "man's work" of saving souls, without overstepping their place.[17]

To the sisters, the conversion of patients to Catholicism was evidence of the continued intercession of the saints. A firm belief in the miraculous was a sustaining and enabling force that guided their lives and their work. They interpreted all events as evidence of the hand of God and his saints. This was particularly true of property deals, which were the subject of much prayer. Burying medals of St. Joseph in the lots adjoining the hospital was a favoured approach to property investment. In fact, St. Joseph was actively involved in all property decisions. For instance,

> St. Joseph chose the property on his feast day as we had asked him to. It had been impossible to get it before without paying a huge price; even then the owner would not sell. Then, a few days later, Mr Massey just decided to sell. Mother Praxedes and Sister Joseph came and found the place so beautiful and so advantageous that they bought.[18]

St. Joseph was also relied upon – sometimes impatiently – to put food on the table. At one point in 1878, the Providence Hospital was in debt for $1,452 and there was only $0.25 in the house.

> In extreme difficulty one uses extreme measures. After having knelt before the Lord many times, first asking his love and then money, and seemingly getting no money and seeing our need so great, the Économie [the sister responsible for budget and housekeeping] went right to the tabernacle door and knocked three times and continued to knock when she got no answer. "I bring you my purse with the twenty-five cents in it," she said. "I am leaving it here until tomorrow." The next evening she went to get her purse, sure that God had heard her. Then the next day

two private patients arrived, one bringing $123 and the other $84 … a sufficient sum to satisfy our creditors.[19]

This faith in the miraculous and belief in the real presence of saints was essential for the sisters to sustain their courage and maintain the confidence that they could rise to fulfill God's demands. It also placed their work outside the realm of the ordinary, or the individual, and reinforced the view that it was God who was to be honoured in their successes. The sisters were only His instruments and remained unworthy of praise or recognition. In fact, Mother Joseph was gently criticized, in a pastoral letter from their confessor Canon Archambeault, for not "fostering a calm and perfect confidence in Divine Providence" in her houses. Canon Archambeault had observed much concern with temporal problems, and insufficient faith and confidence among the sisters.[20] He blamed Mother Joseph for this worldly preoccupation and excessive concern with debt. Total faith, then, was clearly something to work on, to perfect in oneself. The sisters' successful inculcation resulted in a freedom from worldly concerns and gave them the courage and confidence to succeed in the material world.

Skilled nurses

For the pioneering sisters, hospital work was central to their mission. But their evangelical imperative was underpinned by competence and skill. The Sisters of Providence took a professional approach to hospital work. The *Matière médicale,* edited by Sister Peter Claver, was published in 1869 as a medical guide for the Sisters of Providence. Sister Peter travelled from hospital to hospital throughout the Northwest, establishing dispensaries and training the sisters and nurses.[21] Translated in 1889 and published as the *Little Medical Guide*, the text comes with glowing testimonials from the medical faculty of McGill University. The book includes an extended pharmacy section (plus information about herbs of North America) and covers anatomy and symptomatology, pathology and disease. There is a section on insanity that includes mania, monomania, dementia and idiocy, with the nursing treatment listed as "rest of mind, attend to functional derangement."[22] It also includes "advice to nurses" that details observation of ventilation, light, cleanliness, noise, temperature and warmth, sleep and diet. It decrees that nurses should have knowledge of dressings, poultices, fomentations, leeches, cupping, enema, hypodermic injections,

suppositories, gargles, nasal bougies, nasal douches, inhalations and baths. There was also an extensive medical dictionary.[23]

The sisters were proud of their skill and dedication, aware that they could save bodies and souls when others failed. Their *Chronicles of Providence Hospital* cites the time that the sisters had no rest for four weeks because they were nursing two patients, a typhoid victim and a sawmill accident victim, "not leaving them for five minutes alone. The odor from the wounded patient was very bad."[24] Both men survived. In 1885, the same *Chronicles* regretfully declared that "after eight years of existence, we lost our first case of typhoid fever – and that after only a week's illness."[25] At St. Joseph's in Vancouver, Washington, Sister Mary Faith was said to have "exhausted her strength caring for Mrs. Pulski, who had cancer of the stomach. She was with us for six months. She demanded constant care and later, towards the end, she was delirious day and night."[26]

This is not, however, to overstate the clinical dimension of the sisters' nursing. Rather, the point is that there was no division for the sisters between devoted and attentive nursing and evangelical work; these were one and the same. It was actually *through* good nursing that hearts were opened to God and souls on the way to hell were rescued. Catholic sisters in general and the Sisters of Providence in particular did not avoid direct patient care and did full "body work" when required. For instance, the annals of Providence Hospital tell of "one paralytic man suffering for ten years ... [who] became horribly afflicted, full of sores so that no nurse would take care of him. Sister Eugene and Sister Annunciation took full care of him then. Their charity touched him and he asked for instruction and baptism."[27] In the interests of propriety, however, the sisters did employ male nurses for the intimate care of male patients in "so corrupt a country" – as was usual practice in hospitals at this time.[28]

Thus, through their practice and determination, sisters became skilled nurses, worked closely with doctors, and were extremely sensitive to the criticisms of anti-Catholics of their hospitals and their nurses. They were openly competitive with other hospitals, county or private Protestant institutions, which they considered inferior to their own. They relished the opportunity, when it arose, of caring for someone who had opposed them and proudly chronicled many tales of the transformation of former foes into firm friends (plus or minus conversion).[29] There were, then, strong motivations for the sisters to succeed as nurses, to run efficient hospitals, to work well with good doctors and to show a world that would have delighted in their failure that they were the best possible nurses.[30]

For their part, the sisters, too, delighted in the failure of opponents and were not above malice, such as when in 1900 the *Chronicles* accused the deaconesses at the competing Methodist hospital of "going back to the fleshpots of Egypt" at the slightest opportunity![31]

Through success, the congregation's reputation for hospital foundation grew. In 1897, Sister Blandine wrote to Sister Joseph of the Sacred Heart, putting the case for hospital work very pragmatically:

> … hospitals are what should be most dear to out hearts, since this is where we can carry out all the works of mercy, whether spiritual or corporeal. For me, this seems to be the useful effort, from all standpoints. It is true that we must act wisely. However, if we do not accept this, others will step in ahead of us, and there will be nothing left for us. We are short of subjects who are familiar with English for our Schools, and our novitiate regularly admits each year enough members who are willing to work in hospitals. This is the Providence for our Western Missions and the best approach to the harvest which lies before us. Other works are decreasing bit by bit, but hospitals are growing day by day.[32]

The sisters decided on the best approach to reap the harvest that lay before them through prayer, pragmatism and hard-headedness. As with other hard-pressed communities at this time, the sisters had no end of opportunities. In a remarkable document, the *Register des missions demandées à La Province du Sacré Coeur Vancouver Wa 1856,* the sisters faithfully recorded all invitations to work, and their acceptance or refusal. Most requests were signed off with the phrase *"remercié faute de sujets"* (refused due to a lack of sisters). Requests for schools, hospitals, orphanages and Indian schools were repeatedly refused for this reason.[33]

The invitations were presented in both business and entrepreneurial terms. For instance, on March 5, 1884, a Jesuit, Father Parodi, wrote to the sisters from Ellensburg, Washington. His letter was followed shortly by a second from another priest, Father Kusters. The priests outlined an attractive proposition for the sisters to set up a hospital at a logging camp at Roslyn, Washington. The letters explained how workers agreeing to take care of their own sick and injured had settled a strike at a coal company. As a result, they sought to employ "some Sisters of Charity" to take care of their hospital. Single men would pay $1.00 per month and married men $1.50. The men would also undertake to provide the sisters with a school for 200 children, plus additional land. They requested five sisters,

two for the hospital and three for the school. As an added incentive, they mentioned that there were "many more logging camps and sawmills with whom the same monthly agreement or else ticket system could be made." The sisters declined.[34] Another request from Dawson City, Northwest Territories, came in December 1896 from another Jesuit, Father William Judge. He wanted the sisters to come and open a hospital for miners. He urged them to come and to make sure they brought printed tickets, since there was no printing press in Dawson City. His plea was strengthened by the information that during the previous summer Episcopalians had purchased the supplies to establish a hospital, but had been unable to organize delivery, so the sisters still had a chance to get in first! They declined.[35] A Father Hartleib of Moscow, Idaho, began his request with the claim that this offer should override all others. Moscow, he declared, offered everything: two railroads, timber, water and no canyons, 5,000 people, and good Catholic families (some of whom were principal businessmen). In addition, county officials had agreed to provide a bonus plus pay for indigent sick and the citizens had promised to also give a bonus to the sisters. They accepted.[36]

The sisters' sense of their position in the "marketplace" also led them to respond to the professionalization of nursing and the emergence of nursing training. They understood it was important for them to keep abreast of these trends "for the renown and the growth of the hospital."[37] In 1890, Theresa Cox, a graduate of the training program at Bellevue Hospital in New York, began instructing the sisters in new nursing procedures and surgical techniques at St. Vincent's in Portland, Oregon. She used her first edition copy of the pioneering textbook written by American Clara Weeks along with the sisters' own *Materia Medica,* while medical staff taught the sisters in their speciality areas.[38] At the end of twelve months, the sisters were examined but were not awarded diplomas, since these were considered unnecessary for sisters.[39] Sister Andrew was then sent to the Presbyterian Hospital in New York to observe teaching and practice there. She recalled the warmth and kindness shown to her, and returned to establish St. Vincent's training school in 1892.

The successes of the sisters' foundations were linked to their nursing abilities and their being prepared to move forward with the increasing professional demands of hospital administration and nursing training; however, this is only part of the story. These women in the Pacific Northwest required not only administrative ability, nursing skill and piety but also an adventurous and entrepreneurial spirit.

Beggars and businesswomen

Adventures in the wilds

We sat upright in the wagon, with rosary beads in hand; frightened at the howling of the coyotes, wolves and panthers, and by noises of various kinds, real or imaginary, that tended to excite fear. Sister Mary Jesus, alone, was fearless, and would even laugh at our apprehensions. After tying the horses to the wagon, she would spread her blankets on the ground, then say her night prayers, take out her pistols, and placing one of them at each side of her, at a convenient distance, she would lie down and sleep as peacefully as if she were in her bed.[40]

The Wild West was larger than life. Somehow, the sisters' communities all seem to have found characters to fill the boots of western legends. Mother Joseph, Sister of Providence, was an accomplished saleswomen and intrepid beggar, who faced wolves, bears and Indians in the mountains of the Northwest. In Minnesota, six-foot, 200-pound Sister Amata Mackett toured the cowboy camps and lumberjack mills by train, handcart, ox and snowshoes to raise revenue for St. Mary's Hospital, which was run by the Benedictine Sisters of St. Joseph.[41] Sister Blandina Segale, a Sister of Charity of Cincinnati and heroine of the Santa Fe Trail, was protected by the outlaw Billy the Kid for the care she gave his wounded men.[42] The Sisters of Charity of the Incarnate Word played their own part in the larger-than-life legends of the west, with Sister Mary of Jesus Noirry, a member of the founding group that had come to America from Lyons, France, going out into the wilds, armed with a brace of pistols, dressed in an oversized man's coat, boots and straw hat (to disguise her habit). She secured money, provisions and hay for her horses on begging missions lasting five or six weeks.[43]

Begging was degrading and humbling, and had been a traditional religious practice of mortification since at least the time of St. Francis of Assisi. It was, thus, perfect as a spiritual practice to induce modesty. The sisters were able to turn a traditional practice to erase pride and self into an effective means to raise funds for their work. In 1880, one begging mission of the Sisters of Providence even went to Chile (where a sister foundation existed). Despite the trip's difficulties, the sisters returned to Oregon with $10,000.[44] Begging involved long trips into the wilderness, among working men in camps, and to cavalry outposts and isolated

settlements, searching for the "kind generous Irish heart."[45] The Sisters of Providence sent begging missions over the mountains to the mines of Idaho, Montana and the Caribou County in British Columbia. The camps could be a wonderful source of revenue. Mother Joseph commented that she found the miners especially generous:

> They [the sisters] were largely rewarded by the excellent reception they encountered from the miners, who were very respectful at all times, and more generous than one would have expected of people who subject themselves to such hard labour and privations to earn a small fortune.[46]

Over the decades of her work in the Northwest, Mother Joseph personally crossed the northern states many times. The journeys of the Sisters of Providence involved riding some 400 miles on horseback in infamously wet country.[47] Although the travellers wore special waterproof riding habits, their riding and "sleeping rough" training was the cause of much amusement for those staying at home.[48] Mother Joseph, always the intrepid leader on these dangerous excursions, recorded one brush with an Indian war party:

> As we were preparing to decamp, we heard the trampling of horses and saw a troop of Indians in the war paint surround our caravan. When they recognised our pectoral crosses, they immediately gave a sign of friendship and respect, [and] our fears were dispelled. We treated them to a meal, but cringed at their scalping knives which they kept ready to carry off scalps of whatever Americans they would encounter. How happy we were to see them depart peaceably. God be praised.[49]

Business initiatives

The shift from begging to the ticket system, under which the workers bought the right to care at the sisters' hospitals for two, five or ten dollars, was an important change in the commercial relationship between the sisters, their patients, medicine and business. As we have seen, the sisters were on occasion directly contracted by companies to run small camp hospitals or hospitals in the cities to care for workers. However, in 1885, a Seattle doctor, Dr. Carmen, set up a small hospital, "luxuriously furnished with Turkish carpets, furniture with marble tops and so forth," to compete with the sisters. The doctor's agents began selling admission tickets for $5

or $10 a year as a form of insurance voucher to individual workers at the many mining and logging camps in the region. These tickets "authorized the purchaser, in case of illness, to come to the hospital free and receive the ordinary and extraordinary care of doctors and nurses, get board and so forth, without any further cost."[50] It was a move that caused the sisters great consternation.

> Our opponent is meeting with success with the workmen. We regretfully see ourselves losing this class of workmen, who are usually poor even in this country where wages are high. It is this class of people who are our bread and butter. What to do? They forced us to send out tickets too.... (but) our opponent has been in the field for four months.[51]

In an effort to hold onto their customers, the sisters too began to sell tickets that entitled the bearer to free care in the hospital with their choice of doctor. The sisters were surprised at their own success, finding that they were able to compete with the doctor even in areas where his custom was firmly established. By 1887, Dr. Carmen's hospital was bankrupt and the sisters' revenue from tickets was $5,700.[52]

In Washington, the company whose workers took so many of these tickets was the Port Blakely Mill. This powerful company ran the largest milling operation in the world during this period.[53] Logging, of course, was dangerous work and there were no facilities available for men to look after themselves when away from home and family. Under the ticket scheme, the only cost the company incurred for the health and welfare of their workers was the administrative burden of pay deductions. So useful was the role of tickets in health care that it apparently became customary for companies to deduct the payment from the men's pay, with or without their permission.[54] A further element of the ticket system of significance was that the workers had the choice of medical practitioner. This promoted the development of private medical practice within the sisters' hospitals. Private practices relieved the sisters of the need to appoint costly medical staff, or engage directly with the medical establishment.

The tight business management practices of the Sisters of Providence are evident in the records of transactions, property lists and "Deliberations of the Corporations." All property decisions were carefully minuted and accounting records maintained. Board meetings were conducted, as demanded by the by-laws, the mother superior was president of the corporation, and only Sisters of Providence were members of the board.

Accounting records distinguished between money in hand and agreements. The latter included all contracts for patients, whether with workers at logging camps, sawmills, railroads and counties, and specifications were listed, such as whether the agreement included cost of physicians.[55]

The well-maintained records, resulting from the requirement that the sisters report all their dealings to Montreal, extended to property registers.[56] The best illustration of this can be found in the book of architectural drawings and land survey documents, *Inventaires des immeubles de La Province de Sacré Coeur*.[57] Sister Anatolie (evidently a talented draftswoman) meticulously executed this document in 1919 when she was sent from Montreal to undertake an inventory of all properties. But despite this level of corporate pragmatism, the sisters were not fully of this world, but "set apart" in a meaningful way. Their mother houses, their training and their rule determined the way the sisters lived and worked, their relation to the surrounding society and the connections between their various houses.

Sisters of Providence: "Our strength comes from our motherhouse"[58]

The rule was the lifeblood of the Sisters of Providence, too. Nonetheless, there appears to have been some latitude given to the sisters to accommodate the needs of a new country. For instance, Mother Joseph dispensed with the rule of silence at meal times, arguing that frontier life was grim and lonely and that the sisters needed to socialize and sustain each other. Montreal reinforced this change in tradition and urged the sisters to use the normally silent meal times to practise English. In fact, Mother Superior Mary Godfrey urged them to plan their week around French and English, so that the Canadian sisters would learn English and the American sisters French: "The language sacrifice will be blessed and will create unity among the sisters."[59] Emphasis was also placed on never missing meals, to ensure the sisters kept their health and spirits strong. Prohibitions on the care of women in labour, too, were somewhat relaxed for missionary hospitals.[60] As self-conscious missionaries, the sisters were sustained in their isolation by the formal connection that their rule required them to maintain with the mother house in Montreal. The *Chronicles* expresses great joy at observing their foundress's day on September 23, knowing that all of their houses, from Montreal to Chile, were united in this enriching spiritual activity. The union of prayer and rituals reinforced

their special identity as Sisters of Providence and sustained them as they faced the challenges of being foreigners in an anti-Catholic place.[61]

On a less profound but equally powerful level, the bounds of the sisters' vow of obedience to rule and superiors gave them a line of command independent of local clergy. At the same time, Montreal appeared to actively administer the missionary outpost, with frequent visits from the superior, a steady supply of postulants and visits back to Montreal by members of the community. This connection with Montreal, however, could be invoked or not as circumstances dictated. The superior had, it appears, a great deal of discretionary power. For instance, when the offer to take county patients in Seattle first came to the sisters, they declared it impossible for them to make a hasty decision, since the invitation would have to be considered by Montreal. The second difficulty was that their immediate superior, Father Prefontaine, was away, so this issue could simply not be resolved under these circumstances. Nonetheless, rather than forsake the offer, the sisters agreed to the deal. They justified this independent action thus:

> Mother Praxedes, Vicar, had prayers upon prayers said [to extend their mission]. Then one day she placed at the feet of St. Joseph's statue a letter pressuring him to make known the will of God. The next day, we received the following telegram:
>
> "Do you wish to take the county patients? Respond immediately. Father Couten."
>
> This unexpected request of the assistant priest put us in a quandary, for we feared the disapproval of the pastor, who was away. But, we thought, this absence in so difficult an occasion was a true act of Providence.[62]

Thus it was, through the combination of obedience to rule and utter faith that they were instruments of God's will, that the sisters were empowered to use their initiative and exercise their judgment. Paradoxically, these actions occurred wholly within a framework of submission, obedience and indifference.

The paradox of power and submission underlines the tension between temporal achievements and the spiritual formation of the sisters as vowed members of a religious congregation. In the nineteenth century, the promotion of self was considered anathema to religious life. As members of a religious community, the sisters considered the self to belong to

the temporal world and, as such, sought to eradicate it through religious practice, submission and obedience. Thus, the desire to avoid singularity, or distinction, was integral to the religious identity of women religious and to their efforts to attain spiritual perfection. Despite the emphasis on modesty, humility and submission that distinguished nineteenth-century religious women, God's work, especially on the frontier, demanded courage, initiative and resourcefulness. It was never the sisters' intention to build an empire for themselves; they were agents of God's empire. But despite their need to shun the limelight, God's work deserved illumination. Their institutions were a beacon for Catholicism and they were proud that God had allowed so much to be accomplished through them.

Foundations at the frontier

On the American frontier, the sisters' work embraced a motley community of miners, immigrant workers in camps, Aboriginal people and freed slaves. The opportunities for a well-endowed community were scarce. In the new towns, it was only the local businesspeople and pious churchgoers whom the sisters could approach for alms. As a result, the sisters were soon forced to look further afield. Given that railroad work teams and miners had money and, not infrequently, the need for acute hospital and nursing care for their illnesses and injuries, the sisters devised an entrepreneurial solution to their cash flow problems. First, they rode to railroad, mining and logging camps, begging from the workers. From here, the sisters moved to collaborate with industry to provide care for workers, setting up by contract with mining and railroad· companies, hospitals with beds allocated to their workers and also setting up mobile hospitals at the campsites. Eventually the sisters worked the camps to sell tickets for health services, what we could today call insurance vouchers. Buried in the sisters' pious language, the significance of this step from begging donations to having workers purchase possible services is easily overlooked. Nonetheless, the sisters' entrepreneurial activities, and their desperate need to seize anything that worked to keep their foundations alive and growing, meant that in a thoroughly contingent manner, the sisters established a system under which the support of a private hospital (and even support of the major provider of health care services for an entire city or region) came through insurance subscriptions.

The Sisters of Providence was motivated by missionary zeal to work in the west of the United States. As foreign women who relied on material

and moral support from their faraway mother houses, they also provided a means for women back home to participate vicariously with their far-flung members sharing prayers and offerings, sharing successes and failures at conversion. On the frontier, the sisters drew courage from the demand for their nursing skills to move further and further into the commercial realm of company hospitals, nursing contracts and insurance schemes. These efforts funded their mission, brought them close to lapsed Catholic souls and gave them the opportunity to inspire Protestants with their piety and self-sacrifice. The sisters knew that their nursing work was the potent brew that could "accomplish so many conversions."

At the same time, however, the sisters had detractors; as prominent symbols of the Catholic Church the sisters were the targets of anti-Catholic sentiment. Against these detractors, there was only one defence: the sisters' hospitals had to be better than any others. A typical story from the 1896 annals of Providence Hospital, Seattle, relates to one such victory and shows how individuals who were opposed to the sisters and worked against the hospital could be transformed by their care. One woman was so hostile to the sisters that her doctor arranged for her to have a private secular nurse when was admitted for care. However, she dismissed her nurse and then her doctor and became a firm friend of the sisters.[63]

To succeed, the sisters had to facilitate modern medicine and provide skilled nursing. It was the combination of factors – evangelism, financial difficulties, developments in medical and nursing training, and anti-Catholic forces – that led the sisters to continually improve their skills, their services and their institutions to be leaders in their field. At the same time, their religious training made them eschew, in principal, the notion of being professionals or businesswoman.

In the Sisters of Providence we find frontier women, intrepid and entrepreneurial. But they achieved these classic hallmarks of individualism through complex religious formation that eradicated self and extolled simplicity and group identity. Thus, through an ancient path of religious perfection acted out at the frontier of a foreign land, these women moved with confidence and competence, building institutions and creating health services for both themselves and for their sisters back home.

Endnotes

1 The material in this essay is more fully developed in the text S. Nelson, *Say Little, Do Much: Nursing, Nuns and Hospitals in the Nineteenth Century* (Philadelphia: University of Pennsylvania Press, 2001). Reprinted with permission.

2 See, for instance, U. Stepsis and D. Liptak, *Pioneer Healers* (New York: Crossroads, 1989); G.C. Stewart, *Marvels of Charity: History of American Sisters and Nuns* (Indiana: Our Sunday Visitor Press, 1986) or S. Farren, *A Call to Care: The Women Who Built Catholic Healthcare in America* (St. Louis: The Catholic Association of the United States, 1996).

3 See Nelson.

4 In France alone in 1878 there were 135,000 women religious, 7 per thousand women. R. Gibson, *A Social History of French Catholicism, 1978–1914* (London: Routledge, 1989).

5 *Chronicles of the Sisters of Providence*, 3 May 1876–July 1878, vol. 1,1 (56), trans. Sr. Dorothy Lentz. Providence Seattle Medical Center Collection, *Sisters of Providence Archives*, Sacred Heart Province, Seattle, Washington (hereafter *SPA*; numbers in parentheses are collection numbers).

6 This was a community fully in the spirit of St. Vincent's Daughters of Charity. For instance, the Customary of the Daughters of Charity Servants of the Poor includes traditional Vincentian exercises such as recollection of prayer with the striking of the clock, see General Chapter, 1938 Montreal, 12, *SPA*.

7 Register secretary General Office Set 1, *SPA*.

8 H. Mason, S.P., *History of St. Ignatius Province of the Sisters of Providence* (Spokane, WA: Providence Administration, 1997), 12, *SPA*.

9 They remained the principal health care providers for the northwest well into the 20th century. As late as 1954 a Sister of Providence was president of the Washington Hospitals Association. Today Providence Health System is the largest non-profit health-care provider on the west coast. See Mason, *History of St. Ignatius*.

10 Mason, 6.

11 L. Dean, S.P., "Special Feature Mother Joseph of Providence," Part I, 1, *SPA*.

12 Ibid., Part II, 1.

13 Letter from Mother Joseph of the Sacred Heart to parishes being visited, 18 December 1876, (13). MJSH, Correspondence, Box 2: Letters of Introduction for Mother Joseph, trans. Sr. Therese Carignan, 13.

14 Sr. Prexedes placed a letter under the statue of St. Joseph the day before the telegram arrived. Western Union Telegraph Company, 6 March 1877, *SPA*.

The telegram is filed in a collection with a curious title: *Correspondence – Other Missions. Correspondence between Emil Kauten and Mother Praxedes*, trans. Sr. Therese Carignan.

15 C. Kauffman, *Ministry and Meaning* (New York: Catholic Hospitals Association, 1995), 100.

16 According to Vincent de Paul, "*Si non Pavasti, occidisti*" – if you have not fed them you have killed them. See E. Rapley, *Les Devotés* (Montreal: McGill University Press, 1990), 80.

17 B. Wall, *Unlikely Entrepreneurs: Nuns, Nursing, and Hospital Development in the West and Midwest, 1865–1915* (University of Notre Dame: Dissertation, 2000).

18 *Chronicles*, 1 July 1878, vol. 1,5 36 (56). Providence Seattle Medical Center Collection, *SPA*.

19 Ibid., 25.

20 Rev. Alfred Archambeault, Ecclesiastical Superior to Mother Joseph, 1 December 1894. MJSH, Correspondence, trans. Sr. Mary Leopoldine, vol. 2, 260–66 (13), *SPA*.

21 E. Lucia, *Cornerstone: The Story of St. Vincent – Oregon's First Permanent Hospital. Its Formative Years* (Portland: St. Vincent's Medical Foundation, 1975), 83.

22 *Little Medical Guide of the Sisters of Providence* (Montreal: Providence Maison-Mère, 1889), 15.

23 Ibid.,15.

24 *Chronicles*, 1 July 1878, vol , 5 36 (56). Providence Seattle Medical Center Collection, *SPA*.

25 *Chronicles*, 24 July 1885 (56). Providence Seattle Medical Center Collection, *SPA*.

26 *Chronicles*, 1871–72, St. Joseph Hospital, Vancouver, Washington Collection, vol. 8, 18, *SPA*.

27 *Chronicles*, 24 July 1885 (56). Providence Seattle Medical Center Collection, *SPA,* Providence Hospital.

28 Lucia, 83.

29 *Chronicles*, 1896–97, 40 (56). Providence Seattle Medical Center Collection, *SPA*.

30 The 1926 customary deals very clearly with the mix of professional and spiritual duties and decorum issues for sisters, and gives an unambiguous account of their professional/spiritual responsibilities.

31 *Chronicles*, 24 July 1885 (56). Providence Seattle Medical Center Collection, *SPA*.

32 Sr. Blandine to Mother Joseph, 14 February 1897 (13). MJSH Personal Papers Collection, Correspondence, Box 1, 1856–1901.

33 Registre des missions demandées à la Province du Sacré Cœur des Sœurs de Charité Servantes des Pauvres, Vancouver, Washington, depuis l'époque de la Foundation 1856, *SPA.*

34 Rev. A. Parodi, S.J., *Request for a school and hospital in Ellensburg, Washington*, (Foundation Requests, A-Z: *SPA*, 5 March 1884).

35 Rev. W.H. Judge, S.J., *Request for a school in Dawson (Circle City), North West Territories* (Foundation Requests, A-Z: *SPA*, 28 December 1896).

36 Referred to another Province and accepted. Foundation Requests, A-Z, Request from Father Hartleib, S.J., Moscow, Idaho, 9 May 1892, *SPA.*

37 Lucia, 95.

38 Clara Weeks wrote *Textbook of Nursing*, the first textbook for nurses to be published in the U.S. (New York: Appleton & Co., 1885).

39 Notes from a collection of papers by Miss Margaret Tynan, RN entitled *St. Vincent's School of Nursing of the Institute of Providence: Its History and Alumnae* (Portland: St. Vincent's School of Nursing, 1930), 53, 1–3, *SPA.*

40 Sr. Margaret Patrice Slattery, *Promises to Keep: A History of the Sisters of the Incarnate Word, 2nd ed., vol. 1,* (San Antonio, TX: Sisters of the Incarnate Word, 1998), 36.

41 Farren, 139.

42 Sr. Blandina Segale was an accomplished self-promoter; her stories require a good dose of salt. Her recollections were published as *At the End of the Santa Fe Trail* (Columbus, OH: Columbian Press, 1932; reprint Albuquerque: University of New Mexico Press, 1999).

43 Slattery, 36.

44 An early party of sisters from Montreal (1852) attempted to return to Canada via Cape Horn from an ill-fated expedition to the northwest. After a hair-raising trip they ended up in Chile, where they remained. Sr. Peter of Alcantara to Mother Amable, Superior General, 18 February 1880 (13). MJSH, Personal Papers Collection, Correspondence, Box 2: Notes of trip to Chile, *SPA.*

45 "We did not find there the kind generous Irish heart that we had met in other camps." "Sister Catherine Mallon's Journal, Part Two," ed. T. Richter, *New Mexico Review* 52, 3 (1977): 151.

46 Letter from Mother Joseph of the Sacred Heart to parishes being visited, Montreal, 18 December 1876 (13). MJSH, Personal Papers Collection, Correspondence Box 1, 1856-1901, *SPA.* It was not always profitable, however, and circumstances changed dramatically from one year to the next. In 1876, for instance, a begging trip in Portland produced little because the local mine had gone bankrupt. See Lucia, 63.

47 The trip from Fort Vancouver to St. Ignatius, Montana was 650 miles, 400 were on horseback and Sr. Mary Edward had been kicked by a horse and was unable to ride for the last section of the journey. See Mason, 2.

48 Apparently at night the sisters in training slept in tents with handbags or saddles for pillows and cooked in the open. Mother Joseph of the Sacred Heart to Bishop Ignatius Bourget, 10 May 1864. MJSH, Personal Papers Collection, Correspondence, Box 1, 1856–1901, vol. 1, 132–36, *SPA*.

49 L. Dean S.P., "Special Feature Mother Joseph of Providence," Part 3, *SPA*.

50 *Chronicles*, 24 July 1885, vol. 1, 21(56). Providence Seattle Medical Center Collection, *SPA*.

51 Ibid., 21.

52 Ibid., 23.

53 R. Berner, "Port Blakely Mill Company 1876–89," *Pacific Northwest Quarterly* (October 1966): 153–71.

54 Sr. Eugene, Superior of Providence Hospital, Seattle to Mr. J. Campbell, 12 August 1895. Port Blakely Mill Co. Collection.

55 Deliberations of the Corporation 1859–1941. Providence Health System Corporation Records, *SPA*.

56 *Registre des missions demandées*, *SPA*. They reported regularly to Montreal. Mother Joseph was instructed to "establish a fixed rule of correspondence" and to write monthly. Mother Philomene to Mother Joseph, 4 June 1863 (13). MJSH, Personal Papers Collection, Correspondence, Box 1, 1856–1901, vol. 1,7 9, *SPA*.

57 Inventaires des Immeubles du La Province de Sacre Coeur, *SPA*.

58 "Our strength comes from our motherhouse." Mother Praxedes to Father Kauten in response for request to take over hospital in Seattle House of Providence, 7 March, 1877, Vancouver. Correspondence, *SPA*.

59 Lucia, 72.

60 See the Customary of the Sisters of Providence, Circulars of the Superior General, vol 1, 1898–1904 (Providence Mother House, Montreal, 1910), 11.

61 The *Chronicles* celebrate occasions of renewal, retreats, foundress day, visits from Montreal, etc. See for instance *Chronicles*, vol 1, 34 (56). Providence Seattle Medical Center Collection, *SPA*.

62 *Chronicles*, May 1886–July 1879, vol 1 (56). Providence Seattle Medical Center Collection, *SPA*.

63 *Chronicles*, 1896–97, 40 (56). Providence Seattle Medical Center Collection, *SPA*.

8

The Educational Work of the Loretto Sisters in Ontario, 1847–1983[1]

Christine Lei

On September 16, 1847, at the invitation of Bishop Michael Power, five members of the Irish Institute of the Blessed Virgin Mary (IBVM) came to serve the educational needs of the diocese of Toronto. For more than a century, the Loretto Sisters (as the order came to be known) established a network of convent and parish schools that was unparalleled in the province of Canada West/Ontario. This essay analyzes the evolution of the Loretto Sisters as a congregation of educators in Ontario.[2] It documents how the IBVM had to reorganize and adapt to political, economic and educational changes that swept the province in the late nineteenth century and throughout the 20th. It concludes by proposing avenues for future research.

Origins

The Institute's methodology, ideology and institutions can be traced back to seventeenth-century England and founder Mary Ward, who realized that she could best serve God through active service as a teacher. Ward's primary ideology was "to form a religious community of women dedicated to educational and missionary work for the restoration of the Catholic Church in England," through the education of young girls.[3] She extracted

methodological and pedagogical formulations from the curriculum and pedagogy of the Society of Jesus, an extraordinarily revolutionary idea since no other religious order of women had previously done so. Ward foresaw her young women students learning music, drama, art, languages (English, French, Spanish and Latin),[4] philosophy and classics.[5] Religious and moral training was also an integral part of Ward's proposed program of studies, yet by offering religious instruction, Ward and her members threatened to usurp the powers and functions of priests. [6]

The most revolutionary aspect of Ward's ideology was placing her Institute under direct papal jurisdiction and not that of the local bishop. To achieve this, members would be free from cloister and would wear secular dress. The Jesuits were especially displeased that women should want to imitate their life.[7] Ward planned that her Institute would depend on Jesuits only for advice in education; in all other matters, it was to remain independent. Her ultimate goal was to educate women to greater independence and give them spiritual and intellectual interests outside the home. The superior general of the Institute would wield much authority, write constitutions for the Institute and command obedience in all matters.[8] In this way, the Institute would not have to adhere to ecclesiastical authority or jurisdiction. Candidates would be carefully examined and educated in the Institute's own colleges.[9] Its members would lead ordinary lives, yet conform to the customs of the particular country and surroundings in which they worked.[10] Ward's plans were original because they made provisions for women religious that challenged previous traditions, customs and ecclesiastical laws.[11] The methodology, ideology and institutions Ward created would make themselves known in the Loretto convent schools in Ontario more than 300 years later.

The establishment of the IBVM in North America

From 1853 to 1865, the Loretto Sisters responded to bishops' requests for filiations in various Ontario towns and cities. Three themes emerge in the histories of these filiations. The Loretto Sisters had to break with the Rathfarnham rule of enclosure in order to teach in the free day schools.[12] They had to be professionally certified from a provincial normal school. In addition, the sisters had to maintain a good relationship with the bishops for their convent schools to survive.[13]

While ecclesiastical authorities had tried to suppress Mary Ward, and her followers had to renounce her as founder of the Institute, Ward's

memory and influence flourished. Wherever Ward opened a boarding or convent school, she also opened a free day school. This is the pattern the Loretto Sisters followed in Ontario. Ward's insistence that her members maintain good relations with members of other religious communities and orders, especially the Jesuits, echoed Canadian Mother Superior Teresa Dease's admonition to her members: "not one slighting word."[14] Ward's program of religious and secular subjects was very much a part of a Loretto convent education in Ontario.

Admission to the Institute of the Blessed Virgin Mary

Becoming a Loretto Sister was not easy. Strict guidelines for admission were designed to ensure "the preservation of [the Institute's] original spirit."[15] From 1847 to 1983, the average number of years it took a woman to make her final profession of vows more than tripled, from 2.33 years in the 1840s to slightly more than seven years from 1900 to 1939.[16] Applicants had to be baptized and confirmed Roman Catholics of legitimate birth between the ages of 15 and 30, to be entering the order of their own volition, to be free of criminal charges and debts, and to be unmarried and independent of familial obligations. The existence of dependents constituted an impediment to becoming a woman religious. One reason for this was to exclude those who could not afford care for elderly or disabled parents or relatives.

Candidates had to go through four stages before they could profess their final vows. The first was the written application. At this point, the candidate had to submit certificates of baptism and confirmation, birth and citizenship, and good health. Also required were a written testimonial of good conduct from the parish priest and testimonial letters about schools attended, examinations passed and employment. The order's constitutions placed great emphasis on good health and adaptability to community life. Deliberate concealment of disease was grounds for dismissal. Physically and mentally disabled candidates were not accepted. The personal qualities of potential candidates that the sisters looked upon with favour included intellectualism; having good sense; behaving with moderation; possessing an excellent character; having an upright, cheerful and peaceful disposition; and being generous, obedient and humble.

The second stage was a probationary period of six months, when the superior and teaching sisters in charge of the candidates observed each one carefully to see whether she showed signs of a true vocation

and adaptability to life in the Institute at Loretto Abbey in Toronto. The successful candidates were now postulants and wore the plain black dress with cape and gauze veil. For nine months, they received training on meditation, examination of conscience, regular daily observance and silence. The purpose of the postulancy was for the sisters to get to know the candidates and test them, and also for the candidates to test the Institute and their own adaptability to religious life. Postulants were given intellectual or domestic work that showed what qualifications they had for "furthering the aims of the Institute."[17] Docility and obedience were highly desired traits of candidates, who would, as a result, be easy to train. Postulants were under the guidance of the mistress of novices and the mistress of postulants, and, through them, thus became familiar with the manner of life in the Institute, its spirit, the first principles of its constitutions and its history.

Toward the end of the postulancy, the mistress of novices or the mistress of postulants asked for a written opinion about the postulant from those who were closely associated with her. These opinions were then submitted to the superior general who, with the consent of her council, decided whether the postulant was allowed to receive the habit. The postulancy ended with an eight-day spiritual retreat. Most postulants were admitted in September; however, the superior general could lengthen this period by an additional six months but no longer.

The third stage to final profession of vows was the novitiate when the candidate became "Sister." Before entering this stage, each postulant had to declare in writing that she had entered the Institute of her own free will, that she was firmly committed to live in the Institute in obedience to her superiors and the constitutions, and that she would not demand payment for services rendered. Entering the novitiate officially took place at the reception ceremony, in which the candidates were symbolically wedded to Christ. Dressed in white, the candidates walked down the church aisle to the altar where they were met and questioned by the bishop. They would then leave the nave, change into their black habits and walk again down the church aisle.

The candidates received the habit in the novitiate house in the presence of the superior general and her council. The novices' habits consisted of a black wool dress, a headdress, collar and cuffs of white linen, and a white veil. All novices were required to wear their habits both inside and outside the Institute, though postulants often wore secular dress when attending college classes and participating in activities that took them

outside Loretto Abbey. The novices then entered into a second, two-year probationary period, spending one complete and uninterrupted year in the novitiate house at Loretto Abbey. If a novice broke her novitiate, she had to begin her term again and complete it. During the first year, the novices studied only the constitutions and prayer.

Novices lived apart from the professed sisters in the mother house and were not permitted to enter other parts of the house or communicate by word or letter with other people, either inside or outside the house, except with the superior general's permission. Similarly, the professed sisters were only allowed to have contact with the novices with the superior general's permission and the consent of the mistress of novices. In the dining hall and chapel, the novices also sat apart from the professed sisters.

The novitiate enabled the young women to obtain a thorough grounding in the constitutions and the Institute's history, characteristics and activities, and to gain a spirit of union and "apostolic zeal which has been fostered in the IBVM since its foundation." The novices learned the rules and, on Sundays, were tested by having to recite them. Three months before the end of the novitiate, the superior general asked for a written opinion of the novices from the mistress of novices and those professed sisters with whom they had been working. The superior general, her assistants and the mistress of novices met and, by a majority of secret ballots, admitted the novices to profession, dismissed them or kept them on probation for no more than another six months.

Successful novices had to be at least 21 to profess their perpetual vows. They had to make a canonically valid novitiate and make their professions in writing and without force, fear or deception. Finally, the superior general had to admit them to profession. Novices made temporary vows three times in preparation for their final vows.

The next stage to final profession was the juniorate. After six years, the juniors spent a probationary period of at least three months, at least six weeks of which were spent in the novitiate house, apart from the novices. The purpose was to test once again the candidates' commitment to God and the Institute. Before final profession, the juniors made a spiritual retreat of eight full days and began spiritual exercises to determine whether they understood and accepted the constitutions and were committed to a life in the Institute, whether they were willing to undertake apostolic work by caring for youth, whether they were willing to take up work or office in any house of the Institute, and whether they were obedient to the superiors.[18]

After pronouncing their vows "in perpetuity," the finally professed sisters were given the title "Mother" and received a silver ring.[19]

Prior to becoming a professed member of the Institute, or a "Sister," the candidate had to present a dowry, or lacking a dowry, talents, qualities, diplomas and certificates "in the hope that they will later be of great use in the Institute."[20] The dowry was usually $100, or enough money to pay for a ticket home if the candidate decided to leave. However, presenting a dowry was generally only required of girls from wealthy families who wished to enter the Institute. The amount they brought depended on the wealth of the family and the number of children who had to share the inheritance.[21] The importance of dowries and bequeathing of monies was fundamental to the Institute's survival from its inception, since the sisters could not have managed on the stipends from their students, some of whom were often unable to pay the required fees.

Most candidates presented talents in music, art, drama or business experience in lieu of money. Others were exceptional artists whose work was evident on the Loretto Abbey walls and in the sacristy. One sister who engaged in domestic chores had been a tailor at Eaton's prior to entering the IBVM and another sewed habits for the sisters to wear. Many sisters produced literary works, such as Latin and French plays, a Chaucer symposium, Shakespearean programs, eighteenth-century comedies, spiritual and historical dramas, poems, and a biographical panorama of Mary Ward. From 1919 to 1950, those who had experience in business or secretarial work were admitted. Three members used their secretarial experience to teach commercial classes, while two others with successful business careers prior to entering were appointed to the position of bursar in the business office at Loretto Abbey.[22]

Teacher certification

By entering the IBVM, a young woman joined a teaching order.[23] The proliferation of women into the IBVM, beginning in the late 1860s, necessitated the training of teachers. This began in the novitiate, when the novice was not only trained in the values and regulations of the IBVM but also in pedagogy. By the 1880s, the Loretto Sisters in Ontario were teaching in elementary and secondary schools, boarding schools, and schools for domestic and commercial instruction. In 1882, Loretto Lindsay was the first convent school in Ontario that prepared its students for departmental examinations. The Institute worked in co-operation

with Catholic associations for girls and women. It could only open day or boarding schools for boys in cases of extreme necessity and on the approval of the local bishop; work in day cares, hospitals and asylums was forbidden.[24]

The Institute highly valued postulants who entered with a teaching certificate. Of those entering with teacher certification from 1847 to 1983, half obtained their teacher training at the Toronto Normal School, ten others were certified at other normal schools, four had an Ontario College of Education certificate, and one possessed a teaching degree from an unspecified institution. Of the 30 teachers, five entered with a BA[25] – two from Queen's University[26] and one from the University of Toronto.[27] In 1907, the Ontario Department of Education set down regulations mandating that all teachers in separate schools that received funding needed certification. Those who worked in private schools or taught music were exempt. The Institute encouraged its members to pursue degrees part time, at the local university, while teaching full time during the day. Other sisters obtained their teacher certification or specialist courses in the summer.[28]

The IBVM and the bishops

The success of the IBVM in Ontario also depended on the Institute's relationship with bishops. The IBVM is a congregation of pontifical right that constitutionally enjoys independence of government and jurisdiction from bishops. The latter could not legally change the constitutions that Rome had approved. On the other hand, the constitutions stated that superiors were "to foster friendly relations with the local bishops, and in difficult circumstances readily approach them for advice, protection and help."[29]

The superior general represented the entire Institute in its relations with the dioceses and conducted business in accordance with canon law and the constitutions of the Institute. The local superiors and communities were instructed to "endeavour, as much as possible, to carry out the bishop's views, and to promote the honour and glory of God, according to his instructions."[30] A bishop's powers were limited in the jurisdiction of the Institute's organization and administration. He could change neither the constitutions nor the governance of the Institute. If he tried, the constitutions mandated the superior general to firmly advise him of her jurisdiction over her Institute. The bishop was also prohibited from

inquiring into the Institute's finances unless the diocese owned the property on which the convent and school operated. On the other hand, the local bishop did have authority in certain matters. Canon law, for example, permitted him to examine potential candidates.[31]

Geography played a vital role in the relationship between the Institute and the bishops. Because the IBVM had filiations in Brantford, Toronto, London, Guelph, Belleville, Niagara Falls, Hamilton, Lindsay and Stratford that were subject to the same rule and obedience to the superior general, the bishops' authority allowed for restrictions and certain limits. In other words, the local superiors were not to infringe on the bishops' authority, nor were the latter to overstep the limits of their diocesan powers as delegated to them by the Holy See.[32] Schools and academies were subject to the inspection of the bishop regarding religious instruction, "integrity of morals, exercises of piety and administration of the Sacraments."[33] Once again, the constitutions dictated very precisely what the respective duties and responsibilities of the superior general and local superiors were with respect to those of the local bishops. This reciprocity ultimately affected the nature of a Loretto convent school and the parochial schools in which the sisters taught.

Administrative positions within the IBVM

The organizational governance in the Institute depended on absolute obedience to the superior general,[34] who could transfer sisters from one house to another, appoint or depose local superiors, admit or reject novices to profession, accept foundations, and authorize and prohibit expenses. Financial matters, though, could only be authorized with the unanimous vote of her four-member council. The superior general served as the legal representative of the Institute. She regulated communications with a member's parents and relatives. Although she "derived her authority from Christ our Lord" and was given full right to require obedience and submission in everything she saw fit to ordain, her power was limited. She could neither change the constitutions nor interfere unnecessarily with the functions of the local superiors in their houses.

Each house had a local superior and at least six professed members of perpetual or temporary vows resident in the convent and school. The duties of the local superior included reprimanding members for faults and negligence and imposing penance, securing "good and suitable books," promoting spirituality and showing "motherly care" towards her subjects.

There were checks and balances to her power, too. She had to consult her council in financial matters and seek the advice of the superior general for "serious matters" although just what is meant by "serious" is not mentioned in the constitutions. She had to submit a report to the superior general every six months of her governance, including financial statements and details on the progress of school and educational matters.

The secretary general was responsible for personnel records, ecclesiastical reports and general correspondence. She wrote letters and acted as record keeper and archivist. Her duties included taking an inventory of possessions and those of the members, and retaining a list of postulants, novices and professed members, and a calendar of key dates in their religious lives. She was also responsible for maintaining a necrology. The procuratix general (bursar) performed the Institute's business duties. She was to be "discreet in the discharge of her duties and uniformly courteous in conversation with others." It was her duty to administer all monies (whether donations, bequests or accumulated interest) on behalf of the superior general. She reported financial accounts biannually to the general council cited above and wrote annual audits of all houses and their annual reports.[35] The various positions, functions and responsibilities the sisters performed indicate that the Institute was highly organized and efficient, and ultimately contributed to the overall success of Loretto involvement in Catholic education in Ontario.

Who became a Loretto Sister?

A woman who entered the IBVM between 1847 and 1983 was usually Irish, often an only child and proficient in music, art or languages. Table 1 shows that the majority of Loretto teachers in the late nineteenth and early 20th centuries were born and raised in Ontario. Sixty-seven per cent of those who professed between 1810 and 1983 were born in Canada. Between 1847 and 1983, at least 37 per cent of Loretto teachers were Irish-born or first-generation Irish-Canadian. There occurred a significant increase in the number of subsequent generation Irish-Canadians. The highest concentration of lay, or those professed members who performed domestic duties, with Irish heritage occurred between 1870 and 1900.

Family size and composition was also a determining factor in who became a Loretto Sister. For example, the Institute's necrology shows that 62 per cent of professed sisters had no brothers. The likelihood of entering religious life decreased with the number of siblings, particularly sisters,

in one's family. Twenty per cent (111 out of 556) had one sister, 10.3 per cent (57) had two sisters, 8.3 per cent (46) had three sisters, 4.3 per cent (24) had four sisters, 3.2 per cent (18) had five sisters and 1.8 per cent (10) had six or more sisters.

Table 1: Known ancestry of members of the IBVM in North America by ethnicity and decade, 1847–1983

	First-generation Irish-Canadian	Irish-born	Total
1847–1849	1	10	11
1850–1859	11	13	24
1860–1869	16	19	35
1870–1879	39	19	58
1880–1889	33	13	46
1890–1899	37	12	49
1900–1909	18	2	20
1910–1919	7	2	9
1920–1929	2	2	4
1930–1939	1	0	1
1940–1949	0	0	0
Unknown			192
Total	165 (30%)	92 (17%)	449

Source: These statistics were prepared and compiled from A. Kerr, IBVM, *Dictionary of Biography of the IBVM in North America* (Toronto: Mission Press, 1984). Kerr's work is located in the Loretto Abbey Archives, Toronto.

The necrology also indicates that of the 556 professed sisters listed, slightly more than half (50.5 per cent) were only children. One hundred and forty-three members (26 per cent) had at least one sibling who was a member of a religious community or order in Canada, and 128 (23 per cent) had siblings in the IBVM. Fifteen had brothers who were members of male religious orders or were diocesan priests. Thirty-three per cent of professed members were educated at a Loretto convent school; only four per cent had attended other convent schools. The average age of profession of novices was 23.7. The mean age for profession for choir, or teaching, sisters was 21.[36] By 1905, the time a postulant entered to the time of her profession had increased from six years to nine years. These numbers indicate that the guidelines for admission to the Institute had become more stringent in an effort to preserve "the original spirit" of the Institute, which included "the instruction of girls and their spiritual formation in accordance with the principles of a holy, upright life."

From 1847 to 1943,[37] the Loretto sisters were divided into two distinct classifications, choir and lay. The necrology lists 105 lay and 354 choir sisters. There is not enough information to delineate between the two for 79 sisters. Sixteen left the Institute for reasons ranging from entering another order to suffering from a mental or physical illness. The choir sisters served as teachers and administrators, while the lay sisters performed domestic duties. Both made the same vows, observed the same rule and worked for the salvation of souls, but their training, duties and roles differed. One of the most visible distinctions between the lay and choir sisters was their style of dress. The teaching sisters wore white cuffs; the lay sisters did not. Not only would the white cuffs soil easily when the lay sisters carried out their domestic duties but also the pins they used to attach the white cuffs to the habit's sleeves could fall off (into the food, in the case of a cook). In the summer of 1933, all these differences were eradicated and the lay sisters began dressing in the same attire as the choir sisters.

The lay sisters were mandated by the constitutions to "revere [the Choir] Sisters for their vocation [teaching]," to observe silence, docility, humility, obedience, and to display cheerfulness and charity.[38] The cook, for example, was instructed to "never forget her station of a Lay Sister, so as to speak with an arrogant look or disedifying tone of voice." If a choir sister were sent to help the cook, the latter, a lay sister, was instructed never to "ask one of a higher rank to clean the kitchen utensils, or perform other actions of this nature."[39]

Lay sisters held varying positions within the school and convent. The keeper of the garments kept an inventory of all articles of clothing and marked and mended each. The cook observed cleanliness and ensured that no food was wasted. The portress informed the superior when the impoverished came to the door for alms. The refectorian left two plates on the table before and after dinner to collect scraps of meat and vegetables, which the dispenser gave to the poor who waited each day at the gates of the convent.[40] It is clear that the IBVM could not have carried out its charism without the support of the lay sisters.

What the sisters taught

The Loretto academies were renowned for offering instruction in the arts, especially instrumental and vocal music, because the constitutions mandated that "the proper training of the teachers in literature and arts [be] abundantly supplied." The constitutions made no such provision for

math or science teachers.[41] Table 2 indicates that more than a quarter of the sisters taught instrumental or vocal music, or both, between 1847 and 1983. There are a number of reasons why the IBVM placed tremendous emphasis on music instruction at its convent schools. First, the institution had a long historical tradition of teaching music. In her first curriculum, Mary Ward had advocated the teaching of singing in order that students not become "slothful." The *Constitutions of 1908* mandated the teaching of music for the same reason: music had to "be taught to daughters of the nobility in order to 'avoid sloth' … the 'root of all evil'."[42] Music also served to make the Loretto academies the cultural centre of a city.[43] There was also a more practical component to teaching music in the boarding schools. The fees students paid for piano, guitar, harp and melodeon lessons often exceeded the standard academic fees.[44] Senior students who were certified by the Toronto Conservatory of Music were able to gain employment as private or public school music teachers.

Table 2: Number and per cent of Loretto teachers and their known course of instruction, 1847–1983

Subject	Number of teachers	Per cent of teachers
Music	60	28
Art	25	12
English	22	10
Modern languages	22	10
Math	16	8
Commercial	16	8
Latin and classics	11	5
Religion	11	5
History	7	3
Science	7	3
Domestic science	6	3
Drama	4	2
Sewing	2	1
Elocution	2	1
Physical culture	1	.47

Source: These statistics were prepared and compiled from A. Kerr, IBVM, *Dictionary of Biography of the IBVM in North America* (Toronto: Mission Press, 1984). Kerr's work is located in the Loretto Abbey Archives, Toronto.

As the provincial curriculum for vocational education changed, so too did the curriculum at the convent schools. Commercial subjects became the norm in the late nineteenth century to meet the need for clerical staff in an increasingly industrialized province. The domestic sciences, or household arts, were introduced in the early 20th century in the hope, as one bishop noted, that the "lost art" of cooking, sewing, mending and darning would form student character and combat "the modern spirit of paganism that prevailed throughout the world."[45] Mary Ward had advocated teaching of sewing so that the hundreds of poor girls who attended her day schools in the seventeenth century could avoid delinquency and crime by having a livelihood. The *Constitutions of 1908* stated that "manual arts" be taught to girls so that they may "acquire not only a taste for the domestic life and aversion to a life of vain amusements, the desire to please men and idle gossip," but also that they "avoid sloth – the root of all evil."[46] There existed class distinctions in the kind of sewing taught. Wealthy students paid for and were taught various kinds of French and silk embroidery while poorer students were instructed in sewing and darning, work that lay sisters usually performed as part of their domestic duties.

Religious education was the primary aim of schooling under the Loretto Sisters. Mary Ward had insisted that students be taught to know and love God and live in obedience to God and their parents. This was to be accomplished by instruction in spiritual practices (that is, going to confession and receiving communion, and preparing to receive these sacraments), Christian doctrine, the catechism and the reverent use of sacred objects.[47] In Ontario, religious pedagogy was expressed in the four constitutions that the sisters followed from the time of their arrival in 1847.[48] By 1942, the word *Catholic* had replaced the all-encompassing words *Christian* and *piety* used in previous constitutions. In the convent schools, this meant that optional attendance in religion class and participation in religious practices were revoked. Perhaps the reason for the change was that the public school system was moving towards restricting religious instruction to a Protestant form of Christianity and finally did so in 1944. To delineate itself as separate and distinct from that Protestant system, the IBVM mandated religious and pedagogical instruction in Catholicism.

Conclusion

For a young woman in the nineteenth and early 20th centuries in Ontario, entering an active teaching apostolate, such as the IBVM, proved to be a viable alternative to marriage, motherhood or remaining single. She had the companionship of her peers and superiors, and was free to aspire to a life as an administrator, a career that was generally denied her in the secular world. In exchange, she had to abide by strict moral and behavioural tenets. Overall, the IBVM organized itself into a teaching corps, systematically training those who did not have the qualifications to become good teachers, or reassigning them to other positions within the convent school, such as librarian. Sister teachers usually had no siblings, were Irish-born or of Irish descent, and likely taught music or art. Those members without strong educational backgrounds performed day-to-day household tasks as lay sisters; this enabled the teachers to perform their jobs unimpeded and also contributed to the overall structured regimen of the entire network of convent schools in Ontario.

By teaching in a variety of educational settings that ranged from kindergarten in the convent schools to higher education at Loretto College, the sisters proved their adeptness and expertise as teachers. Initially, they prepared girls and young women for their place in the world as Christian wives and mothers who would in turn raise their children in the Christian faith. Honesty, integrity and generosity were the foundation of the characteristically female qualities of modesty, gentleness and compassion, evidenced by the deportment prize awarded each year at Loretto academies throughout the province. The post–World War I society, concerned with technological advancement and innovation, required the sisters to prepare their students for the world of work. Part of this preparation meant that the sisters had to upgrade their own academic credentials with both academic and vocational training. By this time, prizes in amiability, order, personal neatness, early rising, regular attendance and good conduct reflected the new ideals, rituals and manners of a dominant capitalist and patriarchal society. By the 1930s, the Loretto academies were in direct competition with the local high schools. "The rules and systems followed by other schools, especially the Public Schools are to be adopted as far as necessary, that our schools may not appear to be inferior to them," mandated the constitutions.[49] By the 1960s, however, the sisters' involvement in education was waning for a number of reasons. First, the conservative tenets of the convent schools' curriculum stood

in direct contrast to societal secularism. Second, the sisters were aging, and without a young, more vibrant teaching corps to replace them, they simply left education to secular teachers.

Further studies need to focus on the sisters' relationships with the bishops and priests and the Catholic community in general to ascertain the precise nature of a Loretto education. Another area of needed research is a comparative study of the Loretto convent schools in Ontario that describes the similarities and differences among them in order to ascertain the exact nature and function of convent schools in Ontario. An examination of the sisters' literary works could reveal how and what the sisters felt and experienced in personal terms with respect to education in Ontario. The number of members of religious orders is declining rapidly; therefore, it is necessary to record their oral histories in order to have an accurate and personal account of their lives as teachers and people in Ontario. The strict guidelines for admission to the Institute, the precise description of duties and responsibilities between the sisters and bishops, and the exact preservation of Mary Ward's original methodological and pedagogical aims and goals for a young woman's education ensured the success of the Loretto schooling experience in Ontario.

Endnotes

1 This paper is based on my doctoral dissertation, "Academic Excellence, Devotion to the Church and the Virtues of Womanhood. Loretto Hamilton: 1865–1970," University of Toronto, 2003. A portion of this paper is also based on a paper presented to the Canadian Catholic Historical Association conference, May, 2003, entitled "The Science Ball." I wish to express my thanks to Sr. Juliana Dusel, IBVM, for her guidance and assistance during the course of my research.

2 This essay limits itself to the experience of the Loretto Sisters and their contribution to education in Ontario. Between 1853 and 1880, Mother Teresa Dease, the first Superior General of the IBVM in North America, made thirteen foundations – twelve in Canada and one in Joliet, Illinois (St. Mary's Academy) in 1880. In addition to teaching and administering in a variety of parochial schools in the United States and Canada, the IBVM established foundations in Sault Ste. Marie, Michigan, in 1896, Wheaton, Illinois, in 1946, and Phoenix, Arizona and Sacramento, California, in 1949. For a listing of the schools that the Loretto Sisters taught in during the late nineteenth and early 20th centuries in Canada, see M. Norman, IBVM, "Making a Path by Walking: Loretto Pioneers Facing the

Challenges of Catholic Education on the North American Frontier," in *Historical Studies*, 65 (1999), 106.

3 M. Wright, IBVM, *Mary Ward's Institute: The Struggle for Identity* (Sydney: Crossing Press, 1997), 8.

4 Oliver noted that the emphasis on language acquisition in Ward's schools arose because the Institute's houses were located in Italy, France and German-speaking countries. M. Oliver, IBVM, *Mary Ward* (New York: Sheed and Ward, 1959), 225–226.

5 Oliver, 225.

6 M.M. Littlehales, IBVM, *Mary Ward: Pilgrim and Mystic, 1585–1645* (London: Burns and Oates, 1998), 116.

7 O'Connor wrote that "it was difficult for people of that time to understand how a women's religious community could follow the same rules as men's and be independent." M. O'Connor, IBVM, *That Incomparable Woman* (Montreal: Palm, 1962), 48.

8 I. Wetter, IBVM, *The Heart and Mind of Mary Ward* (Quidenham, Norfolk: Carmelite Monastery, 1985), 113.

9 E. Orchard, IBVM, "Rome," in *Till God Will: Mary Ward Through Her Writing* (London: Darton, Longman and Todd, 1985), 63–65; Wetter, 122.

10 Ward, in Wetter, 111–112.

11 Orchard, "Correspondence concerning the Confirmation of the Institute," in *Till God Will*, 69.

12 In a letter written to Rathfarnham in 1877, Mother Dease complained that the sisters "work hard, too hard, but there is no avoiding it. Education here is carried to excess, and I think they will find such is the case." The limitations of enclosure and curriculum may have contributed to the formation of the North American generalate in 1881. Those who taught at convent schools in Ireland were forbidden to leave the convent grounds, while the sisters in Ontario broke free of this rule to teach in separate schools. In addition, the sisters in Ireland taught a severely limited curriculum in music, art and languages. The sisters in Ontario pushed for higher education for girls with an extensive academic curriculum. M. Costello, IBVM, *Life and Letters of Rev. Mother Teresa Dease* (Toronto: McClelland, Goodchild and Stewart, 1916), 27.

13 Dease, "Mother Teresa Dease to Mother Berchmanns, Toronto, June 3rd, 1856," in Costello, 76.

14 Dease, "Mother Teresa Dease to Mother Berchmanns, Toronto, June 25th, 1847," in Costello, 38–39.

15 Loretto Abbey Archives (hereafter referred to as *LAA*). Constitutions of the Institute of the Blessed Virgin Mary (Commonly Called the English Virgins) Toronto (Toronto: IBVM, 1942), 3.

16 The statistics for years to profession were compiled and prepared from information in Sr. A. Kerr's, IBVM, *Dictionary of Biography of the Institute of the Blessed Virgin Mary in North America: Lives of the Members of the Institute of the Blessed Virgin Mary in North America from its beginnings in 1847 to 1983* (Toronto: Mission Press, 1984). Although this essay focuses exclusively on the teaching sisters and schools in Ontario, Sr. Kerr's necrology includes information about sisters who taught outside Ontario including Loretto schools in Sedley, Saskatchewan, Sault Ste. Marie, Michigan, and Chicago, Illinois. The majority of Loretto convent schools were located in Ontario, and most of the Loretto Sisters were born and raised in Ontario. For an exact calculation of the birthplace of Loretto members in North America, see my doctoral dissertation, "Table 1: Birthplace of Professed Members of the North American IBVM: 1810–1983," in *Academic Excellence, Devotion to the Church and the Virtues of Womanhood: Loretto Hamilton, 1865–1970* (Toronto: University of Toronto Press, 2003), 79. For the exact years to profession by decade, see "Table 4: Number of Years to Profession for Members of the North American IBVM, 1847 to 1983," 83.

17 Constitutions of 1942, 2–8, 19.

18 Constitutions of 1942, 11–13, 16–17, 19, 22–23, 27–28.

19 Personal communication with Sr. Juliana Dusel, IBVM, Loretto Abbey, Toronto, 1 May 2002.

20 Constitutions of 1942, 30–31.

21 Personal communication with Sr. Juliana Dusel, IBVM, Loretto Abbey, Toronto, 1 May 2002.

22 Kerr, 62, 131, 156, 163, 166, 174, 177.

23 In September 1911, several Loretto Academy high school graduates of the preceding June remained at the old Abbey and were taught first-year university subjects by the Loretto Sisters. During the 1911/1912 school year, Loretto College and St. Joseph's College were affiliated with St. Michael's College of the University of Toronto. The College operated within the convent-academy building where the Sisters taught languages. It is now a residence. The Loretto students who attended in 1911 were specifically chosen to start Loretto College, and therefore, the Loretto Sisters always date the birth of Loretto College in 1911. In 1915, four former Loretto students graduated from St. Michael's College. Personal communication with Sr. Juliana Dusel, IBVM, 31 July 2003. For a detailed analysis of Loretto College, see E. Smyth, "'Not…Vital for the College nor interest to the Canadian hierarchy': The Establishment of Catholic Women's Colleges at the University of Toronto." Paper presented to the *Canadian Catholic Historical Association* 3, 20 (1996), 23.

24 Constitutions of 1942, 81.

25 Kerr, 70, 73, 77, 82, 83.

26 The Loretto Sisters often obtained their degrees "extramurally through Queen's University" or through summer schools. Norman, 24.

27 It was not until 1872 that a woman was admitted to university; Mount Allison, in New Brunswick. The University of Toronto first graduated women in 1885. M.L. Friedland, *The University of Toronto: A History* (Toronto: University of Toronto Press, 2002), 88, 93. St. Michael's College did not accept women students until 1912. Norman, "Making a Path by Walking," 24.

28 Mother Agatha O'Neill taught education department courses in Hamilton, ON, and worked for forty years to advance the certificate and university studies in the schools. She had a First Class Normal School Certificate from the Toronto Normal School and had taught since 1866. *LAA*. Loretto Sisters, "One Hundred Years in Retrospect," (Toronto: IBVM, 1965), 9.

29 Constitutions of 1942, 113, 151.

30 *LAA*. Rules and Constitutions of the Congregation of Nuns of the Institute of the Blessed Virgin Mary Founded in Dublin (Dublin: IBVM, 1861), 29, 58.

31 *LAA*. Constitutions of the Institute of the Blessed Virgin Mary Commonly Called the English Virgins, translated from an exact copy of an approved text deposited in the archives of the Institute at St. Polten, the manuscript of which is kept in the archives of the Sacred Congregation of Bishops and Regulars, in Rome (Toronto: IBVM, 1908), 292–293, 297.

32 Constitutions of 1908, 295; Constitutions of 1942, 151–152.

33 *LAA*. Rules of the Institute of the Blessed Virgin Mary (Dublin: Coyne, 1832), 12.

34 Constitutions of 1861, 59.

35 Constitutions of 1942, 115, 125–128, 130–132, 136, 140, 142, 144.

36 The Choir Sisters were usually of the higher classes and better educated. They taught and/or performed administrative work in the convents and schools. The Lay Sisters were usually of the lower or working classes and possessed neither property nor presented with a dowry. They performed domestic tasks in the convents and schools. A. McLay gives a detailed description of their differences in *Women on the Move: Mercy's Triple Spiral. A History of the Adelaide Sisters of Mercy, Ireland to Argentina 1856–1880 to South Australia 1880* (Adelaide: Vanguard Press, 1996), 92.

37 The Loretto Sisters in North America petitioned for the end of the Choir/Lay distinction at the General Chapter of 1937/1938. The distinction came into being in 1943. B.J. Cooper, "'That We May Attain to the End We Propose to Ourselves':

The North American Institute of the Blessed Virgin Mary, 1932–1961" (Ph.D. diss., York University, 1989).

38 Constitutions of 1861, 9, 24–25.

39 Constitutions of 1832, 26, 37.

40 Constitutions of 1861, 31–35.

41 Constitutions of 1942, 79, 83.

42 Ward wrote that "virtue is not to be got by sleeping or crying, that is by slothfulness or anxiety." Ward, in Wetter, *Heart and Mind*, 48; *LAA*. Constitutions of 1908, 180–182.

43 The accomplishments were the curricular norm of education for young women in the late nineteenth century. This kind of education encouraged young women to "excellence in music, modern languages, and painting with an understanding that female achievement must not be used in the public sphere." Very often, the "masculine" subjects of Latin, Greek, Mathematics, and commerce were absent from such a curriculum. For a more detailed discussion of the accomplishments curriculum see M. Theobald's "'Mere Accomplishments?': Melbourne Ladies' Schools Reconsidered," in *History of Education Review* 13, 2 (1984), 74.

44 Those students who studied piano paid significantly higher fees than those who did not. In 1865, at Loretto Hamilton, for example, a boarder who studied music would have paid $132 per annum, while a day student without music instruction paid $28 to $32. Hamilton Public Library Special Collections (Hereafter referred to as *HPLSC*). "Terms," in *The Daily Spectator*, 5 September 1865. Microfilm #212.

45 *HPLSC*. "New Addition to Old Academy (January 1934)," in *Loretto Hamilton Centennial Academy Yearbook* (Hamilton: Loretto Sisters, 1965).

46 Constitutions of 1908, 181.

47 Ward, in Wetter, *Heart and Mind*, 71, 111–112.

48 The Constitutions of 1832 stated as its aim to perfect and save "our neighbour, by the instruction of the female sex"; the Constitutions of 1861 "to always endeavour to instill in children's minds a spirit of true and solid piety"; the Constitutions of 1908 to educate "girls in a truly Christian life"; and the Constitutions of 1942 to instruct "girls and their spiritual formation."

49 *LAA*. Constitutions of 1908, 180.

9

Writing a Congregational History: The Insider Problematic

Veronica O'Reilly, CSJ

In the autumn of 1936, Sister Aloysius Kennedy was novice director for the Sisters of St. Joseph of Peterborough. Sister Aloysius reminded two of her charges at the Kirkfield mission that the "ever present danger from Communists should help to make us saints."[1] The novice director's reminder of the political picture of the time was intended to minimize the domestic drama playing itself out among the Sisters of St. Joseph of Peterborough. In their 22 associated convents in Ontario and two in Alberta, rumours were flying that the northern Ontario missions were about to be separated from their Peterborough mother house. It was not idle speculation. Fifteen years earlier, in 1921, such a separation in the northeastern Ontario diocese of Pembroke had hived off three of their missions and some 27 of sisters as the base of a new foundation there.[2] Not surprisingly, the air was electric during the 1936 summer retreats at the Peterborough mother house and in the northern missions. As with other religious congregations of women and men directly subject to the authority of diocesan bishops, the Sisters of St. Joseph were keenly aware that forces beyond their control engineered such divisions. Pembroke was a case in point, as was the Peterborough congregation's separation in 1890 from the mother house of the Sisters of St. Joseph of Toronto. In both cases, diocesan bishops had exercised the right given them in church law to determine the configuration of religious groups within their jurisdictions.[3]

By 1936, the northern Ontario contingent of the Peterborough congregation comprised 169 sisters, or about 43 per cent of the total membership of 395. Although these sisters in the north operated within the diocesan boundaries of Sault Ste. Marie, carved out of Peterborough diocese in 1904, they remained connected to the Peterborough mother house and under the authority of the Peterborough bishop.[4] In the vast Sault diocese, stretching from North Bay on the shores of Lake Nippissing westward and northward towards the eastern limit of the Rainy River district, the Sisters of St. Joseph of Peterborough managed 21 educational establishments and two acute care hospitals. Nine convents established variously at Fort William, Port Arthur, Sault Ste. Marie, Sudbury and North Bay sustained their community life and apostolate. By the late 1930s, it was becoming apparent that this configuration of personnel posed serious issues: the mission houses of the Sault diocese were hundreds of miles distant from the administrative centre at Peterborough, and direction from two diocesan bishops complicated decision making. The stage was set for a move towards northern autonomy.

As North Americans struggled out of the Great Depression and Europe moved to the brink of war, the Sisters of St. Joseph of Peterborough became the focus of a canonical procedure that led to a major division of the congregation. Between February 1936 and August 1937, the local ordinary of the Sault Ste. Marie diocese, Bishop Ralph Hubert Dignan, took steps in Canada and in Rome to circumscribe the northern missions of the Sisters of St. Joseph as an independent foundation under his control. One hundred twenty of the sisters, or about 30 per cent of the total Peterborough congregation, eventually formed the base of this new group.[5] Mission assets in the five northern cities remained with the Sisters of St. Joseph of Sault Ste. Marie, although Rome would eventually determine a token cash settlement.

Among the several partitions that have occurred among the Canadian Sisters of St. Joseph, this particular severance appears to have been clouded by mystery and freighted with strong emotion.[6] At the time of my entrance into the Peterborough congregation of the Sisters of St. Joseph two decades after the event, an unwary reference to the separation was met with the silence usually reserved for public funerals. Twenty-five years further on, in 1982, a dramatic re-enactment of the event was proposed for a community gathering at Peterborough. The suggestion was gently but firmly dismissed with murmurs of "too soon, too painful for those who went through it." However, in that same decade of the 1980s and in subsequent years, warm

and frequent interaction between the Sault Ste. Marie and Peterborough sisters opened the way for a more objective exploration of the late 1930s events. An obvious forum was provided in 1992, when the Canadian Federation of the Sisters of St. Joseph commissioned me to write a history of their combined works since the order's 1851 founding in Toronto.[7] The task involved collating existing data derived from primary sources plus further research to assess critically the sisters' contribution to education, health care and social work in Canada. It became clear at the outset that periodic fracturing into separate foundations such as that in the Sault diocese was an integral part of the 150-year mission history. In each case, the ruptures were declared essential to the furthering of good works in a specific geographic and ecclesiastical territory. As a case in point, the architect of the Sault congregation argued that a religious institute governed in the northern diocese could give more and better local care to orphans, the frail elderly and the sick.[8]

The Federation's choice of an inside chronicler of these events was deliberate, since I benefited from the several privileges accruing to membership: trust, gender and kinship in the subculture, and access to esoteric lore. That said, the challenge of objective recounting, inasmuch as that is possible, was particularly stiff when moving away from numbers, place names and dates to interpretative comment on an event such as the separation. I was very aware of predispositions arising from the very fabric of the historical surround and long familiarity with certain of the *dramatis personae*. As a "family" member, I knew also that expectations inhered respect for the sensibilities of the living and the good name of the deceased who were not present to sue for defamation of character. Both written and oral sources available provided nuanced versions of the relevant events, and my task was to set these out synoptically, trusting that discerning judgment could deliver a reasonably accurate account. In the final analysis, I agreed with French historian Claude Langlois, who said that the Sisters of St. Joseph, as with other congregations of women religious, wants to be described as it really is.[9]

As a religious insider, in this case a double insider, I had access to an impressive range of historical data. These included, at a primary level, constitutions, directories, annals, chapter directives, governance council minutes and leadership circulars. Among this cache of official documentation were financial reports to church and government, necrologies and celebratory tracts, personal journals of inner spiritual lives, recorded interviews, and original works of drama, poetry and music. The

language of official documents such as decrees and constitutions generally precludes personal bias, but the same cannot be said of annals and general council minutes, which have considerable status in themselves.[10] In these, the recorder's personality and preferences may well leave their imprint on the material. Outsider historians may have much the same access; for the insider, a rich oral tradition in which she shares plus closely guarded in-house accounts may gloss some of the material; they certainly allow for a uniquely qualifying footnote or three. As an insider, I found that an important challenge lay in exploring the archival material within the public as well as the subcultural context of its moment. New insights occasionally emerged when insider information was allowed to resonate within the archival contexts of diocesan centres, board offices and government ministries, as well as religious and secular media reports. Sisters' private views were qualified alongside those of institutional personnel, and former residents and pupils. The insider problematic centred on the task of allowing an authentic picture to emerge from this reticulation, without second guessing any of the material on the grounds of special knowledge or personal indignation. There was neither a great deal of secular involvement nor much media interest in the Peterborough–Sault Ste. Marie separation. But there was a goodly amount of public and private documentation within ecclesiastical circles beyond the congregation. I offer a few reflections on this interplay among established perspectives of public and private sources. Within that nexus of fact and foible, the search for an authoritative voice focused sharply the hoary dilemma of objectivity for the engaged interpreter.

The writer approaching this particular separation story is immediately struck by anomalies attendant upon the legal process by which it was effected. In the nine months between March and November 1936, it became clear that Bishop Dignan, under his own volition and despite the express disapproval of the Peterborough bishop, Dennis O'Connor, had established an independent congregation of the Sisters of St. Joseph. Bishop Dignan issued a decree to that effect under his episcopal coat of arms on November 5 of that year, proclaiming the foundation of the Sisters of St. Joseph of Sault Ste. Marie to be authorized "with the permission of His Eminence Cardinal La Puma, Cardinal Prefect of the Sacred Congregation of the Affairs of Religious ... in the presence of the Reverend Adam C. Ellis of the Society of Jesus ... Consultor of the Sacred Congregation."[11]

With this impressive authorization, Bishop Dignan's decree defined the membership as those Sisters of St. Joseph "resident in, or belonging

to our Diocese." Implicit in the definition was the assumption that all 169 sisters living and working in his diocese would remain there and that those women native to the area would return from their missions in other dioceses. In the final statement of the decree, however, Bishop Dignan relaxed the membership imperative to allow for "Sisters not wishing to remain in the Diocese of Sault Ste. Marie." The procedure to be followed in that event, he declared, would be that described in the preface to the sisters' 1926 *Constitutions*. As the decree shrewdly (and accurately) noted, this was the process ascribed to Bishop Richard Alphonsus O'Connor when he separated the Peterborough Sisters from their mother congregation in Toronto.[12] This procedure, when followed, offered each sister in the houses affected by the separation the choice of remaining in the Sault diocese or returning to the mother congregation.[13]

Bishop Dignan, in his decree, declared two actions he had taken to consolidate his foundation. The first was his personal appointment of internal leadership for the new congregation, enjoining on the sisters "absolute and complete obedience" to the authority of the Apostolic See and to himself as local ordinary.[14] Second, he granted permission to the superior general, newly appointed by him, to establish a diocesan novitiate. This was followed by a promise that a regular election of leadership within the congregation would take place "as soon as possible." The same day as the decree was promulgated, November 5, 1936, Bishop Dignan notified the Peterborough authorities, Bishop O'Connor and Mother Bernadine Farry. By letter he stated that he had established the Sault congregation. Prior to doing so, Bishop Dignan, according to an extant letter, notified the mission houses in his diocese, instructing the northern superiors that he and his appointee, Mother St. Philip McGrath, were now in charge of the new congregation.[15] Almost immediately, sisters began "signing" for one or other congregation.

Eighteen days later, on November 23, 1936, the Sacred Congregation for Religious at Rome sent an official letter to Bishop O'Connor, as ecclesiastical superior of the Sisters of St. Joseph of Peterborough. It stated that permission had *not* been given for Bishop Dignan's initiative.[16] No notification of this fact appears to have been made public by either bishop and certainly the sisters making their choice did not know about it. Three months later, in February 1937, Bishop Dignan opened a novitiate at St. Joseph's Academy in North Bay, which place he would eventually designate as the new headquarters.[17] Evidently he took this action, a risky one given the lack of Roman approval, because he trusted that Vatican authorities

would rescind their decision on appeal. And in the early months of 1937, as subsequent events would prove, the bishop had actively lobbied to have that decision overturned on the grounds that the original permission had been validly obtained. Ten months later, in August 1937, his appeal was successful and the apostolic delegate to Canada and Newfoundland officially recognized the new congregation.[18] In the interim, however, great confusion existed as rumours circulated that the first decree was invalid. Sisters who had signed for one or other group were left in an ambivalent situation, and the congregational leadership was in an untenable position. With the allocation of personnel up in the air (29 teaching sisters in the northern schools had opted to return to Peterborough), fulfilling contracts with school boards in the north was impossible for the proposed new congregation. Other ministries were equally under duress. Hospital staffs, community support personnel and music teachers, north and south, were choosing to shift their congregational membership. Paralysis in the regular financial transactions created awkwardness for the mother house and local treasuries in the north. Superior general Mother Bernadine Farry had gone to Ottawa in May 1937 to seek clarification from the apostolic delegate. She was informed that the decree was indeed *invalid*, information that she communicated to every house in the congregation, including those in the Sault diocese.[19] Bishop Dignan's appeal to Rome, however, was moving through helpful channels during this period of confusion. By July 1937, when he had received assurance that he would get the rescript he sought, the Sault bishop once again began to organize his new diocesan congregation. The choices the sisters made were confirmed and the two congregations began to move along their separate paths.

In the best of circumstances, the event would have been stressful. For many sisters who were directly involved in the chaotic uncertainty, with the alleged pressure on both sides to "sign" and the painful parting with friends they loved, the separation became a nightmare that was to haunt them for the rest of their lives.

The Peterborough–Sault Ste. Marie story is available to the insider from at least three distinct perspectives. One such derives from official correspondence, ecclesiastical decrees, diocesan minutes and some general council documentation. A second perspective is that found in an unrecorded oral tradition, and the third emerges from privately written accounts and interviews during and after the event.

Official sources

The official sources corroborate the basic elements of the story but there are some surprising lacunae, omissions that skew the course of events. The archives of the diocese of Sault Ste. Marie holds a key document, the *Memorale* that Bishop Dignan sent to Rome with his first petition.[20] This is a lengthy, quasi-historical document framing his request for a separate congregation within precedent and constitutional precept. The *Memorale* repeatedly states the bishop's desire for additional sister personnel and charitable institutions in his diocese and alleges the reluctance of Peterborough religious authorities to respond to this need. As a supporting argument in the document, he presents internal evidence that Bishop Dennis J. Scollard, his predecessor as bishop of the Sault diocese, both expected and made provision for a separate congregation.

Present in the diocesan archival files, as well, are Bishop Dignan's initial decree of October 6, 1936 (written in Italian and English) and copies of the letters he sent to Bishop O'Connor and Mother Bernadine Farry on November 5, 1936, announcing the separation. There exists, written in Italian, Bishop Dignan's letter of protest to Cardinal La Puma about the rescinding of permission for the 1936 foundation, which he received, he admits, on December 6, 1936. The Sault bishop's letter of protest includes a reformulated petition and plea for a rescript of the permission he believed he originally received. The much anticipated and finally valid permission from the apostolic delegation, dated July 16, 1937, is prominent in the files, along with copies of subsequent letters to the superiors of the Sault mission houses and correspondence with Mother Bernadine Farry at Peterborough arranging personnel and financial transfers. The 1937 diocesan minute book, in which the bishop records the first election, the first reception and the renewal of vows of the sisters in the new congregation, supplies further detail of the event.

Missing and unaccounted for are the 1936 letter of Roman denial, the official account of the novitiate opening in February 1937 and half of a fascinating correspondence with Archbishop James McGuigan of Toronto. Proof that the correspondence occurred, however, is contained in the Toronto archdiocesan archives, which holds Bishop's Dignan's letters to the Toronto archbishop. The correspondence reveals that Archbishop McGuigan shepherded Bishop Dignan's first and second petitions through Roman channels, arranging an effective end run around Bishop O'Connor.[21] The Roman denial is never mentioned on paper between the Sault and

Toronto clerics; in referring to the "setback," Bishop Dignan implies that the cause lay in a mysterious letter sent to Rome from an unnamed North Bay sister, who "sought a quick solution" to the difficulties. Both this correspondence and Bishop Dignan's letter to Bishop O'Connor the previous November make it very clear that the latter had indeed refused his permission for the separation and that the Sault bishop had gone ahead without his permission or his knowledge. Canonically speaking, it could be argued that as local ordinary, Bishop Dignan was within his rights, although custom strongly favoured a consensual agreement among the bishops concerned.[22]

The archives of the Sisters of St. Joseph of Sault Ste. Marie located at their North Bay mother house hold letters from Bishop Dignan to sister superiors at the Lakehead, dated November 4 and 5, 1936, announcing his first decree of establishment. The archives also has copies of the actual 1936 and 1937 decrees of establishment, and the letters arranging money matters. Signatures of those sisters opting for the new congregation are also preserved. General council minutes did not really come into effect in the Sault until after the final re-validation and therefore are not a source of information regarding the initial separation events.

The paucity of official sources at Peterborough is surprising. The archives at the mother house of the Sisters of St. Joseph have copies of the original letter from Bishop Dignan to Mother Bernadine Farry in 1936, announcing the establishment of the new congregation. Two other pieces of archival evidence verify that Mother Bernadine and her council took the bishop's declaration in that letter at its face value and received no countermanding order. According to a letter of the time, Mother Bernadine informed her sisters, including the Peterborough novices, in late 1936 of the need to choose between the Peterborough and Sault Ste. Marie congregations. "You came to help us do God's work, and we were glad to have you, and would be glad to keep you," she reportedly told them. "But you will pray about it, and will do whatever seems God's will."[23] A yellowing packet in the files contains the signed and witnessed statements, dated November and December 1936, of those sisters native to or working in the northern diocese who opted to remain with the Peterborough congregation.

Communications from the apostolic delegate in the months preceding the final confirmation, and correspondence dated in late 1937 about money and dowries and deeds, have been preserved. The latter are polite on all sides, and most of the requested information and transfers appear

to have been supplied and complied with promptly. The official Roman correspondence kept in these archives is noncommittal in bureaucratic fashion but, in the absence of matching correspondence (especially from Peterborough), its prescriptions and circumlocutions suggest a relatively sharp dispute over the ultimate arrangements. It is obvious that Rome, through the apostolic delegation, took in hand the business of bringing on side the Peterborough bishop and superior general and hammering out the property and cash settlements.[24] The most startling gap in documentation of this long and complicated saga is evident at the Peterborough mother house. There, all general council minutes for these pertinent years have disappeared, as has any correspondence of the superior general in the months preceding the final validation.

In the archives of the diocese of Peterborough, apart from official notifications, there is a chilling lack of documents.

Oral tradition

In the years immediately following the definitive 1937 separation, it is possible that sisters of both congregations were too preoccupied with the works at hand, and the leadership too involved in administrative concerns, to assemble documentation or prepare formal accounts of what happened. These religious women evidently resigned themselves with varying degrees of joy to the inevitability of events, given the almost total control of diocesan bishops and the lack of information available to the sisters. A tacit agreement seemed to be reached, founded on the principles of charity and the furtherance of God's reign, to officially put the whole affair to rest. As the Sault annalist, Sister Evarista Walsh,[25] reasoned in somewhat tortured syntax:

> To many Sisters it was a heart-rending separation; true, but we Sisters (at least many of us) know from past experiences – it is the price God in His love asks the Sisters to pay from time to time in order to render the called for need in accordance with the growth of the different Dioceses ... Religious life is made up of renunciation of this world's joys, and immolation of our human nature.[26]

Some years later, a Peterborough annalist, with obvious effort, determined to be upbeat also.

Our daughter community has grown fast, has opened many houses and the work of God is being diligently forwarded. This is the great purpose for which we exist, and the Motherhouse at Peterborough has been well content to start anew to struggle and build, as in the early difficult days at the turn of the century. We have not yet attained the status we had reached in 1937, either in the number of subjects or in the value of our foundations, but we hope we have constantly maintained our spiritual strength.[27]

Both statements reflect the pain of loss and a sincerity of purpose to make the separation part of a larger plan for the good of the mission. This practical and profound spirituality no doubt sustained both congregations in the long run, as it has dozens of religious congregations faced with arbitrary decisions affecting the personal lives of their members.

The high mindedness, however, was not universal. Among some of those most directly affected, an unwritten tradition smouldered and now and then flamed into life, replete with formulaic repetitions worthy of an Homeric epic, coloured by remembered grievances and triumphs, and shot through with black humour and the poignancy of broken relationships. Not surprisingly, this oral tradition was nuanced differently north and south of Nippissing, a discrepancy I noted shortly after entering the congregation in 1956. Two family members were Sisters of St. Joseph: an aunt, Irene O'Reilly, and her first cousin, Kathleen O'Loughlin. The former stayed in Peterborough without a question and the latter signed with great enthusiasm for the Sault. While neither spoke willingly about the separation, it was evident from them and others that two distinct versions of the event existed.

Some of the sisters working in the northern diocese shared Bishop Dignan's feeling that the long-distance administration from Peterborough shortchanged the northern missions and was fiscally conservative, even stodgy. Bishop O'Connor's caution and conservatism in initiatives that were marginally risky was well known. In the minds of several sisters in the north, the personnel and assets of the congregation in the Sault diocese constituted, *de facto*, a separate entity. More than a few of them had spent their entire lives, including their formation years, in Sault missions, and had made their annual retreats, vacationed and studied in that diocese. From their perspective, the women who chose to move with the new congregation were pioneering heroes and Bishop Dignan a courageous architect of the *de jure* separation. As Sister Sheila O'Loughlin avowed,

"He was a lovely man, so zealous for the diocese and so very friendly and helpful to all our Sisters."[28] Survival and maintenance of missions with diminished staffs were immediate issues for the new group, and the sisters faced these with buoyant energy. The membership was largely youthful; opportunities to expand seemed probable, as did the likelihood of leadership positions for those so inclined. Fervid recruitment of candidates was almost immediately successful.[29] Having made their choice, the sisters of the Sault congregation intended to justify it by prospering, and those who entered shortly after the event maintain that little or nothing was said to them about the difficulties of the separation. Some of those women who agonized over their choice admitted the special pain of separation from good friends but tended, like Evarista Walsh, to consider it part of the cost of service.[30]

Some Peterborough sisters felt more aggrieved; they had parted with a large segment of their young and active membership, several of their most vital missions and recruitment bases, and a good deal of valuable real estate. As does the deserted party in a marriage separation, it was difficult not to feel rejected. The sisters' lore has emphasized the angst involved, since those who lived and loved in the northern diocese still felt bound in loyalty and love to the mother congregation in the south. This oral tradition is clearly reflected in an historical account that declares, "the most painful experience of our Peterborough Congregation occurred at the time of the 1937 Separation, when 121 [sic] Sisters volunteered, after much agonizing discernment, to pioneer our daughter congregation in the Diocese of Sault Ste. Marie." [31] Sisters native to the Sault diocese who nonetheless opted to stay with Peterborough told of their own and their families' pain at the very real separation that ensued because of distance and the rarity of home visits. Some few bitterly resented the loss of hospitals, nursing schools, boarding academies and day schools that their hard work and dedication had made possible. In the south, Bishop Dignan was seen as the villain of the piece, indicating that many sisters did not accept the necessity of the separation as he (and others) defined it. One of the mild-mannered elders in Peterborough confessed that every night she prayed for the safe repose of Bishop Dignan's soul.[32] In her eyes, he was guilty of gerrymandering the separation on dubious legal grounds, using his position to intimidate those sisters who wished to stay with Peterborough and bribing with special privileges those who supported the separation. In this version of events, Mother Bernadine, as superior general, was treated in cavalier fashion, was told nothing of the impending separation and was generally ignored

in the process. The bishop of Peterborough appears grossly betrayed by his former seminary pupil, now Bishop of the Sault, reputedly grieving as though for Absalom, "Ah, Ralph, Ralph, I had not expected this from you." Peterborough midrash, too, carries the conviction that a small but determined number of their sisters in the north acted as something of a fifth column, aiding and abetting Bishop Dignan's plan of separation. The notion that these women may have genuinely believed in the necessity and inevitability of the new foundation seems not to figure prominently in at least one oral tradition at Peterborough.

Other perspectives

Three written documents, with quasi-official status, fill in some blanks. They explain and occasionally nuance the oral tradition. Ralph Hubert Dignan, like most bishops, kept a journal in which he took pains to tell his side of the entire complicated process.[33] This remarkable document is full of surprises, revealing a passionate, zealous, opinionated and witty man, understandably determined to place himself in a favourable light. Bishop Dignan confides to his journal that his brother bishop in Peterborough, Dennis O'Connor, brushed him off on his first approach about a separation and firmly opposed any such move.[34] The journal registers his hurt and indignation at the senior bishop's parsimony concerning payments against the North Bay hospital debt, an indication that financial transactions did indeed play a part in the decision to form an independent Sault Ste. Marie congregation.[35] Bishop Dignan cites two verbal conversations with Mother Bernadine while she was visiting her convents in North Bay and alleges her prior agreement to the separation.[36] This startling evidence, if true, challenges the oral tradition among the Peterborough sisters that the bishop effectively kept Mother Bernadine in the dark about the whole matter. In another entry concerning the separation, Bishop Dignan's frankness about his motives is both revealing and somehow endearing. He admits baldly that he wants and feels he has the right to govern independently in his own diocese and, mission concerns aside, intends to claim this right. In the privacy of the journal, he openly acknowledges Rome's denial of his first decree.[37] More dramatically, he alleges Italian fascist politics at high civic and church levels in Canada, Rome and Romania as the primary cause.[38] To 21st-century ears, Bishop Dignan's certainty that he was the victim of a personal vendetta sworn against him by a former apostolic delegate seems a little paranoid, perhaps. Given the political climate of

the late 1930s, however, his allegations may well have basis in fact. Like a good mystery novel, the journal eventually reveals the identity of the mysterious sister whose letter to Rome was supposed to have caused the difficulty, and he directs his pointed accusations about electioneering in the new congregation at this woman, among others.[39] Fortunately, he kept these comments to the pages of his journal, as well as his exasperation with what he considered jealousy among the Sault Ste. Marie congregation's newly elected leadership. This fact, he asserts, proves the "truth" that *monialis bis mulier* (a nun is twice a woman).

Bishop O'Connor also kept a journal, but it records no comment on any part of the process. One entry, dated August 20, 1937, formally acknowledges receipt of the Roman rescript that established the Sault congregation.[40]

One further and important document fills in some blanks from a sister's point of view and serves as counterpoint to the Dignan diary. Sister Ursula Harrington, former general superior in Peterborough and a high school teacher in Fort William at the time of the separation, later wrote at the request of her leadership a detailed account of the 1936–1937 events surrounding the decrees of establishment.[41] Sister Ursula Harrington's handwritten account, obviously based on a personal diary and a formidable memory for detail, accords in dates and times with information verified in official correspondence. It also reveals in telling detail what the major players were actually doing behind the scenes at those times. It is she who records a painful experience for the sisters in particular: Bishop Dignan was precipitate in his haste to consolidate his gains after he made the first decree but before either the mother congregation or the senior bishop was informed. Sister Ursula documents daily, even hourly, the bishop's moves and their calculated impact from the time he drafted the first decree. An entry dated Wednesday, November 1, 1936, states in part:

> Bishop Dignan asked that all the Sisters of St. Joseph's Academy, North Bay and St. Joseph's Hospital, North Bay, assemble in the Academy Chapel at 7:30 p.m. Accompanied by two priests, (one of whom was the Chancellor, I understand) he entered the chapel in full pontifical robes, and read a decree, proclaiming the [nine] religious houses of the Sisters of St. Joseph of Peterborough then located in the Diocese of Sault Ste. Marie as being erected into a new diocesan congregation of the Sisters of St. Joseph.

Her account then follows the bishop to convents in Sault Ste. Marie on November 2 and Sudbury on November 3. A daylong train ride to the Lakehead then brought him, in Sister Ursula's account, to the door of St. Joseph's Hospital in Port Arthur at 10:30 p.m. that evening, where "there was always a room reserved for the bishop." Enjoining silence on the night supervisor who showed him to his room, Bishop Dignan pre-empted the chaplain at Mass the following morning and made his dramatic announcement. Similar visits in all houses at the Lakehead are documented. So, too, is a dinner there on Sunday evening, November 5, to which the local clergy were invited, informed of the decree and, Sister Ursula presumes, asked to co-operate "in urging the Sisters to join the new congregation."

A vivid picture of the confusion the sisters must have felt a month after Bishop Dignan's original proclamation emerges. Of the attempt by congregational leaders to ensure ministerial continuity and legitimate obedience, Sister Ursula records a happening in mid-December 1936:

> Notice [sent] that Sisters would remain in their assignments for the remainder of the school year – regardless of their affiliation or non-affiliation with the new congregation! Also, Superiors remained in office assigned them by authority in Peterborough! From that time until the following May (1937), Sisters were subject to their local Superior, regardless of "their" or "her" affiliation; but, for permission for matters referable to the Superior General, were subject to "Peterborough" Superior General or a "North Bay" Superior General, according to their affiliation recorded on December 8, 1936.

It is only in this account that the mandate to "sign" is recorded.

Sister Ursula carefully worded her account so as not to make any explicit accusations against Bishop Dignan, but the precise documentation of his semi-secret activities builds a fairly damning picture. The very restraint with which Sister Ursula records events, exclamation points excepted, suggests an abiding distaste for the way in which the separation procedure unfolded. When her account is read in tandem with Bishop Dignan's journal entries about the same events, the interpretive dilemma is clear. For the insider or, indeed, the outsider telling the story, the safest route seems to be compilation and presentation of as much verifiable detail as possible. In the end, the reader must make what she or he will of the fallible human beings who played upon the stage.

Conclusion

Not all the information available from the three perspectives is recorded here but sufficient data are present to indicate that the task of telling fairly a story such as the one of the separation is not simple. It is tempting but unwise, finally, for the insider to try to be other than who she is, a partisan scribe. Straining for a perspective that is beyond one's ken can lead to an artificiality of reporting and a self-conscious attempt, in the name of objectivity, to discount points scored by the home team. On the other hand, the insider should at least try to monitor her proclivity to make the enterprise to which she has committed appear in its best light. The best she can do is to search whenever and wherever possible for evidence that corroborates or contradicts the available evidence.

As a congregational insider, approaching this separation event was akin to a first reading of Durrell's *Alexandria Quartet*, in which the same story is written from four perspectives.[42] In this work, the first three novels occur in roughly the same time frame and speak of the same events from the point of view of three protagonists; the last novel is set after a lapse of time and is told by yet another person. Durrell intended this fourth novel, *Clea*, to be a sequel that would unleash the time dimension of the first three and create, if not a *roman fleuve*, at least a sort of epilogue. Three accounts of the 1936–1937 separation, writ very small, also exist: the official recorded perspective, the unofficial recorded picture and the oral tradition. Perhaps the latest telling of this story by an insider, set marginally free by time, reconciliation and new information, can aspire to a sort of objectivity. As an insider with a penchant for literature, I trust that a narrative recounting of private and public sources has the power to organize from chaos and present a reasonable picture of the events. The hope persists that within this, as in all good narrative, sufficient irony exists to critique its own perspective.

Endnotes

1 Letter of Sr. Aloysius to Sr. Lenore and Sr. Margaret Ann, n.d., Archives of the Sisters of St. Joseph of Peterborough [hereinafter *ACSJPet.*]

2 Bishop Patrick Ryan established a motherhouse of the Sisters of St. Joseph of Pembroke in the town of that name and attached the teaching missions at Douglas, Mount St. Patrick and Killaloe.

3 *Code of Canon Law: Latin-English Edition* (Washington, DC: Canon Law Society of America, 1983) # 579, 221.

4 The Sault Ste. Marie diocese was constituted 16 November 1904 from the districts of Nippissing, Algoma and Thunder Bay, including Manitoulin and St. Joseph Islands. For details of its division from the Peterborough jurisdiction see "Bishop's Book," held at Archives of Peterborough Diocese [hereinafter *APD.*] Although the city of Sault Ste. Marie was originally designated as the diocesan seat, the new diocese's first bishop, D.J. Scollard, later moved his headquarters to the pro-cathedral of the Assumption at North Bay. The same city would become headquarters for the Sisters of St. Joseph of Sault Ste. Marie.

5 The official number of 121 includes a postulant, Miss Nora Brennan, who entered at North Bay on 3 February, into a novitiate opened by Bishop Dignan. See "The Journal," in *Sources: Ralph Hubert Dignan,* ed. G. Humbert (Archives of the Diocese of Sault Ste. Marie, 1995) 112 [hereinafter *ADSSM.*]

6 Sisters of St. Joseph of Toronto and Hamilton were established as congregations independent of the Sisters of St. Joseph of Carondelet, Missouri, in 1860; Hamilton remained in an informal connection with Toronto from 1852 until 1856. London Sisters of St. Joseph were separated from the Sisters of St. Joseph of Toronto in 1870.

7 On 20 September 1966 Rome granted formal permission to establish a Federation of the Sisters of St. Joseph of Canada, its constitutive members being the congregations with Ontario motherhouses at Toronto, Hamilton, London, Peterborough, Pembroke and Sault Ste. Marie. Statutes received Roman approval 20 May 1985.

8 Letter of Bishop R.H. Dignan to Bishop D. O'Connor, 5 November 1936, *APD.*

9 Claude Langlois, *Le catholicisme au feminine* (Paris: Cerf, 1984), 14.

10 Canon law requires of all particular churches and the religious institutions under their jurisdiction that careful and accurate accounts of their activities be kept (see Code of Canon Law, #'s 482–491, 1283, 1284, 1306). Within religious congregations duly appointed personnel, usually general secretaries and annalists, carry out these duties, and commentators on the 1917 Code extrapolate from bishops' obligations a like duty of religious to maintain proper archives that would house the official record. See J. Creusen, *Religious Men and Women in the Code* (Milwaukee: Bruce, 1953), 286.

11 R. Uberto, Decreto di Erezione Canonica delle Suore di S. Giuseppe della Diocesi di Sault Ste. Marie, Canada, *ADSSM.*

12 Constitutions of the Sisters of St. Joseph of Peterborough, 1926. The statement in the historical preface (9–10) reads as follows: "In 1889, Right Rev. R.A. O'Connor upon taking charge of the Diocese of Peterborough (then embracing that of Sault Ste. Marie) at once took steps to have the Sisters located at Port Arthur, Cobourg and Fort William Indian Mission formed into a separate diocesan Community. Accordingly in May, 1890, His Lordship notified the authorities at Toronto of his intention, and later sent to the above-mentioned convents a document to be signed by those Sisters wishing to remain in the Peterboro Diocese."

13 In fact, in both the Sault separation and the original Peterborough separation the choice extended to sisters living and working in other dioceses as well.

14 In claiming this prerogative, Bishop Dignan was within his rights. Although for decades honoured more in the breach than in actual practice, Canon Law tacitly included this privilege in its concession to the Ordinary of a female diocesan congregation "full power to confirm or cassate the result of the election as his conscience dictates." See Canonical Legislation concerning Religious: Authorized English Translation, Libreria Editrice Vaticana, Città del Vaticano, MCMXLIX, Canon 506 §4.

15 Letter to Mother M. Rita, Fort William from Bishop R.H. Dignan, North Bay, 5 November 1936, Archives of the Sisters of St. Joseph of Sault Ste. Marie [hereinafter *ACSJSSM*.] Mother St. Rita, superior of the boarding school in Fort William, is notified of the identity of her new superior general (Mother St. Philip) and instructed to assemble her community and read the decree of erection.

16 Ex Secretaria Sacrae Congregationis de Religiosis n. 2605=36, to Rev.mo acExc.mo Ordinario Peterboroughen, signed +FSM Piasetto Secr., Romae die 23 novembris 1936. *APD*. Translated for author by W. Irwin, csb.

17 Decree of Erection of the Mother-House and Novitiate of the Congregation of the Sisters of St. Joseph of Sault Ste. Marie, 8 January 1939, *ADSSM*.

18 Decretum, N.446. 19 August 1937, Delegatio Apotolica Ditionis Canadensis et TerraeNovae, *APD*.

19 U. Harrington, CSJ, "A Brief History of the Beginning of the Congregation of the Sisters of St. Joseph of Sault Ste. Marie," 4 (held at *ACSJPet*.)

20 Memoriale riguardante le Suore di San Guiseppe, *ADSSM*.

21 Letters of Archbishop J. McGuigan, Toronto, to Cardinal Nicola Canali, Rome, 30 March 1936 and from Bishop R.H. Dignan to Archbishop McGuigan 12 April 1937, Archives of the Roman Catholic Archdiocese of Toronto [hereinafter *ARCAT*.]

22 Code of Canon Law, # 595.

23 *ACSJPet*. Letter of Sr. Aloysius Kennedy to Sr. Lenore and Sr. Margaret Ann.

24 Letter of U. Mazzoni, Secretary at Apostolic Delegation, Ottawa, to Bishop D. O'Connor, Peterborough, 4 June 1937; Decretum, 19 August 1937, containing rescript of validation, *APD*.

25 Walsh was a senior member of the Peterborough group who, after opting for the Sault foundation, put together 'retrospective' annals for the new congregation. These included the congregation's experience as the Peterborough foundation from 1890 to 1936.

26 Sault Ste. Marie Annals, 1909–1939, 409 (held at *ACSJSSM*).

27 Annals, n.p., *ACSJPet*.

28 Interview with author at North Bay, 28 December 1996.

29 Reception Book, *ACSJSSM*. See Humbert, "The Minute Book," *ADSSM*.

30 Interview with Sr. M. Lalement, North Bay, 18 July 1996.

31 *As the Tree Grows: Celebrating 100 years of the Sisters of St. Joseph of Peterborough 1890–1990* (Peterborough: Sisters of St. Joseph, 1993), 187.

32 Interview with author at Peterborough, 24 May 1992.

33 Humbert, "The Journal," *ADSSM*.

34 Ibid., 59. Bishop Dignan notes that he met with Bishop O'Connor at Peterborough 14 February 1936 and proposed "that the 166 Sisters of St. Joseph laboring within the diocese of Sault Ste. Marie be constituted an independent diocesan congregation." He states that O'Connor was "very opposed to the idea and would not give his consent to the division."

35 Ibid., 109.

36 Ibid., 62, 66.

37 Ibid., 111. Dignan acknowledges receipt of a rescript from the Sacred Congregation, 7 December 1936, to the effect that "it was not expedient to grant the division."

38 Ibid., 110–11.

39 Ibid., 114.

40 Bishop's Book, 76, *APD*.

41 Harrington, 1–5.

42 Lawrence Durrell, *The Alexandria Quartet: Justine, Balthazar, Mountolive, Clea* (London: Faber and Faber, 1962).

Teaching Sisters, Leading Schools: Two 20th-Century Canadian Women Religious in Educational Leadership[1]

Elizabeth M. Smyth

I must say I admire the nuns. When I write my obituary, the one thing I'm going to say is that being a sister allowed me the privilege of knowing high-quality women who saw their duty and who pursued it with the utmost conscientiousness. That to me was the most outstanding privilege.[2]

When the late School Sister of Notre Dame Margaret Traxler (1924–2002), educator, feminist, social justice activist and co-founder in 1969 of the National Coalition of American Nuns, spoke these words to journalist Carol Reed, she stressed that, as a sister, she had lived her life as part of a unique cohort of women. In the United States, Canada and elsewhere in the world, women religious provided leadership in education, social service, health care, organized religion and politics; yet to a large extent the historical record of their contributions is either non-existent or minimal.[3]

Religious vocation defined the life of a woman religious who undertook leadership in an educational setting. Whatever title she was given or role she played, she was a member of a religious congregation and to that congregation she was bound by her vows. In addition, her vows sealed her commitment to live her life in the religious spirit of her community,

including her involvement beyond the convent walls. Especially in the period before the Second Vatican Council, her daily life, in all its minutia, was highly regulated by the community's constitutions and customs: how and when she rose and slept, ate and prayed; how she dressed and walked; when and at what she recreated; and all that she did in her congregation and professional life.

Community was the key feature in the lives of women religious – and that community both supported and exerted pressure upon them. The leadership women religious gave – either in the secular or the religious world, whether by happenstance or by careful orchestration – occurred within their chosen community. Initially, the pressure and support of their congregations created many tensions, both personal and professional. Additionally, the tensions between their dual professional lives contributed to a continuous reshaping of their lives. Third, sister teachers lived at the intersection of gender and religion. Finally, they were individuals living among women within a male-dominated organization.[4]

This essay analyzes the experience of two 20th-century Canadian women religious, Sister Genevieve Williams, Order of St. Ursula, and Sister Mary Lenore Carter, Sister of Providence of St. Vincent de Paul of Kingston, whose leadership developed in different ways. Both women served as teachers, teaching supervisors, educational activists and general superiors of their religious congregations. While the impact of both sisters' careers can be viewed from congregational and public perspectives, this essay uses the congregational lens to explore the career of Sister Genevieve and the lens of public perspective to explore that of Sister Lenore. These two women religious and the congregations of which they were members are being studied as part of a larger course of research on Canadian women religious and their enterprises in education, social service and heath care. Sisters Genevieve and Lenore were chosen for study because they are members of different congregations, they were leaders in different generations and in different aspects of education, and the questions their lives raise stimulate further scholarly investigation.

Sister Genevieve Williams

Mary Margaret Eleanor Williams (1871–1946), known in religion as Sister Genevieve, was a member of the Ursulines of the Chatham Union. The Ursulines are a congregation dedicated to education. They were founded at Brescia, Italy, in 1535 by Angela Merici. It was from the Ursuline

foundation in Tours, France, that the first Ursuline congregation was established in Canada, by Marie Guyart (Mother Marie de l'Incarnation) in 1639. The branch of which Sister Genevieve was a member was established in 1860 in Chatham, a small agricultural town in southwestern Ontario, by Yvonne de Bihan, an Ursuline from Le Fouet, France. In keeping with their orientation as a congregation of teachers, the Ursulines founded a day and boarding school, set in a grove and aptly named The Pines, at their convent mother house. The Ursulines became a dominant group within the separate school teachers in southwestern Ontario and, in time, expanded their work into the higher education of women and the education of exceptional children. In addition, the Ursulines offered music education at the Pines and in the smaller convents that they established to house the sisters teaching in the Catholic schools.

Sister Genevieve was from a large family that placed high value on faith and learning. Born near Chatham, she was the second youngest of nine children. At age 19, she entered the Ursulines of the Chatham Union and rose through the ranks from teaching sister, through the positions of religious superior, supervisor of teachers and member of the congregational leadership team, to the highest office, mother superior. Henceforth, she was known as Mother Genevieve. At her death, the congregation directed one of its members, Madeleine Fernande Rosier (Mother Marie Rosier), to write her biography, as is the custom among the Ursulines of the Chatham Union (and indeed, among many congregations of religious). This unpublished manuscript, *Joy in the Pattern: A Study of the Ursuline Life and Teachings of Reverend Mother M. Genevieve Williams*, is a rich collection of Sister (and later Mother) Genevieve's writings, copies of documents she generated and a narrative of her life. It is from this source that many of her words are drawn.

Unlike in many jurisdictions, Catholic schools in Ontario exist as one of two funded public school systems: one Roman Catholic, called separate; and one non-denominational, called public. As was typical of some teaching sisters of her generation, especially those who joined a congregation whose mother house was outside of the major centres of population, and located some distance from the teacher education institutions, Sister Genevieve received her initial teacher education within the congregation, as part of her training as a novice. Until 1899, she taught on a letter of permission, an Ontario department of education document that enabled her to teach without possessing state-sanctioned teacher education qualifications. As soon as the opportunity for formal

teacher education presented itself, she pursued it. She attended the first special summer school for women religious held under the auspices of the newly opened normal school in London in 1899. As state regulation over teacher education became more dominant, women religious who were assigned to teach in publicly funded schools found themselves meeting the ever more exacting certification demands. The sisters were mandated to follow provincial curricula and were subject to annual inspection by two governing bodies: the state and their religious congregation. Sister Genevieve's life evidenced these changing trends.

Sister Genevieve's career advanced in the schools of southwestern Ontario, where she became a teacher, a supervisor and a superior, acquiring the necessary knowledge and skills while on the job. In later years, she commented on her lack of opportunities for formal education:

> Those fields that were always so alluring to me, but that have long since been laid away with other buried desires ... I am not regretting the past. I know we of earlier days made good use of the opportunities that came our way. These opportunities were not numerous, but they were scarce in convents all over North America at the time. And everything was arranged by Providence.[5]

In the fall of 1919, Sister Genevieve was assigned two new roles: superior at the recently acquired Glengarda property and supervisor of the seven Ursuline schools in the town of Windsor. This latter role offers an initial glimpse of Sister Genevieve's developing leadership abilities.

Although the Ursulines of the Chatham Union are related by founder and by initial constitution to the Ursulines of Paris, the realities of life in nineteenth-century Ontario dictated that the documents governing the daily temporal and spiritual lives of the religious (the constitutions, rules and customs) be modified to the conditions the sisters encountered. These included teaching boys, teaching outside the convent walls and teaching the provincial curriculum. In her role as supervisor of schools, Sister Genevieve gained firsthand experience that led to the revision and subsequent publication of the congregation's teaching manuals.

Sister Genevieve's writings reveal the proactive role the congregation took in managing the professional development of its teaching sisters. Sister Genevieve explained the role of the supervisor to the members of the congregation:

The purpose of having a supervisor is to find out what each school has of excellence to contribute to the general good of the Order. Her intercourse with you will arise from the experience she gathers in visiting our different school rooms and from getting from you the best you have to give. The Supervisor's visit is not intended as a period of entertainment but of regular teaching.[6]

Any 21st-century educator can see that Sister Genevieve was a firm advocate of teacher-centred professional development. She planned grade conferences through input gathered from the teachers themselves. Samples of her agendas for these events show that there were four components: a lesson presented before a group of children and the assembled teachers; following the dismissal of the children, discussion of the lesson and suggested improvements; an essay given by another participant addressing a specific methodology or problem; and planning for a subsequent session.

Sister Genevieve communicated her thoughts in a variety of ways, including meetings and letters. She gave her teachers two guiding principles as their prime directives: "Am I making thinkers of my pupils? Am I teaching underlying principles in each case, rather than forms and problems only?"[7] She advised the teaching sisters to "plan, plan, plan. Leaving nothing to chance … a plan book is a great aid for insuring that solid work shall be done. Some teachers are inclined to be superficial. The keeping of their lesson plans will show them just what they are doing. The weekly tests given for the purpose of the bi-monthly reports should be substantial tests."[8] While she was concerned with how all subjects were delivered, her writings on the teaching of religion are particularly telling. She wrote that religion must be taught well "because notwithstanding, it is frequently the subject which is most poorly taught. Really it is often so badly taught that if it were not a divine doctrine it would have been dead and buried long ago."[9] She cautioned her teachers that religion "must be taught … in such a way that he will have nothing to unlearn or to smile at when he grows up"[10] and advocated "careful preparation of each lesson and applying thereto of pedagogical principles used in teaching other subjects … conscientiously and efficiently."[11] She advised her teachers to set high standards for themselves. She wrote,

We shall never rise above mediocrity, if the quality of our efforts be not alive and vigorous. The very fact of having a task to perform should rouse us. Effort is most healthy. It prevents stagnation. Ask

yourself often: 'Am I making effort or am I drifting?' Be doggedly determined not to drift. There is something gloriously stimulating about effort.[12]

She challenged her teaching sisters:

Do not deceive yourself. You cannot give what you have not. If you have not staunch principles of attachment to duty, if you are not devoted to truth, modesty, simplicity and charity; if you do not entertain noble and kindly thoughts, you shall never implant the seeds of these qualities in the hearts of your pupils. If you have not a firm resolution to grapple with the difficulties of your own life, to accept the trials imposed on you by circumstances, by human nature, by the Rule, by common life, how shall you induce your pupils to accept the sacrifices demanded of them?[13]

Within her words, one can see how Sister Genevieve was guiding the teaching sisters under her charge through the major issues they confronted in their lives as teachers and as religious. She challenged them to develop best practices, as both teachers and sisters.

Her fellow religious recognized Sister Genevieve's administrative skills, and on July 12, 1933, she was elected general superior. As the chief executive officer of the Ursuline congregation, Mother Genevieve oversaw all of the Ursuline enterprises, until her death in office in 1945. She increased her expertise in educational leadership to include higher education, through her work with the congregation's Brescia College, the Ursuline women's college at the University of Western Ontario, and with exceptional children, through the expansion of Glengarda Academy, the innovative residential school for developmentally delayed children. Both institutions extended the continuum of Ursuline education to include diverse needs.

In the time between Mother Genevieve's appointment as local superior and her death as general superior, Glengarda Academy played a prominent role in her career as an educational leader. Glengarda, formally known as Glengarda Ursuline Academy of Our Lady of Prompt Succour, was initially a residence for the sisters teaching in Windsor[14] but in 1935 the Ursulines expanded it in purpose and in prominence. The new Glengarda was described as the brainchild of Mother Kathleen Taylor, who, as director of the school, articulated the origins of the Ursulines' involvement:

We saw the need for specialized attention for retarded children as we taught in the auxiliary classes of the city ... We realized it was impossible to give them the proper care in the large classes. It required a more personal supervision and a closer attention to detail than was permitted in the ordinary school auxiliary class. We believe we have accomplished something. We find a response from our children that we could not get when their attention was more divided. Here we are with them 24 hours out of every day.[15]

In 1938, the fifth year of Mother Genevieve's superiority, a cornerstone was laid for an expanded building. The *Windsor Star* described Glengarda's philosophy and purpose as follows:

... an academy wholly devoted to the education of retarded children. Here the child, mentally backward, who finds it difficult to compete with pupils of an average intelligence in the ordinary school, may advance at his or her own pace and find his or her level. Experience has demonstrated that the backward child has profited by residence in a school of this type. The teachers are carefully selected. They must have the qualifications of mind and character which adapt them for this work ... they must be ingenious in their methods of presentation and observant to note the slightest improvement.[16]

Part of Mother Genevieve's role as general superior was to guide the deployment of her community. When she assumed the office of general superior, Brescia College was entering its eighth year of operation in its purpose-built structure on a hill overlooking the main Western campus.[17] In consultation with her council, Mother Genevieve played an active role in selecting those sisters who would pursue higher education, in preparation for careers at Brescia College. One of those young sisters, Sister St. Michael Guinan, remembered that "Mother Genevieve also gave me a formal obedience to not give up studying until I finished a Ph.D."[18] In preparation for a career as an academic, Sister St. Michael was first sent to Catholic University, in Washington, D.C., to obtain a Master of Arts in sociology. She did this successfully and undertook her role at Brescia College, with the support of Mother Genevieve, to continue studies for a doctorate. But not all the plans that general superiors made would remain intact after their deaths. Sister St. Michael later recalled:

> [Mother Genevieve] had a stroke from which the doctors said she would never recover ... Mother Kathleen was elected General Superior in her place... Shortly after her election Mother Kathleen sent for me and said she was aware that Mother Genevieve had intended that I go for doctoral work ... but she decided against it. Mother Genevieve had died and I remember in my prayer that night saying to her, "You evidently do not have the influence in heaven that you did on earth."[19]

Mother Genevieve's will did eventually prevail and Sister St. Michael completed her PhD at Laval University in 1951.

Mother Genevieve oversaw the further expansion of Brescia's programs with the addition of a home economics department, the only such department on the campus of the University of Western Ontario. To staff this department, she sent Sister Dominica Dietrich for graduate studies at the University of Toronto. Sister Dominica would become dean of the college and general superior of the congregation. Brescia College is and was an example of the Ursuline charism of action through education. As Sister St. Michael explained:

> I am still convinced that the greatest of all poverties is the poverty of ignorance: that the greatest service a Catholic Women's College can offer today's women, to abused minorities and to the Third World poor is to free them from the shackles of ignorance through education and so empower them to free themselves. To me, this is Brescia's mission.[20]

Mother Genevieve's decisions concerning the education of young sisters gave the Ursulines the educated personnel to continue a tradition of leadership. As well, she guided her congregation by expanding the teaching sisters' activities in the schools of Ontario and across the west and implementing a structured, congregationally based professional development program. She supported the enhancement of programs at Glengarda Academy and Brescia College. She oversaw the diamond jubilee celebrations of the Ursuline's flagship boarding school, The Pines, the 400th anniversary of the arrival of the Ursulines in Quebec and the publication of a commissioned history of the community, *From Desenzano to 'The Pines.'*

Mother Genevieve's career is typical of that of a teaching sister in leadership during the first part of the 20th century. Although her leadership

decisions influenced the educational scene outside of her congregation, the focus of her activities was primarily on the Ursuline community. Mother Genevieve died in 1945. The changing times of the post-war era created opportunities for women religious to exercise leadership in different domains. The career of Sister Mary Lenore Carter demonstrates just how much broader some of these opportunities could be, and how a woman religious could exercise leadership within the public sphere.

Sister Mary Lenore Carter

The career of Sister Mary Lenore Carter evidences a different form and style of educational leadership. The Carter family, of which Sister Mary Lenore was a part, played a prominent role in the leadership of Canadian Catholicism throughout the 20th century. On October 28, 2001, The Carter Centre for Excellence in Leadership was officially opened in Aurora, Ontario. Its aims are to facilitate and support leadership development and to provide an atmosphere for the examination of critical issues related to the formation of healthy communities of faith. The centre is named for the Carter family in recognition of the leadership that four of the eight children of Tom Carter and Mary Agnes Kerr gave to the Catholic Church: Alexander Carter, Bishop of Sault Ste. Marie; Gerald Emmett Cardinal Carter, Cardinal-Archbishop of the Archdiocese of Toronto; Sister Mary Carter, Religious of the Sacred Heart of Jesus; and Sister Mary Lenore Carter.

Irene Isobel Carter (1897–1990) was born in Montreal, the second of the eight Carter children. Raised in an Irish-Catholic household, where religion, music and learning were highly prized, she was educated by the sisters of the Congregation de Notre Dame. She was employed as a secretary before she entered the Sisters of Providence of Kingston. In 1916, she received the habit and took the name in religion of Sister Mary Lenore. The community she entered had been established in 1861 as an independent foundation of the Sisters of Charity of Providence of Montreal. The founding superior, Sister Mary Edward McKinley, expanded the original work of the congregation – social services to orphans, the sick and infirm – to include education in the Catholic schools of Ontario.

Sister Mary Lenore's community took its commitment to education seriously. The state demanded certification and Sister Mary Lenore, designated by her community as a teaching sister, went to teachers' college. All teacher education was state-controlled and so Sister Mary Lenore

would have had the same expectations placed upon her, as a woman religious, as any other woman planning to enter the profession. Frequently, beginning teaching sisters were sent to practise teach in public schools, where their religious habits led to many a teachable moment among their young charges, a number of whom had never seen, much less spoken to, a woman religious.

In addition to the teacher education that Sister Mary Lenore received at the Ottawa Normal School, she was inducted into the culture of the teaching sisters within her congregation. As is the case with all religious congregations involved in teaching, the community rule clearly set out expectations for teaching and for the supervision of teachers. The *Rules and Customs of the Daughters or Sisters of Charity, Servants of the Poor and the Sick (1900)* instructed sisters assigned to teach to "diligently prepare for class that they may explain clearly and simply the different subjects they have to teach … taking special pains with the less favoured ones and at the same time careful not to retard the progress of the others."[21] To help the teaching sisters in their work, the directress of the teaching sisters had a number of duties. She had to "render herself capable of forming good teachers," prepare herself with "sufficient knowledge to enable her to solve whatever difficulties [that] may present themselves to the sisters under her direction" and "study the best works in teaching … adopt[ing] those principles which seem to her the best adapted to the method of teaching used in the houses of the Institute."[22] Further, the directress was responsible for annual professional development conferences that integrated religious practices (a retreat) with pedagogy:

> During Vacations the sisters will meet together and discuss the best means to be adopted in order to teach with profit and to promote the welfare of the schools … One or two of these conferences may take place before the retreat and one after the appointment of teachers. During her visits the directress may call together all the teachers of the district if she finds it advisable to do so.[23]

In developing her sense of professionalism, Sister Mary Lenore had the model of both a state-directed teacher education program and an ongoing, congregationally based professional development program.

At the same time as Sister Mary Lenore was gaining experience as a full-time elementary and high school teacher, supervisor of music and finally secondary school principal, she continued her own professional education. By enrolling in part-time study either during the school year

or in the summer, she acquired an array of additional qualifications in a number of subjects (music, guidance, English and French) and divisions (kindergarten, primary, high school), a Bachelor of Arts from Queen's University (1937) and a Master of Arts in English literature from the University of Ottawa (1949), exiting with a thesis entitled *The Quest: The Search for Happiness in Poetry.*

While Sister Mary Lenore had a long and active career as an educational leader within her religious congregation and within the communities she served in Eastern Ontario, it is her work with the Ontario English Catholic Teachers' Association (OECTA) that launched her career as a national educational leader. In 1944, Sister Mary Lenore began an association with OECTA that would lead her to becoming the first woman religious (and the third woman) president of that organization from 1951 to 1953. In 1956–1957, she served as president of the Ontario Teachers' Federation (OTF), the first woman religious to hold this position.

OETCA was formed as a provincial organization on February 18, 1944. It is one of the four teacher unions in Ontario. The *Teaching Profession Act,* which became law on April 5, 1944, established the Ontario Teachers' Federation, the umbrella association for teachers employed in Ontario's publicly funded school systems. Membership is compulsory for these teachers and is based on the sector in which they are employed. Elementary teachers belong to the Elementary Teachers' Federation of Ontario (formed in 1998 with the merger of the former Federation of Women Teachers' Association of Ontario and the Ontario Public School Teachers' Federation, formerly the Ontario Public School Teachers' Men's Federation). Francophone teachers belong to the Association des enseignants franco-ontariens. Secondary school teachers belong to the Ontario Secondary School Teachers' Federation. Teachers employed by the Catholic system, whether elementary or secondary, belong to OECTA. Each of these unions organizes its local membership into districts conterminous with the district school boards. One of the key responsibilities of the executive of these units is to negotiate collective agreements with the publicly elected trustees and the administrative officers of the district school boards.[24]

OECTA is unique among the affiliates of OTF. Its original membership was male and female, religious and lay, and elementary and secondary. In its founding constitution, OECTA declared the following as its purposes:
• to promote the principles of Catholic education by the study of educational problems;

• to work for the advancement of understanding among parents, teacher and students;

• to work for the moral, intellectual, religious and professional perfection of all members;

• to improve the status of the teaching profession in Ontario;

• to secure for teachers a larger voice in education affairs.[25]

Sister Mary Lenore is representative of a number of women and men religious who participated actively in the early years of OECTA. Her presence indicates that, from the outset, some religious congregations supported their members' participation. The significance of this cannot be overemphasized, for not only does this indicate that teachers who were members of religious congregations were interested in collectively tackling issues that had previously been the sole domain of their internal governance structures, but it also illustrates that the congregations were willing to adapt their customs and structured daily rituals to a changing educational environment.

The OECTA archives contain a number of files relating to the activities of Sister Mary Lenore. One, an undated typewritten document, signed in Sister Mary Lenore's hand, details her reasons for her involvement in the federation. She wrote:

> It was through choice that I joined OECTA. I recognized the need for an association of Catholic Teachers in the Ontario Teachers' Federation when the Teaching Professions Act was being drawn up. Only under such circumstances could we have an effective voice in policy making and in protecting the rights of our Catholic schools as well as making known its philosophy.[26]

Her initial involvement with OECTA at the provincial level was as a member of the Adult Education Committee, a subcommittee of one of the ten standing committees. Her work with this committee caused her to live her life as a religious in the public eye. She commented:

> I was principal of St. Michael's high school in Belleville and I recall for many years I left the school at 2:00 pm on Friday afternoons in order to catch the train to Toronto ... often working from nine in the morning until nine Saturday nights. We took a break for supper when we walked ... to a restaurant on Bloor Street where you could get a pretty good meal for a couple of dollars. By Sunday

noon I was back on the train to Belleville. I did this for about 15 years both for OETCA and OTF.[27]

Contrast this excerpt with the following directions contained in the *Rules and Customs* of the Sisters of Providence:

The Daughters of Charity should not forget that the parlour [of their motherhouse] is as dangerous as the public streets or the houses of seculars where they go on their mission of charity. They should hold the parlour in great dread as being a place where, without great vigilance, they may lose much in the matter of religious perfection … Penetrated with holy fear, the sisters will go to the parlour only when obliged to and while in it they will be particularly reserved and modest in their deportment … They will take care that their conversations are cheerful and pleasant and thereby remove the false impression held by worldings viz that the religious life is not a happy one.[28]

Sister Mary Lenore stated how her role in OECTA caused her to break with the common practices of women religious: she travelled alone by public transport; she worked outside of the community all weekend, not participating in community prayers; and she ate her meals in public. With the support of her community, she laid the foundations for her acceptance as an educator who was also a woman religious, by behaving such that her secular colleagues overcame the barriers the religious habit presented. She described her time in OECTA as "time-consuming and onerous, but the broadening influences and the enrichment that it brought far outweighed the difficulties."[29]

Sister Mary Lenore served on the provincial executive of OECTA for ten years. Her commitment and leadership to OECTA exemplify the union's fourth goal: teacher professionalism. Sister Mary Lenore's role as the spokesperson for OECTA gave her a platform from which to articulate her philosophy of education and of teaching. She was an active proponent of values-based curriculum, to which end she founded the Christian Curriculum Development Conference. She spoke passionately about the need to move teachers into an active engagement with what they taught and how they taught it. In her 1953 presidential address, she used her experience at the Association for Supervision and Curriculum Development conference to analyze the important issues in education. She concluded:

> True education is the development of the integrated personality –
> not over and above all else the social efficiency of the individual
> but the development of all the powers of the person: physical,
> mental, esthetic, social, spiritual, to their highest possible
> perfection.[30]

She pointed out that it is the teachers who take the lead in this development
and encouraged teachers to further their own learning:

> We are proud of the enthusiasm with which our teachers have
> entered into the study of educational problems. There is a great
> demand today for adult education and in what better way can a
> teacher advance his or her education than by studying matters
> pertaining to his or her profession. The wider the vision, the
> deeper the understanding, the better teacher he or she will be
> and the greater will be the influence on the pupils.[31]

Sister Mary Lenore believed that, as professionals, all teachers,
including women religious, should be justly compensated for their
services. She successfully advocated for the reassessment of how women
religious were paid and played a key role in initiating the movement that
ultimately saw secular and religious educators receive equal pay for work
of equal value. At OECTA's 1959 annual general meeting, she initiated
the following motion:

> That the Religious and the Lay Committees be discontinued as
> standing committees and that special committees be set up if
> and when necessary, to handle any problems which may arise in
> either or both groups.[32]

Speaking to the motion on the floor, Sister Mary Lenore reminded the
gathering that "the salary for a religious teacher is at least two-thirds of
that paid to a lay teacher having the same qualifications, experience and
responsibility" and clarified that in her opinion "religious teachers could
accept a higher figure than the two thirds where a board was willing to
pay and provided all religious communities were treated alike."[33]

In 1959, the Sisters of Providence elected Sister Mary Lenore to the
office of superior general. Sister Vincentia, a member of the Congregation
of the Sisters of St. Joseph and president of OECTA, acknowledged Sister
Mary Lenore's leadership in her presidential address. "It is with regret
that we learn that Rev. Mother Mary Lenore, whose great wisdom, logical

thinking, keen perception and charming personality is known across the Dominion ... must leave the executive."[34]

As a religious superior, Mother Mary Lenore saw her congregation through times of significant change, including expansion to mission fields in South America and the implementation of the changes in religious life mandated by the Second Vatican Council. As a member of the Canadian Religious Conference, the governing body for congregations of men and women religious, she was the first woman religious to hold the office of president of its Ontario Branch.

As with so many women religious, Sister Mary Lenore never did retire; she merely changed her habit. The state recognized her work in education with the Queen's Coronation Medal. She was elected a fellow of the Canadian College of Teachers and a fellow of the Ontario Teachers' Federation. She was awarded honorary life memberships in the Ontario Association for Curriculum Development and OECTA. The citation for her OECTA Life Membership well assesses her achievements:

> For the inspirational leadership she gave in the many offices she held on committees and on the executive of OECTA and OTF; For the honours she brought to Catholic teachers when she was awarded a Fellowship in both the Ontario Teachers' Federation and the Canadian College of teachers; Always an ardent advocate of the Christian vocation, Mother directed the studies of the young sisters of her own community and has addressed youth and social life groups across Canada.[35]

Sister Mary Lenore continued her active engagement in adult education through retreat work and by participating in community endeavours, until her death at age 92.

Two sisters, two careers

The careers of Sister Genevieve Williams and Sister Mary Lenore Carter exemplify the various types of leadership of Canadian women religious in the field of education. Both women began their careers as members of a religious community: the former, almost exclusively within a teaching community; the latter, involved in education, social service and health care. Both progressed through an induction and socialization process that intertwined their lives as religious and as educators. Yet the two women's careers took divergent paths.

Sister Genevieve remained within a congregation. The Ursulines shaped her own education, both as a teacher and a learner. Her induction into teaching was as a novice and, in the absence of institutes for teacher education, she relied on Ursuline initiatives to guide her growth as a teacher. Although she did attend normal school when the opportunity became available, her own higher education was generally self-directed. This impressed on her the need for young sisters to have opportunities for higher education. She was a leader in the teaching sector of her congregation through her role as sister supervisor. Finally, as general superior, she led her entire congregation in all its enterprises. As congregational leader, she encouraged a number of innovations for groups of learners previously marginalized within the education sector: mentally challenged children and adolescents, and young women seeking opportunities for higher education.

The type of leadership Sister Genevieve undertook and delivered was typical of her era. Congregations of women religious cultivated internal leadership. Mothers superior and their councils annually assessed their members for leadership potential and gave them opportunities within their organizations to develop their talents and skills. Sister Genevieve's community identified her as a candidate for leadership and she did all of her work primarily within the context of her own congregation.

Almost two generations separate the lives of Sister Genevieve and Sister Mary Lenore. Sister Mary Lenore lived her professional and religious life in a much different context than did Sister Genevieve. While not to undervalue the significance of her Kingston-based religious congregation, Sister Mary Lenore had the additional support of her family network, which both she and her congregation undoubtedly used to enhance their enterprises and initiatives. By the time she was a provincial leader in education, she had three siblings who were all very active in religious organizations and education: two of her brothers were bishops and her sister was a member of another religious congregation. It is evident from her travels as provincial president and councillor that she took advantage of the hospitality of her family when addressing annual general meetings and attending conferences. Sister Mary Lenore was also active in the emerging institutions of her time, especially a Catholic teachers' union for both lay and religious. Sister Mary Lenore saw neither her habit nor her life in community as impediments to leadership in this emerging organization; in fact, she saw these elements as both pluses and incentives. She quickly recognized that all individuals, groups and organizations supporting

teacher development, from school principals through district school boards, provincial ministries of education and religious congregations, could be more effective if they worked together. While she advocated the importance of denominationally based curriculum development, and indeed was one of the founders of the Christian Curriculum Development Conference, she also saw the importance of active participation in national groups such as the Association for Supervision and Curriculum Development and the Ontario Association for Curriculum Development.

As is evident in the lives and careers of Sister Genevieve Williams and Sister Mary Lenore Carter, the study of women religious who served as educational leaders can contribute significantly to scholarship in a number of fields. Lives of teaching sisters who led schools and other organizations are studies of how groups induct members into a profession and how groups provide for the ongoing professional growth of those members. As a study of women engaged in leadership at the highest levels, looking at the lives of women religious in education can supply critical missing details concerning women's work in the professions. As a study of a gendered sphere, it can advance our awareness of how gender was constructed within the communities of religious and the enterprises they administered. As a study of women religious and their educational enterprises, it can explore the interplay between secular and religious systems of education. Finally, as a study of women and leadership, it can document shifts in power, authority and decision making within both closed communities and on the wider public stage.

Sisters Genevieve and Mary Lenore were strong-minded women, with definite views on education in general and on the professional development of the teaching sisters for whom they were responsible in particular. At various points in their lives, both women took professional risks and advocated for change within respective communities. Their contributions to the historical record affirm the words of Sister Margaret Traxler. Through their actions and the decisions they made, appropriate to the times in which they lived, both Sister Genevieve and Sister Mary Lenore demonstrated through their lives and careers that they were "high-quality women who saw their duty and who pursued it with the utmost conscientiousness."[36]

Endnotes

1 The author thanks the Archivists and Leadership Teams of the Ursulines of the Chatham Union and the Sisters of Providence of St Vincent de Paul of Kingston for access to the archival materials reviewed here and the Social Science and Humanities Research Council of Canada for support of this ongoing course of research.

2 C.L. Reed, "Faith and Values: Margaret Traxler lived life on front lines of social issues," *Chicago Star Tribune,* 2002. Accessed 20 May 2004 at http://www.startribune.com/stories/614/1915594.html

3 In the English Canadian literature on women and educational leadership, the role of women religious is significantly absent in spite of the pioneering efforts of such scholars as Sr. A.T. Sheehan CSJ, *Role Conflict and Value Divergence in Sister Administrators* (Ph.D. diss, University of Toronto, 1972). In the groundbreaking collection *Women Who Taught* (Toronto: University of Toronto Press, 1991) edited by Canadian feminist historian A. Prentice and Australian feminist historian M. Theobald, no essay is included on women religious – either as teachers or educational leaders – nor did the fine 1995 collection edited by C. Reynolds and B. Young, *Women and Leadership in Canadian Education* (Calgary: Detselig, 1995) include a contribution on women religious. The edited collection of essays by K. Weiler and S. Middleton, eds., *Telling Women's Lives* (Buckingham: Open University Press, 1999), and the series of case studies by K. Casey, *I Answer With My Life* (New York: Routledge 1993), offer theoretical constructs against which to analyze the experience of women religious as educational leaders. In addition, some studies that have explored women religious as educational leaders in higher education. Among these are T. Corcoran, *Mount Saint Vincent University: An Unfolding Vision 1873–1988* (Lanham: University of America Press, 1999); M.O. McKenna, *Charity Alive: The Sisters of Charity of Saint Vincent de Paul, Halifax, 1950–1980.* (Lanham: University of America Press, 1988); J. Maynard, "Catholic Post-secondary Education for Women in Quebec: Its Beginnings in 1908," *CCHA Historical Studies* 59 (1992): 37–48; H. MacDonald, *The Sisters of St. Martha and Prince Edward Island Social Institutions, 1916–1982* (Ph.D. diss., University of New Brunswick, 2000); E.M. Smyth, "Sister Colleges: Women Religious and the Professoriate," in P. Stortz and E.L. Panayotidis, eds., *Historical Identities: The Professoriate in Canada* (Toronto: University of Toronto Press, 2005). Australian educational historian S. Burley has contributed to this literature through her work on the Mercy Sisters: "The Staffroom: Consensus, Conflict and Contradictions," in F. Gale, ed., *Making Space: Women and Education at St Aloysius College Adelaide 1880–2000* (Ken Town, SA: Wakefield Press, 2000), 71–98; and S. Burley and K. Teague, *Chapel, Cloister and Classroom: Reflections on Dominican Sisters at North Adelaide* (Adelaide: Lutheran Publishing House, 1993). For New Zealand, see J. Collins, *Hidden Lives: The Teaching And Religious Lives Of Eight Dominican Sisters, 1931–1961* (M.A. diss., Massey University, 2002). In the Irish literature,

the leadership endeavours of women religious are somewhat more represented. See for example M. MacCurtain, ed., "Religion, Science, Theology and Ethics, 1500–2000" (459–9) and A. Connor, ed., "Education in Nineteenth Century Ireland" (647–739) in A. Bourke, S. Kilfeather, M. Luddy, M. MacCurtain, G. Meanet, M. Ni Dhonnchadha, M. O'Dowd and C. Wills, *The Field Day Anthology of Irish Writing,* (Cork: Cork University Press, 2000). In the American literature, the work of women religious as educational leaders in education in general and higher education in particular is more represented. In addition to the review article by C. K. Coburn, "An Overview of the Historiography of Women Religious: A Twenty-Five-Year Retrospective," *US Catholic Historian* 22 (1): 1–26, see also, for example, J.A. Eby, *A Little Squabble Among Nuns? The Sister Formation Crisis and the Patterns of Authority and Obedience Among American Women Religious 1954–1971* (Ph.D. diss., St. Louis University, 2000); M.J. Daigler, ed., *Through the Window: A History of the Work of Higher Education Among the Sisters of Mercy of the Americas* (Scranton: University of Scranton Press, 2000); A. Harrington and P. Moylan, eds., *Mundelin Voices: The Women's College Experience 1930–1991* (Chicago: Loyola, 2001); T. Schier and C. Russett, eds., *Catholic Colleges for Women in America* (Baltimore: Johns Hopkins, 2002); M.C. Chandler, *Supporting the Social Identity of Women Religious: A Case Study of One Apostolic Congregation of Women Religious in the United States* (Ph.D. diss, Graduate Theological Union [Berkeley], 2001); B. Puzon, ed., *Women Religious and the Intellectual Life: The North American Achievement* (San Francisco: International Scholars Press, 1996); M. Oates, ed., *Higher Education for Catholic Women* (New York: Garland, 1987).

4 For further discussion, see E.M. Smyth, "Writing the History of Women Religious in Canada (1996–2001)," *International Journal of Canadian Studies* 23 (Spring, 2001): 205–11; E.M. Smyth, "Preserving Habits: Memory Within Communities of English Canadian Women Religious" in S. Cook, L. McLean and K. O'Rourke, eds., *A Century Stronger: Women's History in Canada 1900–2000* (Kingston and Montreal: McGill-Queen's Press, 2000), 22–26; E. M. Smyth, "'Writing Teaches Us Our Mysteries': Women Religious Recording and Writing History," in A. Prentice and B. Boutilier, eds., *Creating Historical Memory: English Canadian Women and the Work of History* (Vancouver: University of British Columbia Press, 1997); E.M. Smyth, "Professionalization Among the Professed," in E.M. Smyth, A. Prentice, S. Acker and P. Bourne, eds., *Challenging Professions: Historical and Contemporary Perspectives on Women's Professional Work* (Toronto: University of Toronto Press, 1999), 234–54.

5 As quoted by Mother Marie Rosier, *Joy in the Pattern: A Study of the Ursuline Life and Teachings of Reverend Mother M. Genevieve Williams* (London, ON: unpublished manuscript, Brescia College Library, 1951).

6 As quoted by Rosier, 73.

7 As quoted by Rosier, 76.

8 As quoted by Rosier, 77.

9 As quoted by Rosier, 74.

10 As quoted by Rosier, 75.

11 As quoted by Rosier, 75.

12 As quoted by Rosier, 84.

13 As quoted by Rosier, 85.

14 For a fuller discussion of this history, see the commissioned history of the Ursulines of the Chatham Union by Mother St. Paul, *From Desenzano to "The Pines"* (Toronto: Macmillan, 1941).

15 As quoted in D. Pink, "Glengarda main offering is care, love for children," *Windsor Star*, np, 17 May 1985.

16 As quoted by Pink, "Glengarda."

17 For a fuller discussion of Brescia's history, see P. Skidmore, *Brescia College 1919–1970* (London: Brescia College, 1980) and E.M. Smyth, "'Writing Teaches Us Our Mysteries': Women Religious Recording and Writing History," in A. Prentice and B. Boutilier, eds., *Creating Historical Memory: English Canadian Women and the Work of History* (Vancouver: University of British Columbia Press, 1997), 101–128.

18 Guinan, Mother St. Michael, *Meandering With Memory* (London, ON: Brescia College, 1995), 48.

19 Guinan, *Meandering*, 62.

20 Guinan. *Meandering*, 147.

21 Archives of the Sisters of Providence of St Vincent de Paul of Kingston (*ASPVK*), *The Rules and Customs of the Daughters or Sisters of Charity, Servants of the Poor and the Sick* (Kingston: Sisters of Providence, 1900) (hereafter *Rules and Customs*), 266–7.

22 *ASPVK, Rules and Customs*, 269.

23 *ASPVK, Rules and Customs*, 270.

24 R. Dixon, *Be a teacher: A History of the Ontario English Catholic Teachers' Association 1944–1994* (Toronto: OECTA, 1994).

25 Ontario English Catholic Teachers' Association Archives (hereafter *OECTAA*). OECTA. *Constitutions and By-Laws of OECTA 1946.* (Toronto: OECTA.)

26 *OECTAA.* Sr. Mary Lenore Carter, SP. Undated signed notes. File: "Sister Mary Lenore SP. OECTA President 1951–53."

27 *OECTAA.* As quoted by G. Dobec, "OECTA Provincial and the Belleville Connection." *OECTALK* #8 June (1984).

28 *ASPVK, Rules and Customs*, 179.

29 *OECTAA*. Sr. Mary Lenore Carter, SP. Undated signed notes. File: "Sister Mary Lenore SP. OECTA President 1951–53."

30 *OECTAA*. Sr. Mary Lenore Carter, SP. "President's Address: Anniversary Reflections" OECTA Annual General Meeting April 7 (1953).

31 *OECTAA*. Sr. Mary Lenore Carter, SP. "President's Address: Anniversary Reflections" OECTA Annual General Meeting April 7 (1953).

32 *OECTAA*. Sr. Mary Lenore Carter, SP. Motion to the OECTA Annual Meeting 21 March (1959).

33 *OECTAA*. Sr. Mary Lenore Carter, SP. Motion to the OECTA Annual Meeting 21 March (1959).

34 *OECTAA*. Sr. Vincentia, CSJ. Presidential Address. Annual General Meeting, April 20 (1960).

35 *OECTAA*. OECTA Life Member 1958–1977.

36 As quoted by Reed.

II

The Process of Transformation: Women Religious and the Study of Theology, 1955–1980

Ellen Leonard, CSJ

This essay examines the relationship between women religious and theology from 1955 to 1980. This was a critical period for women religious that includes the years immediately before the Second Vatican Council, the years of the Council (1962–1965) and the period following the Council. These were years of great change in the Roman Catholic Church and in the lives of women religious. They were also years of profound change in theology and in theological education, as Catholic theologians moved away from the restrictions of neo-scholasticism and began to employ other theological methods.[1] Theology had previously relied on the philosophy of Thomas Aquinas as its dialogue partner. Implicit in this partnership was the belief that there was an unchanging body of truths to be preserved. Whereas in the thirteenth century Aquinas himself had been an innovator in his use of Aristotle as his dialogue partner, his brilliant work had later been reduced to textbook answers, often addressed to unasked questions. During the period under study, theologians turned to contemporary philosophy, history and the social sciences. New voices emerged along with the traditional male European clerical voices, as lay people, women and men from various contexts, brought new questions and concerns to the theological enterprise.

How did the study of theology affect women religious? How did women religious introduce new theological voices to what had been a clerical preserve? I draw upon my experience as a member of a religious congregation, the Sisters of St. Joseph of Toronto, during this turbulent and exciting time, as well as my experience as a student and later as a professor in the faculty of theology at the University of St. Michael's College. Similar studies could be done on the experiences of professors and students at Saint Paul University in Ottawa or Newman College in Edmonton as well as seminaries such as that at Laval in Quebec.

Women religious before Vatican II

The lives of pre–Vatican II women religious were regulated by rules that were monastic in origin.[2] The 1917 *Code of Canon Law* laid out prescriptions for all women religious that were very different from the visions of the women who founded apostolic religious congregations – often creative women responding to a particular need of their time by joining with other women to carry out their project. Those who succeeded the founders became bogged down with numerous rules and regulations covering every aspect of their lives. While living a highly structured monastic life, apostolic women religious were also heavily involved in education and health care. The ideal was to carry out one's apostolic activity and then quietly return to the convent and a monastic, communal life. This demanding schedule often included study for accreditation in apostolic ministry.

At times, young sisters were assigned work for which they were not adequately prepared. In response to this situation, the Sister Formation Movement in the United States was established in 1954 to educate sisters theologically as well as professionally. Much of the vision and effort that inspired and developed this program came from Sister Madeleva, a Holy Cross sister who served as president of St. Mary's College, Notre Dame, Indiana, for 27 years. Madeleva wanted women religious to be well-trained, professional women.[3] Through her untiring persistence, sisters obtained degrees before embarking on their apostolic ministry in education or health care. Often the sister's education took place in colleges owned and operated by the religious congregation to which the sister belonged.

In Ontario during this period, teachers in elementary schools were not required to have a degree. Many sisters, including me, attended Toronto Teachers' College and later the University of Toronto extension program

in the evenings and summers. Thus, our academic preparation took place over a number of years and lacked an adequate foundation in theology, although we had excellent lectures given by Basilian and Jesuit priests, including scripture scholars David Stanley and R. A. F. McKenzie, both professors at Regis College, the Jesuit seminary. These lectures were usually on Saturday afternoon and were offered for all the women religious in the Toronto area who wished to attend.

Although women religious were not yet involved as theologians, they were not strangers among the teaching staff and the student body of undergraduates at St. Michael's College, a federated college of the University of Toronto. As early as 1911, sisters from St. Joseph's College and Loretto College were registered through St. Michael's and received their degrees from the University of Toronto. The first woman graduate was Sister Mary Agnes Murphy. The women had separate classes at St. Joseph's and Loretto until the early 1950s, when they were fully integrated into the classes at St. Michael's. Sister professors taught English, French and Latin, while priests taught the course on religious knowledge.[4]

During the pre–Vatican II period, sisters were often discouraged from studying psychology or philosophy, and were only taught theology in a modified form, religious knowledge. Psychology was viewed with suspicion and some priest professors considered women incapable of the abstract thinking required to study philosophy and theology. For sisters responsible for preparing their junior sisters to teach the courses required in secondary schools this lack of training was a concern.

Until the mid-1960s, the Church provided theological education almost exclusively for male seminarians who were preparing for ordained priesthood. The young men lived in the seminary and were taught by male professors. During this period, opportunities for women to undertake graduate study in theology were limited. The first theology program for Catholic women took place at St. Mary's College in Indiana. In the summer of 1944, the School of Sacred Theology was established through the initiative and leadership of Sister Madeleva and with the approval of Pope Pius XII. The school developed a graduate program that granted doctoral degrees in religion. Reflecting on these developments, Sister Madeleva wrote, "Once Saint Thomas might have had to prove that women have souls. Now he can regard happily their Thomistic minds and the home in which they honor his *Summa*."[5]

The Vatican created Regina Mundi in Rome in 1953 for the education of sisters, closely following the St. Mary's program. The Catholic University

of America in Washington also provided summer programs in theology. St. Mary's College offered graduate degrees from 1946 to 1970. During this period, the school granted 76 doctoral and 354 masters degrees to both religious and laity.[6] Once women religious had been admitted to theological study, laymen and laywomen sought this education as well. The fact that the degrees were in religion rather than in theology suggests that theology was still considered the prerogative of the clergy.

Among St. Mary's illustrious early graduates were two women whose voices were to influence feminist theology: Mary Daly and Margaret Brennan. Mary Daly, who graduated in 1954, went on to pursue degrees in philosophy and theology in Europe, where she was the only woman among classes of clerical students. Her book *Beyond God the Father* is a powerful critique of Christianity.[7] Daly taught for many years at Boston College, a Jesuit school. She continued to publish and to provide a strong post-Christian feminist voice.[8] Margaret Brennan (formerly known by her religious name, Sister Benedicta) graduated from St. Mary's in 1953. She served in the leadership of her congregation, the Sisters of the Immaculate Heart of Mary, and as president of the Leadership Conference of Women Religious in the United States in the 1970s. In 1976, she moved to Toronto where she taught at Regis College and exercised a strong feminist presence there for the next 25 years.[9]

Women who wanted to pursue doctoral degrees in theology in Canada had to look for alternatives. Some studied history, classics or languages and wrote their dissertations on religious topics. Mary Malone, at the time a member of the Faithful Companions of Jesus, did her work in classics at the University of Toronto, with a doctoral thesis entitled *Christian Attitudes Toward Women: Background and New Directions*. In her words, "That was my way of getting to study theology through the back door, as there really was nothing else available."[10] She taught for many years at St. Augustine's Seminary, part of the Toronto School of Theology. When the seminary authorities decided to limit the enrolment in her popular history of Christianity courses by conducting the class in the evening at the seminary rather than on the downtown campus, students took public transportation in order to attend. Malone, now retired in Ireland, has completed a trilogy that documents the lives and contributions of Christian women from the beginning of Christianity to the present.[11] As with Daly and Brennan, Malone provided a strong feminist voice in theology at a time when few women had any voice in the discipline.

In the decade before Vatican II, there was a growing awareness of the need for the lifestyle of women religious to adapt to modern times. In 1954, the Canadian Religious Conference (CRC) was formed, comprising the major superiors of both female and male congregations. Separate plenary sessions of women and of men were held once a year, as well as general assemblies of both sections every three years. This group, which is bilingual, recognized the need for theological formation for their members. In 1959, they replaced their bulletin with a publication, *Donum Dei,* in order to reach beyond the major superiors to the members. In the foreword to the first issue, the president of the CRC wrote that the organization professed no doctrinal authority, much less disciplinary.

> It merely wishes to offer assistance to the great family of Canadian religious, both men and women, 'in opere et caritate concordes' to stimulate collaboration and exchange of views, to raise problems and help solve them, to heighten the appreciation and above all, to live more fully the GIFT of a religious vocation and in that way, give practical help to the Church in Canada, to its diocesan and parochial life.

The introduction to the first issue referred to courses in philosophy and theology as "undoubtedly most useful, since it helps them [the religious] to strengthen their own religious life and to spread it amongst others."[12]

Many women religious were aware that they needed to adapt their way of life to a changing world. Even Pope Pius XII had suggested modification of outmoded religious garb. By the 1960s, many sisters were ready for change, although none could foresee how great that change would be. External changes in lifestyle were accompanied by profound changes in spirituality and theology.

Women religious and Vatican II

Ecumenical observers were invited to Vatican II but they were all men. It was not until the third session of the Council in 1964 that 23 women, nine of whom were women religious, were admitted as auditors. Only one married couple was included. Carmel McEnroy, a Sister of Mercy who did her theological studies at the University of St. Michael's College in the 1970s, tells the stories of women at the Council in *Guests in Their Own House*.[13] Auditors were not allowed to speak, although they helped to draft *The Pastoral Constitution on the Church in the Modern World (Gaudium et*

Spes)[14] and had an indirect effect similar to that exercised by the Protestant observers through informal conversation with the council fathers. In spite of requests, women religious were not allowed to participate in the preparation of *The Decree on Religious Life (Perfectae Caritatis)*, although the majority of religious are women.

In calling for a council, Pope John XXIII hoped for a "New Pentecost." The whole Church was to be involved in renewal. *Perfectae Caritatis* laid down how religious should carry out their renewal. Two simultaneous processes were involved: a continuous return to the sources of all Christian life and to the original inspiration behind a given community; and an adjustment of the community to the changed conditions of the times.[15] Women religious accepted with enthusiasm the mandate for renewal. Each congregation convened special chapters, gatherings of sisters representing the entire congregation and serving as the highest authority when in session, as women religious began the complete reorganization of their lives and the rewriting of their rules. I recall sisters quoting from the council documents as we searched out our history and original inspiration or charism. At the same time, we studied the "signs of the times" in the spirit of *Gaudium et Spes*.

Women auditors had lacked a voice at the Council but women religious throughout the world received the call to renewal with energy and courage. The task, which was a theological one, demanded discernment and patience as well as communal conversion. Collegial structures replaced hierarchical ones as women religious accepted responsibility for decisions affecting their lives. Life would never be the same again.

In 1985, Sister Luke Tobin, a Loretto Sister who had been an auditor at the Council, looked back on the experience: "For me, in regard to the status of women, Vatican II was an opening, although just a crack in the door, to a recognition of the vast indifference to women and the ignoring of their potential for the whole body of the Church."[16] Disappointment is evident in these words of a pioneering woman writing 20 years after the Council. Vatican II had raised the hopes of many women religious that they would be actively involved in the mission of the Church to the world and that their contribution would be welcomed among the renewed people of God. Some of these hopes would be realized but in spite of Vatican II's recognition of the women's movement as one of the "signs of the times," the Church remained a patriarchal institution. In the years following Vatican II, patriarchy has become even more entrenched.

Women religious after Vatican II

Sandra Schneiders suggests that women religious passed from the Middle Ages to postmodernity within 30 years, a transition that took Western humanity nearly 700 years to make. We moved from a unified world view to one that is pluralistic. Schneiders suggests that following Vatican II we embraced the modern world just as modernity had almost run its course.[17]

In response to Vatican II's directives, we changed our relationship with the world from one that renounced the world to one that embraced the world.[18] In many congregations, the rejection of the world had been ritualized in the clothing ceremony. The new novice removed her bridal dress, had her hair cut and was dressed in the holy habit. The most evident reflection of the change in attitude toward the world was the sometimes slow and often painful adjustment of dress from habit to secular garb. Carmel McEnroy describes this transformation as "more than a tailor's one-night job."[19] Our seventeenth-century Sisters of St. Joseph wore the dress of "respectable widows." When our chapter of 1969 decided that the habit and veil would be optional, many of us chose to dress as contemporary women. One sister recalled that chapter as one at which "we decided questions around habit and scheduling and living situations, really things that had seemed immutable and unchangeable forever"[20]

As we studied our early documents, we learned that our first sisters lived among the people in small groups rather than in one large mother house. A number of us moved from our large mother house located on the northern perimeter of Toronto into small communities of four to six sisters in the city proper. At the time, these communities were considered experimental. All the changes in lifestyle were in response to Vatican II's understanding of the mission of the Church to the world. We replaced the attitude of rejection and suspicion of the world that had characterized pre–Vatican II religious life with one of solidarity with the world and all humanity.[21] This was in keeping with the vision of our founder and the first sisters, who reached out in service to the "dear neighbour."

The council fathers had debated whether to have a special document on religious life. They finally decided to include a chapter on religious in *The Dogmatic Constitution on the Church* (*Lumen Gentium*), following the chapter "The Call of the Whole Church to Holiness," one of the most significant to come out of the Council. The universal call to holiness replaced the teaching on religious life as a higher state and left many

religious questioning their vocation. The document stated that religious life was not "a middle way between the clerical and lay states of life. Rather it should be seen as a way of life to which some Christians are called by God, both from the clergy and the laity, so that they may enjoy a special gift of grace in the life of the Church and may contribute, each in their own way, to its saving mission." Those who embrace this life profess the vows of poverty, chastity and obedience. The council stated that religious life did not belong "to the hierarchical structure of the Church" but to its "life and holiness."[22] Many religious women were happy *not* to belong to the "hierarchical structure of the Church" and readily identified themselves with their lay sisters and brothers. Others felt somewhat unsure where they really belonged among the people of God.

One of the unexpected aspects of renewal was the departure of many religious who no longer felt called to a life that had been transformed. The life they had chosen had been replaced, although no one seemed to know what was replacing it. The new theological emphasis on the universal vocation to holiness validated other options for women who sought to serve the Church. In addition to departures, fewer young women were choosing the religious life, which was very much in flux. Schneiders comments on this unexpected result of the renewal process: "The incredible speed and the radicality of the transition Religious made from an enclosed medieval institution to a fully modern one precipitated a virtual cataclysm in the life, perhaps the most painful evidence of which was the departure of tens of thousands of Religious."[23]

Reflecting on the changes in religious life, one sister commented:

Life as a Catholic in the forties and fifties had a wholeness. With religious life there was also a wholeness of vision, of commonly held beliefs and of the visible externals. That was shattered at a point in time. The shifts were more to the individual and to invisibility, but it was not just in religious life. It was a whole world shift. Vatican II, of course, was part of that shift as was women's changing role in society and the whole psychological revolution, the emphasis on personal development and personal growth...I do not reflect on this with nostalgia about the past, although it might sound that way, but there is, I think, a profound sense of loss that came with the shifts.[24]

Schneiders suggests that this sense of loss and uncertainty that women religious experienced corporately and personally is analogous to

what John of the Cross called the "dark night," "a dangerous and painful purificatory passage from a known and comfortable but somewhat immature spirituality to a radically new experience of God."[25]

Certainly the dramatic shifts that religious congregations made in response to Vatican II's call to renewal required a new theology and a different spirituality, one that drew on the whole tradition rather than merely the past 400 years, a period in which the Church had assumed a ghetto mentality. This mentality had been shaped by the Council of Trent's response to the Protestant Reformation and the defensive reaction of Vatican I to the modern world. Now another council, Vatican II, provided a new ecclesiology, one that was at home in this world. Women religious joined enthusiastically with other lay people in receiving the council's teaching.

Actually getting the teaching of Vatican II to the whole people of God was a daunting challenge. My study of theology was occasioned by the pastoral need recognized by the Toronto separate school board for theologically trained teachers who understood the post–Vatican II catechetical program, "Come to the Father," and who would work with teachers, parents and priests. Each year, the board selected five teachers to study the new catechetics and then serve as resource teachers for religious education. In return for this paid leave, we had to work for three years as resource teachers. Most of those selected attended Divine Word, an institute in London, Ontario, founded by Gerald Emmett Cardinal Carter, bishop of London from 1964 to 1978. I asked to go to Manhattan College in New York, which was owned and operated by the Christian Brothers. At the time (1969), Gabriel Moran, who was well known in the area of religious education, was the director of a master's program in catechetical theology there. Divine Word, modelled on Lumen Vitae in Brussels, offered a certificate program, although eventually its graduates were given credit towards a degree from Saint Paul University in Ottawa.

As well as personal and congregational changes, institutions also changed in response to the challenges of the Council and the spirit of the 1960s. St. Basil's Seminary, where Basilian priests taught Basilian seminarians, became the faculty of theology of the University of St. Michael's College. Vatican II's emphasis on ecumenism was one of the inspirations for the formation of the Toronto School of Theology, in which Catholics, Anglicans, Presbyterians and members of the United Church of Canada joined their theological schools in a federation.[26] This new entity, of which St. Michael's was a founding member, allowed people preparing

for ministry in various denominations to study together while maintaining their own traditions. At the same time, the doors of St. Michael's were opened to the first women to enroll in the master's of divinity program, along with seminarians and laymen. This program had formerly been restricted to clerical students preparing for ordination. A master's of religious education program was added later, responding to the need for theological education for teachers.

St. Michael's also saw the need to provide for the academic study of theology. The result was the establishment of the Institute of Christian Thought in 1969, which became the Advanced Degree Program of the Faculty of Theology in 1978. This was a graduate program designed primarily to meet the needs of lay students wishing to study for academic degrees in theology. The phrase *Christian thought* was included in the Institute's name to avoid the confusion associated with the words *theology* or *theological* and to acknowledge the program's distinctive character.[27] In the fall of 1973, having completed my three years as a religious education resource teacher, I began doctoral studies in this program.

Dean Elliot Allen, who had a vision of a faculty representing the whole Church, women and men, lay and religious, promoted the appointment of women to the faculty. Joanne McWilliam Dewart, the first doctoral graduate of St. Michael's in 1968, became the first woman faculty member of the newly formed Institute. Maureena Fritz, a Sister of Sion, joined the faculty in 1972, followed by Margaret O'Gara, a laywoman appointed in 1976, myself and Caroline Dawson, a Loretto Sister, in 1977, Mary Ellen Sheehan, an Immaculate Heart of Mary sister, in 1978, and Mary Rose D'Angelo in 1980. My appointment to the faculty in 1977 and the granting of the PhD in theology in 1978 marked my formal credentials as a theologian.

Women religious enrolled in the pastoral programs as well as in the academic program. After completing studies, many of the sisters served as parish assistants, while those who graduated with doctorates took teaching positions in Catholic seminaries and schools of theology throughout North America, including at St. Michael's. Other graduates, such as Donna Geernaert, a Sister of Charity of Halifax, served in various ecclesiastical positions and as leaders in their congregations.[28]

For me, the changes inspired by Vatican II, my theological studies and the women's movement came together and changed my life. My study of theology, which began in 1969 at Manhattan College, was an experience of transformation, as I studied with women and men from many parts

of the world and developed a feminist consciousness. When I went to New York I was Sister Loyola, the name I had been given in 1952 when I received the habit. During the course of my studies, I, along with the rest of my congregation, was given permission to return to my baptismal name, a reminder of the significance of my baptism. I gladly gave up the name of the soldier saint, Ignatius Loyola, for Ellen. At the time, I felt like my life was just beginning, although in retrospect I have also come to appreciate my early years as a woman religious.

The 1970s were an exciting time theologically. In response to Vatican II, the Roman Catholic Church wholeheartedly joined the ecumenical movement. Bilateral dialogues were set up internationally and nationally. I served on the first national Roman Catholic/United Church Dialogue (1975–1984). Those whom Catholics had previously considered heretics were now regarded as our separated sisters and brothers. Through dialogue, we grew in our appreciation of one another's tradition as well as of our own religious family.

The 1970s were also a time of growing feminist consciousness. Professor Joanne McWilliam Dewart gathered a group of women students to read Mary Daly's *Beyond God the Father*. The male students asked to join us but we insisted on an all women's group. The experience of discussing Daly's thorough critique of Christianity with a group of women was my introduction to feminist theology, an approach that became very important in my theological work as I studied other feminist authors who were undertaking not only the task of deconstruction but also the retrieval of women's history and the reconstruction of a theology that is explicitly feminist. Feminist theology became for me a "transforming grace."[29]

In the mid-1970s, our Anglican sisters in Canada were preparing to be ordained as priests and on November 30, 1976, six women received priestly ordination.[30] In the spirit of the time, a number of us Roman Catholic women expected that we too might become priests. We attended the first Women's Ordination Conference in Detroit in 1975 and were inspired by the articulate women, many of them women religious, who addressed the more than 1,200 participants. We discovered a new form of sisterhood that struggled to be inclusive.[31] A more consciously feminist approach characterized the second Women's Ordination Conference, held in Baltimore in 1978. In 1981, a group of Canadians found a similar organization, Canadian Catholics for Women's Ordination, which was replaced by Catholic Network for Women's Equality, when members realized that there were other issues to address besides ordination.[32]

An inclusive understanding of sisterhood that had grown was evident when Sister Theresa Kane, president of the Leadership Conference of Women Religious, welcomed Pope John Paul II to the United States on October 7, 1979, and courageously requested that the Church provide "the possibility of women as persons being included in all ministries of our Church."[33] The Pope's response to her request was an emphatic and consistent "no." He refused to meet with her, although she did meet in Rome with the Congregation for Religious. John Paul II silenced the ordination issue that had been openly debated during the pontificate of Paul VI.[34]

The fact that we could not be ordained as priests within our tradition had led a number of women religious, myself included, to pursue the academic study of theology. Rosemary Radford Ruether comments on the prominence of Catholic women among feminist theologians: "Ironically the very intransigence of the Roman Catholic Church toward women's aspirations for equality in the Church may have spurred theological energy, while liberal Protestantism's openness to women in ministry lessened the challenge."[35] If we had been ordained, we would have been involved in pastoral ministry with little time for theological reflection and writing. The opportunity to study and to teach theology provided a base from which to reflect on other issues in addition to the ordination question. Even more basic theological questions required consideration: the nature of our humanness, the nature and mission of the Church, images and language for God, the maleness of Jesus the Christ, the meaning of salvation.

Theology was changing as new questions were being raised. No longer the exclusive task of male European clerics, new voices were emerging from Latin America. But liberation theology was not limited to one particular context. It offered a new starting point for theological reflection, one that attended to the experience of groups who had previously been ignored and excluded.

Not all theology is done in an academic setting. Following Vatican II, religious congregations were asked to respond to pastoral needs in Latin America. In 1968, four Toronto Sisters of St. Joseph opened a mission in Guatemala. Here, the sisters lived liberation theology, as their comments reveal: "Being among the poor and the suffering of Guatemala was a gift... The poor revealed Jesus to me in a new way." "Little by little, I discovered that it was the poor who were evangelizing me." The sisters experienced the change "from the hierarchical Church to the Church of the people of God and to small basic Christian communities."[36] Our sisters remained

in Guatemala until forced to leave in 1982 because of threats against their lives and the lives of the people with whom they worked. The sisters shared their experience with the larger congregation at various chapters. The preferential option for the poor became more than a slogan, as women religious grappled with its implications for our lives and our ministries.

Women religious and theology

The impact of the study of theology was explored in the oral history project undertaken as part of the 150th anniversary of the Sisters of St. Joseph of Toronto in 2001.[37] For many, the study of theology was significant in the process of their transformation from pre–Vatican II to post–Vatican II women religious. Gradually, most sisters had the opportunity to study theology. Often this was in preparation for a particular ministry, but for many it became a transforming experience, one that helped them to make sense of their lives. One sister stated that the study of theology gave her a new image of God. Another said it gave her permission to think for herself. Another spoke of theology as helping her to integrate her life. Sister Jacqueline summed up her experience: "My studies in theology opened up a whole new world to me and I am still delighting in it. They were very enriching years. I loved the intellectual challenge as well as the experience of faith my studies offered."[38]

As women religious studied and taught theology, we were challenged to change. Theology also changed, as did pastoral practice. Many women became spiritual directors, accompanying people on their spiritual journeys, and leading retreats and prayer services. Some became chaplains in hospitals, prisons and schools. No longer were these ministries the exclusive domain of ordained male priests. Women and men learned to appreciate the pastoral ministry of women.

The majority of theology students are now lay people, married and single, young and mature, perhaps retired, preparing for a variety of ministries; in turn, women and men, ordained and lay, teach them. The diversity is enriching, since students from various traditions and backgrounds study together. Women religious prepared the way for other lay people, women and men, to study theology and to become pastoral ministers. Mary Malone commented on the 1970s: "Those were the days! Little did we realise that we were making a kind of history."[39] Through their teaching and mentoring, women religious nurtured the next generation of women theologians. For example, four of our graduates from St. Michael's

faculty of theology, one Sister of the Presentation and three laywomen, are now professors at Saint Paul University, Ottawa.

Women religious who are theologians have also contributed to the lives of their congregations by being resource persons. Religious congregations have become a locus for theological reflection, as members discern together their response to the challenges of the present and the future. In doing so, they are building on the work of the women who provided a bridge from pre–Vatican II monastic life to a form of apostolic religious life that is still evolving. The contemporary form, with its direct service to the dear neighbour, looks more like the original form of apostolic religious life than the institutionalized semi-monastic form of the 1950s. Our habits have truly been transformed!

Endnotes

1 Neo-scholasticism was the term used for the revival from 1860 to 1960 of the philosophical tradition of the medieval and baroque universities. It was presented in textbooks and was an oversimplified version of the work of Thomas Aquinas.

2 For a history of women religious in the Western world see J.A. McNamara, *Sisters in Arms: Catholic Nuns through Two Millennia* (Cambridge: Harvard University Press, 1996); M. Ewens, *The Role of the Nun in Nineteenth Century America* (New York: Arno Press, 1978) and "Women in the Convent," *American Catholic Women: A Historical Exploration,* ed. K.M. Kennelly (New York: Macmillan, 1989).

3 Sr. Madeleva CSC organized a symposium for the National Catholic Education Association in 1949 on "The Education of Sister Lucy," a plea for theological as well as professional education for sisters. For a biography of this remarkable woman see G. Porter Mandell, *Madeleva: A Biography* (Albany: State University of New York Press, 1997), especially her chapter on "Educating Women" (177–94). See also *Women Religious and the Intellectual Life: The North American Achievement,* ed. B. Puzon (San Francisco: International Scholars Publications, 1995); *Catholic Women's Colleges,* eds. T. Schier and C. Russett (Baltimore: Johns Hopkins University Press, 2002).

4 L.K. Shook, *Catholic Post-Secondary Education in English-speaking Canada: A History* (Toronto: University of Toronto Press, 1971), 155–60; Congregational Annals of Sisters of St. Joseph of Toronto.

5 Sr. M. Madeleva, CSC, *My First Seventy Years* (New York: Macmillan, 1959). Quote from p.118. See also Mandell.

6 Mandell, 187–8.

7 M. Daly, *Beyond God the Father: Toward a Philosophy of Women's Liberation* (Boston: Beacon Press, 1974).

8 For an account of Mary Daly's career see her work *Outercourse: The Be-Dazzling Voyage* (San Francisco: Harper, 1992); for her description of her experience at St. Mary's see 50–54. After receiving her Ph.D. in religion she applied to the doctoral programme in philosophy at the University of Notre Dame and was refused "solely on the basis that I was a woman."(53)

9 For an account of Margaret Brennan's contribution see M. McDevitt's Foreword to *Light Burdens, Heavy Blessings: Challenges of Church and Culture in the Post Vatican II Era,* Essays in Honor of Margaret A. Brennan, IHM, eds. M. H. MacKinnon, M.McIntyre and M.E. Sheehan (Quincy, IL: Franciscan Press, 2000).

10 Correspondence with Mary Malone, May 7, 2003.

11 M. Malone, *Women and Christianity, Volume I: The First Thousand Years* (Ottawa: Novalis, 2001); *Volume II: From 1000 to The Reformation* (2002); *Volume III: From the Reformation to the Present* (2003).

12 *Donum Dei* (1959), 7.

13 C. McEnroy, *Guests in Their Own House: The Women of Vatican II* (New York: Crossroad, 1996). See especially Chapter Five, "The Nun in the World,"(161–97) for an account of the impact of the Council on women religious. In the Postscript McEnroy tells her own story of being fired in 1995 from her tenured position at St. Meinrad's School of Theology because she signed (with two thousand others) an open letter to the pope and U.S. bishops requesting a continuation of the discussion on women's ordination. McEnroy had taught at St. Meinrad's since 1981.

14 "The Pastoral Constitution on the Church in the Modern World," in *Documents of Vatican Council II*, a completely revised translation in inclusive language, ed. A. Flannery (Northport, NY: Costello, 1996). This pastoral constitution (*Gaudium et Spes*) along with "The Dogmatic Constitution on the Church" (*Lumen Gentium*) presented a renewed ecclesiology and the theological basis for the other documents of the Council and for the renewal which they mandated.

15 "Decree on the Appropriate Renewal of Religious Life," 2.

16 M.L. Tobin, "Women in the Church: Vatican II and After," *Ecumenical Review* 37 (July 1985): 296. See also H.M. Ciernick, "Cracking the Door: Women at the Second Vatican Council," in *Women and Theology*, eds. M.A. Hinsdale and P. Kaminski (Maryknoll, NY: Orbis, 1995), 62–82.

17 S.M. Schneiders, *Finding the Treasure: Locating Catholic Religious Life in a New Ecclesial and Cultural Context* (New York: Paulist Press, 2000), 100; see especially Chapter 3, "Religious Life in a Postmodern Context," 99–119.

18 In addition to changes in theology of religious life there were organizational changes. For a qualitative study investigating the experience of women religious during these changes, see H.J. Gonsalves, *The Experience of Catholic Religious Women Following the Organizational Changes of Vatican Council II* (Ann Arbor, MI: UMI, 1996).

19 McEnroy, 163–68.

20 *Sisters of St. Joseph of Toronto Archives*, Oral History Anniversary Collection, 2000, 132.

21 Our solidarity with humankind is now extended to include all of creation as the "dear neighbour."

22 "The Dogmatic Constitution on the Church" (*Lumen Gentium*), 43, 44.

23 Schneiders, 104.

24 Sr. Jean Gove in *Wisdom Raises Her Voice: The Sisters of St. Joseph of Toronto Celebrate 150 Years: An Oral History*, eds. E.M. Smyth and L.F. Wicks (Toronto: Sisters of St. Joseph, 2001), 214.

25 Schneiders, 106; this analogy is further developed (153–209). Constance FitzGerald, a Carmelite sister, suggested the "Dark Night" as a useful analogy for analyzing the experience of societal impasse in the face of the suffering of late modernity in "Impasse and Dark Night," first published in *Living with Apocalyptic Spiritual Resources for Social Compassion*, ed. T.H. Edwards (San Francisco: Harper & Row, 1984).

26 TST began in the academic year 1969–70 as a pooling of resources on the part of seven theological colleges including three Roman Catholic colleges: St. Michael's, Regis, and St. Augustine's.

27 Report of the Committee on Theological Studies presented to the Senate of the University of St. Michael's College, April 29, 1969. University of St. Michael's College Archives.

28 Donna Geernaert was ecumenical officer for the Canadian Conference of Catholic Bishops (CCCB) for many years and has served as the General Superior of her congregation.

29 See A.E. Carr, *Transforming Grace: Christian Tradition and Women's Experience* (San Francisco: Harper & Row, 1988).

30 For an account of the events leading up to the ordination of Anglican women in Canada see W.L. Fletcher, *Beyond the Walled Garden* (Dundas, ON: Artemis Enterprises, 1995).

31 Mary Jo Weaver describes this movement in *New Catholic Women: A Contemporary Challenge to Traditional Religious Authority* (San Francisco: Harper & Row, 1985), 109–144. In 1972 the United Nations declared that 1975 would be International Women's Year. This inspired Catholic women to come together.

32 "The purpose of CNWE is to enable women to name their giftedness and from that awareness to effect change in the Church that reflects the mutuality and co-responsibility of women and men within the Church." *CNWE News* V (Spring, 2003), 1.

33 For an account of this event see *The Inside Stories: 13 Valiant Women Challenging the Church*, ed. A. Lally Milhaven (Mystic, CT: Twenty-Third Publications, 1987), 1–23.

34 See the 1976 declaration *Inter Insigniores* (*Origins* 6 [Feb. 3, 1977]517 ff; and the more recent apostolic letter, *Ordinato Sacerdotalis* (*Origins* 24 [June 9, 1994]49ff).

35 R. Radford Ruether, "The Emergence of Christian Feminist Theology," in *Cambridge Companion to Feminist Theology*, ed. S. Frank Parsons (Cambridge: Cambridge University Press, 2002), 8.

36 Smyth and Wicks, 182, 183.

37 Ibid.

38 Conversation with Jacqueline de Verteuil CSJ, May 2, 2003.

39 Correspondence with Mary Malone, May 7, 2003.

12

The Process of Renewal of the Missionary Oblate Sisters, 1963–1989

Rosa Bruno-Jofré

Introduction

In 1904, Monseigneur Adélard Langevin, Archbishop of St. Boniface, founded the Missionary Oblate Sisters of the Sacred Heart and Mary Immaculate, a bilingual (French and English) teaching congregation. The founding of the Missionary Oblate Sisters was a means for Archbishop Langevin, in the midst of political isolation, to counterbalance the Anglicization of the public schools in the aftermath of the crisis known as the Manitoba School Question.[1] After 1897, Rome had effectively prevented the Quebec hierarchy from exerting political influence on behalf of Manitoba Catholics.[2] Documents related to the creation of the Missionary Oblate Sisters show a tension between Langevin's religious concern, the specific needs of his Catholic constituency, and his fear of Anglicization, on the one hand, and his culturally dual, French-English view of Canada, on the other hand.[3] The sisters, through their teaching in private and public schools in Manitoba and in other parts of Canada, and through their parish work, would play a role in elaborating the identity of what Marcel Martel calls the French-Canadian nation (Quebec and communities outside Quebec).[4] The Oblate Sisters worked in the residential schools for Aboriginal chil-

dren as auxiliaries to the Oblate Fathers. In fact, the congregation's 1931 constitutions shifted the sisters' mission and subordinated their role as educators to the Oblate Fathers. The congregation was born out of the need to provide Catholic services relevant to the mission and goals of the Church at the time.

I examined the foundational years of the history of the Oblate Sisters in *Missionary Oblate Sisters: Vision and Mission.*[5] In this essay, I am concerned with developments in the congregation between 1963 and 1989. This period includes a phase of decadence and crisis followed by efforts at reintegration and re-envisioning. The re-envisioning phase was framed by the internal contradictions emerging in the congregation and by the limits set by the Church itself after the great movement toward change that followed the Second Vatican Council. The overall process was, of course, influenced by the conciliar document *Perfectae Caritatis* and other documents on religious life that came out after the Council, such as *Evangelica Testificatio* (issued by Paul VI). It was also contextualized by the loss of the congregation's original instrumental mission to French Canadians and Aboriginal people. One element remained always strong: the sisters' sense of being women consecrated to God.

This essay centres on the unique leadership of three general superiors who stewarded different phases of the process of crisis and renewal in the congregation: Sister Jeanne Boucher (1963–1973), Sister Lea Boutin (1973–1981) and Sister Alice Trudeau (1981–1989). I relied heavily on the testimony of Sister Dora Tétreault, who has played a leading visionary role in the congregation. She wrote many of the documents reinterpreting the charism and vows of the Missionary Oblate Sisters, all of which the congregation discussed at various congresses and general chapters.

This essay also pays particular attention to the theological sources to which the sisters were exposed and to the inspiring leaders and thinkers such as Yves Congar and Jean Vanier with whom they came into contact. The preoccupation with self-development, healing and inner freedom, which was prominent during the entire period, led to close work with teams from Personality and Human Relations, the program founded by Father André Rochais, who in turn was inspired by psychologist Carl Rogers. My intention here is to deal with internal processes, and with the complexities involved in renewal and in the reformulation of the sisters ministry within the overall project of liberating the self.

The general framework applied in this essay to analyzing the congregation's process of renewal is a modified version of the path for transforma-

tion conceptualized by Cada, Fitz, Foley, Giardino and Lichtenberg, who specified periods and tasks in relation to the "revitalization effort."[6]

Breakdown and conflict (1963–1973) and first steps toward exploration

During the 1950s and early 1960s, changes to religious life seemed inevitable and were apparent in the output of the meetings of the Canadian Religious Conference (an organization of all the religious congregations in Canada). However, the superior of the Missionary Oblate Sisters, Mother Jean-de-la-Croix (1951–1963), did not go along with the efforts of other congregations to respond to the signs of a new era. She did not share information about changes with her congregation. During this decade, motivated by Sister Louis de France, who was in charge of studies, the sisters had started to go to school to obtain degrees and were exposed to contemporary authors in education, psychology and theology. Further, the Sister Formation Movement had reached Canada. In the 1950s, the Missionary Oblate Sisters, along with sisters from other congregations in St. Boniface, attended courses on scripture and theology delivered by Sulpician professors at the St. Boniface Major Seminary. As a result, the sisters became conversant with the works of Karl Rahner and Yves Congar,[7] theologians who resituated the Church in the modern world, integrated modern human experience with Christian dogma and revisited ecumenism. Access to these liberal ideas generated a long list of questions among the sisters and also revealed latent tensions in the congregation.

The first manifestation of problems affecting the hierarchical structure that had been cultivated by Mother Jean-de-la-Croix quickly became apparent with the election of Jeanne Boucher as general superior in 1963. The denial of change had generated uneasiness in the congregation. The impact of Vatican II (that started deliberations in the autumn of 1962 and ended in the autumn of 1965) and the developments motivated by the Council and the associated Vatican documents, including nine decrees, among them *Perfectae Caritatis*, set the frame of reference. Furthermore, two pillars of the mission of the Missionary Oblate Sisters – being a French-English teaching congregation building a French-Canadian identity and an auxiliary to the Oblate Fathers in the residential schools – had started to crumble. In fact, the understanding of Quebec as the "basic polity" of French Canada in the 1960s and the movement away from building a

common identity for all French Canadians created a new political scenario with which the congregation had to contend.[8] Meanwhile, in the late 1960s and early 1970s, the entire ideological configuration sustaining the residential schools collapsed. The mission of the congregation, whose foundation had emerged from an instrumental motivation, lost the important thrust of its original purpose.[9]

During the Vatican II Council, in particular after the second session in the autumn of 1963, the sisters attended informational meetings on church renewal, the nature of the Church and the need to start a dialogue with the contemporary world. The ideas of liberal theologians fully reached all sisters through the developments associated with the Council. In the early 1960s, the sisters had discovered Teilhard de Chardin. Some even took courses on his ideas in places such as Marymount College, affiliated to Loyola University in Los Angeles. The sisters were attracted by his notion that God's creation worked through cosmic evolution, his understanding of the Cosmic Christ as the element in virtue in which all things are related to each other, his idea that human life could be justified on the basis of achievement of future perfection, his new insights into Scripture (that they were not to be taken literally, e.g. Genesis), his view of the development of human consciousness as leading to greater individuality, and his notion of a potential unified common consciousness of humanity. Sister Dora Tétreault, one of the transformative leaders, read the *Phenomenon of Man* and the *Divine Milieu* and found these books, in her words, "so enlightening" and different from what she had previously read and "so true." For Sister Dora, the science teacher, de Chardin's ideas reconciled science and faith. She started to believe that there was no contradiction between the two. She was inspired by de Chardin's two sources of knowledge: the evidence in the world as linked to scientific knowledge and what constitutes revelation.[10] Future general superior Sister Lea Boutin was taught de Chardin by Father Hanley, SJ, and she read all she could find written by de Chardin.[11] The sisters tried to situate themselves in the new constellation of ideas and in the new political milieu, in an effort to understand their role and also to deal with the increasing lack of clarity of their role.

During the late 1950s and early 1960s, sisters doing undergraduate work were exposed to lectures on personalism and its creator Emmanuel Mounier (1905–1950). Some sisters recall Father Germain Lesage giving lectures on the topic at the University of Ottawa. Personalism was interpreted as a "new concept of the person and as person engaged with the world," said Sister Dora.[12] A personalist civilization would enable

every individual to live as a person – that is, to display initiative, assume responsibility, and develop a spiritual life. Mounier rejected individualism and saw humans taking a very active role in history. This entailed building a new social order, a new world view that moved beyond collectivism and individualism to embrace personalism and communitarism in social relations.[13] This was very revealing to the sisters who were becoming familiar with personalism. Sister Dora interpreted it "as awareness of the self, that we could have freedom and rights and exist in our own right in the community."[14] She construed this innate potential that people have as persons as a democratic concept. Among some members of the congregation, the idea that the sisters could not grow spiritually unless they became morally and intellectually autonomous persons started to take root and was seen in a positive light. Sisters tried to integrate these new notions into their daily examination of consciousness.[15]

This practice converged with Rahner's and Congar's ideas and led to an understanding among the sisters that the Bible needed to be interpreted in the light of not only anthropological and biblical research but also of the configuration of religious life and dogma. Early in the 1960s, the sisters' religious life did not match that in the world around them. It was the beginning of a journey of self-discovery for the sisters, although they were trapped in an authoritarian setting until 1963 and lacked a way of articulating a new approach. It would take some time for the sisters to begin to reintegrate and revitalize the community beyond the initial perceived chaos.

During Sister Jeanne Boucher's tenure as general superior (1963–1973), a time that was recalled by the sisters as therapeutic, the congregation went through a rapid and uneasy process of changing obsolete customs and traditions that affected daily life and encouraged immaturity and inequality. Many of the structures of common life built upon observance of rules were discarded, among them taking recreation in common and the daily timetable. Sisters took back their secular names, modified the habit and then gradually began to wear secular clothes. The congregation also changed the regulations regarding the requirements for the "trousseau" (number and kind of clothing items each sister could have as traditionally listed in the "coutumier") and objects for personal use, the use of the telephone, correspondence (until then, the superior read all personal letters), travel (sisters could not go out alone), visits, holidays and swimming.[16] The congregation went through defections, and loss of identity and mission. The sisters had suffered under the previous authoritarian leadership; they

had been treated as children, in Sister Lea Boutin's view.[17] Rituals such as public penances and "la coulpe" or chapter of faults (confessing external violations of the rules in front of the community) were soon abolished, while assertion of the self and reference to rights became prominent. Holiness could not be measured by fidelity to the rule any longer, as Sister Lea said.[18] In practice, the sisters began to question their vows even before the chapter of *aggiornamento* (renewal) took place in 1968–1969, during which the congregation would, as requested by Rome, update its constitutions along the lines set out in *Perfectae Caritatis*. In particular, the sisters began to question their vow of obedience with reference to assigned tasks. Sisters were consulted regarding their duties during Sister Jeanne's tenure, although the consultation process did not always lead to the desired assignment. Sister Lea made clear that the vows were invented for the patriarchal system: "Poverty, to control women materially, chastity, to control their bodies, and obedience, to control their minds. And it was a 'fantastic' system!"[19]

In 1967, a number of sisters were eager for greater grassroots participation in the affairs of the congregation. The preparation for the general chapter of *aggiornamento* offered sisters an opportunity to voice views and desires regarding every aspect of their lives. In Sister Lea's view the preparations for those meetings were the turning point. There were questionnaires and "loads of questions" that the sisters could discuss in community in local groups. Sister Lea went on to say, "It was like we evacuated a lot of stuff. This was the first time ever something like that happened. It felt good."[20] A committee, not only members of the general council, gathered views and information.

From 1970 to 1981, the congregation was regulated by *ad experimentum* constitutions, entitled *Witnesses* (*Témoins*), outlined at the general chapter of *aggiornamento* in 1968–1969. In 1981, the general chapter finally approved new constitutions after years of experimenting and discussion. They received approbation from the Roman Congregation for Consecrated Life in 1983. The *ad experimentum* constitutions introduced tentative new values, guidelines for life and a more flexible understanding of the vows. The sisters started to reinterpret the vow of poverty in relation to their commitment to the poor, evangelical poverty and the refusal of privileges. Chastity would make possible availability to others without discrimination, bringing love, responding to their needs. Obedience was still seen as a vow conducive to organic unity.[21] Overall, *Witnesses* was a

conservative document somewhat out of tune with the lived experiences of the sisters in an environment of crisis and search.

The process of *aggiornamento* aimed at complying with the documents produced by the Vatican Council, including *Perfectae Caritatis* and *Gaudium et Spes* with their emphasis on personal responsibility and freedom. *Gaudium et Spes* underlined the importance of each religious developing his or her gifts to the fullest, which was in contrast with being assigned tasks in light of the collective mission and the perceived needs of the congregation.[22] Within this context and the historical framework regarding the residential schools and serving French Canadians outside Quebec, individual sisters started to move away from school teaching. The Missionary Oblate Sisters, first involved in an individualist search along with rethinking their particular spiritual identity, turned to the program offered by Father André Rochais to immerse themselves in self-development and a new relationship with God.

Father André Rochais (1921–1990) was a French teacher and educator who had been influenced by Carl Rogers' work, in particular *On Becoming a Person*, which provided him the initial conceptual tools to address human development and then a reconstituted relationship with God. Important components of the workshops and courses Father André and his teams taught, known as Personality and Human Relations (Personalité et Relations Humaines, PRH), included the notion of persons growing to their full potential, acknowledgment and search of the subjective, existential freedom that can be observed, discovering meanings within oneself, listening to one's self-experience and finding direction from within, looking within oneself to develop unity and harmony, distinguishing between what we say about ourselves (knowledge) and our felt experiences (sensations), being aware of our own sensations, and having a relationship with God.[23] The sisters were eager to be involved in self-development that, in the secular world, had taken on a life of its own in the 1960s, along with the expressivist movement. They searched for clear self-awareness through the meticulous observation of the inner self and the discovery of their individual freedom in their relationship with God.

In the fall of 1970, the leaders of the congregation organized regional meetings to study themes such as conversion of mentalities, government principles, personality zones and relationship with God, within the context already delineated. By the end of 1971, more than 70 sisters had taken those study sessions, and the leaders of the congregation continued organizing them, since they considered the sessions to be of great help

for better self-knowledge and for greater confidence in self, in God and in others. This approach to the recreation of the sisters' own selves led to a different notion of the congregation's mission and ministry. The sisters started to acknowledge and support projects of interest to a particular sister or a small group of sisters that were not collective projects embraced by the community as a whole. However, there was great disparity among the sisters with regard to the changes. As Sister Jeanne Boucher, the superior at the time, said, "It was a very difficult period because for one thing, some were for change and others were against it. And for some we never went fast enough while others thought we went too fast. So it was a period of struggle. I can't say otherwise."[24] Vatican II had delegitimized the tradition and generated new directions that included previously censored views. New terms, such as charism, that appeared in post-council documents quickly became natural words, legitimized by the Vatican. The crisis that accompanied the initial process toward renewal was framed by a directed process of change coming from the centre of power, the male Vatican. In this early phase, many sisters, motivated by their commitment to God as consecrated women, were eager to find new and meaningful ways to channel their vocation. However, they did not seem inclined to discover the spiritual women within themselves.

In the fall of 1973, Jean Vanier, founder of L'Arche International, a non-profit corporation providing community living for adults with intellectual disabilities, came to Manitoba to conduct a spiritual retreat in Gimli. The retreat was attended by six hundred people, lay, religious and priests, among whom were several Missionary Oblate Sisters. Vanier's message, his radical lifestyle, and his commitment to build community with the poor and marginalized and to integrate them fully in society made a profound impression on the sisters who attended, including future general superior Sister Alice Trudeau. She said about the retreat that it had a tremendous impact on her spiritual growth and her growth as a woman. She was impressed by the presence of lay people, women and men, and, as she put it, "Hearing Vanier calling us forth to open up to the world, to the pain of the world, to the people of the world – that was for me a stepping stone."[25]

Community life changed dramatically and the sisters started to move away from school teaching, since they felt encouraged to follow their own inclinations and gifts. The number of sisters doing university degrees continued to increase and they started to extend their studies to graduate school. In addition, others graduated from normal school.[26] The

character of the ministry and the mission started to change in practice, although this would be more evident in subsequent years under Sister Lea Boutin's leadership.

In 1977, Sister Lea, at the end of her first term as superior, summarized community life issues from 1969 to 1977, since the previous superior did not make a report in 1973 at the end of her tenure. Sister Lea conceptualized this historical time as one of full transition in the congregation's style of community life. She referred to these years as an era of individualism. She wrote:

> We needed freedom and independence. Now more and more we feel the need of others, the need of structures in as much as they help us to live in relationship with others. The Rule is perceived, not so much as an activity to be accomplished but more as a means of entering into relationship, first with God, then with our Sisters and the poor to whom we are sent.

However, Sister Lea was clear that the change in vision and attitude was not happening in all the sisters simultaneously and that many did not feel the need to share their faith, to communicate in depth, and to give themselves periods of silence and reflection. She concluded by saying, "We are experiencing a time of tensions, of fears and of hungers – common in periods of transition."[27] Developments in the sisters' mission in Brazil in August 1966, when three of the sisters stationed there left the congregation as a consequence of misunderstandings with the general administration, show the state of crisis of the congregation in the early years of the process of *aggiornamento*.

Exploration, new insights and movement toward spiritual renewal and reintegration (1973–1981)

Sister Lea was only 36 when she was elected general superior in 1973, following the resignation of Sister Jeanne Boucher due to health problems. Sister Lea was superior from 1973 to 1981. During her first term (1973–1977), Sister Dora Tétreault, who served as general assistant, produced important documents regarding the congregation's historical identity and its spirituality.

Sister Lea's initial aim was "to gather" because, in her words, "everybody was all over the place." Sister Lea reminisced in an interesting dialogue with Sister Jeanne:

I could see that there was a lot of dissatisfaction. There was a lot of "where do we go now?" And some were tired of having done their own thing already and wanted to have a bit more structure but not the old structure. So [this is the reason for] the emphasis that I put on that. The changes like the external changes had to be done: the habit, the rules and so forth, that had to be done.

Sister Jeanne added: "And that had to be done first because you could not build the spiritual unless we had gone through that."[28] The eight-day and the 30-day retreats (called months of renewal) on personality and human relationships conducted by educators who were part of Father André Rochais' Personality and Human Relations program continued to provide a personal and community avenue.

Sister Lea and Sister Dora promoted the emphasis on the spiritual and personal development at a point when the directed retreats movement had already started in religious communities. There were traditional preached retreats for the sisters who preferred them, as well as a good number of directed retreats in various houses. Invited resource people from other religious communities also guided individual sisters. Later on, the sisters participated in inter-community retreats. There was a clear shift from a model based on rigid following of the rule and obedience to authority to a person-centred model. [29]

In the 1970s, Sister Lea and Sister Dora explored the Missionary Oblate Sisters' origin and spirituality in light of *Perfectae Caritatis*. Sister Dora focused on the founder, Archbishop Langevin. Both sisters had a strong sense of history, a desire for refounding grounded in Archbishop Langevin's vision and his spirit of faith, which in Sister Dora's view was revealed in the first constitutions of the congregation (1906). [30] According-ing to Langevin, a spirit of faith was essential to a good religious life. The sisters turned to the past to imagine a future while trying to rediscover the original inspiration for the congregation (a mandate from *Perfectae Caritatis*). This initial search seemed to be guided by the need to find some indication that the community would emerge from the crisis and to take a retrospective look at God's will.[31] The place of women religious and their experience was not articulated in the writings of this period, although, later on, Sisters Lea, Dora and Cecile Fortier were strongly influenced by feminist theologians. There was a delicate balance between questioning the understanding of the congregation's past and acknowledging the legacy that legitimized its own existence. Sister Dora moved away from a language of

pain, which she defined as masochistic, and asserted that "before repairing the neighbours' houses we should repair ours first." There was a shift from a language of mortification and grace to a language of social justice that was rooted in Archbishop Langevin's vision of justice for the Catholic people in Manitoba and Franco-Manitobans.[32] The notion of reparation, central to the congregation's spirituality, seemed in Sister Dora's analysis to be attached to the mentality of another time. As Sister Dora explained, "Reparation in the past was part of our identity, but it was reparation to God for offences committed against Him [sic] of course by us, but also by the world, by sinners. So it was a contemplative, cloistered notion of reparation, of adorators who would pray day and night, fast and do all kinds of sacrifices to atone." Sister Lea interrupted to say that the idea of reparation came from a theology of atonement and redemption. Sister Dora concluded that with the new theology, social justice being one of the elements, the notion of reparation moved from a vertical dimension to a horizontal one, and hence, became restoration, transformation and growth. The new notion embraced the understanding that people were wounded, that it was necessary to repair (heal) the woundedness in all.[33] Instead of an atonement theology from above, it was a theology from human experience that moved away from the notion of a God that had to be appeased. The new notion was elaborated and reframed during Sister Lea's and Sister Alice Trudeau's mandates. The preoccupation with poverty, which was central to the new understanding of reparation, appeared grounded in the evangelical notion of poverty.

The leadership of the community made a serious attempt to integrate the richness of ideas, experiences and personal explorations that emerged from retreats, Personality and Human Relations workshops, courses, and new relations with the external world. However, during Sister Lea's tenure, the priority was, out of necessity, the internal rebuilding of the congregation as a religious community, and the development of a participatory style of leadership and a new model of governance. The Acts of the 1977 chapter show the pursuit of an integrative process, a slight movement away from searching the self in order to favour community rebuilding. Using *Evangelica Testificatio* and articles on community experience, the chapter approved the creation of community life projects in each group of sisters, thus replacing old regulations and encouraging participation and sharing of faith and prayer. It was also recommended that local communities study an article entitled *Consciousness Examen* by Father F. A. Aschenbrenner in order to make the daily exam an exercise of conscientization and dis-

cernment.[34] The members of the chapter discussed the mission. There was no mention of the residential schools or the historical French issue in Manitoba. The sisters attending the chapter proposed that each Missionary Oblate Sister become more conscious that her first service to the Church is personal and community prayer and a life of fraternal charity, real and profound. They also proposed to "conscientize" the sisters on the importance of their role as educators of the faith and the need to revalorize that role.[35] The sisters seemed to be looking for a new alignment of their charism and the reality surrounding them; they tried to develop a new legitimizing framework. An important issue was that of belonging to the Oblate family and making it concrete through active participation in the life of the community. (It was a time when a number of sisters preferred doing activities with friends and family or just watching television.) The overall approach represented a new turn in the understanding of internal freedom and self-confidence, placed in the context of the community. In this regard, the chapter put great emphasis on continuing formation in relation to the sense of belonging and personal commitment to the community, and on governance and participation. It is not surprising that an important section of the Acts was devoted to the policies on alcoholism and dependency on drugs, although there were no references to specific cases.[36]

During Sister Lea's second term as superior (1977–1981), the sisters continued exploring Rahner and Congar, in particular when taking courses on theology and pastoral studies. Sister Dora had the privilege of attending Yves Congar's courses at the Dominican College in Ottawa during the 1978–1979 academic year, when he was a visiting professor there. During the same academic year, Sister Dora and other sisters took courses on social justice and on Christian basic communities in Latin America. These courses covered all the letters and documents on social justice the Canadian bishops had written. Social justice in the context of "the option for the poor" took roots in the congregation. Many sisters, in particular those who took courses on pastoral work, read Gustavo Gutierrez and Leonardo Boff, among others.[37] These liberation theologians strongly stressed the need to deal with social and economic problems. Some sisters went to Gonzaga University (Jesuit) in Spokane, Washington, in the late 1970s. In the 1970s, the Canadian bishops brought attention to issues of social justice and the needs of the poor worldwide. The congregation created a social justice committee in 1976 to make the sisters aware of world problems. The activities included internal educational workshops,

dissemination of information among the sisters, work with the Canadian Catholic Organization for Development and Peace, and guest speakers from Chile (which was under the Pinochet dictatorship at the time), South Africa (still under apartheid at the time), other South American countries and Asian countries. The sisters participated in letter-writing campaigns and supported agricultural producers from the South. The 1979 meeting of the Latin American bishops in Puebla, Mexico, brought to the forefront "the option for the poor" as an articulated form of the religious vows.[38] The expression carried with it the suffering of the poor and a rich new theology that had emerged from grassroots reflections. "The option for the poor," Reiser asserts, clarifies what the gospel story and Christian reflection are about: that God has "chosen" the side of the poor and the oppressed in the journey towards justice and equality.[39]

During her second term as general superior, Sister Lea and her administration surveyed in a systematic way the needs and desires of the parishioners with whom the sisters worked. It became evident on one side that the parishioners expected the sisters to be more involved in the apostolate of youth movements and the parish in general. There were suggestions that as a missionary community the Oblate Sisters be in line with an apostolate with the poor, the disabled and the marginalized, as well as with Aboriginal peoples. The parishioners requested more responsibility for the laity. As with the sisters themselves, not all the parishioners were at the same point in relation to changes in the Church. Thus, for a number of those who responded to the sisters' survey, changes in the sisters' lifestyle and way of dressing generated concerns regarding the personal engagement of the sisters and their religious vocation.[40]

In 1977, the congregation had 231 sisters; in 1981 there were 208. Four left the congregation and nineteen died. The median age of the congregation was 63 and the average 63.54. There were very few candidates for the novitiate. By the end of Sister Lea's second term in 1981, the sisters had articulated their role as missionary educators, educators of the faith, inclusive of their role as school teachers. They had also gained a new sense of the institution as a re-organized community based on a participatory model and respect for the individual. There were 33 sisters teaching in schools in 1981. There were also sisters doing pastoral work in parishes and hospitals, and with Aboriginal people. One sister gave reflexology and shiatsu treatments, another provided behaviour therapy, while yet another worked with the deaf. One sister even worked as an audio-visual technician in a college. There were many other occupations.

The number of sisters completing post-secondary studies was again very high and in a variety of fields. The sisters continued taking courses related to the Personality and Human Relations program and had a preoccupation with the healing power within oneself. The *ad experimentum* constitutions were revised and the final version was approved by the general chapter in 1981 and by the Vatican in 1983.[41] The new constitutions reflected many of the changes that emerged from embracing personal development and inner freedom and a new sense of community. The congregation had gone through an intense process of spiritual and personal growth and had redefined its communal identity, having as a mission education in all its forms. The congregation had moved from an authoritarian pyramidal model to a circular one, with the superior at the centre. In addition, communal identity was linked to the desire for a commitment to social justice as restorative justice that could take a more concrete shape.

However, the woman's religious experience had yet not been named and assumed, although the new constitutions talked of "the promotion of women so as to intensify their free and indispensable participation in establishing a society that is more human and life-promoting."[42]

At the end of her tenure, at the 1981 general chapter, Sister Lea introduced the sisters to the historical model of the evolution of religious life developed by Lawrence Cada, Raymond Fitz, et al., to situate the congregation in the life cycle of religious communities and to foresee the path toward transformation.[43] The historical model helped the congregation to understand the various phases of breakdown and conflict, darkness and exploration, and reintegration.

Attempt at revitalization and reintegration: the call for a prophetic leadership (1981–1989)

Sister Alice Trudeau was elected general superior in 1981 and was re-elected in 1985 for a second four-year term until July 1989. Sister Lea and Sister Dora had set a strong basis for developing the spirituality of the community. Sister Lea instituted a structural framework and a reconstituted model of governance that moved away from authoritarianism. The problem of polarization between those who wanted to continue growing and those who resisted more and more was still a serious concern.[44]

The thrust of Sister Alice Trudeau as general superior was external, in relation to the world, directed toward the ministry and a repositioning

of the leadership at the interface with society and the Church. She had a commitment to social justice and to the oppressed and openness to building a new understanding of the work with the Aboriginal peoples. Sister Alice's approach to leadership and spirituality was women-centred and assertive of their role on equal grounds with men. Her vision of the congregation was nourished by women's experiences of spiritual life. Her style was integrative while pursuing the continuation of healing, the development of a sense of freedom, and the restoration of the person in all phases of growth towards personal and communal integration.[45] However, toward the end of her mandate in 1989, Sister Alice subdued her tone in light of persistent resistance and the conservative approach taken by the Church, although her personal commitment had even increased.

Sister Alice led the sisters in articulating a mission statement that, although within the framework of the 1983 constitutions, represented her unique view of the role of the congregation. It had as point of reference "the needs of a suffering world"; the need to follow in the footsteps of the compassionate Jesus; and the need to be in solidarity with the promoters of peace, justice and unity, empowered by faith and audacity. She defined the mission and vocation of the sisters as missionary-educators who enable individuals and groups, especially those who are most deprived, to undertake their personal growth and self-actualization in order to build a more compassionate society and change the world.[46] The mission statement was also rooted in the community congress of 1983 that revisited the original charism.[47] For Sister Alice, the commitment to justice was not a matter of social action but of social transformation.[48]

In her 1985 circular *Onward in Hope*, Sister Alice called on the sisters to become challengers in their own communities and to perform concrete actions in line with the radicalness of the Oblate mission statement. She called the sisters to exercise prophetic leadership, a way of life contesting the established order and injustice. Many religious had been advocating this prophetic role since the late 1970s.[49] Sister Alice addressed what continued to be a major issue: the need for solidarity within the congregation.[50] At the same time, she decentralized the office of the general superior and put great emphasis on supporting sisters in their ministry, encouraging new small group projects or even individual ones without being apart from the congregation rather than community projects directed from the centre.[51] Dialogue with the sisters and the right of the sisters to turn down assignments (obediences) was central to Sister Alice's vision of growth. She later elaborated that the change was necessary, saying, "[it was] like

wanting them [the sisters] to attend more self-growth programs and then come back and stay the same, but wanting to journey."[52]

Archbishop Langevin, the founder, had been an Oblate, and the sisters' spirituality and charism were nourished by Oblate spiritual traditions. However, after the archbishop's death in 1915, the sisters' relation with the Oblate Fathers had always been a sensitive one. Sister Alice, even more so than her predecessors, did not hesitate to question oppressive practices of the past, in particular in relation to the congregation's work in residential schools run by the Oblate Fathers. The residential schools had become over time a very important part of the sisters' missionary work, although many sisters thought that teaching in residential schools was not their deepest purpose as a congregation. It would not be until 1983 that the sisters would unravel their memories in relation to the residential schools and name their pain. Sister Alice made a presentation to the Oblate Fathers' congress in which she characterized the sisters' role as missionary educators and auxiliaries to the clergy as one of subordination. The sisters, she said, were in a disadvantageous and, in some cases, abusive situation. "The Sisters," Sister Alice told the fathers, "saw themselves as inferior, as not being motivated to develop their autonomy, or to show initiative and assume responsibilities. Immaturity was encouraged and many felt used." She continued, "Some of the Sisters kept memories of resentment because they felt exploited but they did not have the courage to confront and make their needs known."[53] In the 1980s and 1990s, the painful testimonies from former Aboriginal students confronted the sisters with a past that had been conceived as God's will and with the role they played as auxiliary to the Oblate Fathers as stipulated in their 1931 constitutions. The situation generated a degree of sorrow and confusion in some sisters and a desire for understanding in others.[54]

During the 1980s, the sisters were inspired by John Paul II's message to the Amerindians in 1984. In the 1985 document, *Pastoral Work with the "Amerindians,"* the sisters, in line with the Vatican, acknowledged that the Aboriginal peoples suffered "from our slowness in rightly understanding their identity and their aptitudes to participate in directing their own future." In the same document, the leadership of the congregation tried to find the future orientation for the apostolate among the Aboriginal peoples and identified the need to grasp and appreciate "the true values inherited and presented by this culture [the Aboriginal culture]." It went on to say, "the Missionary Oblate, aware of her poverty, opens wide her heart to receive the riches that are present in the culture and in the very soul of the

Native People among whom she works." However, the document reveals contradictory understandings still wrapped in an ethnocentric colonial discourse, such as when its reads, "These values are purified and ennobled by the Revelation of Jesus Christ." [55] Several sisters attended national Aboriginal conferences over a few years and also the International Conference of Kateri Tekakwitha in 1983 and 1984 in the United States.

It is important to note that Sister Alice had a profound feeling for women well before becoming acquainted with feminist theologians and feminist writers. She said in an interview, "Even with Vatican II opening many doors, I recall as a religious beginning to ask myself: Is there a place for women in the Church? I mean I would carry this question, but not necessarily that I would go out there and do something about it."[56]

During her second and third year as general superior, Sister Alice became acutely aware of the differential way in which women were treated and had her first struggle with the bishops. She wanted the sisters who were in pastoral ministry in parishes to have a contract. Not a single sister had a signed contract with a local priest or bishop. The sisters had little reward for their work and they did not have even a day off as the priests had. Sister Alice received help from the Canadian Religious Conference so that she was able to ensure that every sister in parish ministry would be under contract when she ended her term in 1989. For Sister Alice, this cause had to do with the dignity and self-worth of the person, so that the person could realize that "Yes, I do have recognition. Though I've left teaching, it is not a diminished ministry that I have."[57]

Sister Alice moved the concept of Christian experience to the concrete lived experience of the Missionary Oblate Sisters as "Women of Good News," creators of unity, at the forefront to detect what is most needed in the world, and thus, radiate life.[58] During the 1980s, the influence of feminist theologians on many of the members of the congregation became evident and was widely recognized by the sisters who read Elizabeth Schussler Fiorenza, Mary Daly, Rosemary Radford Ruether and later on Barbara Fiand, among others.[59] In 1988, Elizabeth Lacelle from the University of Ottawa was invited to help develop and articulate the congregation's spirituality and introduce the notion of Jesus as a servant of justice. Lacelle was known for her conceptualization of the women's movement in North American churches.[60] A few years later in 1991, Sister Lea Boutin authored *Women in the Church: The Pain, the Challenge, the Hope* and argued for a theology of service for women.[61]

Sister Alice and her team understood that Archbishop Langevin had challenged the newly born community to serve the marginal and the poor. The point was to continue exploring what the charism (or spirit) of the congregation was and what it would be for the sisters and their times. The critique of the hierarchical, dualistic and patriarchal character of the Church that characterized many actions and statements during the post–Vatican II renewal never touched the founder. As I said in *The Missionary Oblate Sisters: Vision and Mission*, with reference to Sister Dora's work on Archbishop Langevin and his charism as founder, there was a delicate balance between questioning the understanding of the congregation's past and acknowledging the legacy that legitimized its own existence.[62] Nonetheless, the repositioning of the spirit of the congregation, and its mission and vision, implied a dramatic shift that not all the sisters accepted. The attachment to the old way of thinking survived in new forms and content, and generated misunderstandings and resistance. Furthermore, as noted, the discovery of the self did not necessarily nourish a sense of shared community.

Sister Alice embraced personal renewal, an area identified by the participants at the congregation's 1983 congress as needing further attention, with passion and within the framework of empowerment.[63] She reflected in 1994, "I think empowerment is still with me even now. Empowerment to me is the most precious thing, the most precious gift I can offer a person."[64] Renewal comprised healing, a sense of freedom and of restoration of the person in all phases of growth toward integration.[65] Former superior Sister Lea taught the sisters about the Enneagram system, a map of the patterns within our minds, hearts and bodies. The objective was to discern paths of growth (personality types). She had learnt about the Enneagram at Gonzaga University in Spokane. Invited presenters delivered sessions on the Myers-Briggs Type Indicator as well as courses on preventive care and well-being. The latter was seen as a condition for a person's wholesomeness. The Personality and Human Relations workshops were delivered again, but this time they were described as a program of adult formation, discernment and understanding of the personal rhythm of growth. Each local community was challenged to become a haven of acceptance and listening, allowing its members to become fully involved in self-knowledge and healing. The Exercises of St. Ignatius (30-day retreats) continued as previously under Sister Lea. Counselling and spiritual direction were aimed at achieving personal autonomy, a sense of interior freedom, and a more profound commitment to the Lord and others.[66]

The persistence of the same needs makes clear that wounds had not been healed and that the reintegration process was still tender.

At the time of the 1989 chapter, held at the end of Sister Alice's second mandate, the Church had moved strongly to question and dissolve the Christian basic communities that had emerged, along with the option for the poor and liberation theology in Latin America. The position of the Church regarding women remained very conservative and male-oriented, framed by a dualistic spirituality that feminist theologians continued denouncing as representing a hierarchical as well as patriarchal view of the sacred.[67] Sister Alice made a call for community discernment of the will of God.[68] The setting had changed and the lay presence in the community added an element of renewal but with its own characteristics. Overall, there was still a poor articulation of the multi-faceted newly discovered self alongside a collective commitment to life (as opposed to death) as a congregation. Sister Alice's prophetic vision found little space to flourish in spite of the work of apostolate the sisters were doing. The changes she envisioned had gone beyond the boundaries set by the Church and many sisters felt comfortable within those boundaries.

The community continued the process of natural attrition, although a small number of sisters left the congregation to start a secular life. In 1989, there were 170 professed sisters, many of the old established missions had closed and new smaller projects were pursued.

After 1989 and through the 1990s, the new leadership of the congregation that succeeded Sister Alice reflected the many contradictions and fears that had grown during the process of change. To an important extent, the new leadership represented a challenge to prophetic renewal as moved forward by Sister Lea and Sister Alice. It found protection in the security of the memories that had made the congregation a growing community with a collective presence in society in the past. But it was also a period of grassroots movements within the community, with visionary insights that questioned memories and historical narratives, traditionalism, spiritual dualism and patriarchy, and that searched for renewed spiritual meanings. The general chapter of 1993 exemplified the characteristics of that decade. The theme of the chapter, "Rebuild the House," was taken from Haggai 1:8, and was a theme Sister Dora Tétreault used in her writings. It reflected her influence and that of the sisters committed to change. The chapter called once more for "a new collective paradigm to open a way towards integral transformation" addressing the integration of the sisters' identity as Oblate women, the refounding of the community, the creation

of diversified types of communities, an understanding of the vows as "elements of transformation for the world," and the ecological dimension of spirituality.[69] The Aulneau Renewal Centre, founded in 1979 at the mother house in Saint-Boniface, was turned into a counselling service centre, mainly for low-income people.[70] The centre became an avenue to channel visions of social justice and the renewed meaning of reparation.

During the 1980s, Sister Alice and Sister Cecile Fortier had established a strong relationship with the Institut de Formation Humaine Intégrale de Montréal. The Institute, founded in 1976 by Dr. Jeannine Guindon, had as its goal to lead the person to become conscious of her vital human strengths and to realize how they can be actualized in spite of traumatic lived experiences. After her tenure as superior, Sister Alice became a leader in integral holistic formation in her community and beyond. In 1995, as graduates of a three-year formation program at the Institut, Sister Alice and Sister Cecile joined an international team of psychologists and therapists to minister to refugee caregivers in Rwanda, including teachers who, in turn, worked with Rwandan refugee children in crisis. The headquarters were in Goma, Democratic Republic of Congo, which is on the border of Rwanda. Oxfam Canada and Terre Sans Frontières sponsored the project. Sister Alice was deeply motivated by her ethical commitment to the poor, and she responded from her heart to questions regarding the context surrounding her decision to participate. Before leaving to fulfill her mission in Rwanda, she said:

> Even if I were to stay, like staying here, my ministry here I love it, because I know I work with leaders and there is an impact But in terms of the Community I don't sense they are losing a leader. I sense even that my going away, my leaving helps. And I am not saying this out of resentment but I think it is part of reality, and the reality being that my vision is a threat. Even my going to Rwanda, I didn't see this at first, but a good friend of mine said: 'What is this silence all about?' There is a reason for the silence, of not speaking about my going away and about the project. Like saying: 'It is not a Community project because I have been asked by the Institute (in Montreal).' And I think that is the tension that we are going through and that is part of the reality.
>
> And therefore, let's say for myself this new project is like a second wind for me ... I don't know how long I will last, that is if my health gives in. I do not know that. It is an unknown.

But what I know is maybe that is where I can best bring my contribution.[71]

Just as she was completing her mission, Sister Alice died on October 27, 2004, in Nairobi, where she had been transferred by air ambulance from Goma, ever faithful to her vision.

Conclusion

The developments in the Church and society preceding the opening of Vatican II, the exposure to liberal theologies and the winds of change, found the members of the Missionary Oblate Sisters suppressed by a general superior, Mother Jean-de-la-Croix, who did not acknowledge the shifts that were taking place. The obvious mismatch between the sisters' lived experience as women religious and the world around them led the way to a profound crisis that crystallized in 1963 and lasted for at least ten years. Sister Jeanne Boucher led the congregation between 1963 and 1973 through a difficult phase of internal breakdown and conflict amidst new freedoms and searches.

The exposure to the writings and ideas of theologians such as Karl Rahner, Yves Congar, Pierre Teilhard de Chardin, the exposure to Jean Vanier, and later on to the ideas of liberation theology as expressed by such theologians as Gustavo Gutierrez and Leonardo Boff, nourished the search for a new legitimizing framework. The sisters' desire to explore the self and discover inner meanings in the pursuit of personal development led them to a lasting participation in the Personality and Human Relations workshops created by Father André Rochais. The search was also inspired by *Perfectae Caritatis* and other documents on religious life. The profound breakdown that characterized the decade between 1963 and 1973 took place when the instrumental mission of the congregation with regard to Catholic French Canadians outside Quebec and the congregation's auxiliary role to the Oblate Fathers in the residential schools had lost meaning.

It was not until 1973, the beginning of Sister Lea Boutin's term as general superior, that the congregation started a systematic spiritual renewal process as well as the interrogation of the past to imagine a future. During Sister Lea's time as superior (1973–1981), and later on as well, Sister Dora Tétreault wrote many historical and spiritual documents that the sisters discussed. It was during Sister Lea's tenure that the sisters fully

rearticulated their role as missionary educators and gained a new sense of the institution as an organized community, based on a participatory model and respect for the individual. The ministry and the mission acknowledged individual and small group projects, a tendency that had started in the previous decade. However, the congregation had great difficulty reconciling the newly discovered sense of self with a sense of community. Furthermore, the sisters were at different points in their development and many resisted new directions for different reasons.

Sister Alice Trudeau, general superior between 1981 and 1989, furthered the sisters' personal growth as empowerment without neglecting their commitment to the community. Sister Alice called the sisters to enact the radical dimension of the Oblate mission that she had conceived. She wanted the sisters to be engaged with a prophetic leadership committed to social justice, the poor of the gospels and all those oppressed because of race, class or gender. She brought women's issues and the spiritual experience of women religious to the forefront, and she even confronted priests. During her time, there were efforts to rethink the sisters' work with the Aboriginal peoples, although the discourse was still permeated by contradictions and ethnocentric overtones. Her call was resisted by many, misunderstood by some and embraced by others. The conservatism of the hierarchy of the Church not only politically but in relation to the role of women did not provide her much room to manoeuvre.

Sister Alice Trudeau's and Sister Cecile Fortier's relationship with the Institut de Formation Humaine Intégrale de Montréal led to their participation in the Rwanda mission. Sister Alice left the congregation in Canada to give life to her prophetic call to work toward transformative personal and social change with the poor and with those who suffered. She felt she would have the space that the hierarchy of the Church did not give her as a woman religious and the possibility to move beyond the contradictions and fears that permeated the renewal process in her congregation.

Endnotes

1 The Manitoba School Question refers to the school crisis between 1890, when provincial legislation abolished dual confessional state-supported schools, and 1896, when a settlement, known as the Laurier-Greenway Compromise, was reached. The consequent modification (1897) of the Public Schools Act set

the legal basis for the building of the common school. The Catholic Church was not allowed to have school districts under its jurisdiction. The new legislation allowed for religious exercises under specific conditions.

2 R. Perin, *Rome in Canada: The Vatican and Canadian Affairs in the Late Victorian Age* (Toronto: University of Toronto Press, 1990), 127.

3 See R. Bruno-Jofré, *The Missionary Oblate Sisters: Vision and Mission* (Montreal and Kingston: McGill-Queen's University Press, 2005).

4 M. Martel, *French Canada: An Account of its Creation and Break-up, 1850–1967*, The Canadian Historical Association, Canada's Ethnic Group Series, booklet no. 24 (Ottawa: The Canadian Historical Association, 1998), 3–5.

5 R. Bruno-Jofré, *The Missionary Oblate Sisters, Vision and Mission*.

6 L. Cada, SM, R. Fitz, SM. et al., *Shaping the Coming of Age of Religious Life* (New York: The Seabury Press, 1979), chapter 4.

7 The Major Seminary had been founded by the Archbishop of Saint-Boniface. Maurice Baudoux, who later participated in Vatican II Council.

8 M. Martel, *French Canada: An Account of its Creation and Break-up, 1850–1967*.

9 The concept of instrumental motivation is taken from M.S. Thompson, "Charism or Deep Story? Towards Understanding Better the 19th-Century Origins of American Women's Congregations," *Review for Religious* (May–June 1999): 230–250. See also R. Bruno-Jofré, *The Missionary Oblate Sisters: Vision and Mission*, chapter 5.

10 Sr. Dora Tétreault, Comments made on 22 September 2006, written and deposited in Archives of the Missionary Oblates [*AMO*].

11 Sr. Jeanne Boucher and Sr. Lea Boutin , interviewed by Rosa Bruno-Jofré and Sr. Dora Tétreault, 26 October 1994, *AMO*.

12 Ibid.

13 E. Mounier, *Be Not Afraid: Studies in Personalist Sociologist* (Harper, 1954); *Personalism* (Indiana: University of Notre Dame Press, 1952).

14 Sr. Dora Tétreault, Comments made on 22 September 2006, written and deposited in *AMO*.

15 Ibid.

16 Lettres Circulaires de Sœur M. Jeanne-d'Arc (Sœur Jeanne Boucher), m.o., Supérieure Générale, 24 August 1968; 27 March 1969; 21 February 1969; 25 April 1969; 8 August 1969, among others.

17 Sr. Jeanne Boucher and Sr. Lea Boutin, interviewed by Rosa Bruno-Jofré and Sr. Dora Tétreault. .

18 Ibid.

19 Ibid.

20 Ibid.

21 "Witnesses. Constitutions and Modalities of the Missionary Oblate Sisters of the Sacred Heart and Mary Immaculate (ad experimentum), St-Boniface, Manitoba," 1970.

22 See F. Danella, "Apostolic Religious Communities in America: Moving in the Right Direction!" *Review for Religious*, 59(3): 263–270.

23 Fondation Personnalité et Relations Humaines, *André Rochais: Founder of PRH*, special edition of the PRH-France 1991 Newsletter (Canada: Winnipeg: D.W. Friesen, 1994). Also Personnalité et Relations Humaines-International, *La personne et sa croissance: Fondements anthropologiques et psychologiques de la formation PRH* (Poitiers, France: Personnalité et Relations Humaines-International, 1997).

24 Sr. Jeanne Boucher and Sr. Lea Boutin, interviewed by Rosa Bruno-Jofré and Sr. Dora Tétreault.

25 Sr. Alice Trudeau interviewed by Rosa Bruno-Jofré and Sr. Dora Tétreault, 21 October 1994, *AMO*.

26 Report of the Outgoing General Superior (Sr. Jeanne Boucher), General Chapter of July 1969, 5, *AMO*. There were, at the time, one sister working on her doctorate and six sisters working on a Master's degree; ten sisters had completed a B.Ed.; seven were working on a B.Ed.; fourteen sisters had completed a B.A.; 28 sisters were working on a B.A.; and 22 sisters had graduated from Normal School. The report referred to the period between 1963 and 1969. In 1967, there were 278 professed sisters and one postulant.

27 Report of the Outgoing General Superior (Sr. Lea Boutin), General Chapter of July 1977, manuscript, 16, *AMO*.

28 Sr. Jeanne Boucher and Sr. Lea Boutin interviewed by Rosa Bruno-Jofré and Sr. Dora Tétreault.

29 Ibid.

30 R. Bruno-Jofré, *The Missionary Oblate Sisters: Vision and Mission*, 63.

31 Ibid., 151.

32 Ibid., 152–153.

33 Sr. Jeanne Boucher and Sr. Lea Boutin interviewed by Rosa Bruno-Jofré and Sr. Dora Tétreault.

34 Report of the Outgoing General Superior (Sr. Lea Boutin). General Chapter of July 1977, manuscript, 4, *AMO*.

35 Ibid., 9.

36 Ibid., 34–35.

37 Sr. Dora Tétreault. Personal communication. Sr. Jeanne Boucher and Sr. Lea Boutin interviewed by Rosa Bruno-Jofré and Sr. Dora Tétreault.

38 W. Reiser, SJ, "Reformulating the Religious Vows," *Review for Religious,* 54 (4): 594–599.

39 Ibid.

40 Report of the Outgoing General Superior (Sr. Lea Boutin). General Chapter of July 1981, manuscript, 1–2, *AMO*.

41 "Constitutions and Modalities of the Congregation of the Missionary Oblates of the Sacred Heart and of Mary Immaculate, St-Boniface, Manitoba," 1983, *AMO*.

42 Ibid., Part One, Chapter one, 5 M4, 3

43 L. Cada, SM, R. Fitz, et al., *Shaping the Coming of Age of Religious Life.*

44 Sr. Alice Trudeau, MO, interviewed by Rosa Bruno-Jofré and Sr. Dora Tétreault, 7.

45 *Together in Hope: New Evangelical Challenges.* Capitular Documents of the 13th General Chapter of the Missionary Oblate Sisters of the Sacred Heart and of Mary Immaculate. Held at the Mother House, St. Boniface, Manitoba, July 4–July 25, 1985, *AMO* .

46 Ibid., Circular Letter 16, Onward in Hope, 13

47 Congrès Communautaire M.O. held in St. Boniface on 4 to 15 July 1983.

48 Also Sr. Alice Trudeau interviewed by Rosa Bruno-Jofré and Sr. Dora Tétreault.

49 See for example Conférence Religieuse Canadienne, *Rôle prophétique des religieux*, collection Donum Dei, 23 (1977).

50 *Together in Hope: New Evangelical Challenges.* Capitular Documents of the 13th General Chapter of the Missionary Oblate Sisters of the Sacred Heart and of Mary Immaculate. Circular Letter 16, Onward in Hope, 2–5.

51 Ibid. Also Sr. Alice Trudeau interviewed by Rosa Bruno-Jofré and Sr. Dora Tétreault, 11.

52 Sr. Alice Trudeau, interviewed by Rosa Bruno-Jofré and Sr. Dora Tétreault, p. 10. Sr. Alice Trudeau, Circular Letter 21, 14 May 1987. Theme: Obediences and Marian Year. *AMO*.

53 Sr. Alice Trudeau, MO, "Une religieuse interpelle les Oblats," manuscript, 1983, *AMO* cited in R. Bruno-Jofré, *The Missionary Oblate Sisters: Vision and Mission*, 153.

54 Ibid., 154.

55 *Together in Hope: New Evangelical Challenges*. Capitular Documents of the 13th General Chapter of the Missionary Oblate Sisters of the Sacred Heart and of Mary Immaculate. Pastoral Work with the Amerindians, 43–44. *AMO*.

56 Also Sr. Alice Trudeau interviewed by Rosa Bruno-Jofré and Sr. Dora Tétreault, 7.

57 Ibid., 16.

58 *Together in Hope: New Evangelical Challenges*. Capitular Documents of the 13th General Chapter of the Missionary Oblate Sisters of the Sacred Heart and of Mary Immaculate. Circular Letter 16, Onward in Hope, 5.

59 A more recent inspiring book is J. Chittister, *Heart of Flesh: A Feminist Spirituality for Women and Men* (Ottawa: Novalis, 1998). For a general framework see M. Dumais, *Diversité des utilisations féministes du concept expériences des femmes en sciences religieuses*, Ottawa, Canadian Research Institute for the Advancement of Women (CRIAW/ICREF) document No 32, 1993; S. Davis Finson, *A Historical Review of the Development of Feminist Liberation Theology*, Ottawa, Canadian Research Institute for the Advancement of Women (CRIAW/ICREF), paper No 34, 1995,

60 É. Lacelle, "Le mouvement des femmes dans les églises nord-américaines," *Études* (November 1985): 541–554.

61 Sr. Lea Boutin, MO, *Women in the Church: The Pain, the Challenge, the Hope* (Aurora, ON: Emmanuel Convalescent Foundation, 1991). Former superior Sr. Lea did both a master's in pastoral studies (University of Ottawa and Saint Paul University) and a doctorate in ministry (University of Toronto and the University of St. Michael's College) in the 1980s.

62 R. Bruno-Jofré, *The Missionary Oblate Sisters: Vision and Mission*, 147.

63 Congrès Communautaire M.O. held in St. Boniface on 4 to 15 July 1983.

64 Sr. Alice Trudeau interviewed by Rosa Bruno-Jofré and Sr. Dora Tétreault, 12.

65 Sr. Alice Trudeau, MO, General Superior, Circular Letter 13, 4 January 1984. Theme: Personal Renewal. *AMO*.

66 Ibid. Sr. Alice Trudeau, Compte-Rendu de la Supérieure Générale de la Congrégation des Missionaires Oblates du S.-C. et de M.I. Soumis au 13e Chapitre général, St. Boniface, 4–28 juillet 1985, *AMO*.

67 See, for example, B. Fiand, *Living the Vision: Religious Vows in an Age of Change* (New York: Crossroad, 1992).

68 Ensemble dans la fidélité. Compte rendu de l' administration général de la Congrégation des Missionaires Oblates du S.-C. et M.I. Soumis au 14e Chapitre général tenu à St-Boniface du 9 au 25 juillet 1989.

69 R. Bruno-Jofré, *The Missionary Oblate Sisters: Vision and Mission*, 154.

70 Ibid., p.156.

71 Sr. Alice Trudeau, interviewed by Rosa Bruno-Jofré and Sr. Dora Tétreault, 36.

Gender and Mission: The Sisters of Saint Ann in British Columbia

Jacqueline Gresko

Although recent studies of women and gender have demonstrated that British Columbia "was never [just] 'a white man's province,'"[1] most academic work on nineteenth-century Roman Catholic missions there focuses on the Durieu System of the male Missionary Oblates of Mary Immaculate and ignores the activities of the Sisters of Saint Ann.[2] For example, Celia Haig-Brown wrote *Resistance and Renewal: Surviving the Indian Residential School*, about the residential school in Kamloops, without consulting the archives of the Sisters of Saint Ann. Her assumption that the Oblates, like Bishop Paul Durieu, set policy and the sisters slaved to carry it out stands unquestioned by most historians.[3]

How would the history of British Columbia Catholic missions read were gender taken into account? This essay seeks to answer that question by discussing the activities of the pioneer generation of Sisters of Saint Ann using a framework from the sociology of religion. The essay shows that the history of the missions of British Columbia is a gendered story. The Sisters of Saint Ann and the Oblates brought systems for their practical works to British Columbia. Each congregation intended to teach and convert Aboriginal peoples, and each missionary system was grounded in gender. The women religious brought the methods of the Sisters of Charity of Montreal to the west: students fees would support services for the needy and Aboriginal peoples, particularly care of orphans. The Oblates intended to convert Aboriginal peoples via a model village system. Priests

would travel among villages of converts where missionary-appointed designates would watch over the faithful between clerical visits. Schools at central mission posts would provide Aboriginal and mixed-race youths with education in "Christian civilization." The Oblates would use church funds, contributions from the sisters and federal government school grants to support their efforts.

Two Catholic missionary systems evolved in British Columbia: the Canadian sisters' educational and caring institutions for the peoples of the province and the French Oblates' Durieu System of modified reductions for conversion of Aboriginal peoples. School teaching, particularly work in residential schools for Aboriginal children, linked the two systems. The sisters, as much as they were the religious subordinates of the Oblates, set most educational policies within both their own institutions and those they ran at Oblate missions.[4]

The pioneer women religious to be discussed include the 24 French- and Irish-Canadians who went from Montreal to the Pacific Coast between 1858 and 1871, setting the pattern for the 157 who followed them between 1872 and 1914. The comparable numbers for the Oblates are 30 French and Irish pioneers and 94 additional men by 1914.[5]

Comparing the origins of the two congregations indicates how autonomy and asymmetry marked gender relations for both. The Sisters of Saint Anne were founded in 1850 as a teaching congregation in the diocese of Montreal. Bishop Ignace Bourget clashed with and then deposed the founder, Mother Marie-Anne (Esther Blondin). Despite this, the sisterhood continued and, in 1858, four members volunteered as missionaries to assist fellow French Canadian Modeste Demers, bishop of Vancouver Island. Before departing, the women religious made their own studies of schools, refuges and hospitals that might serve as models for work in the missions. The Oblates, founded in 1816 in Provence, struggled to develop the congregation in post-revolutionary France. Foreign missions, for example, to Oregon in 1847, spurred Oblate growth. By 1858, difficulties in Oregon caused the Oblates to move north to British territory to have autonomy to develop missions to Aboriginal peoples.[6]

A model for narration and analysis

A model adapted from the sociology of religion is used to advance the narrative and analysis of the religious organizational history. While Canadian historians have drawn on the model of sociologist Joachim Wach

for "founded religions" in discussing congregations, most of these scholars' writings have concerned Quebec francophone communities.[7] Barbara Misner adapted the Wach model to study eight Catholic sisterhoods in the United States from 1790 to 1850. As with the Canadian Sisters of Saint Anne, these American women served in dioceses where clergy were often Frenchmen or men educated by French seminary professors.[8]

According to Misner's framework, religious congregations went through three stages: forming a circle of disciples around the founder, forming a brotherhood or sisterhood to spread the founder's ideas, and institutionalizing the organization. Accordingly, Mother Marie-Anne and Eugene de Mazenod (the founder of the Oblate Fathers) gathered associates and began their congregations. After the deposition of Mother Marie in 1854 and the death of de Mazenod in 1861, the members of their congregations worked on spreading their ideas. The rules and their interpretations were determined more by what branches of the religious congregation chose to do, rather than what they "were capable of doing." As the organizations matured they became institutionalized – that is, they not only sought pontifical approval but they also standardized their oral traditions into doctrinal statements. Misner notes that the sisters' efforts to centralize and consolidate their operations often conflicted with those of ecclesiastical authorities.[9]

For the Sisters of Saint Ann in British Columbia, the first stage of Misner's model lasted from 1858 to 1871, as the pioneer members arrived, bringing the founders' ideas. During the second stage, from 1871 to the late 1880s, the sisterhood expanded its works across the province. Institutionalization came in the 1890s and 1900s, as provincial superiors consolidated activities and codified practices in face of challenges from church leaders and government officials. Politically, the dates for these periods coincide with the colonial era, 1858 to 1871, the Confederation period, and the years from the building of the transcontinental railway through to the boom of the early 1900s. The terminal dates of the three stages – 1871, 1887 and 1910 – are used as vantage points from which the organizational history is analyzed in light of the Misner framework to bring out gender issues.

Foundations: 1858–1871

A geographical survey of what the Sisters of Saint Ann achieved in British Columbia during their foundation years shows convent schools

founded in Victoria in 1858 and New Westminster in 1865, and mission schools established for Salishan peoples at Cowichan in 1864 and at St. Mary's Mission on the Fraser in 1868. The women religious received help from Bishop Demers to purchase and renovate their "log cabin convent" in Victoria; however, Demers could give them little further aid in funds or manpower.[10] Members of the Clerics of St. Viator assisted with buildings until they returned to Quebec in 1862.[11] The Oblates provided chaplains in Victoria only until leaving for the mainland in 1865.[12]

By 1871, when the Sisters of Saint Ann in British Columbia laid the cornerstone of their new Victoria convent, 20 members of the pioneer group were still living in British Columbia.[13] One Aboriginal student had taken temporary vows as a lay assistant,[14] and three Victoria convent alumnae had completed their novitiates at the Lachine, Quebec, mother house.[15]

The extent to which the pioneer sisters directed their own works in the west can be seen in the activities of their leaders. The first superior, French-Canadian Sister Mary of the Sacred Heart, recognized that the 1858 gold rush, which coincided with the sisters' arrival, meant that plans to serve fur trade and Aboriginal families would have to be adjusted. She requested English-speaking sisters to set up a select school in order to gather funds for charitable works. The pioneer superior stepped down once Irish-Canadian Sister Mary Providence arrived in 1859.[16] Under her leadership, the sisters anglicized the congregation's name and curriculum. They developed educational and social services centred on the Victoria fee-paying convent academy, which included a charity school, an orphanage and home nursing. Women religious, lacking direct access to missionary society funds, had to be self-supporting. They had to balance the costs of charity work against student fees, donations and the benefits of their annual bazaar. The mother house could afford little beyond the costs of sending additional sisters west.[17] The colonial authorities made it difficult for the Sisters of Saint Ann, as a Roman Catholic society, to incorporate and to undertake property transactions that might have supported the schools.[18]

Competition from other private schools meant Sister Mary Providence and her council had to make tough decisions.[19] In order to market their educational services to white Victoria parents who wanted racially segregated classes, the women religious had to separate Aboriginal and black pupils from white pupils in the select school. The parents of blacks protested to the sisters and Bishop Demers. When the bishop did not

overturn the sisters' policy owing to white parent protests, the black parents withdrew their children.[20] Few Aboriginal students came or stayed. Mixed-race students who were enrolled as fee-paying students by their white fathers did attend the Victoria select school. Those mixed-race students who were consigned to the sisters' care by Aboriginal mothers did not.[21]

When the Sisters of Saint Ann answered the 1865 request of the Oblate superior of the mainland, Bishop Louis-Joseph d'Herbomez, to begin a school for girls in New Westminster, the congregation followed the model it had established with the Victoria convent. Again, white parents wanted their daughters taught in select, segregated classes. The sisters ran separate classes until 1868, when they accepted the Oblates' invitation to run a school for Aboriginal girls at St. Mary's Mission.[22]

Sister Mary Providence and her superiors had to negotiate assertively with Bishop d'Herbomez. As with other French bishops, he wanted to control women religious serving in his diocese. As an Oblate missionary vicar, he wanted to subsume their efforts to those of his congregation. However, d'Herbomez had to respect the sisterhood, since he depended on its financial support for establishing the girls' school at St. Mary's Mission.[23]

In founding that school in 1868, Sister Mary Lumena and Sister Bonsecours followed the pattern set by Sister Mary of the Sacred Heart and Sister Mary Conception when they established the school in Cowichan four years earlier. They modelled the curriculum of religion, basic elementary education and domestic skills on that of the orphanage charity schools of Montreal. At both Cowichan and St. Mary's Mission, the women religious struggled to build and furnish the school, to establish the garden and feed the pupils. The Salishan peoples' response to these schools was similar in each case: initial curiosity; attendance for songs, stories and festivities; and then withdrawal from disciplined classes for domestic and farm labour. Over time, Cowichan became a charity school/orphanage with some paying pupils.[24] At Cowichan, Father Pierre Rondeault, a priest of the Vancouver Island diocese, ran the parish church, a day school for boys and travelled among Aboriginal villages.[25] At the St. Mary's Mission girls' school on the mainland, as at Cowichan, the sisters cared for several mixed race children.[26]

A summary of Catholic missions on the mainland of British Columbia in 1871, written by Bishop d'Herbomez, illustrates their gendered aspects. D'Herbomez spoke of plans for a modified reduction system for conversion

and control of Aboriginal peoples, drawing on Oblate experience in the west and contacts with the Jesuit missions in the Rocky Mountains. In each region, missionary posts would serve as bases for priests who travelled, evangelizing Aboriginal communities and setting up governance via chiefs and watchmen. The Oblate prototype boarding school at St. Mary's would provide agricultural and elementary education as well as religious instruction. The boys' school was managed by "two Brothers," and the girls' by the Sisters of Saint Ann.[27]

Although teaching was the most easily comparable work of the Oblates and the Sisters of Saint Ann, the gender differences were clear. While teaching was the actualization of the sisters' vocation, the priestly function was the main vocation of the Oblates.[28] Priests might teach catechism classes to both sexes or secondary subjects to adolescent boys. Brothers in the Oblate congregation did domestic and technical work, such as building design, and taught younger boys. The Oblates did not have a specific group of trained teaching brothers.[29]

Nevertheless, by 1871 the two congregations' activities overlapped in teaching school and caring for orphans, particularly in the mission residential schools. The Oblates ran only one college for settlers' sons, assorted mission day schools and two mission residential schools. Anglophone Irish brothers were recruited to teach and supervise children. Bishop d'Herbomez believed schools would fit future generations into the modified reduction system only if girls were educated as well as boys.[30] Inviting the Sisters of Saint Ann to run the girls' school and orphanage at St. Mary's Mission fit this aim. It also meant the Oblates could apply for more government grants for Aboriginal schools and more French missionary society funds for care of orphans.[31]

Thus by 1871, Oblate superiors saw themselves as the missionaries and the brothers and sisters as mere auxiliaries.[32] The sisters, however, saw themselves as missionaries, too, and negotiated with the Oblates as a separate congregation in the Church, and a congregation based in Montreal and Victoria, not New Westminster and Paris.

When set against Misner's model of the development of religious congregations, pioneer Sisters of Saint Ann fit the foundation pattern. As disciples of Mother Marie-Anne, the sisters worked together on her ideas. Initially, they relied more on oral tradition than written documents. They came west without a written contract with Bishop Demers.[33] The first Victoria directress followed the founder's example in stepping down from her position for the good of the organization.[34] When the sisters

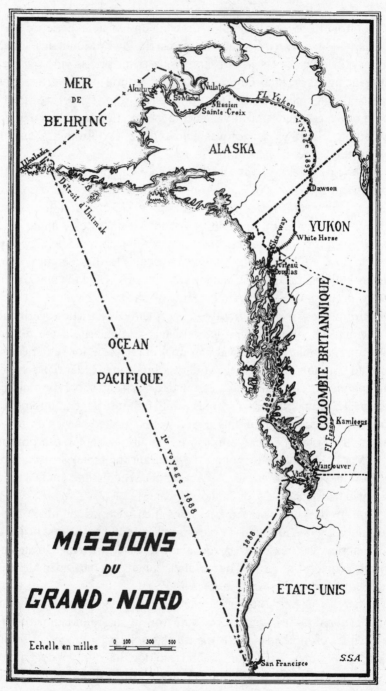

Sisters of Saint Ann missions in British Columbia, the Yukon and Alaska took them toward the missionary ideal of carrying the gospel to the ends of the earth.

Soeur Marie-Jean-de-Pathmos, s.s.a., *Les Soeurs de Sainte-Anne Un Siècle d'Histoire. Tome I, 1850—1900* (Lachine, 1950), facing p. 433.

negotiated with the Oblate superiors regarding the mainland schools, they pressed for written confirmation so that these could be managed according to their own rules and customs.[35]

Expansion years: 1872–1887

Between 1871 and the late 1880s, the Sisters of Saint Ann expanded their organization in British Columbia in face of Oblate leaders' attempts to subordinate them to masculine direction with regard to missions and schools. New transcontinental railways aided the sisters' communications with their Lachine superiors. Long-time directress Sister Mary Providence remained in Victoria to advise successors.[36] The annual retreats and vacations at the Victoria convent unified the British Columbia sisters. Only one left the congregation, likely because of burnout, although her reason was not reported publicly.[37] The leaders drew on the experience of the thirteen pioneer sisters still active in British Columbia, the energies of 38 additional sisters from Lachine and the assistance of young half-breed women hired as dormitory supervisors and teachers' helpers.[38]

The Sisters of Saint Ann diversified their works in British Columbia between 1872 and 1887. Since the number of paying boarders at Victoria rose and the number at Cowichan declined, the sisters transferred the Victoria orphans there in 1876. The same year, the sisters opened a boarding school at the Oblates' St. Joseph Mission in Williams Lake. Then, in 1877, they began a convent school in Nanaimo and, in 1880, one in Kamloops. Many non-Catholic families supported such denominational academies, since public high schools were barely in existence.[39] The sisterhood undertook two new activities, St. Joseph's Hospital in Victoria in 1876 and a hospital in Juneau, Alaska, in 1886.[40] The hospital founders studied nursing with the Sisters of Providence at its hospital in Portland, Oregon. The sisterhood got involved in Alaskan missions in response to the persistent requests of the head of the Victoria diocese, Archbishop Charles John Seghers, who superintended that territory.[41] The Alaskan convents were initially directed by the Lachine mother house but used the Victoria provincial house as a local administration centre.[42]

The Alaskan missionary venture, as with the hospital and the Nanaimo school, were in the Vancouver Island diocese, not the Oblate-directed New Westminster diocese. Assignments to the Alaskan missions, involving efforts with Aboriginal peoples further to the missionary ideal of going to

"the ends of the earth," had greater prestige as missionary ventures than did assignments in residential schools.

What the Sisters of Saint Ann did not do between 1872 and 1887 is also significant. In 1873, the sisters declined Paul Durieu's requests for staff for additional Oblate mission schools in British Columbia.[43] Through their friendship with the Montreal-based Sisters of Providence, who served in nearby American states, the Sisters of Saint Ann knew Oblates were lobbying them, too.[44] Both sisterhoods got on well with individual Oblates but generally not with the administration.[45] The Sisters of Saint Ann took its time before finally acceding to Oblate pleas for staff for a school for settlers' children at the St. Joseph Mission in Williams Lake.[46]

In the late 1880s, when the decline in paying pupils at St. Joseph's Mission school and the costs of supporting its few charity students led to its closure, both congregations moved staff to other needs. The women set their own priorities – Alaskan missions and a school for the new city of Vancouver – over Oblate requests for staff for a mainland hospital and residential schools.[47]

That the Sisters of Saint Ann were not teaching in government-funded separate schools in British Columbia by the 1880s had more to do with religion than gender. During the colonial period in British Columbia, non-sectarian schools had been established for the children of settlers, and this principle was confirmed when the province entered Confederation in 1871.[48] In 1876 and 1881, the Roman Catholic bishops of British Columbia were unsuccessful in petitioning the provincial government for schools for settlers' children on the model of separate schools in Quebec, Ontario and Manitoba.[49]

In the expansion stage, the activities of the Sisters of Saint Ann and Oblates continued to overlap in the area of education. The Oblates continued to rank pastoral activities over educational ones and to assign brothers or obtain the assistance of sisters to deal with the latter. The Oblates' shortage of manpower accentuated this trend. The Sisters of Saint Ann brought recruits from Quebec to British Columbia, but the leadership insisted on the congregational right to administer their operations as it saw fit. The sisters refused several Oblate requests for teachers while, on the other hand, acting on those of the Victoria bishops.

The refusal of the Sisters of Saint Ann to staff new Indian residential schools is significant in gender terms. This conflict between women superiors and the male hierarchy parallels what Misner found for American women religious at the expansion stage of development. The Sisters of

Saint Ann would not take up management of such schools unless there were young half-breed women available to care for the young boys. The sisters considered such work morally incorrect for themselves as vowed religious women, but not for their lay helpers.[50]

An additional way in which the Sisters of Saint Ann and the Oblates in British Columbia fit Misner's framework for the expansion stage of their development is that written records were becoming more important for both groups. In the 1880s, Mother General Marie Anastasie visited and emphasized the congregation's rules and customs, for example the need to file regular reports.[51] Meanwhile, d'Herbomez' auxiliary, Bishop Durieu, wrote long letters to a veteran missionary, Jean-Marie LeJacq, restating the Oblates' methods for making and keeping converts.[52]

Both congregations dealt with members who preferred their own scholarly interests to ordinary mission work by moving them from assignment to assignment and then letting them write history. Sister Mary Theodore became congregational historian in Victoria. The Oblate Adrien-Gabriel Morice pursued his research at the northern mission of Fort St. James. The difference was that Sister Mary Theodore was fit in at regional headquarters and Morice was allowed out on his own.[53]

Comparison of the Oblate and Sisters of Saint Ann's published records of events such as the grand missionary reunion for Salishan converts at St. Mary's Mission in 1887 further illustrates patterns of gender and mission. Both congregations had this event written up to generate public support and vocations. Oblate publications minimized the participation of the Sisters of Saint Ann, edited out mention of Salishan resistance and maximized the role of heroic missionary Frenchmen, such as Bishop Durieu. The sisters' published accounts, mainly congregational histories, showed the women religious as honoured participants in Aboriginal and Catholic ceremonies at the 1887 reunion and minimized mention of particular French clerics.[54]

Institutionalization: 1888–1910

Twenty years after the reunion of 1887, the Sisters of Saint Ann and Oblates planned 50th anniversary celebrations. The sisters marked 1908 as the golden anniversary of their arrival in British Columbia, while in 1910 the Oblates celebrated the 50th anniversary of the establishment of their New Westminster headquarters.

These events cast light on the institutionalization stage in the history of the two congregations in the region, especially of the Sisters of Saint Ann. By 1910, eight pioneer sisters were still resident in British Columbia and 65 more had come west from the mother house. The opening of the Victoria novitiate in 1890 increased the number of western entrants to the congregation. The sisterhood's northern missions, "midst snow and ice," attracted vocations from Europe as well as eastern North America.[55] A total of 54 women completed their novitiate in Victoria between 1891 and 1914.[56]

A geographical survey of the sisters' works in British Columbia between 1887 and 1910 shows the maturing of institutions and consolidation of activities. In 1896, the congregation organized British Columbia and Alaska as St. Joseph province.[57] Its convent academies in Victoria, New Westminster and Kamloops offered kindergarten, elementary and secondary classes, and instruction in music, art, stenography and typewriting. Pupils sat provincial government exams for high school entrance and matriculation.[58] St. Mary's Mission girls' school received federal grants as an Indian boarding school but still admitted a few half-breed pupils. At Cowichan, the number of orphans declined and the number of local settler families rose so the sisters made the school there a boarding school. In 1904, the girl students transferred to Nanaimo, and the building became a boys' orphanage.[59] The sisters opened an elementary school in Vancouver in 1888 for which they bore the sole financial responsibility.[60] The congregation took on several Alaskan and Yukon hospitals and schools, but these were directed from Victoria.[61] In British Columbia, the sisters staffed the Kamloops Industrial School in 1890 for a short term, left and then returned in 1892. The same year, the sisters began classes for girls at Kuper Island Industrial School in the diocese of Vancouver Island.[62] The Victoria convent supplied a sister to teach at the Songhees reserve day school from 1894 through 1910. An even more notable venture was the initiation of the St. Joseph's Hospital school of nursing in Victoria in 1900.

The sisters of the 1890s and 1900s opened more institutions in the Victoria bishop's domain and in Alaska than in the Oblate-directed mainland diocese. As the Oblate organization matured, it conflicted with the sisters' leadership. Meanwhile, several bishops of Victoria served such short terms that they could not attempt consolidation of Catholic education. These bishops had to cope with the departure of successive groups of teaching brothers and to depend on the Sisters of Saint Ann

to run institutions.[63] The Victoria bishop agreed with the superiors of the Sisters of Saint Ann that they should have hired help for dormitory supervision for the Victoria boys' orphanage in the 1890s, whereas the Oblate superiors were less willing to provide similar assurances.[64]

In the mainland diocese of New Westminster, particular conflicts arose between the Sisters of Saint Ann and the Oblate bishops. In 1891–1892, Bishop Durieu wanted the sisters to send the half-breed orphan pupils from St. Mary's Mission school to a new orphanage being opened by the Sisters of the Good Shepherd in New Westminster. He could thus meet requirements for federal funds for Indian boarding schools. Sister Mary Lumena, the longtime superior at St. Mary's Mission, wanted to keep "her" orphans and her commitment to their parents to educate them locally.[65] Bishop Durieu succeeded in having Sister Mary Lumena transferred to St. Ann's Convent in Kamloops. Within a year, however, she was caring for a new set of "her" orphans as she liked at the Cowichan convent.[66]

Bishop Durieu had to accede to the Sisters of Saint Ann's policy, organization and rules for the Kamloops Indian Industrial School. He had no other staff for it and did not want to let the government contract to fund such a school go to Protestant missionary competitors. Before the school opened in 1890, Durieu had agreed to have Michael Hagan, a Roman Catholic layman, as principal so as to secure the government grant.[67] Durieu and Department of Indian Affairs bureaucrats expected "Sisters of Charity" would staff the classes and dormitories, and provide domestic services.[68] The Sisters of Saint Ann, however, objecting to Hagan's management of the Kamloops school as unsuited to the life of women religious and incompatible with their rules, withdrew their services in 1891. The sisters demanded a priest principal, an on-site chapel and schedules suited to their religious life, especially daily Mass.[69] Hagan brought in Oblate Father Albert Lacombe to survey the situation. Based on his experience with the Grey Nuns at prairie residential schools, Lacombe took up the sisters' side by pointing out the poor design of the school laundry and kitchen.[70] In 1892, Chief Louis and other Secwepemc parents pulled their children out of the school, since they were dissatisfied with the lay staff replacing the sisters. The Department and Durieu reorganized operation of the institution under a priest principal and the Sisters of Saint Ann returned. The Kamloops case illustrates an ongoing issue in Roman Catholic gender relations: interference with women religious in a congregation with historic rights and abilities to organize and serve as they saw fit.

The Sisters of Saint Ann did find individual Oblates supportive of their works. As superior at St. Mary's Mission school, Father John O'Neill worked harmoniously with the Sisters of Saint Ann and also found them Irish vocations, including his own sister.[71] Augustin Dontenwill, as principal of St. Louis College and later as bishop, assisted the sisters' educational enterprises at St. Ann's Academy in New Westminster.[72]

After Dontenwill left British Columbia to become superior general of the Oblates in 1909, the Victoria superior of the Sisters of Saint Ann withstood the attempt of the new Archbishop of Vancouver, Neil McNeil, a non-Oblate from the Maritimes, to take over direction of Catholic schools. He wanted to put the sisters on salary as parochial school teachers and bring in the Religious of the Sacred Heart, headquartered in France, to run an elite convent academy in Vancouver. That would threaten the financial balance of the pioneer teaching sisterhood. The Sisters of Saint Ann did contract with the archbishop to provide paid parochial school staff, since the arrangement alleviated the problem of supporting charity students in Vancouver. However, the sisters pointed out to the archbishop that they would keep operating boarding academies in other cities, since these contributed to their Victoria novitiate.[73] In this manner, the sisters held on to the right to reproduce themselves as they saw fit. The congregation's plans to begin an elite Vancouver academy, Little Flower Academy, were delayed until 1926. The sisters continued to run a girls' high school in Vancouver for those families who could not afford the fees for the Convent of the Sacred Heart, or preferred the British Columbia provincial curriculum or commercial classes.[74]

Between 1888 and 1910, the Sisters of Saint Ann had to deal with other organizations that were also entering the institutionalization phase of their history. The Sisters of Saint Ann, as a congregation of religious women within a patriarchal church and state, faced conflicts centred particularly on policy, organization and rules.

The Sisters of Saint Ann's organizational development in this period fits patterns noted in Misner's study of American women religious. Conflict between a local bishop and the superiors of a sisterhood was the most important factor in the difficulties early American communities of women had moving to the institutional stage.[75] The "women religious had to shoulder most of the responsibility for their own finances and … management of their institutions," yet had to have "major decisions" approved by the local bishop. The bishops often disagreed with what the American women religious wanted to do.[76] To maintain their founders'

ideas, American communities of women turned to "written documents to insure the unity of the common goals and the way in which these goals were met."[77] When sisterhoods chose to, or had to, "set limits on the extent of their work," they justified their position "in terms of the needs" as the "sisters saw them ... not in terms of what they ... were capable of doing."[78]

From the 1880s through the 1900s, the Sisters of Saint Anne in Quebec, as the directors of the whole congregation, promoted institutionalization along the lines Misner suggests and supported the maturation of their English-speaking western province. By the 1900s, the general administration circulated printed English-language versions of the rule, the pedagogy and the letters of the mother general.[79] Administrators mandated inspection tours by a British Columbia–based prefect of studies.[80]

The Sisters of Saint Ann in British Columbia took advantage of opportunities to document the congregation's works and promote its autonomy within the Church. The congregation sent in information requested by Vatican delegate Falconio in 1901 regarding secondary education both in its Victoria convent academy and the St. Mary's Mission Indian boarding school.[81]

Oblate institutionalization in British Columbia centred on fitting Aboriginal missions and schools into a western Canadian pattern of government-funded residential schools serving as centres for itinerant mission efforts. Sisterhoods became the main teaching group in the residential schools. The Oblates' one non-Aboriginal school, St. Louis College in New Westminster, suffered from a lack of replacements for aging Irish teaching brothers. Other congregations were brought in to assist with settler parishes and schools. Until the 1900s, French Oblates remained the bishop administrators of western Canada. An increasingly Anglo-Canadian civic society and Catholic Church challenged them. By the 1920s, anglophone bishops took control of western Canadian sees and the Oblate congregation in Canada split into English and French provinces.[82]

It is interesting to note the changing place of the "Durieu system" for Aboriginal Missions and of the Sisters of Saint Ann in the reports of British Columbia Oblate superiors. In the 1890s, Bishop Durieu put Oblate efforts for Aboriginal communities first and subsumed the religious women's efforts to those of the Oblate missions. By the 1900s, his successor, Bishop Dontenwill, emphasized the residential schools as central sites in

the mission system.[83] He recognized the Sisters of Saint Ann who taught in parish and residential schools, and the Sisters of the Child Jesus from Le Puy, France, who had recently taken on management of several of the residential schools.

Conclusion: two systems

Two missionary systems evolved in the history of the Catholic Church in British Columbia between 1858 and 1914: the Sisters of Saint Ann's educational and caring institutions for the peoples of the province and the French Oblates' Durieu system of reductions for Aboriginal peoples. The sisters' system and the Oblates' system came together at mission residential schools, where, owing to gender politics, the women religious who taught were officially subordinate to the Oblates. But the women religious had a separate culture and were not entirely integrated into that male system. As a female religious congregation in the Catholic Church, the sisterhood could choose which schools or missions to operate and how to manage them. The sisters set policies and shaped Oblate missions in British Columbia, most notably in the structuring of the Kamloops Indian Industrial School in the 1890s.

The gender history of pioneer missionary organizations in British Columbia does not simply reverse the standard history, in which the Oblates, as men, appear central and the Sisters of Saint Ann, as women, appear on the margins. Instead, as feminist historians of this province contend, "taking gender into account" both widens the range of discussion and points out to scholars "the complex interaction of gender" with other aspects of its history.[84]

Endnotes

1 A. Perry, *On the Edge of Empire: Gender, Race and the Making of British Columbia, 1849–1871* (Toronto: University of Toronto Press, 2001), 200. See also M. Rutherdale, *Women and the White Man's God: Gender and Race in the Canadian Mission Field* (Vancouver: UBC Press, 2002); and J. Hare and J. Barman, *Good Intentions Gone Awry: Emma Crosby and the Methodist City Mission on the Northwest Coast* (Vancouver: UBC Press, 2006).

2 For example, R. Fisher, *Contact and Conflict: Indian-European Relations in British Columbia, 1774–1890* (Vancouver: UBC Press, 1977); and V.J. McNally, *The Lord's Distant Vineyard: A History of the Oblates and the Catholic Community in British Columbia* (Edmonton: University of Alberta Press and Western Canadian Publishers, 2000). For history of the Durieu system see J. Gresko, "Paul Durieu," in *Dictionary of Canadian Biography*, Volume XII (Toronto: University of Toronto Press, 1990), 281–185.

English-language histories of the Sisters of Saint Ann include [Edith Down] Sr. Mary Margaret Down SSA, *A Century of Service: A History of the Sisters of Saint Ann and Their Contribution to Education in British Columbia, the Yukon and Alaska 1858–1958* (Victoria: Morriss Printing for the Sisters of Saint Ann, 1966), and M. Cantwell SSA, *North to Share: The Sisters of Saint Ann in Alaska and the Yukon Territory* (Victoria: The Sisters of Saint Ann, 1992).

3 C. Haig-Brown, *Resistance and Renewal: Surviving the Indian Residential School* (Vancouver: Tillacum, 1988), 32. For citation example see E. Furniss, "Resistance, Coercion and Revitalization: The Shuswap Encounter with Roman Catholic Missionaries 1860–1900," *Ethnohistory* 42,2 (Spring 1995): 231–263. Two scholars who do discuss gender issues are J.A. Fiske, "Gender and the Paradox of Residential School Education in Carrier Society," in *Women of the First Nations*, ed. C. Miller and P. Chuchryk (Winnipeg: University of Manitoba Press, 1996), 167–182; and J.R. Miller, *Shingwauk's Vision: A History of Native Residential Schools* (Toronto: University of Toronto Press, 1996).

4 This essay draws on J. Gresko, "Gender and Mission: The Founding Generations of the Sisters of Saint Ann and the Oblates of Mary Immaculate in British Columbia 1858–1914," (University of British Columbia: Ph.D. diss., 1999), and research in the Archives of the Sisters of Saint Ann Victoria, B.C. [*ASSAV*], Lachine, Quebec [*ASSAL*] and the Oblate archives in Vancouver, B.C. and the Oblate Archives Deschatelets in Ottawa.

5 Gresko, "Gender and Mission: The Founding Generations," 50–88 on background and 327–336 for lists of generation members.

6 Gresko, 6–12.

7 B. Denault et B.Lévesque, eds., *Elements pour une sociologie des communautés religieuses au Québec* (Montréal: Les Presses de l'Université de Montréal, 1975).

8 B. Misner, "Highly Respectable and Accomplished Ladies," in *Catholic Women Religious in America, 1790–1850* (New York: Garland, 1988), 13, 14.

9 Ibid., 253.

10 J. Usher, "Modeste Demers," in *Dictionary of Canadian Biography*, Vol. X (Toronto: University of Toronto Press, 1972), 221–222.

11 F. Lanoue, "Joseph Michaud," *Dictionary of Canadian Biography*, Vol. XIII (Toronto: University of Toronto Press, 1994), 700–701.

12 *ASSAV* RG I S 24-1-1, "Dix premières années des Sœurs de Sainte-Anne à Victoria, 1858–1868." Narrées par Sœur Marie des Sept Douleurs. *ASSAV* RG I S 24-2 "Chronicles Book One," translated by J. Jodouin SSA, 79–83.

13 Sr. Mary Emerentienne's death was attributed to her difficult voyage west via Nicaragua, and those of Sisters Mary Alphonse, Catherine of Sienna and Anne of Jesus have been attributed to tuberculosis.

14 For example, Amanda, a Saanich woman who had worked as a cook for the sisters in the 1860s. See *ASSAV* RG I S 24-1-1, "Dix premières années des Sœurs de Sainte-Anne à Victoria, 1858–1868." Narrées par Sœur Marie des Sept Douleurs. *ASSAV* RG I S 24-2 "Chronicles Book One," translated by J. Jodouin SSA, 114–118.

15 *Necrology SSA* I, 98–100, Cecilia McQuade took vows as Sr. Mary Charles in 1870. *Necrology SSA* I, 243, Anna McQuade took vows as Sr. Mary Agnes in 1871. *Necrology SSA II*, 34–35 Mary McEntee took vows as Sr. Mary Catherine of Siena in 1871.

16 J. Gresko, "Salomée Valois, Sœur Marie du Sacré-Coeur," *Dictionary of Canadian Biography*, Vol. XII (Toronto: University of Toronto Press, 1994), 1048–49.

17 *ASSAV* RG I S 24-1-1, "Dix premières années," 83–85 regarding arrangements and financing for sending additional sisters west from Montreal in 1863.

18 J.E.Hendrickson, ed., *Journals of the Legislative Council of British Columbia 1866–1871*, Vol. V, Journals of the Colonial Legislatures of the Colonies of Vancouver Island and British Columbia 1851–1871 (Victoria: Provincial Archives of British Columbia, 1980), 163 and 171.

19 E. Watts, "Attitudes of Parents Towards the Development of Public Schools in Victoria, British Columbia during the Colonial Period," (Vancouver: Simon Fraser University M.A. Thesis, 1986) surveys the competition.

20 *ASSAV* RG I S 24-1-1, "Dix premières années," 39, 53–55.

21 *ASSAV* RG I S 24-1-1, "Dix premières années," 53–61.

22 *ASSAV* RG I S 24-1-1, "Dix premières années," 108–112.

23 *ASSAV* RG I S 24-1-1, "Dix premières années," 153–154. Also see *ASSAV* RG II S 55 55–1 "Monograph St. Mary's Mission School, Mission City, B.C. 1868–1950."

24 *ASSAV* RG I S 24-1-1, "Dix premières années," 98–103.

25 Down, *Century of Service*, 32, 53.

26 *ASSAV* RG I S 24 box 1 file 8, Sr. Mary Lumena (Brasseur), "Diary Account of St. Mary's Mission B.C. 1868–1892," 11–12.

27 [Louis-Joseph d'Herbomez], A. Louis, O.M.I., "Letter from His Lordship the Bishop of Miletopolis and Vicar of British Columbia," in *British Columbia: Report of the Hon. H. L. Langevin, C.B. Minister of Public Works* (Ottawa, 1872), 158–160.

28 E. Smyth, "Christian Perfection and Service to Neighbours: The Congregation of the Sisters of St. Joseph, Toronto, 1851–1920," in *Changing Roles of Women in the Christian Church in Canada*, eds. G. Muir and M.F. Whiteley (Toronto: University of Toronto Press, 1995), 51.

29 See W. Woestman, *The Missionary Oblates of Mary Immaculate: A Clerical Religious Congregation with Brothers* (Ottawa: Faculty of Canon Law, Saint Paul University, 1995).

30 Missions de la Congrégation des Oblats de Marie Immaculée [Missions] 1865, 313.

31 R. Huel, *Proclaiming the Gospel to the Indians and the Métis* (Edmonton: University of Alberta Press and Western Canadian Publishers, 1995), 71–72.

32 Woestman, 207.

33 *ASSAV* RG I S 24-1-1, "Dix premières années," 3–5, regarding the verbal request of Demers October 19, 1857 and the sisters' verbal acceptance.

34 J. Gresko, "Salomée Valois, Sœur Marie du Sacré-Coeur, in *Dictionary of Canadian Biography*, Vol. XII (1994), 1048–49.

35 *ASSAL* Letterbook No. 55 Louis [d'Herbomez] Ev. de Miletopolis, Vic. Ap., à Sœur Marie de la Providence, 10 juin 1865; and Louis-Joseph Ev. de Miletopolis à Rev. Mère Sup. Gén. des SSA, 22 juin 1865, regarding St. Ann's convent school, New Westminster.

36 Necrology SSA.

37 Sr. Marie du St. Rosaire was born in 1855, professed in 1874, arrived in Victoria in 1875, was assigned to St. Mary's Mission in the 1880s. She left the congregation in 1897. See Gresko, "Gender and Mission," 216 n. 47.

38 *ASSAV* RG I S 24-1-1, "Dix premières années." *ASSAV* RG I S 24-2 "Chronicles Book One," translated by J. Jodouin SSA, 225 ff. "Dates of Arrival of Sisters at Victoria, B.C."

39 British Columbia, Superintendent of Education, *Annual Report 1876–77*, 20.

40 Gresko, "Gender and Mission," 337–339.

41 Cantwell, *North to Share*, 15–17. See also G.G. Steckler, "Charles John Seghers," in *Dictionary of Canadian Biography*, Vol. XI (1982), 805–806.

42 Cantwell, *North to Share*, 15–17 and Down, *Century of Service*, 98–102.

43 *ASSAL* Letterbook No. 184, "P. Durieu à Rev. Mère, 1 décembre 1873"; and No. 185, "Sr. M. Eulalie à Rev. Père Durieu, 19 janvier, 1874."

44 *ASSAV* 14-3-17 "Victoria Convent Historical Eye-View and Nominations," discusses the friendship of the two congregations dating from the 1850s. The Sisters of Providence opened St. Mary's Hospital, New Westminster, 1886 and St. Paul's Hospital, Vancouver in 1894.

45 M. McGovern, SP, "Perspective on the Oblates: The Experience of the Sisters of Providence," in *Western Oblate Studies 3/Etudes Oblates de l'Ouest 3*, ed. R. Huel (Edmonton: Western Canadian Publishers, 1994), 91–108.

46 *ASSAV* RG II S63, Williams Lake, B.C. St. Joseph's Mission 1876–1888, Sœur Marie-Octavie, "Notes historique de la Mission St. Joseph (1876 à 1883)" [n.d. typescript], 1. Down, *Century of Service*, 76–79, on agreement to staff Williams Lake.

47 Down, *Century of Service*, 107–109.

48 J. Barman, "Transfer, Imposition or Consensus? The Emergence of Educational Structures in Nineteenth Century British Columbia," in *Schools in the West: Essays in Canadian Educational History*, eds. N. Sheehan, J.D. Wilson and D.C. Jones (Calgary: Detselig, 1986), 241–264.

49 *Journals of the Legislative Assembly of British Columbia 1876*, 34, 27 April 1876 regarding a petition signed by Charles Seghers and others. The 1881 one was printed in A.L.J. D'Herbomez, compiler, *Secular Schools versus Denominational Schools* (Printed with the Press of St. Mary's Mission, B.C. partly by the pupils of the Indian School, 1881).

50 *ASSAV* RG I S 17 Box 5, Williams Lake Correspondence, "S.M. de la Providence to Msgr., [Durieu], 11 juin, 1891."

51 *ASSAV* RG I S 3-1-9, "Recommendations de notre très Revde Mère Générale M. M. Anastasie Sup. génl. [1886]," [Signed, Victoria avril, 1886]. Compare Misner, *Highly Respectable and Accomplished Ladies*, 30–31 and 155 on Sisters of Charity conflict with Bishop Hughes of New York in the 1840s.

52 Archives Deschâtelets Oregon 1, C-vii, 2 Durieu's System, [Also listed as HPK 5 241] "Lettres de Mgr. DURIEU au R.P. Le Jacq sur la direction des Sauvages" (typescript of MSS), 23 novembre 1883, 23 et 25 février, 1884.

53 *Necrology SSA* on Sr. Mary Theodore, and D. Mulhall, *Will to Power: The Missionary Career of Father Morice* (Vancouver: University of British Columbia Press, 1986). See also E. Smyth, "Writing Teaches Us Our Mysteries: Women Religious Recording and Writing History," in B. Boutilier and A. Prentice, eds., *Creating Historical Memory: English Canadian Women and the Work of History* (Vancouver: University of British Columbia Press, 1997).

54 *Missions* 1888, 72 ff. Le Jacq's account of 1887 events at St. Mary's Mission is based on Codex historicus, St. Peter's House, New Westminster, from February 1887 to December 31st, 1889. *ASSAV* RG 1 S 24 box 1, file 8, Sr. Mary Lumena (Brasseur), diary Account of St. Mary's Mission B.C. 1868–1892. Published

accounts by Sr. Mary Theodore SSA include her *Pioneer Nuns of British Columbia. Sisters of Saint Ann* (1931), 43–44 and *Heralds of Christ the King: Missionary Record of the North Pacific 1837–1878* (New York: P.J. Kenedy & Sons, 1939), 194–201 and 256.

55 See Sr. Mary Joseph Calasanctius SSA (De Ruyter), *The Voice of Alaska* (Lachine: St. Ann's Press, 1947); Cantwell, *North to Share*, 55, and 267 note 16; and H. MacDonald, "The Social Origins and Congregational Identity of the Founding Sisters of St. Martha of Charlottetown, PEI, 1915–1925," *CCHA Historical Studies*, 70 (2004), 30 n. 5.

56 Gresko, "Gender and Mission: The Founding Generations," 222–251 and 345–48 for discussion and list of entrants to the Sisters of Saint Ann from British Columbia families. Twenty-two women entered the sisterhood but only four sons of local families entered the Oblates.

57 Sœur Marie-Jean-de-Pathmos, ssa, *Les Sœurs de Sainte-Anne, un siècle d'histoire, Tome I: 1850–1950* (Lachine: Les Sœurs de Sainte-Anne, 1950), 355–356.

58 Down, *Century of Service*, 113–115. See also M. Milne Martens and G. Chalmers, "Educating the Eye, Hand and Heart at St. Ann's Academy: A Case Study of Art Education for Girls in Nineteenth Century Victoria," *BC Studies* 144 (Winter 2004–2005), 31–60.

59 Down, *Century of Service*, 124–126.

60 Ibid., 107–109.

61 See Cantwell, *North to Share*. The northern missions included schools and/or hospitals at Holy Cross Alaska in 1888, Douglas Island near Juneau in 1894, Akulurak in Alaska from 1894 to 1898, Dawson in the Yukon in 1898, Nulato in Alaska in 1899.

62 The Oblates did not work at Kuper Island until the mid-20th century. Diocesan priests, then the Montfort Fathers, served at Kuper Island.

63 Down, *Century of Service*, 124–126.

64 Ibid., 125.

65 Sr. Mary Theodore SSA, *Heralds of Christ the King: Missionary Record of the North Pacific 1837–1878* (New York: P.J. Kenedy and Sons, 1939), 256. Oblate Archives, Vancouver, St. Peter's *New Westminster Codex historicus 1889–1914*, May 23, 1890 and April 11, 1892.

66 *ASSAV* RG I S 24 box 1 file 8, Sr. Mary Lumena, Diary Account of St. Mary's Mission B.C. 1868–1892, for Sr. Mary Lumena's views.

67 See Down, *Century of Service*, 118–119. See note 114.

68 National Archives of Canada, RG 10 Indian Affairs Vol 3799, file 48, 432–1 contains Department of Indian Affairs and Oblate correspondence 1889–1892. The actions of Chief Louis are recorded in RG 10 Vol. 39181, file 116, 659–1,

Hagan to Vowell, May 26, 1892. Sr. Marie Anne Eva SSA, *A History of the Sisters of Saint Anne Volume One 1850–1900* (New York: Vantage Press, 1961), 296–297, draws on Sr. Marie Joachim's report on the Industrial School, July 12, 1890, and Mother Marie de l'Ange Gardien, Report of the Official Visit, Kamloops, April 28, 1893.

69 Sr. Marie Anne Eva SSA, *A History of the Sisters of Saint Anne Volume One 1850–1900*, 297. See also *ASSAV* RG I S 17 St. Ann's Williams Lake and Kamloops Correspondence, typescripts of original letters. Paul Durieu to Rev. Mother, 8 April 1890 and 15 April, 1890. S.M. Anne of Jesus to His Grace, 10 April 1890, S.M. Anne of Jesus to his Grace [Durieu], 18 September 1890. Oblate Bishop Durieu passed on the sisters' complaints. For the correspondence regarding them see RG 10 Indian Affairs Vol. 3799, file 48, 432-1. J.M. LeJacq OMI, by order of Bishop Durieu to J.A. Macrae, Dominion Inspector Industrial Schools NWT, August 2, 1890; J. A. Macrae to Superintendent General Indian Affairs August 8, 1890; Paul Durieu to E. Dewdney, 25 September 1890.

70 RG 10 Indian Affairs Vol. 3799, file 48, 432-1, [Private Letter] Albert Lacombe to Edgar Dewdney, 20 June 1890. G. Carrière, *Dictionnaire biographique des Oblats de Marie Immaculée au Canada* (Ottawa: Editions de l'Université d'Ottawa, 1977) tome II, 219–222 on Lacombe.

71 Carrière, *Dictionnaire biographique*, (1979) tome III, 26–27. His sister became Sr. Mary Inez SSA.

72 See his columns on schools in the diocesan newspaper, *The Month*, 1893–1896.

73 *ASSAL* B51/74, 7, 79, handwritten letter, N. McNeil, Archbishop Vancouver, to Dear Mother General, September 2, 1910.

74 Down, *Century of Service*, 147–148.

75 Misner, "Highly Respectable and Accomplished Ladies," 153–54.

76 Ibid., 252.

77 Ibid., 254.

78 Ibid., 202.

79 *ASSAV* RG I S4–1, "Sisters of Saint Ann Circular Letters of Mother General, January 25, 1914 to September 8, 1919." Mother M. Melanie Superior General.

80 Down, *Century of Service*, 133–34.

81 E. Smyth, "The 'True Standing of Catholic Higher Educational Institutions" of English Canada: The 1901 Falconio Survey," *CCHA Historical Studies* 66 (2000), 114–131.

82 Huel, *Proclaiming the Gospel*, 226–228.

83 *Missions* 1893, 385–409; 1898, 245–257; 1905[1904 report], 269–288; 1909 [1908 report], 1–12.

84 G. Creese and V. Strong-Boag, "Introduction: Taking Gender into Account in British Columbia," in *British Columbia Reconsidered*, eds. G. Creese and V. Strong-Boag (Vancouver: Press Gang, 1992), 5. Compare the "Introduction," to S. Carter, L. Erickson, P. Roome and C. Smith, eds., *Unsettled Pasts: Reconceiving the West Through Women's History* (Calgary: University of Calgary Press, 2005), 8–9.

Contributors

Dr. Sheila Andrew is professor emerita of the Department of History at St. Thomas University, Fredericton. She has published several articles on nineteenth-century Acadian women as teachers, fishing industry workers, consumers, nationalists and religious.

Dr. Rosa Bruno-Jofré is professor and dean, Faculty of Education, Queen's University, Kingston, Ontario. She is the author and editor of books and articles on the history of education in Latin America and Canada, including *The Missionary Oblate Sisters: Vision and Mission* (Montreal and Kingston: McGill-Queen's Press, 2005).

Dr. Jacqueline Gresko is faculty emeritus, History Department, Douglas College in New Westminster, B.C. She continues teaching Canadian History as a sessional instructor at Corpus Christi College at the University of British Columbia. Dr. Gresko is researching the Catholic women religious who taught the Japanese evacuees in the British Columbia Interior during World War II.

Dr. Christine Lei is a sessional lecturer at Nipissing University (Brantford Campus). She is currently researching the Sisters Servants of Mary Immaculate who taught in Ancaster, Ontario, from the 1950s to 1970s.

Dr. Ellen Leonard, a Sister of St. Joseph of Toronto, is professor emerita, University of St. Michael's College. She was the 2004 recipient of the Catholic Theological Association of America's Anne O'Hara Graff Award and the 2005 YWCA Woman of Distinction Award, both for her contribution to women and education.

Dr. Heidi MacDonald is associate professor and chair, Department of History, University of Lethbridge. She is engaged in a study of youth in English Canada during the Great Depression.

Dr. Tania Martin is assistant professor, School of Architecture, Université Laval. She also holds the Canada Research Chair in Built Religious Heritage.

Dr. Elizabeth W. McGahan is a sessional lecturer at the University of New Brunswick, Saint John. In addition to her studies of women religious, she is completing a history of the University of New Brunswick, Saint John.

Dr. Mary Olga McKenna is a Sister of Charity of Halifax. She is professor emerita at Mount Saint Vincent University. She is the author of books and articles on education including *Charity Alive: Sisters of Charity of Saint Vincent de Paul, Halifax, 1950–1980* (Lanham, MD: University of America Press, 1998).

Dr. Sioban Nelson is professor and dean, the Lawrence S. Bloomberg Faculty of Nursing, University of Toronto. She is the author and editor of books and articles on the history of nursing including *Say Little, Do Much: Nurses, Nuns, and Hospitals in the Nineteenth Century* (Philadelphia: University of Pennsylvania Press, 2001); and *The Complexities of Care: Nursing Reconsidered* with Suzanne Gordon (New York: Cornell University Press, 2006); and Editor-in-Chief of the international journal *Nursing Inquiry,* Blackwell Publishing.

Dr. Veronica O'Reilly is a Sister of St. Joseph of Peterborough, with a background in education, administration and ecumenism. Currently, she holds the position of Executive Director of the Federation of the Sisters of St. Joseph of Canada and is involved in writing a two-volume history of the six congregations in the Federation.

Dr. Elizabeth Smyth is professor at the Ontario Institute for Studies in Education of the University of Toronto. She is the author and co-editor of articles and books on women religious and education, including *Wisdom Raises Her Voice: The Sisters of St. Joseph of Toronto Celebrate 150 Years* (Toronto: Transcontinental Press/Sisters of St. Joseph of Toronto, 2001).

Dr. Rebecca Sullivan is associate professor, Faculty of Communication and Culture at the University of Calgary. Her published works on women religious and popular culture include *Visual Habits: Nuns, Feminism and American Postwar Popular Culture* (Toronto: University of Toronto Press, 2005).

Index

A

Academy of the Assumption,
　Wellesley Hills, MA 80
Acadians 21–33, 51, 73
Act for the Better Encouragement of
　Education, An (1865) 72
Adsum House, Dartmouth 82
Allen, Elliot 239
Alphonsus, Sister SCIC 50, 51, 52
Amethyst House, New York 82
Ami du Peuple 111
Anatolie, Sister SP 164
Andrew, Sister SP 160
Annunciation, Sister SP 158
Anthony of Padua, Saint 140
Aquinas, Thomas 230, 232
Archambault, Canon 157
Arseneau, Adelina 33
Arseneau, Catherine 33
Aschenbrenner, Father F. A. 257–8
Association des enseignants franco-
　ontariens 219
Association for Supervision and
　Curriculum Development 221,
　225
Association of Universities and
　Colleges of Canada 79
Augustine, Mother SCIC 49
Augustine Hospitalières de la
　Misericorde de Jésus of Dieppe
　7
Augustines of the Hôtel-Dieu of
　Quebec 15, 133
Aulneau Renewal Centre, Saint-
　Boniface, MB 266

Authentic Narrative of the Horrors,
　Mysteries and Cruelties of
　Convent Life, An 106
Awful Disclosures of Maria Monk, The
　106
Axelrod, Paul 92

B

Barth, Gunter 111
Beck, Jeanne 17
Beecher, Lyman 114, 115
Belliveau, Alphée 33
Belliveau, Marie 33
Benedicta, Sister IHM (*see* Brennan,
　Margaret)
Benedictine Sisters of St. Joseph 161
Bennet, John 47
Berkshire Conference on Women's
　History 16
Bernard, Sister SCIC 48
Bernstein, Carol 107, 121, 122
Bethléem convent, Montreal 141
Beyond God the Father 233, 240
Billy the Kid 161
Biron, Abbé 23
Blandine, Sister SP 159
Blondin, Esther (*see* Marie-Anne,
　Mother SSA)
Boff, Leonardo 258, 267
Bonsecours, Sister SSA 278
Boston College 233
Boucher, Sister Jeanne MO 248,
　249, 251–2, 254, 255–6, 267
Boudreau, Jerome 31
Bourassa, Chantal 17
Bourgeois, Sister Elisabeth NDSC 26
Bourgeois, Frances (see Regina,
　Sister)

Bourget, Bishop Ignace 275
Bourne, George 115
Boutin, Sister Lea MO 248, 250,
 252, 255, 256–60, 263, 264,
 265, 267
Bray, Bishop Patrick A. 53
Brendan, Sister M. SCIC 38, 39,
 47, 48
Brennan, Margaret 233
Brescia College, University of
 Western Ontario 214, 215, 216
Bridges, Dr. Henry S. 50
Brownsville Community Council
 Project, New York 78
Burley, Stephanie 10

C

Cada, Lawrence 249, 260
Canadian Benevolent Association,
 New York 114
Canadian Catholic Historical
 Association 16
Canadian Catholic Organization for
 Development and Peace 259
Canadian Catholics for Women's
 Ordination 240
Canadian College of Teachers 223
Canadian Historical Association 16
Canadian History of Education
 Association 16
Canadian Religious Conference 223,
 234, 249, 263
Canadian Society for the History of
 Medicine 16
Cantin, Sister Paule SC 81
Carmen, Dr. 162, 163
Carney, Joanna (*see* Alphonsus, Sister
 SCIC)
Carroll, Archbishop John 69–70
Carter, Bishop Alexander 217
Carter, Gerald Emmett Cardinal
 217, 238
Carter, Irene Isobel (*see* Carter,
 Mother Mary Lenore SP)

Carter, Mother Mary Lenore SP 13,
 210, 217–25
Carter, Sister Mary RSCJ 217
Carter, Tom 217
Carter Centre for Excellence in
 Leadership 217
Catholic Network for Women's
 Equality 240
Catholic University of America,
 Washington 75, 232–3
Catholic Women's League 17
Census of Religious Sisters of Canada 7
Central High School, Halifax 74
Chinnici, Joseph P. 134
*Christian Attitudes Toward Women:
 Background and New Directions*
 233
Christian Brothers (*see also* De la
 Salle Brothers) 44, 45, 238
Christian Curriculum Development
 Conference 221, 225
Christie, Nancy 17
Chronicles of Providence Hospital 158,
 159, 164
Clark, Lynn Schofield 109–10
Claver, Sister Peter SP 157
Clement VIII 141
Clerics of St. Viator 277
Coburn, Carol 10, 93
Code of Canon Law (1917) 231
Collège St-Joseph, New Brunswick
 22, 23, 31
Collège St-Louis, New Brunswick
 23, 31
Come to the Father catechetical
 program 238
Commercial Advertiser 117
Common Schools Act of 1871, The
 (New Brunswick) 22, 24, 43,
 44, 45, 48, 51
Congar, Yves 248, 249, 251, 258,
 267

Congrégation de/of Notre-Dame 13, 24–5, 26, 27, 30, 31, 32, 88, 217
Congregation for Religious, Rome 241
Connolly, Bishop Thomas Louis 41–2, 44, 72
Consciousness Examen 257–8
Constance, Sister SCIC 51
Constitutions of 1908 (Loretto Sisters) 183, 184
Constitutions (Sisters of St. Joseph, 1926) 195
Convent of the Sacred Heart, Vancouver 286
Council of Trent 238
Couten, Father 165
Cox, Theresa 160

D

D'Angelo, Mary Rose 239
Dalhousie University, Halifax 75, 77, 95
Daly, Mary 233, 240, 263
Danylewycz, Marta 17, 86–7, 88, 89, 105
Daughters of Charity 69, 153, 156
Dawson, Sister Caroline IBVM 239
de Bihan, Yvonne OSU 211
de Chardin, Pierre Teilhard SJ 250, 267
De la Salle Brothers (*see also* Christian Brothers) 72
de Mazenod, Eugene OMI 276
de Verteuil, Sister Jacqueline CSJ 246
Dease, Mother Superior Teresa 174
Decree on Religious Life (*see also* Perfectae Caritatis*) 235
Demers, Bishop Modeste 275, 277–8, 279
Depression, the (*see* Great Depression, the)
Dewart, Joanne McWilliam 239, 240
d'Herbomez, Bishop Louis-Joseph OMI 278, 279, 283

Dictionary of Biography of the IBVM in North America 181, 183
Dietrich, Sister Dominica OSU 216
Dignan, Bishop Ralph Hubert 192, 194–6, 197–8, 200, 201, 202, 203, 204
Divine Word Institute, London, ON 238
Dogmatic Constitution on the Church, The 236–7
Doiron, Elizabeth 30, 32
Dominican College, Ottawa 258
Dominican Sisters of Trois-Rivières 17
Dominican order 16
Donnelly, Catherine SOS 10
Dontenwill, Bishop Augustin OMI 286, 287–8
Donum Dei 234
Dumont, Micheline 23
Dunphy, Father Edward J. 38–9, 41, 44, 45, 55
Durieu, Bishop Paul OMI 274, 282, 283, 285, 287
Durieu System 274, 275, 287, 288
d'Youville, Mother Marguerite 139, 141

E

Elementary Teachers' Federation of Ontario 219
Elizabeth Seton Academy, Dorchester, MA 82
Elizabeth Seton Centre for Asians, Lawrence, MA 82
Elizabeth Seton Lecture Series, Mount Saint Vincent University 80
Elizabeth Seton Psycho-Educational Centre, Wellesley Hills, MA 78
Ellis, Reverend Adam C. SJ 194
Enfants de Marie 129
Enneagram 264
Eugene, Sister SP 158
Eunic, Sister Catherine SP 154

Evangelica Testificatio 248, 257
Everett, Charles A. 43

F

Fahmy-Eid, Nadia 23
Faith, Sister Mary SP 158
Faithful Companions of Jesus 233
Farmer, Sister Irene SC 88–9
Farry, Mother Bernardine CSJ
 195–6, 197–8, 201, 202
Fathers of the Holy Spirit 137
Federation of Women Teachers'
 Association of Ontario 219
Feretti, Lucia 17
Fiand, Barbara 263
Fiorenza, Elisabeth Schussler 263
First Vatican Council 238
Fitz, Raymond 249, 260
Foley, Gertrude 249
Fortier, Sister Cecile OM 256, 266,
 267
Foucault, Michel 122
Francesca, Sister SCIC 49, 50
Franchot, Jenny 107, 118
Francis of Assisi, 161
Fritz, Maureena NDS 239
From Desenzano to 'The Pines' 216
*Further Disclosures of Maria Monk,
 The* 117

G

Gamelin, Mother Émilie SP 153,
 155
Gaudium et Spes (*see also Pastoral
 Constitution on the Church in the
 Modern World*) 253
Gauvreau, Michael 17
Geernaert, Sister Donna SC 239
"Gentlemen's Agreement," the (1875)
 44, 48, 49, 53, 54, 55
Giardino, Thomas 249
Glengarda Academy, Windsor, ON
 214–5, 216
Glengarda Ursuline Academy of Our
 Lady of Prompt Succour (*see*

Glengarda Academy, Windsor,
 ON)
Godfrey, Mother Superior Mary SP 164
Goffman, Erving 108, 121, 122, 140
Gonzaga University, Spokane, WA
 258
Graff, Harvey 87
Great Depression, the 13, 53, 86–7,
 91–2, 97–9, 192
Grey Nuns 11, 15, 108, 124,
 129–35, 137, 139, 141–4, 274
Guernet, Marie (*see* Marie de Saint-
 Ignace, Mother)
Guests in Their Own House 234
Guinan, Sister St. Michael OSU
 215–16
Guindon, Dr. Jeannine 266
Gutierrez, Gustavo OP 258, 267
Guyart, Sister Marie OSU (*see* Marie
 de l'Incarnation, Mother)

H

Habermas, Jurgen 110
Hagan, Michael 285
Hagerty, Sister Mary Albertus SC 88
Halifax Infirmary 74, 77, 95
Hall, Stuart 110
Hamilton, Alexander 114
Hanley, Father SJ 250
Harrington, Sister Ursula CSJ 203–4
Hartlieb, Father 160
Hecker, Father Isaac 41
Histoire sociale/Social History 17
History of Women Religious
 Conference 16
Holy Ghost Hospital, Cambridge,
 MA 133
Home of the Guardian Angel, Halifax
 74
Hoover, Stewart 109–10
Horgan, Sister Katherine SC 90, 97
Hôtel Dieu Congregation 108
Hoyt, W. K. 114, 115, 117

I

Institut de Formation Humaine
 Intégrale de Montréal 266
Institute of Christian Thought 239
Institute of the Blessed Virgin Mary
 (*see* Loretto Sisters)
International Conference of Kateri
 Tekakwitha 262
International Federation of Historians
 16
*Inventaires des immeubles de La Province
 de Sacré Cœur* 164

J

Jean-de-la-Croix, Mother MO 249, 267
Jenkins, Kathleen 113, 115
Jesuit order 154, 173, 174, 232, 233
John F. Kennedy School, Montreal 77
John of the Cross 238
John Paul II, Pope 241, 262
John XXIII, Pope 235
Joseph, Mother SP 153, 155, 157,
 161, 162, 164
Joseph of the Sacred Heart, Sister
 SP 159
Joseph, Saint 140, 156
*Joy in the Pattern: A Study of the
 Ursuline Life and Teachings of
 Reverend Mother M. Genevieve
 Williams* 211
Judge, Father William SJ 160

K

Kamloops Indian Industrial School
 285, 288
Kane, Sister Dennis Marie SC 78
Kane, Sister Theresa RSM 241
Kelly, Sr. Mary James SC 78
Kennedy, Sister Aloysius CSJ 191
Kerr, Sister Mary Agnes IBVM 217
Kerwin, Dr. Larkin 78
Kirk, Helena (*see* Paul, Sister)
Kusters, Father 159

L

La Puma, Cardinal 194, 197
Lacelle, Elizabeth 263
Lacombe, Father Albert OMI 285
Lajemmerais Hospice, Varennes, QC
 145
Landry, Aldea 33
Landry, Valentin 21, 31
Langevin, Monseigneur/Archbishop
 Adélard OMI 247, 256–7, 262,
 264
Langlois, Claude 193
L'Arche International 254
Leadership Conference of Women
 Religious in the United States
 233, 241
LeJacq, Jean-Marie 283
Leonard, Ellen CSJ 239
Lesage, Father Germain 250
Lichtenberg, Carol 249
Life in the Grey Nunnery at Montréal
 106
Liguori, Sister M. SCIC 46
Lilies (1934 Sisters of Charity) 96, 97
Little Flower Academy, Vancouver
 286
Little Medical Guide 157–8
Lorette: Story of a Quebec Nun 115
Loretto Abbey, Toronto 175–6, 177
Loretto College, Toronto 185, 232
Loretto Lindsay, Ontario 177
Loretto Sisters 10, 11, 172–86
Louis de France, Sister MO 249
Loyola, Ignatius 240, 264
Loyola, Sister CSJ (*see* Leonard, Ellen)
Loyola University, Los Angeles 250
Lumen Gentium (see *Dogmatic
 Constitution on the Church, The*)
Lumen Vitae, Brussels 238

M

Mackett, Sister Amata SP 161
Madelva, Sister CSC 231, 232
Maillet, Mary-Marguerite (*see* Marie-Julienne, Sister SC)
Malone, Mary 233, 242
Manhattan College, New York 238, 239–40
Manitoba School Question 247
Marie Anastasie, Mother General SSA 283
Marie de l'Incarnation, Mother OSU 7, 211
Marie de Saint-Ignace, Mother a.m.j. 7
Marie-Anne, Mother SSA 275, 276, 279
Marie-Hélène, Sister SC 29
Marie-Julienne, Sister SC 29
Marie-Regina, Sister SC 24
Martel, Marcel 247
Mary Conception, Sister SSA 278
Mary Lumena, Sister SSA 278, 285
Mary of Jesus Noirry, Sister SP 161
Mary of the Sacred Heart, Sister SSA 277, 278
Mary Providence, Sister SSA 277, 278, 281
Mary Theodore, Sister SSA 283
Marymount College, Los Angeles 250
Materia Medica 160
Matière médicale 157
Matthews, Sister Mary Fabian SC 78
Maura Clarke–Ita Ford Center, Brooklyn, NY 82
McCarthy, Sister Francis d'Assisi SC 76–7
McDannell, Colleen 143
McDonald, Mary (*see* Francesca, Sister SCIC)
McEnroy, Sister Carmel RSM 234, 236
McGill University 157

McGrath, Mother St. Philip CSJ 195
McGuigan, Archbishop James 197
McGuirk, Abbé Hugh 24
McKee-Allain, Isabelle 33
McKenna, Veronica (*see* Constance, Sister SCIC)
McKenzie, R. A. F. 232
McKinley, Sister Mary Edward SP 217
McNeil, Archbishop Neil 286
Merici, Angela 210
Meyers, Sister Bertrande DC 77
Michaud, Felix 27
Michaud, Marguerite (see Marie-Hélène, Sister)
Misner, Barbara 276, 279, 282–3, 286–7
Missionary Oblate Sisters: Vision and Mission, The 14, 248, 264
Missionary Oblate Sisters of the Sacred Heart and Mary Immaculate 11, 14, 247–68
Missionary Oblates of Mary Immaculate 15, 248, 249, 254, 255, 262, 274, 275, 276, 277, 278, 281–8
Modell, John 92
Moir, John 9
Moniteur Acadien 25, 33
Monk, Maria 111, 106, 115–18, 120, 123, 124
Montreal Courier, The 111
Moran, Gabriel 238
Morice, Father Adrien-Gabriel OMI 283
Morning Freeman 41
Morse, Samuel 114, 115
Mounier, Emmanuel 250, 251
Mount Saint Agnes School, Bermuda 80
Mount Saint Vincent Academy, Halifax 80
Mount Saint Vincent College, Halifax 73, 74–5, 76–7, 78, 95
Mount Saint Vincent University 79, 80

Murdock, Graham 110
Murphy, Sister Mary Agnes CSJ 232
Myers-Briggs Type Indicator 264

N

National Coalition of American Nuns
209
National Council of Colleges and
Universities 76–7
Nealis, Margaret (*see* Liguori, Sister
M. SCIC)
New Brunswick Parish Schools Act
(1858) 43
Newman College, Edmonton 231
Nightingale, Florence 153
Nugent, Sister Carmela SCIC 51
Nun's Story, The 122

O

O'Brien, Teresa (see Thomas, Mother
SCIC)
O'Connor, Bishop Dennis 194, 197,
198, 202, 203
O'Connor, Bishop Richard
Alphonsus 195
OECTA (*see* Ontario English
Catholic Teachers' Association)
O'Gara, Margaret 239
O'Loughlin, Kathleen (*see*
O'Loughlin, Sister Sheila CSJ)
O'Loughlin, Sister Sheila CSJ
200–01
On Becoming a Person 253
O'Neill, Father John OMI 286
Ontario Association for Curriculum
Development 223, 225
Ontario College of Education 178
Ontario Department of Education 178
Ontario English Catholic Teachers'
Association 219–23
Ontario Public School Teachers'
Federation 219
Ontario Public School Teachers'
Men's Federation 219

Ontario Secondary School Teachers'
Federation 219
Ontario Teachers' Federation 219,
221, 223
Onward in Hope 261
Operation Continuous, Boston 78
Order of St. Ursula (*see* Ursulines)
O'Reilly, Irene CSJ 200
O'Rielly, Thomas 46–7
OTF (*see* Ontario Teachers' Federation)
O'Toole, Mary (*see* Augustine, Mother)
O'Toole, Sister Katherine SC 81
Ottawa Normal School 218

P

Parent Commission Report, The
(1965) 78
Pariseau, Mother Joseph SP 154
Parodi, Father SJ 159
*Pastoral Constitution on the Church in
the Modern World* 234–5
Pastoral Work with the "Amerindians"
262
Patrick, Saint 140
Paul, Sister SCIC 51
Paul VI, Pope 241, 248
Pères de Ste-Croix 22
*Perfectae Caritatis (see also Decree on
Religious Life)* 248, 249, 252,
253, 256, 267
Personalité et Relations Humaines
(*see* Personality and Human
Relations)
Personality and Human Relations
248, 253, 256, 257, 260, 264,
267
Phelan, Father 118
Piché, Alphonse 144
Pines, The, Chatham, ON 211, 216
Pinochet, Augusto 259
Pius IX, Pope 70, 71
Pius XII, Pope 232, 235
Poirier, Obelline 32–3
Pope John XXIII School, Montreal 77

Pottier Commission on Educational
Finance (1956) 77
Power, Bishop Michael 11, 172
Power, Sister Maura SC 76
Praxedes, Mother SP 156, 165
Préfontaine, Father 165
Presentation Sisters 16–17
PRH (*see* Personality and Human
Relations)
Protestant, The 115
Protestant Vindicator, The 111
Providence Hospital, Seattle 156, 167

Q

Quebec Act (1774) 113
Queen's Coronation Medal 223
Queen's University 178
*Quest: The Search for Happiness in
Poetry, The* 219
Quirk, Agnes 52 (*see also* Quirk,
Mother Loretto SCIC)
Quirk, Mother Loretto SCIC (*see also*
Quirk, Agnes) 52

R

Rahner, Karl 249, 251, 258, 267
Reed, Carol 209
Reformation, Protestant 238
Regina, Sister SCIC 51–2
Regina Mundi, Rome 232
Regis College, Toronto 232, 233
*Register des missions demandées à
La Province du Sacré Coeur
Vancouver Wa 1856* 159
Règles des Filles de la Charité 69
Reiser, W. SJ 259
Religieuses Hospitalières de St-
Joseph 24, 25, 26, 30, 32
Religious Hospitallers of St.
Joseph (*see also* Religieuses
Hospitalières de St-Joseph) 11,
13
Religious of the Sacred Heart 16, 286
Report of the Royal Commission of
Inquiry on Education in the

Province of Quebec, 1963–
1966 (*see* Parent Commission
Report, The)
Richardson, Sarah J. 106, 118–21, 123
Rochais, Father André 248, 253,
256, 267
Rogers, Bishop James 25, 72
Rogers, Carl 248, 253
Rogers, Sister Martina SC 72
Roman Catholic/United Church
Dialogue 240
Roman Congregation for
Consecrated Life 252
Rondeault, Father Pierre 278
Rosier, Madeleine Fernande (*see*
Rosier, Mother Marie OSU)
Rosier, Mother Marie OSU 211
Rosie's Place, Boston 82
Royal Commission of Inquiry on
Education report, 1965 (*see*
Parent Commission report)
Ruether, Rosemary Radford 241, 263
*Rules and Customs of the Daughters or
Sisters of Charity, Servants of the
Poor and the Sick* 218, 221

S

Sacred Heart School, Meteghan 73
St. Ann's Academy, New Westminster
286
Saint Ann's orphanage, Worcester,
MA 139
Saint Anne's parish, Eel Brook 73
St. Augustine's Seminary, Toronto 233
St. Basil's Seminary, Toronto 238
St-Bernard's School, Moncton 27, 30
St. Boniface Major Seminary 249
Saint Bridget's Refuge, Montreal 142
Saint Francis Xavier College,
Antigonish 74
Saint-Jean-de-la-Croix, Sister SGM
132, 143
Saint John High School 48, 52, 53
Saint John's Convent, Halifax 74

Saint Joseph Hospice, Beauharnois, QC 138
St. Joseph's Academy, North Bay 195
St. Joseph's Church 73
St. Joseph's College, Toronto 232
St. Joseph's Hospice, Saint Benoit, QC 133, 143
St. Joseph's Hospital, Fort Vancouver 155
St. Joseph's Hospital, Port Arthur 204
St. Joseph's Hospital, Vancouver, WA 158
St. Joseph's Mission, Williams Lake, BC 281, 282
St. Joseph's Orphanage and Convent 73
St. Joseph's parish, Halifax 73
St. Joseph's School, Saint John 46
St. Louis College, New Westminster 287
St. Malachy's Hall, Saint John 45, 46
St. Malachy's Memorial Boys' High School, Saint John 53
Saint Mary Academy, Church Point, NS 73
Saint Mary Convent, Halifax 70–71, 73, 75
St. Mary's College, Notre Dame, IN 231, 232, 233
St. Mary's Hospital, Minnesota 161
St. Mary's Mission, British Columbia 277, 278, 284, 285, 287
St. Mary's Mission Girls' School, British Columbia 278, 284, 285
Saint Mary's parish, Church Point 73
Saint Mary's School, Halifax 72
St. Michael's College, Toronto (see University of St. Michael's College, Toronto)
St. Michael's High School, Belleville, ON 220
St. Patrick parish, Halifax 71
St. Patrick's Church, Halifax 71

St. Patrick's Convent, Halifax 71, 73
St. Patrick's parish, Roxbury, MA 74, 78
St. Patrick's School, Arvida 77
St. Patrick's School, Halifax (see also Central High School, Halifax) 73, 78, 89
St. Patrick's School, Saint John 38–9, 45, 46
Saint Paul University, Ottawa 231, 238, 243
Saint Paul's Hospital, Saskatoon 133
St. Peter's parish, Dartmouth 72
St. Peter's School, Dorchester, MA 97
St. Teresa's Retreat, Halifax 74
St. Vincent's Boys' High School, Saint John 53
St. Vincent's Boys' School, Saint John 53
St. Vincent's Convent, Saint John 46, 48, 50
St. Vincent's Girls' High School, Saint John 52, 53, 55
St. Vincent's High School, Saint John 49, 50, 52
St. Vincent's School, Saint John 45, 46, 48, 49, 51
Sainte Anne de Ruisseau parish (see Saint Anne's parish, Eel Brook)
Savoie, Alexandre 26
Say Little, Do Much: Nursing, Nuns and Hospitals in the Nineteenth Century 152
School of Sacred Theology, Notre Dame, IN 232
School Sisters of Notre Dame 209
Schools Act (New Brunswick, 1966) 54
Schneiders, Sandra 236, 237–8
Scollard, Bishop Dennis J. 197
Second Vatican Council 8, 55, 130, 210, 223, 230, 231–42, 248, 249, 250, 254, 263
Second World War 55, 92, 95

Segale, Sister Blandina SC 161
Seghers, Archbishop Charles John 281
Seltice, Chief 154
Seton, Mother Elizabeth Ann SC 13, 69, 70, 80, 82
Seton Academy, Vancouver 80
Seton Hall High School, Patchogue, NY 80
Sheehan, Sister Mary Ellen IHM 239
Shortland, Mary (*see* Bernard, Sister SCIC)
Sister Formation Movement 77, 231, 249
Sisterhood of St. John the Divine 16
Sisters for the 21st Century 77
Sisters of Charity of New York 11, 24, 70, 71, 78, 98
Sisters of Charity of Quebec 15, 24, 25
Sisters of Charity of Saint Vincent de Paul, Halifax 10, 11, 12, 29, 30, 69–82, 87–99
Sisters of Charity of the General Hospital of Montreal (*see* Grey Nuns)
Sisters of Charity of the Immaculate Conception 11, 13, 14, 22, 23, 26, 27, 29, 30, 31, 32, 38–55
Sisters of Charity of the Incarnate Word 161
Sisters of Charity of Providence of Montreal 217
Sisters of Mercy 16
Sisters of Miséricorde 88
Sisters of Providence, Montreal 11, 14, 15, 153–67, 281, 282
Sisters of Providence of Saint Vincent de Paul of Kingston 11, 13, 217–25
Sisters of St. Ann, British Columbia 11, 14–15, 274–88
Sisters of Saint Anne, Quebec 275–6, 287

Sisters of St. Joseph, Canadian Federation of the 193
Sisters of St. Joseph, Toronto 10, 14, 93–4, 191, 231, 236, 241–2
Sisters of St. Joseph of Peterborough 14, 191, 192–6
Sisters of St. Joseph of Sault Ste. Marie 192–6, 198
Sisters of St. Margaret 16
Sisters of St. Martha, Antigonish 10, 74
Sisters of Service 10, 17
Sisters of the Child Jesus 288
Sisters of the Church 16
Sisters of the Good Shepherd 285
Sisters of the Immaculate Heart of Mary 233
Sisters of the Presentation 243
Slocum, Reverend 117
Smith, Martha 93
Society of Jesus (see Jesuit order)
Spigel, Lynn 103–4
Stanley, David 232
Stone, Col. William 117
Stray Bits of Verse 54
Sweeny, Bishop John 44, 49

T

Taylor, Mother Kathleen OSU 214–16
Teaching Profession Act (1944) 219
Tekakwitha, Kateri 263
Témoins 252
Temperance Hall, 45, 46
Tétreault, Sister Doris MO 248, 250, 251, 255–8, 260, 264, 265, 267
Thomas, Mother SCIC 52
Tobin, Sister Luke IBVM 235
Toronto Normal School, 178
Toronto School of Theology 233, 238–9
Toronto Teachers' College 231
Traxler, Sister Margaret SSND 209, 225
Trudeau, Sister Alice MO 248, 254, 257, 260–67, 268

Trudel, Sister Mary RHSJ 26–7

U

Université de Moncton 33
Université Laval, Quebec City 231
University of New Brunswick 59
University of St. Michael's College,
 Toronto 231, 232, 234, 238–9,
 243
University of Toronto 178, 231–2
University of Western Ontario,
 London 214, 215, 216
Ursulines 7, 10–11, 13, 15, 131,
 132, 141, 210–17, 223–4

V

Vanier, Jean 248, 254, 267
Vatican I (see First Vatican Council)
Vatican II (see Second Vatican Council)
Verge, Gabrielle L. K. 131
Viger, Sister Amanda RHSJ 25
Villeneuve, Father 144
Vincent de Paul, Saint 69, 70, 156
Vincentia, Sister CSJ 222

W

Wach, Joachim 275–6
WAITT House, Roxbury, MA 82
Wall, Barbra 156
Wallace, Sister Catherine SC 79
Walsh, Bishop William 70, 71, 72, 98
Walsh, Sister Evarista CSJ 199, 201
Walsh, Sister Francis Xavier SC 89,
 96
Ward, Mary, Institute of Mary
 172–4, 177, 183, 184, 186
Weber, Edward Joseph 143
Weeks, Clara 160
What Girls Can Do 48
White, Robert 110
Williams, Mary Margaret Eleanor (see
 Williams, Mother Genevieve
 OSU)
Williams, Mother Genevieve OSU
 13, 210–17, 223–5
Williams, Raymond 110

Witnesses 252
Women Helping Women, Queens,
 NY 82
Women in the Church: The Pain, the
 Challenge, the Hope 263
Women's History Conference of the
 International Federation of
 Historians 16
Women's Ordination Conference 240